Best Wishes, 1983
Sarah Davidson
Haida , B. C.

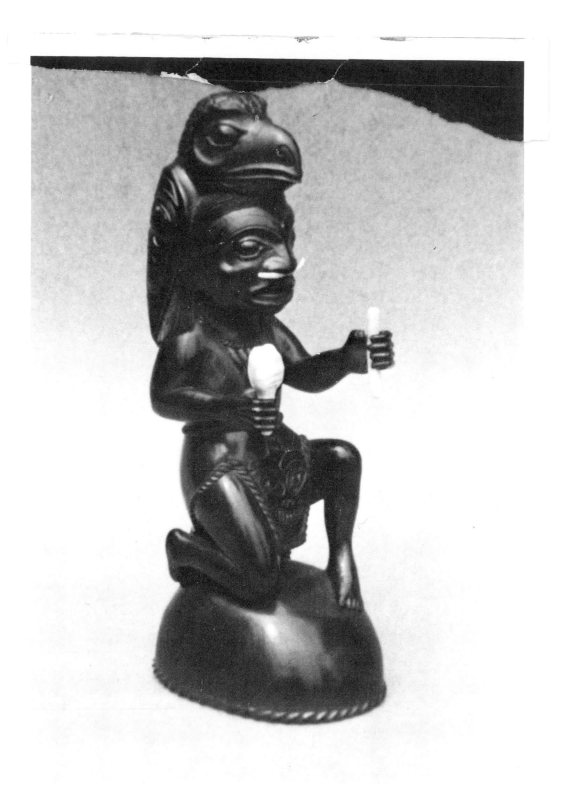

Shaman by Alfred Collinson, carved in 1977.
— *Duart A. MacLean. Courtesy Dr. Ray Martin*

ARGILLITE

Art of the Haida

by Leslie Drew
and
Douglas Wilson

ISBN 0-88839-037-8
Copyright © 1980 Drew, Leslie

PRINTED IN CANADA

Cataloging in Publication Data

Drew, Leslie
 Argillite, Art of the Haida

 ISBN 0-88839-037-8
 1. Haida Indians - Sculpture. 2 Haida Indians.
3. Argillite. 4. Indians of North America -
British Columbia - Queen Charlotte Islands -
Sculpture. I. Wilson, Douglas, 1943 - II. Title.
E99.H2D74 731'.7 C80-091137-7

Designed by NICHOLAS NEWBECK DESIGN

Distributed in the United States by
Universe Books, 381 Park Avenue South, New York, 10016
Tel (212) 685-7400

Published by
HANCOCK HOUSE PUBLISHERS LTD.
#10 Orwell Street, North Vancouver, B.C. Canada V7J 3K1

Contents

Dedication

To the forgotten carvers

Acknowledgments

Our thanks are due to many institutions and individuals who have helped and encouraged us in the preparation of this book. We are especially grateful to:

The First Citizens' Fund of the British Columbia government which provided a grant enabling Douglas Wilson to visit museums on this continent; the staffs of the British Columbia Provincial Archives and the Provincial Museum for their unfailing courtesy and patience; likewise, the National Museum of Man at Ottawa and the Public Archives Canada; the Department of Rare Books and Collections, McGill University Libraries; Surveys and Mapping Branch, Energy, Mines and Resources Canada; the Canadian Centre for Folk Culture Studies, National Museum of Man, National Museums Canada, for permission to use for publication the first paragraph of W.A. Newcombe to Marius Barbeau letter dated March 15, 1928; the United Church of Canada Committee on Archives; the Public Libraries Department, City of Birmingham, England;

Clifford Armstrong; Mr. and Mrs. Eli Abrahams of Masset; Reg Ashwell, Salt Spring Island, B.C.; Kathleen Bishop-Glover, Assistant Curator of Collections, Canadian Ethnology Service, National Museums Canada; Laura M. Bracken, Alaska State Museum, Juneau; Staffan Brunius, Etnografiska Museet, Stockholm; Julia Burnett, Curatorial Assistant, Glenbow-Alberta Institute, Calgary; Roy G. Cole, Hamilton, Ontario; Minnie Croft of Skidegate; Claude Davidson of Masset; M.S. Evick, Manager of Collections, The Devonian Group, Calgary; Dr. John C. Ewers, Senior Ethnologist, Department of Anthropology, Smithsonian Institution, Washington, D.C.; Anne Fardoulis, American Department, Musée de l'Homme, Paris; Dr. Christian F. Feest, Museum für Völkerkunde, Vienna; Knut R. Fladmark, Department of Archaeology, Simon Fraser University, Burnaby, B.C.; Sandy and Daryl Foster, Victoria; Dr. Helmuth Fuchs, Curator-in-Charge, Royal Ontario Museum, Toronto; Trisha Gessler, Curator, Queen Charlotte Islands Museum Society; Rolf Gilberg, Curator, the National Museum of Denmark, Copenhagen; The Council of the Hakluyt Society, for permission to quote from *The Journals of Captain Cook*, edited by J.C. Beaglehole; Ron Hamilton at Port Alberni; Kathleen Hans of Skidegate; Deborah G. Harding, Registrar, the Florida State Museum, University of Florida; Dr. Horst Hartmann, Museum für Völkerkunde, Berlin; Rev. Lloyd Hooper, Chemainus, B.C.; Dale Idiens, Assistant Keeper, the Royal Scottish Museum, Edinburgh; Jonathan C. H. King, Assistant Keeper, Ethnography Department of the British Museum, for his unstinting assistance in providing information of various kinds; Renée Landry, Archives, Canadian Centre for Folk Culture Studies, National Museums Canada; Carole Kauffman for permission to quote from her doctoral dissertation on argillite; Leona Lattimer, Manager, Centennial Museum Gift Shop, Vancouver; Dr. Robert Levine, Linguistics Division, British Columbia Provincial Museum; Lavina and Bill Lightbown at Haida; Professor R.D. Lockhart, Honorary Curator, Anthropological Museum, Marischal College, University of Aberdeen, Scotland; Dr. Andreas Lommel, Staatliches Museum für Völkerkunde, Munich, and Callwey Verlag, for permission to quote from *Shamanism: The*

Beginnings of Art; Jean Low, Atherton, California; Peter Macnair, Senior Ethnologist, British Columbia Provincial Museum; Robert McMichael, the McMichael Canadian Collection, Kleinburg, Ontario; Carol E. Mayer, Assistant Curator, Ethnology Division, Centennial Museum, Vancouver; Dr. Marjorie Mitchell, anthropologist at Camosun College, Victoria, who edited this text for its ethnographic content; Donald W. Munro, M.P.; Phil Nuytten, Vancouver; Margaret Jean Patterson, Curator, Museum of Northern British Columbia, Prince Rupert; Alice E. Postell, former Curator, Sheldon Jackson Museum, Sitka, Alaska; Julian Reid, who architected this text; Dr. Atholl Sutherland Brown, Chief Geologist, British Columbia Mineral Resources Branch; Stephanie Steel, Victoria; Dr. D.A. Swallow, Assistant, University Museum of Archaeology and Anthropology, Cambridge, England; Dr. Jaap H. van den Brink, The Hague; Pirjo Varjola, Curator, Museovirasto, Helsinki, Finland; Ronald L. Weber, Research Assistant, Field Museum of Natural History, Chicago; Richard S. Wilson, Skidegate; Vicky Wyatt, New Haven, Connecticut; Robin Kathleen Wright of Seattle, for permission to quote from her thesis on argillite pipes; and Professor Otto Zerries, Staatliches Museum für Völkerkunde, Munich.

We also thank the many private collectors who allowed us to examine and, in some instances, to photograph their collections of argillite.

Foreword

Marjorie Mitchell,
Department of Anthropology,
Camosun College, Victoria
August 7, 1980

Haida argillite carving has captured the interest of non-Indian buyers and collectors for over a century, but only in the past thirty years have a handful of students of Northwest Coast art and culture attempted to focus systematically upon the vital attributes of this unique aesthetic adventure. Fewer still have attempted to direct their analyses beyond the academic audience to a broader public, including that ubiquitous, often maligned, but economically necessary individual — the tourist.

With the publication of ARGILLITE *Art of the Haida*, Doug Wilson and Leslie Drew provide us with an ambitious yet thoroughly satisfying undertaking. Argillite master craftsman of Haida descent and journalist-newspaper editor have collaborated to make the world of Haida argillite carvers and their work intelligible not only to Haida artists and other serious scholars, but also to experienced collectors, first time buyers, and those who simply stand appreciatively before displays of those elegant black sculptures.

While recognizing, as Gunther notes, that the slate carving of the Haida is a "truly 'tourist' art . . . [whose] style changed with the demands and influence of the visitors to the Queen Charlotte Islands,"[*] the authors have not been content with this traditional model of Indian-white contact. Rather, they have probed further to examine not simply a one-way influence in which standards and tastes in the Euro-Canadian and American markets dictate style and form to Haida artistic endeavours, but the subtle and not-so-subtle interplay between native and non-native cultures, between the creative imagination and skill of Haida carvers, and the acknowledgment by a largely non-Indian audience, of that extraordinary inspiration, and between a wide range of economic, social, and symbolic factors that gave argillite carving its initial impetus and sustained it through to its present-day renaissance.

In addition, this collaborative effort on the part of the authors is more than a meticulous description of design elements and the symbolism of crest forms, just as it is more than a well-researched chronicle of Haida-European contact. Disclaimers to anthropological training notwithstanding, the writers' attention to ethnographic detail is evidence of their joint appreciation that art cannot be truly understood outside of the cultural framework that shapes artist, artistic process, and finished product.

Finally, as they sketch the life history of one artist or describe the carving style of another, we glimpse something of the variety of roles each carver in argillite may play: cultural conservator, taking familiar forms from nature and Haida mythology to render them anew, within the confines of traditional aesthetic principles; innovator, experimenting with design elements and themes from new cultures; historian, recording in panel pipes and skilfully-executed figures of European sailors, colonial women, and Christian angels, the chronicles of Haida-European contact; and contemporary myth-maker, symbolically recounting in argillite experiences that occur within the artist's own lifetime.

This book, then, brings Haida carver and argillite carving out of their "splendid isolation" and into the intellectual reach of all who would know Raven, Eagle, and the cool black slate that is their transformation.

* Erna Gunther: "Northwest Coast Indian Art", in *Anthropology and Art, Readings in Cross-Cultural Aesthetics*, edited by Charlotte Otten. Garden City, N.Y.: Natural History Press, 1971, p. 329.

Introduction

By Leslie and Frank Drew

In the autumn of 1976 Douglas Wilson came to our apartment in Victoria. He wanted to see a few jet-black stone carvings we had collected. The first thing we noticed about him was how he handled the carvings. It was the way a connoisseur examines rare porcelain, only with him there seemed to be a personal, deeper affinity with the object. He looked at them one by one, slowly, from every angle, scarcely saying a word. Very lightly, he ran a finger over the cool, glossy surfaces. Without ever being told, he knew who had carved them.

Douglas Wilson is a Haida from the Queen Charlotte Islands off the northern British Columbia coast, the westernmost islands of Canada. For generations his people have been making these carvings from a peculiar slate called argillite (pronounced with a soft "g.") Wilson himself is a professional carver.

Argillite carving is the most exclusive of surviving Pacific Northwest Coast native arts. It could be argued that Chilkat blankets made by a Tlingit people on the northern mailand are exclusive too, but in their case the raw material — goat hair — can be obtained from many different sources. Argillite, however, is a unique slate that comes only from one isolated valley in the Charlottes. Its carvers have been the Haida, people who were at one time the sole occupants of these islands. They alone have custody over the deposit. From one "stone," one place, one people, argillite carvings have gone all over the world spanning a period of nearly two hundred years. That so much could come from so singular a source seemed incredible.

Equally surprising was the fact that little was known about argillite. The various names it had been given reflected the uncertainty — stone, black slate, shale, jadeite. On one occasion in 1940, an imaginative Detroit dealer had gone so far as to suggest that it came from outer space. He advertised a collection of argillite carvings as having been made from "jadeite from meteorites." Moreover, for a long time the academic community had relegated argillite to a status below that of other Northwest Coast native arts. It was thought to be derivative, an imitation of scrimshaw, a mere trade good, scarcely worth bothering about. "Due to the nineteenth century view that an ethnographic collection should reflect a pristine culture, there was never any great effort directed to collecting argillite," an eastern American museum says in explanation of the smallness of its collection today. Misnamed and underrated, argillite art has continued nevertheless. Carvers like Douglas Wilson quietly went on doing what generations of Haida carvers had done.

As Wilson studied our carvings, he discussed with us the uniqueness of the art, its perennial appeal to both academics and laymen, and how little the public knew of it. Throughout the 1960s, when we lived in Prince Rupert on the British Columbia mainland coast across from the Charlottes, we had taken an interest in various native art forms. We had often visited the Charlottes to talk with carvers, several of whom have since died. Wilson now brought us up to date. He spoke of accomplished young carvers whose works had never been publicized, even in magazines.

He also spoke of the lack of readily-available reference books to guide them in their renewal of a venerable art. Apart from several technical books by Marius Barbeau published in the 1950s, there was no book-length "popular" source dealing exclusively with argillite. Indeed, most books on Northwest Coast native art have been either comprehensive, highly-technical productions or illustrated catalogs prepared for museum or exhibition purposes. Yet there had been occasional magazine articles on the subject, and American university students were focusing attention on argillite. In 1969, Carole Natalie Kaufmann wrote a doctoral thesis, *Changes in Haida Indian Argillite Carvings, 1820-1910*, applying componential analysis to devise a method of establishing a chronology in Northwest Coast art. She had chosen argillite carvings because of the specific controls they permitted in contrast to most other categories of Northwest Coast art.

Meanwhile, a new generation of carvers had sprung up in the 1970s — carvers who were innovating as never before. So, too, a generation of North Americans was emerging that had been made aware of Northwest Coast native art and apparently was eager to learn more about it. It was time the argillite carver, the most prolific of these Northwest artists, received recognition in the eyes of a new audience.

Because all three of us wanted to know more about argillite, Wilson urged us to collaborate in writing a handbook as an illustrated guide for the modern carver, for the collector who has helped to sustain the art for many years, and for the novice who wants an introduction to this important art form. None of us had been formally trained in art history or anthropology, but Wilson, from years of earning his living as a carver and repairer of argillite, had developed the penetrating eye of experience. And although we are people of different cultural backgrounds, all three of us are British Columbians. Two of us had been born in this province and one, Wilson, while the youngest in years, was in truth the "oldest" British Columbian of us all. Like most Haida, he is intensely proud of being Haida. He feels as we do, that with an understanding of the art of his people, particularly of argillite carving, can come an understanding of the Haida themselves.

This book therefore, is our attempt to present for a general audience the artistic and historical significance of argillite. There will be errors, of course, both of omission and fact. We have chosen illustrations from as many sources as possible. These particular panel pipes, miniature poles, bowls, dishes, boxes and figurines from the glorious past and the highly-promising present are what we regard as outstanding specimens of the art. In search of them, and in company with Douglas Wilson, we visited the National Museum of Man at Ottawa and several other Canadian museums. Individually, we also visited museums in the United States and the British Isles. To them, and to the many other museums which we were unable to visit but which gladly provided us with information and photographs, we owe a deep debt of gratitude.

Much research remains to be done in identifying carvers' works

and styles. Science, as its techniques become more sophisticated, may one day be able to date argillite by chemical analysis. The succession of ownership of great works in argillite may eventually be traced more accurately. And Haida people like Douglas Wilson will continue to make their contributions to our knowledge of an art form that is at once their extraordinary heritage and their lasting gift to the world.

Wherever possible, the standard alphabet used by Northwesternists has been followed in the spelling of Haida words. A pronunciation guide for those spellings, in the Skidegate dialect, follows:

ǰ = j as in "judge"
ʌ = u in "but"
c̓ = made as "ts" but sounded in a manner that has no English equivalent
ŋ = ng in "sing"
ł = ll as in Welsh language
x̣ = a heavy "h"
G = like a "g" but made far back in the throat, where "ch" of "Bach" is made
ʔ = glottal stop as in Cockney "bottle"
λ = tl

Historical proper names are given in their most frequently used spellings, and are generally imprecise phonetically. For example, the place name Tanu should more correctly be written ṭanu.

CENTIMETERS	INCHES
2.54	1
25.4	10
50.8	20
76.2	30
METERS	FEET
1	3.28
5	16.40
10	32.80
30	98.42
70	229.66
100	328.08
KILOMETERS	MILES
1	0.621
5	3.107
10	6.214
50	31.069
70	43.496
100	62.137

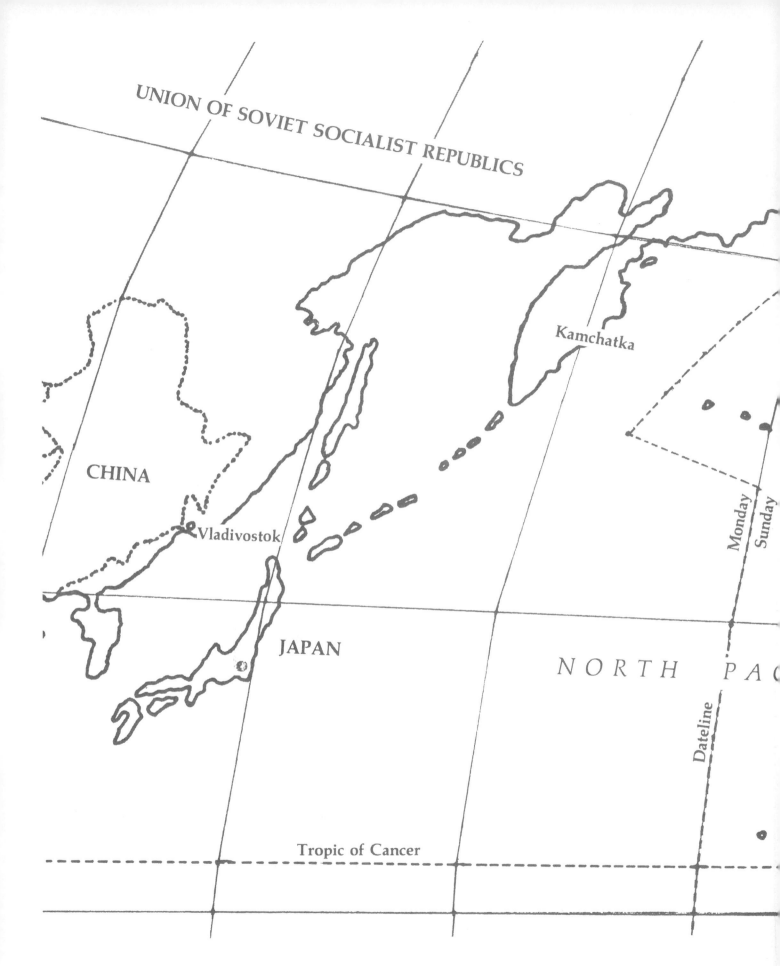

UNION OF SOVIET SOCIALIST REPUBLICS

Kamchatka

CHINA

Vladivostok

JAPAN

Monday

Sunday

NORTH PAC

Dateline

Tropic of Cancer

PART 1
An Old People in an Old Land

NORTHWEST TERRITORIES

ALASKA

YUKON

RING SEA

Yakutat B

CANADA

Sitka

BRITISH
COLUMBIA

ALBERTA

Queen Charlotte Islands

Vancouver

Victoria

Seattle

Columbia River

Portland

UNITED STATES
OF AMERICA

C OCEAN

San Francisco

Hawaiian Islands

F.WMD.

Map shows Haida and neighboring territories ● major Haida villages of the 19th Century and modern communities.

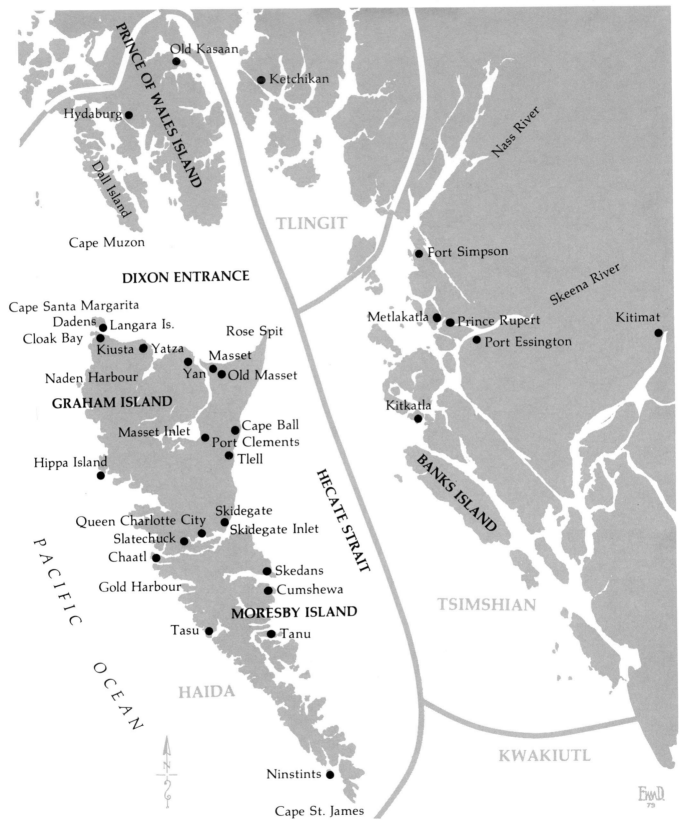

PRINCE OF WALES ISLAND

Old Kasaan

Ketchikan

Hydaburg

Dall Island

Cape Muzon

TLINGIT

Nass River

Fort Simpson

Skeena River

DIXON ENTRANCE

Cape Santa Margarita
Dadens ● Langara Is.
Cloak Bay
Kiusta ● Yatza

Rose Spit

Masset
Yan ● Old Masset

Metlakatla ● Prince Rupert
Port Essington

Kitimat

Naden Harbour

GRAHAM ISLAND

Kitkatla

Masset Inlet
Cape Ball
Port Clements
Tlell

Hippa Island

BANKS ISLAND

Skidegate
Queen Charlotte City
Slatechuck
Skidegate Inlet

HECATE STRAIT

Chaatl

Skedans
Gold Harbour
Cumshewa

TSIMSHIAN

MORESBY ISLAND
Tasu ● Tanu

PACIFIC OCEAN

HAIDA

KWAKIUTL

N

Ninstints

Cape St. James

EmmD
79

16

1.
A land apart

Haida carving in argillite is an honest, spontaneous expression of what the carver feels and sees. Essentially, the great ones speak to us through the slate medium. Their oration has been going on a long time, surging and slowing, altering gradually or dramatically as change has swept over the Haida people. So to try to understand the art form, we must first consider the Haida people themselves. We need to know what made them confident, proud, sensitive, individualistic. Culturally, they had much in common with their nearest neighbors, the Tlingit to the north and the Tsimshian to the east — shared customs, corresponding social organizations, and close trading links. Geographically, they were something else — aloof, sea-buttressed, distinct. They were people apart, just as their islands were a land apart.

Even today, a trip to the Queen Charlotte Islands is one of discovery. A sense of remoteness, at times approaching unreality, overtakes the visitor. It is partly the realization that the major North American population centers lie far away. The nearest city, Prince Rupert on the mainland coast, population 15,000, is about 130 kilometers distant. In between is Hecate Strait, named for the surveying vessel H.M.S. *Hecate* but also recalling, appropriately, the name of the Greek goddess of sorcery, for this can be one of the wildest bodies of water to be found anywhere in the world. Normally, today, the visitor makes the crossing by air.

The Charlottes are actually a cluster of more than 150 islands strung out 320 kilometers long, and triangular in shape, like a tooth in the maw of the North Pacific. Put together, they would form a land mass not much bigger than the province of Prince Edward Island and less than half the size of the combined Hawaiian Islands. They are situated almost opposite the Soviet Union's Kamchatka Peninsula. The warm Kuroshio current, sweeping around the Pacific Rim, tempers the climate so that although the Charlottes are at a latitude approximating that of Petropavlovsk and of Goose Bay, Labrador, the temperatures are much less severe. The annual average is 8 degrees C., and the lowest temperature ever recorded, 19 below zero C. During a cold snap in late December, 1968, a float plane due to leave Port Clements for Prince Rupert was almost prevented from taking off because the saltwater of Masset Inlet was freezing on its pontoons. Normally the temperatures are comfortably mild on the seashore strips, the only inhabited parts of the Charlottes.

The weather is another matter entirely. Because the Charlottes sit in the path of storms spawned in the Gulf of Alaska, they are first to receive what weather forecasters euphemistically refer to as "disturbances." Storms can be fiercer here than anywhere else on the British Columbia coast. The highest wind velocities have been recorded at Cape St. James, at the southernmost tip of the Charlottes. A sustained velocity of S.S.E. 176 kilometers per hour was recorded there in October, 1963. It was calculated as gusting up to 237 kilometers an hour. The intensity of storms is matched only by the changeability of the weather, which can be deceptively calm one moment and whip up raging seas in a few hours. After days of scudding black clouds passing in endless succession, comes a day of brilliant sunshine. It bursts on the landscape with a clarity like

the dawn of creation. On days like these, along the North Beach, mirages appear off toward the mountains of Alaska. Mystifying rose-tinted forms rise, flicker and then fade under the changing skies.

Phenomena of a more permanent kind exist the length and breadth of this grandly lonesome land. Far to the south off Moresby Island, one of the two main islands of the Charlottes, hot springs bubble and steam. From the central highlands, eternally snow-capped mountains rise to a height of 1,200 meters. On the wave-pounded west coast, mountains drop straight into the sea. Newton Chittenden, exploring the islands for the British Columbia government in 1884, asked about that seldom-visited terrain. His Haida guide replied wryly: "There is no land, it is all mountains, forests and water."[1]

Peculiarities also crop up in plant species. Close by the banks of the Yakoun River stands a golden spruce tree, a biological freak in color. Certain plants, especially in the Moresby Island area, are found only on the Charlottes and nowhere else on earth. Others differ greatly from their mainland counterparts. Of the animals on the islands, the black bear also differs from its mainland cousins, as does the weasel. And the islands once supported the Dawson caribou, a mere meter-high member of the deer family, now believed extinct.

Pat McGuire's ink drawing evokes the lonely spirit of the land.

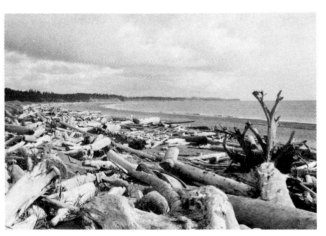

Driftwood-laden beach at Tlell, looking north-ward.
— *Government of British Columbia*

Thus, in many respects this is an unusual land, inviting exploration and further discovery. If the first-time visitor should need any additional excuse for returning there is always St. Mary's Spring which constantly refreshes itself and is located by the roadside south of Tlell. Legend says that all those who drink here will return to the islands.

It is a blustery November day in 1978 as the three of us fulfill the promise of those waters. We travel by seaplane from Seal Cove at Prince Rupert to Masset on the northern Charlottes, a forty-minute flight. In this weather we would just as soon not be flying, and everyone aboard chatters nervously.

The passengers are the usual assortment. A few whom we do not

know look as though they might be commercial fishermen. There is an accountant paying his weekly visit to a branch office in the Charlottes. Two Haida women returning from a shopping trip to Prince Rupert. An elderly man from Thunder Bay, Ontario, who is on a sentimental journey spent a year on the islands fifty years ago as a young logger. Feeling at home among other northerners, he immediately strikes up a conversation.

After steering a course that avoids "deadheads," butt ends of driftwood floating in the harbor, the plane rises, teeters on a strong gust, then heads toward Metlakatla Passage where an ominous black cloud bank merges with the dark forms of offshore islands. In no time at all, it passes over Digby Island and then, at an altitude of sixty meters, runs into thick fog and heavy rain.

Looking across the aisle, we notice that "Thunder Bay's" hands have a firm grip on the arm-rests and that his knuckles are white. "Looks a bit dicey," he says. The pilot, visible through the open cabin door, wriggles in his seat, puffs hard on his pipe and leans forward at the controls, trying to see what's ahead.

We passengers fall silent. Plainly, this is no time for talk. After bringing the plane down to thirty meters, the pilot regains visibility — and sees more than he had wished. He banks sharply left, out of the path of an islet bristling with dark green trees and a few dead gray ones, snags of the sky. Breathing a sigh of relief, he adjusts his pipe, and then, having navigated the squall safely, sets a course due west across Hecate Strait.

More islands pour back beneath the plane. Soon there is only a vast expanse of gray ocean flecked with whitecaps. Before long there appears the faint outline of the northeastern coast of Graham Island, the better known, more populated of the two main islands of the Charlottes. A broken whited line runs northward. What we are seeing is a sandcliff headland which tapers into a long, foam-fringed tusk called Rose Spit, whose shoals have long been notorious to mariners. Behind the spit, the landmark of Tow Hill rises from muskeg swamps. Our plane passes over the spit, then follows the fabled sands of the North Beach, and finally dips into Masset harbor at the head of Graham Island's inland sea, Masset Inlet.

Masset, the white man's settlement where we disembark, is a place of wide roads and few people. Oil tanks, the spars of fishboats, and a fish processing plant break the flatness of land and sea. The houses are wood-frame, most of them modest. The majority of the residents are government employees, fishermen, loggers, shopkeepers, some of them descendants of the first white settlers of eighty and ninety years ago. Close by is housing for a defense communication installation opened in 1972, a far westerly arm of a continental tracking system.

A kilometer or so along the shore from Masset's business center, separated from the town by a strip of undeveloped land, is the native village of Haida, formerly called Old Masset. At one time, just beyond living memory, it had post and beam Haida houses, giant weather-beaten cedar totem poles facing seaward, and rows of canoes on the beach. Today, its houses look much like the ordinary wood-frame houses of Masset or any other small community in British Columbia. A few vestiges of the Haida past are

preserved in the Ed Jones Memorial Museum. Otherwise, little remains visible of what existed when the Charlottes belonged exclusively to the Haida.

Yet this village has the largest concentration of Haida people anywhere today — 1,000 men, women and children — living primarily on the proceeds of commercial fishing and logging. The only other Haida village is Skidegate, 150 kilometers to the south, with a population of 400. Together they make up nearly half the total population of the Charlottes. In addition, an estimated 2,000 Haida reside elsewhere in British Columbia, mostly in Prince Rupert, Vancouver and Victoria. There are also Haida in Alaska, descendants of those who, scientists say, migrated to Dall Island and Prince of Wales Island, possibly about the year 1700.

To get from the north shore of Graham Island to the island's southern end on Skidegate Inlet, we rent a car. The highway south from Masset takes a lonely path through stands of Sitka spruce and cedar trees. Jack pines, standing like little old men, guard scenic meadows of muskeg. Logging tracks intersect the road at intervals. The highway bypasses Port Clements, a little settlement at the south end of Masset Inlet, then strikes off on an almost straight tangent for twenty kilometers to the sand-dune seascape of Tlell. Here the only habitations are summer cottages of well-to-do Americans and Canadians who fly in for coho fishing in the Tlell River, and a few houses of resident whites, most notably the pioneer Richardson Ranch.

We stop briefly here to stroll along the beach, past grass-tufted dunes, and breathe the salt air. The mainland, which is clearly visible across Hecate Strait on a cloudless day, is shrouded on this gray afternoon. To the north, toward the river mouth, the bleached bones of a shipwreck continue to defy the storms.

For most of its forty-kilometer route from Tlell to Skidegate Inlet, the island's solitary coastal road hugs the shoreline. Can there be a drive like this anywhere else on the British Columbia coast, where you don't see a single soul, where you have beaches all to yourself? A wild, exhilarating sense of freedom seizes people who come here. One has the urge, like Zorba the Greek, to dance barefoot in the sand. Locals have been known to picnic on Tlell beach on Christmas Day. We had done so ourselves in 1968 just before the thermometer crashed to its record low. Christmas Day can be as good as any other day for hunting agates, shells, and glass floats that have broken from Japanese fishing nets and been swept across the Pacific.

But we must press on to Skidegate, close to the source of argillite carving. One wishes the road would go on forever since it is almost entirely within sight and sound of the sea. But no. It ends abruptly at Queen Charlotte City, a grandly-named white settlement that has never grown much beyond 1,000 residents. It is to Skidegate what Masset is to Haida — the white neighbor. It has existed since 1908 when a townsite was laid out and land sales were touted far and wide. Tacking "City" onto the name was part of the real estate promotion, a touch of prestige. For years the whites of "Charlotte" kept to themselves, as did the Haida of ancient Skidegate a few kilometers back on the road. But today, through intermarriage,

they mingle amiably. Relations between the two are generally friendly.

Why Skidegate alone of ancient villages in the "southern" Charlottes should have survived is at once obvious. The location is almost ideal: in the background, a heavily-forested mountain from which sparkling creeks issue; in front, a gently-curving bay with a pebble and sand beach; in between, enough land for housing. All this with a southern exposure. Compared with Haida (Old Masset), Skidegate has a slightly more prosperous, up-to-date look. It has several new houses, built by the men of the village when they are not logging or fishing. It has a modern, well-equipped recreation center for the popular winter sport of basketball. It has a new longhouse or meeting hall, and standing proudly in front of it is a cedar story-pole of the Raven moiety, newly carved by Bill Reid. Further on is a very old eagle-and-beaver pole that teeters in the wind, last of a once-magnificent phalanx of carved poles. At the other end of the village is the Queen Charlotte Islands Museum, of recent construction. Thus, at the physical limits, stand both old and new in cultural guardianship.

Back among his family and friends, Douglas Wilson receives the cordial reception that is everywhere accorded the return of the native. Word of his homecoming has already gone around the village. He stays at the home of his father, James Wilson. In the comfortable living room, the talk centers on a momentous coming event.

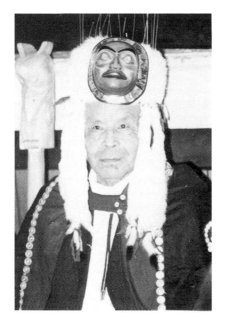

James Wilson as Gidansta, Chief Skedans.

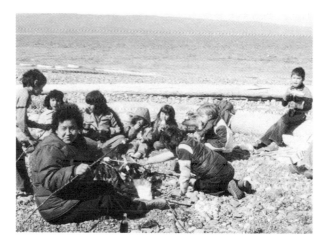

A Wilson family picnic on a sunny but cool March day 1980, a short distance from the bay of Skidegate village.

It seems that all his relatives' home deep-freezers are overflowing. For weeks his aunts have been baking pies and preparing salmon, abalone, octopus and red snapper. Douglas Wilson himself has brought a headdress from Victoria — a modern replica of the frontlet-type headdresses worn by Haida chiefs on ceremonial occasions. It is a beautiful object, complete with abalone shell and ermine ornamentation. The only concession to the twentieth century — and this to protect an endangered species — is that the bristles are made of plastic instead of sea lion whiskers.

The headdress will be worn by Douglas's father when he becomes the new hereditary Chief Skedans (Gidansta) in a few weeks'

time, in succession to his mother's late brother, George Young. Haida social organization is composed of two named divisions, called moieties by anthropologists. Membership in either the Raven or Eagle moiety is hereditary and is determined by one's mother's membership. Thus, every Haida belongs by birth to the moiety of his mother. These hereditary matrilineal moieties are further subdivided into more localized social groupings called lineages. Consequently, James Wilson is a Raven, his mother's roots in Skedans, a village south of Skidegate on Moresby Island. The village was abandoned in the last century. Because he is a Raven, the principal guests will be members of the "opposite" Eagle moiety. There will be Haida songs and dances and more than enough food for everyone.

In their homes the Haida speak either the English or the Haida language, or a mixture of both. Elders like Douglas Wilson's aunts and uncles are fluent in Haida. Younger members of the family may know only a few words, but they retain a passive knowledge of the language which enables them to pick up snatches of conversation. Most speak English eloquently, with slight traces of a Haida accent. Many of the older people went to a now-defunct residential school, Coqualeetza, in southern British Columbia. Today Haida children attend public schools on the Charlottes together with non-Indian children and at Masset there is a class in the Haida language to encourage its use among the young. Except at ceremonies, when speech-making goes on at great length, the Haida are not verbose. When working, they talk very little. They have always regarded silence as a virtue.

Beneath their restraint, most Haida people are gracious, generous, hospitable and sensitive — at times hypersensitive. Many possess a quiet, whimsical humor and wisdom. This wisdom comes partly from being good listeners — almost too good for their own good. If they disagree with an expressed opinion or even a statement of fact, they often refrain from saying so. It is considered rude to contradict. "A person is entitled to his or her own opinion. We never judge people," one Haida explains.

Right or wrong, this custom has not exactly encouraged the spread of reliable information about the Haida. It has, however, enabled them to come readily to an accommodation with other people. Most especially, this combination of humor and a philosophical outlook has sustained them through many years of poverty, disease, and worst of all, racial discrimination.

The Haida wisdom expresses itself in many ways. Right now, in the Wilson living room, children come in and greet Uncle Douglas. Then they settle down to watch television, to play games, and after a while to sit listening to what he has to say; how he made the headdress, what he has carved in argillite lately.

Uncles, especially the mother's older brothers, have an important place in the Haida family. "From our grandparents we learn the philosophy of life; from our uncles and aunts we learn the practical things of life," Haida Lavina Lightbown confides. "How can a mother or father be objective about their own child?" This is a clever lesson in psychology. In practice, it tends to produce a closely-knit family unit. The family indeed is all-important to the

Haida. Its ties are strong and durable.

Different though they are culturally, both Haida and white on the Charlottes have certain characteristics in common. Both accept whatever weather comes their way. Both ignore light rain as though it did not exist. "You always know when a person has been around these parts for some time," a forest ranger once told us, "when you see him standing in the middle of the road, bareheaded, talking to someone for half an hour while it is drizzling." And anywhere in British Columbia one can spot a Queen Charlotte Islander by a single betraying gesture. Wherever he goes he takes off his shoes at the door — in case he should track in mud.

Beneath these superficial customs lies something deeper which is related to the isolation of the Charlottes — a quality of timelessness. Nowhere is there anything resembling a sense of urgency. If someone fails to show up at an appointed hour, no matter — he will arrive. A cafe closes when the cook decides to go fishing for the day. Work gets done when it is the right time to work. And what is work, anyway?

True, work in the late twentieth century brings the wherewithal for material comforts. But the run of the tide, the set of the wind, the call of the birds must be listened to. The harvests of the sea — salmon, halibut, crab, clams, abalone — must be gathered at the right time. For the Haida there has always been an abundance of food, and in the midst of plenty, the thrill of the search equals the reward of the finding. Work becomes a satisfying pastime when it is done at their choosing. In fact, in everything the Haida enjoy doing and have done for centuries, work and pleasurable pastimes become one and the same.

In the past, argillite carving was very much a seasonal activity, done in the winter after the food-gathering months. At this very moment, during this month of storms, when the seas rage and flocks of migrating geese have thundered south, carvers are taking up their tools. Ron Wilson shows his cousin a design pencilled on writing-paper which he intends to follow for his next carving. Together, the two men sit across the coffee table and think about it. Each tries to visualize the finished work. The dreaming is almost as satisfying as the act of creation . . . almost.

Map of the Northwest Tribes

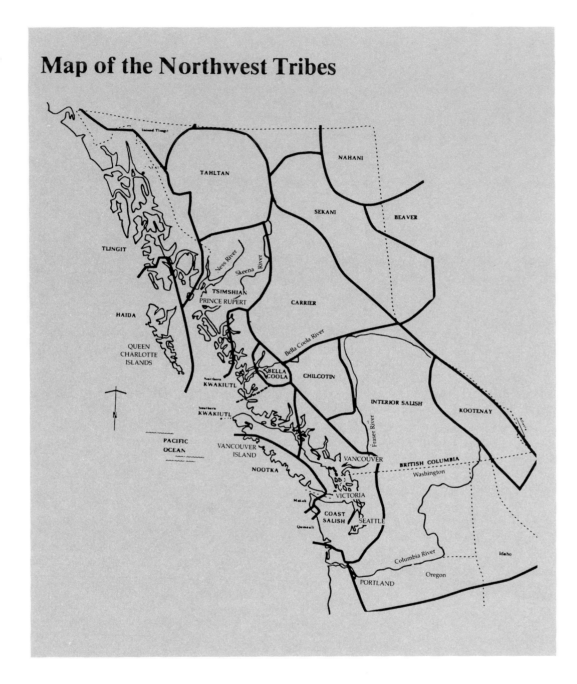

The Haida are an old people in an old land. Exactly how long they have possessed their island chain is not known, but they had probably been there thousands of years before the white man stumbled on them.

The first Europeans arrived in 1774 in the *Santiago*, commanded by Juan Perez, who had been ordered by the viceroy of New Spain to search out whatever lay between present-day California and Cape St. Elias, at 60 degrees north latitude, then the southernmost limit of Russian exploration. Perez and his men first encountered the Haida at Langara (North) Island, and his naming of Cape Santa Margarita on Langara was the first European place-naming to be recorded on the entire coast from Monterey to Cape St. Elias.[1] On that historic occasion, a ship-to-canoe exchange of goods took place, but the first white trader to deal seriously with the Haida did not come along until thirteen years later.

The trader was England's George Dixon, who sailed into Haida waters in 1787 and named the islands after his ship, the *Queen Charlotte*. Dixon had served with the famous navigator-explorer James Cook on his third and final world voyage. As an armorer aboard the *Discovery*,[2] Dixon had seen at Nootka Sound in 1778 what Cook alerted the western world to — the presence of innumerable sea otters, whose luxurious pelts Chinese mandarins were already buying at high prices from the Russians who were currently exploiting the Aleutian Islands. Dixon had realized then that an excellent opportunity lay waiting in the unknown Pacific Northwest, and had decided to become a merchant-navigator.

Financed by an English company, the two-ship expedition of which Dixon was part was the most ambitious to reach this coast since Cook's day. The commander was Nathaniel Portlock aboard the *King George* and, as was customary for trading efficiency and safety, the two ships coasted separately and rendezvoused later.

In July of 1787 Dixon put into a cove on North (Langara) Island. An enthusiastic William Beresford, ship's purser, wrote:

> A scene now commenced, which absolutely beggars all description, and with which we were so overjoyed, that we could scarcely believe the evidence of our senses. There were ten canoes about the ship, which contained, as nearly as I could estimate, 120 people; many of these brought most beautiful beaver (sea otter) cloaks; others excellent skins, and in short, none came empty handed, and the rapidity with which they sold them, was a circumstance additionally pleasing; they fairly quarrelled with each other about which should sell his cloak first; and some actually threw their furs on board, if nobody was at hand to receive them; but we took particular care to let none go from the vessel unpaid. Toes (iron wedges with a cutting edge) were almost the only article we bartered with on this occasion, and indeed they were taken so very eagerly, that there was not the least occasion to offer any thing else. In less than half an hour we purchased near 300 skins, of an excellent quality; a circumstance which greatly raised our spirits, and the more, as both the plenty of fine furs, and the avidity of

2.
A people apart

the natives in parting with them, were convincing proofs, that no traffic whatever had recently been carried on near this place, and consequently we might expect a continuation of this plentiful commerce. That thou mayest form some idea of the cloaks we purchased here, I shall just observe, that they generally contain three good sea otter skins one of which is cut into two pieces, afterwards they are neatly sewed together, so as to form a square, and are loosely tied about the shoulders with small leather strings fastened on each side.[3]

Dixon named this place of good fortune Cloak Bay. He went on to pick up more furs, and in all on that memorable trip acquired 1,821 sea otter pelts. Other merchant-navigators — English, American, even French — soon followed in Dixon's wake, but he was the first to tell the world at large of the bonanza existing in the Charlottes. The combined Dixon-Portlock cargoes of 2,552 sea otter skins sold in China for $54,857 (Spanish dollars), a fortune in those days.

What the Haida thought of these strange people who bought the very clothing off their backs one cannot imagine. But trading they did like. They had long engaged in exchanging their own goods with the various other native peoples of the Pacific Northwest coast, whose territories stretched from Yakutat Bay at about 60 degrees north latitude south to 45 degrees or just south of the Columbia River mouth in present-day Oregon state. From north to south, these peoples were the Tlingit of present-day Alaska; the Tsimshian of the northern mainland coast of British Columbia, who were concentrated around the valleys of the Nass and Skeena Rivers; the Kwakiutl, who occupied the central coast and part of northern Vancouver Island; the Bella Coola, who formed a pocket within Kwakiutl mainland territory; the Nootka of the west coast of Vancouver Island, whom Cook and Dixon had encountered; and the Coast Salish of southwestern British Columbia and western Washington state. Through kinship with the Kaigani Haida of the southern half of Prince of Wales archipelago, the Haida of the northern Charlottes had a corridor into Tlingit lands. Dixon Entrance, the body of water separating the Charlottes from the Kaigani Haida, was a much-used canoe crossing. It is only twenty-five kilometers from Langara Island to Cape Muzon. For as long as the Haida traveled by canoe, when visiting the Tsimshian at Kitkatla and villages near the mouths of the Nass and Skeena Rivers, they would coast along the northern route in risky weather, knowing it to be shorter and thus safer than the direct Hecate Strait crossing.

In the ancestral homeland in the Charlottes, the Haida had built widely-separated villages along the deeply-indented, tree-lined shores and on the offshore islands. Each village — and they were not large — spoke its own dialect of Haida, itself a language that the linguists call an "isolate" — that is, one totally unrelated to any other language, like that of the Basque of Europe and the Ainu of Japan. While linguists say it contains words borrowed from the Tsimshian and Tlingit, the basic vocabulary, at one time believed to be distantly related to Athapaskan with which the Tlingit language is thought to be remotely linked, is now considered unique, neither sharing a vocabulary nor having an ancestral form in common with

CEDAR BOX.

Sketches from the Dawson Report of 1878, published in the Geological Survey of Canada *Report of Progress for 1878-79*, showing Haida household and ceremonial equipment.

— *Geological Survey of Canada*

any other language in the world.[4]

The Haida also had their own social structure, a class system with wealthy leading families at the top, a broad middle class and, at the bottom, slaves taken in forays against mainland villages. Food was as close as the seashore. Time swung on the seasons and the stars. The word Haida means simply "people" — people of the islands. This was a nation to itself, protected by forbidding seas. Other native people the length of the Northwest Coast knew the Haida as a people apart. Others came *via* the sea; the Haida came *from* the sea.

The Haida islands were incredibly rich in resources per capita. In 1840, there were thirteen villages which contained, it has been estimated, nearly 7,000 people in all.[5] While that estimate was probably low, the fact remains that they nevertheless lived in the midst of a seafood pool that now helps to feed the entire world. If we could see with the eagle's eye as he soared around the pristine Haida domain, we would observe some of the myriad resources available to the Haida: teeming halibut banks off Langara Island, streams alive with trout and spawning salmon, prolific clam beds, bird colonies whose nests supplied eggs, Eden Lake and Cumshewa Inlet on whose shores grew big cedars for canoe-making, berry patches, bogs yielding plants that made medicines. Each village, averaging 500 residents, had freshwater streams nearby. The Haida knew what to use and how to use it. They had centuries of learning behind them.

Their family houses, arranged in rows in each of these permanent seaside villages, were remarkably substantial. They were made from cedars trimmed whole or split and hewn into planks so smooth that they appeared sawn, though crafted with tools no better than wooden wedges and hafted axes, adzes and hammers of polished basalt and nephrite. Inside, the ground area was either flat or stepped-down to a central fireplace from which the smoke escaped through an opening in the roof. Arranged around were the household belongings — storage boxes for dried salmon, grease, dried seaweed, berries and wild crabapples; boxes for storing traditional ceremonial dress, cedarbark mats to sleep on, pestles and mortars for grinding food, and tool kits of scrapers and knives. By the time the white man came, the Haida also had metal implements. Their iron is generally thought to have been retrieved from the wrecks of Japanese junks. Inside and out, the houses were decorated with carvings. The exterior carvings were house posts and poles, or designs cut into house boards and then painted with natural dyes. The Haida home was thus strikingly decorative at a time when most of the log cabins of white homesteaders in Lower Canada and vast regions of the American West were crude, barren places.

View of Cumshewa village, photo by George Dawson, 1878.
— *Provincial Archives, Victoria, B.C.*

RATTLE.

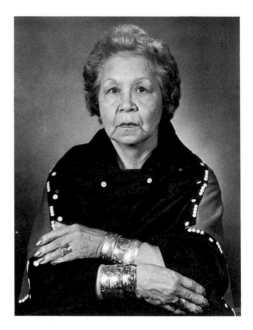

Gold and silver bracelets and rings adorn Douglas Wilson's "Auntie Minnie" — Mrs. Minnie Croft of Skidegate. She also wears her button blanket, successor to the traditional Haida ceremonial cloak.

— *Alex Barta*

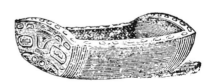

WOODEN TRAY.

This love of ornamentation extended from household surroundings to dress and person. The Haida garments were those famous sea otter cloaks and other furs, cedarbark wraps, and fine tanned leather jerkins and skirts brightened with feathers, shells and puffin beaks that were strung or sewn on by leather thonging. Tattoos of designs indicating heritage and ranks were also worn, as were nose pieces. Upper class women wore oval labrets or plugs in their lower lips. Lip piercing was an occasion for ceremony and the giving away of property. Each woman also wore several copper bracelets as additional ornamentation. "The deportment of the women in general," Dixon noted, "was decent, modest and becoming."

From the moment they first saw European and American dress fashions, the keen-eyed Haida were fascinated. Ornamentation did not have to serve a purpose; in their eyes it was admirable in itself. Indeed, the Haida were quick to give visiting sailors a new, historical appreciation of the frills they wore.

The American, William Sturgis, who first visited Haida territory aboard the fur-trading vessel *Eliza* in 1799, engaged in small talk one day with a Haida chief he called Altatsee, a name that survives today in the argillite-carving Yeltatzie family. Sturgis, young and nosey, questioned the chief as to why the Haida should adorn themselves with brass and gilt buttons and old keys that seemed wholly out of place. Altatsee replied that he had noticed that the American also used buttons that served no purpose — he "could never discover the usefulness of a half dozen buttons upon . . . coattails." Moreover, if keys had to be polished for dress wear, what about the brass balls he had heard of upon iron fences in front of American houses, that had to be "polished every day and tarnished every night?"[6] The logic defeated Sturgis.

We use the word "art" very broadly these days: the art of painting, the art of house building, the art of tattooing, the art of dress designing, the art of macrame. The original Haida craftsman had no such self-important notion of what he did. He simply followed ancient practice when he ornamented himself, his clothing, his houses and his villages. Everything that he collected from nature which could be elaborated upon he did elaborate upon, in a very distinctive way. Educated Europeans were not slow to recognize this extraordinary expression of the culture, even though it was totally alien to them. "One could call the Haida, and also the Bella Bella, Tsimshian, and Tlingit . . . nations of artists, for there is nothing they use that is not skilfully decorated with meaningful designs," the Norwegian Adrian Jacobsen wrote on visiting the North Coast nearly a century ago. In the case of the Haida, he cited their carved wooden dishes, mountain goat horn spoons, and their "stone pillars" — a popular term of the day for argillite totem poles.[7]

The tall, blond Jacobsen, himself a northerner, was echoing what members of a French scientific expedition had been astonished to find nearly a century earlier. These men sailed in the world voyage of the *Solide*, led by Etienne Marchand, in 1790-92. Looking at Haida houses at Langara Island, the Frenchmen were amazed to see "paintings everywhere, everywhere sculpture, among a nation of hunters."[8] One observer, ship's surgeon Claude Roblet, was parti-

cularly impressed by the musical instruments he saw in the houses.

The Frenchmen, and all the early visitors, stopped by during summer months when their sailing ships were less likely to come to grief in storms. Had they called in the winter, they might have been invited to attend a full range of ceremonials featuring Haida singing, dancing and instrument-playing. As it was, the summer visitors were given an immediate reception in song. The first fur traders reported that from every village, canoe-loads of Haida approached their ships singing. Before and after every transaction, a song was sung. Singing accompanied almost every formal act of Haida life. There were songs of war, of love, of welcome, of life, of death. Songs went with the dances that surged through the winter ceremonials in the permanent villages. The sounds of rattles, drums, whistles and other sound-making devices, properly timed, gave dramatic emphasis.

The dances, performed at a variety of winter ceremonies, were group or solo acts. Not all were especially strenuous but made up instead of subtle, swaying, rhythmic body movements honoring the event being celebrated. The role of dance was central in the inter-relationship between the applied and performing arts that involved story-telling, song and dance composition, and costume. In fact, Bill Holm tells us, knowledge of dancing is essential to an understanding of the painting (and carving) art. "The constant flow of movement, broken at intervals by rather sudden, but not necessarily jerky, changes of motion-direction, characterizes both the dance and art of the Northwest Coast," he writes.[9] We see this same quality in Haida designs today, in the deceptive ease of direction changes. (This adroitness may not have been confined to depictive art; several observers, Chittenden among them, remarked on how a canoeist could turn a big canoe around suddenly, with merely one or two powerful paddle strokes!)

The songs and dances, including those freshly created for a particular occasion, were inherited through matrilineal descent. Everyone knew to which moiety and its particular family the songs and dances belonged. Legends and crests, those other symbols of lineage within moiety membership, were also inherited within the mother's line. (See diagram page 30.) All were property, or "real estate," just as much as were the family lands, ownership of which conferred the perpetual right to use of their resources (a salmon-spawning stream, a cedar stand), whether for the direct use of one's own people, or to exchange, or to give away.[10]

Elderly Haida of rank thus had more than material wealth to pass on. The intangibles they owned were of equal or greater value than their property in the modern sense. So, to the property-conscious Haida, it was important that one's inheritor should be of one's own blood line. And since it's a wise child that knows its own father, the Haida in ancient times hit on a sensible scheme — inheritance would be through the matrilineal line. A man's heir was usually his sister's child. The position of chief was (and remains to this day) hereditary, usually passing to a sister's son. In the rare event that there is no male heir, a chief's sister or his sister's daughter could inherit the position.[11] The presence of women chiefs in olden times was indicative of the high status of women.

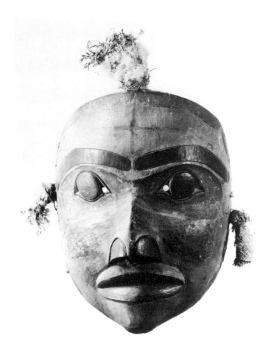

One of a great variety of Haida wooden masks.
— *National Museums of Canada, Ottawa*

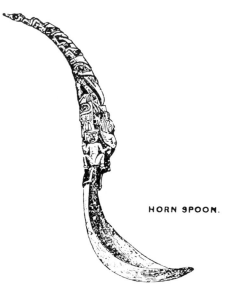

HORN SPOON.

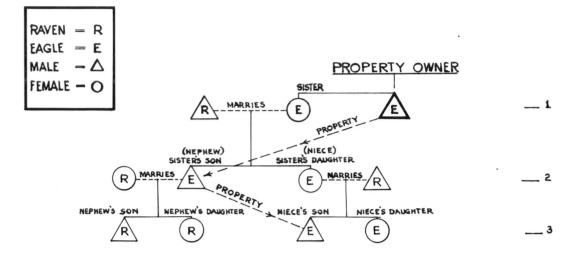

RAVEN = R
EAGLE = E
MALE = △
FEMALE = ○

PROPERTY OWNER

This simple diagram shows how property usually descends to a nephew within the moiety. The Haida system of inheritance is matrilineal, but does not constitute a matriarchy in that most property is controlled by a woman's brother. For example, the Eagle heir on line two will inherit property including names, crests, house, etc., from his mother's brother.

We have mentioned the two Haida moieties, Raven and Eagle. (Moiety and phratry both refer to exogamous divisions. The word moiety, whose French root means "half," is commonly used in referring to societies that are divided into two halves, such as those of the Haida and Tlingit. Phratry denotes a four-part system such as the Tsimshian have.) Within the two Haida moieties are lineages and family groupings each having their own crests, the legend-linked symbols of background, more important in personal identification than the name Raven or Eagle itself. Crests, too, were passed down through the mother's line, the importance of each being ordered by lineage tradition.

The particular combinations of crests owned, and their order of importance, would vary from family to family and from individual to individual within a lineage. Several factors determined the relative importance of each crest, including the exclusiveness of the legend to which the crest was attached. Crests could be granted to a person in his lifetime and a person could inherit his father's crests by being adopted into his lineage. These are some of the reasons why it is almost impossible to establish the identity of an early argillite carver through his use of crests. The real complexity involved in determining who owned what and why, as in the case of other forms of inheritance, goes right back to the two-moiety, inter-marrying, matrilineal system.

The system meant, of course, that everyone was related to everyone else, distantly if not closely, even where a Raven or Eagle had selected a mate from a corresponding "opposite" division among the Tlingit or Tsimshian. To each village, this interlocking kinship structure gave unifying strength. A child growing up in the most isolated place had a sense of security and belonging which inspired self-confidence. As a young Eagle, for instance, he belonged to every other Eagle. At the same time, through his father he was affiliated with all the Ravens. His welfare was the general responsibility of a very extensive family.

At the top of the social structure were the chiefs. There were lineage chiefs, such as the Stastas Eagles, town chiefs, and there were household chiefs. Leading chiefs could wage war on other Haida villages, but these conflicts were more in the nature of raids than full-scale battles — responses to feuds that often started as challenges to a chief's right to his title or some other slight to family pride. The preferred method of hitting back was to demand payment in property. That hurt more. On the whole, a chief did not rule absolutely. "He has no power of compelling work from other members of the tribe," George Dawson wrote. "Should he require a new house he must pay for its erection by making a distribution of property, just as any other man of the tribe would do; and indeed it is expected of the chief that he shall be particularly liberal in these givings away, as well as in providing feasts for the people."[12]

"Givings away." This brings us to a flamboyant display of power which had a clever twist, the giving away of property in a ceremony that currently goes by the Chinook name of *potlatch*. Practiced by all coastal peoples, it was a redistribution of wealth by someone to mark some important event — a move up in rank, a house-building, the erection of a memorial totem pole, for instance — and it brought villagers together for days of feasting, dancing and ritual observances. The unique feature was that some guests had an obligation to return to the giver more than they received. At its extreme, property was actually destroyed to defy or humiliate a rival. In the last century, symbols of property such as coppers (copper beaten into shield shapes), canoes or blankets were sometimes thrown into the sea or burned. To the white man brought up in the Protestant work ethic, such "redistribution" or disposal of wealth was incomprehensible. He regarded the potlatch as heathenish, a waste of capital, impoverishing to some natives (who therefore became a charge to him), and a demonstration of contempt toward what he held most dear — money. In the official view, church and school could not flourish where potlatching held sway.[13] Colonial officialdom's immediate response was enforced crowd dispersal. Do away with these gatherings, and control becomes much easier; divide and rule. At the first opportunity, the authorities banned the potlatch.

With the hindsight we have today, the potlatch in its original time and place seems positively ingenious. In a wealthy society, it spread the riches and gave the distributors perpetual credit. All real wealth is based on scarcity, and any vigorous society that is not blessed with scarcity must create it. Surpluses must be dispersed, if only to keep people busy producing new wealth. Apart from economics, the potlatch played a vital role in maintaining family ties and social cohesion. This was what Church and State tacitly recognized when they said that church and school could not flourish (that is, be imposed) where potlatching held sway. The potlatch was also a dynamic stimulant to creativity in the arts. Everyone took part in preparations, whether in a major or minor role, from chiefs to slaves. Anticipation of the next festival gave infinite zest to life.

Potlatches were by no means the only occasions for ceremony among the Haida. The arrival of a Tsimshian group bringing oolachan grease, a much-valued oil rendered from a smelt-like fish,

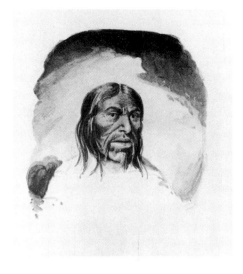

A Cumshewa chief, painted in watercolor by Paul Kane in Fort Vancouver, 1846-47.
— *Royal Ontario Museum, Toronto*

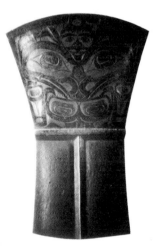

A great ceremonial copper.
— *National Museums of Canada, Ottawa*

would be worthy of a celebration. Any significant event in a person's life such as an initiation, the acquisition of a new name, a marriage or a mourning, called for a ceremony. Secret societies had their rites also. At the head places were the chiefs, and with them, the Indian doctors.

The shaman, or *sGaga*, now generally referred to as *śtˆw*, could be either a man or a woman and was recognized as having powers beyond those of ordinary mortals. He served as an intermediary for supernatural beings, and could temporarily lose his identity in the process. He was both doctor and clairvoyant, endowed with special skills and sensitivity and was consulted on all vital matters of life and death. Before taking a raiding party afield, a chief sought his advice on propitious omens concerning the weather and chances of victory. The shaman's insight enabled him to interpret, from dreams or visions, into precisely which child the spirit of a dead person would return. And, by the use of an instrument called a soul-catcher, he could reputedly capture the departing spirit of a seriously-ill patient and with it restore full life.

Needless to say, he was handsomely rewarded for his efforts. Whether a general practitioner or a specialist, he was a highly-paid professional, like doctors today. The name *sGaga* was derived from a word meaning long-haired ones. Shamans of both sexes wore their hair long at the back and tied in a knot on the crown of the head.[14]

Unfortunately, little is known about shamans and their knowledge and practice. Even to the Haida they were shadowy figures because they lived apart. Each *sGaga* and his one or two apprentices kept most of their arcane knowledge to themselves. If their secrets were disclosed to others, they stood to lose their powers, which seems reasonable enough: any secret revealed ceases to be a secret. And before the piercingly cool eye of modern science could be focused on the shamans, they had collided head-on with the missionary and come out bitter losers. They lost partly on medical grounds — to vaccines and chemical pain-killers — yet when their profession died in the 1880s, so also died any hope of retrieval of the full range of their herbal, psychological and artistic information. The shaman was more than casually familiar with native plants. He knew all those having curative properties, and those like the psychedelic *Psilocybe semilanceata* mushroom, which can produce hallucinatory effects. In addition, he would have known a strange tobacco plant which is of particular interest in our story. In ceremonial and private practice the shaman was above all an artist, a master of special effects. Popular literature reduced the shaman to a sinister purveyor of hokum. In truth, the shaman was a trained person of immense prestige, entrusted with the collective knowledge accumulated by his culture over many generations. Moreover, he was perceptive enough to detect inner fears among his people and deal with them as he thought best. There was more than a little of the psychologist in the shaman.

The ever-present peril of day-to-day living for all classes of Haida society was death by drowning in those unpredictable seas that were, paradoxically, the great protection of the Haida. The canoe, hollowed from a tree trunk, was the sole means of transportation

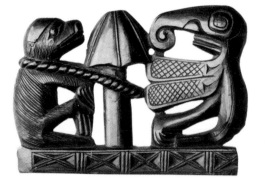

This fragment of an argillite panel depicts what appears to be a mushroom in the center. Figure at left may be sea otter. At right is butterfly. Entered in museum in 1857. Museum No. H.c.324a. Length 12.2 cm., height 8.8 cm., thickness 1.4 cm.

— *Department of Ethnography, The National Museum of Denmark*

until approximately 1910 by which time the gas boat had come into general use. Even today there are stories in circulation that recall the days when travel was measured in canoe distances. One of Douglas Wilson's great uncles, when courting, would paddle from Tanu to Skidegate — some eighty kilometers. When villages like Tanu were still inhabited, small and large canoes coasted the shorelines daily in fine weather. Their occupants would be out gathering birds' eggs from seacliffs, hunting seals or other fur-bearing animals, fishing, or calling on neighboring villagers. In the summers, whole villages packed up and moved to camps close to major sources of food such as halibut banks and salmon streams to gather supplies for the winter. Those days of feasting, after all, required enormous quantities of dried and smoked food.

Wherever the group happened to be, the pace was even and unhurried. Children played by the seashore, picking a lunch of chitons or sea urchins. Women wove cedar bark and spruce roots into water-tight baskets, rain hats or mats. Men sat around gambling with marked sticks and, when the time suited them, turned to house-building or canoe-making. As the weaving had to have designs incorporated, so too did the houses and the canoes. Paintings and carvings, as the Frenchmen found, were essential splendors. Under the comfortable cloak of the culture, a people of pride and self-confidence developed. They had long memories. They were keen traders. And they were hospitable.

More than a few of the first whites to call at the Charlottes complimented the Haida warmly in their journals. One was the Spanish naval officer Jacinto Caamaño, sent out from New Spain on an exploratory mission in the corvette *Aranzazú*. In 1792, on the northern Charlottes, he met an elderly chief he called Taglas Cania. This is one of several spellings of the name of a chief sometimes called Douglas Conneah who exchanged names with Captain William Douglas of the *Iphigenia* in 1789. Caamaño compared the chief's bearing, simplicity and dignity with that of "a respectable inhabitant of old Castile."[15] Summing up, later, he stated: "Indeed, along the whole of that coast populated by Indians, I do not believe that one will meet kinder people, more civilized in essentials or (of) better disposition."[16]

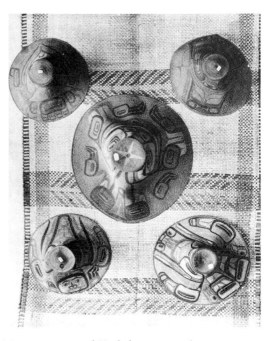

An assortment of Haida hats woven from spruce roots.

National Museums of Canada, Ottawa

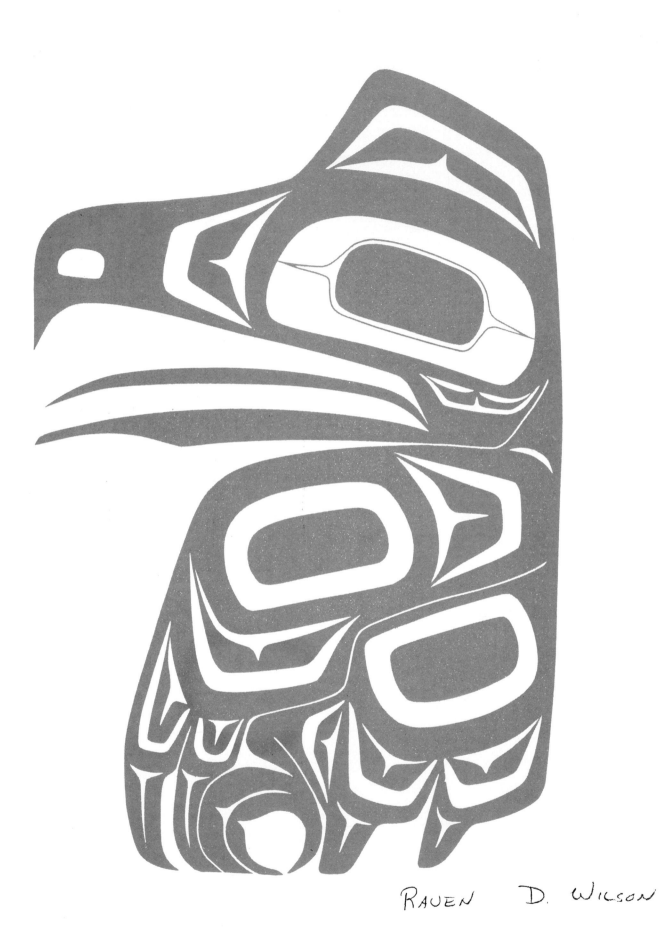

RAVEN D. WILSON

3.
A world apart

In an environment subject to sudden and violent changes in weather, it was perfectly natural that the Haida should build an expanding treasurehouse of legends. Personal experiences of deliverance from death by drowning or from other misfortune became the subject of legends. Ideas behind the founding of Haida people were stated in legends. Good fortune, such as the sudden acquisition of wealth, was worthy of celebration in legends. Disasters were memorialized in legends. It was the Haida way of coming to terms with an unpredictable world. And since the legend was a symbol that could be widely understood, it was strengthening and served as a unifying bond. It was spoken, sung, danced, and portrayed in the decorative arts.

The Haida of the past considered himself to be very much a part of nature. He lived in harmony with the many animal species that were part of his immediate environment and therefore felt one with them. Eagle's cry was often more familiar than the tongues spoken by hostile people who dwelt on the mainland. A bird would call one's name. Killer whale would surface close to a silent canoe, talk to the occupant, and might lead a person to safety in storms. In a land of dark, brooding forests and crashing seas, one had need of the mysterious physical powers of members of other species. The Haida had known them, and they him, for centuries. In the very language, that most revealing expression of how a people think, is manifested the metaphor of oneness. (The word for teeth, for example, is the same as the word for beaver, *cij*, the word for foot and tail fin are the same, *stai*.) Animals could be defined in human terms and vice versa. The relationship was old and deeply symbiotic.

All living things were imbued with supernatural powers. Every animal was — or might be — the embodiment of a being who could appear in a human form of his own free will. This did not mean that they could not be hunted, or presented as food to the Haida by another animal who was also a supernatural being. Furthermore, the supernaturals had a community life of their own. They could take human beings into their villages, mate with them,[1] and help or harm them, just as man would do with other members of his own species.

Raven was a prime example of interchangeability. Anyone who asks why this should be has only to watch raven play the scold, the comic, the thief. He can be raucous-voiced, warning or berating his listeners; he can make rattling noises, and on rainy days he can utter mellifluous sounds, like gurgling water. He hops and steps sideways, like a dancer. And he is notorious for taking away and returning objects. To the Haida, raven could take different visible forms himself, and he could transform things, often for the benefit of people. He could also be a trickster, a supreme player of pranks. Because of the uncertainty about his role at any given moment, he had to be watched carefully. He had to be understood and treated with respect at all times.

There were other creatures of legend, some closely linked with certain villages and certain moiety divisions. Wasco was one. To some he was sea wolf, to others grizzly bear of the sea, and to yet others, sea dog. Wasco was a hunter of whales, and had ties with

Skidegate, since he reputedly lived in a mountain lake behind the village.

Wasco and the other personae of legend were very real. Many had specific attributes and origins. A young woman could be seduced by a bear and give birth to a child that was sometimes human and sometimes bear. She thus became the bear-mother figure of legend. A girl could be transformed into a sea creature under certain circumstances, and change back again later. To be alert to the possibilities of a situation, one had to know the legends. Always one had to be conscious of the possibility of the double-take. An old man working on a canoe at the other end of the village might be heron in disguise, guarding a killer whale village that lay beneath the sea. Cedarbark, to some Haida, was "every woman's elder sister."[2]

There existed — and still does exist — a concept of rebirth transcending mortal years. A person could be reborn several times, in the embodiment of others. In the end, the $x\,\check{}nji$, as the Haida call it today, could be annihilated and become "earth, knowing nothing."[3] "I am my grandfather," a young man will say today. The act of transfer took place when he was born. Another Haida will say she is the reincarnation of her grandfather's sister who died in childhood. The transfer of identity was often made to a new-born relative. It was a symbolic, unifying gesture that reinforced pride in individual heritage.

Ron Wilson's argillite depiction of legend of the frog thrown in the fire. (Frog appears on canoe bow and in form of woman's tears.) Purchased by the Provincial Museum in 1971. Museum No. 13888. Height 13.8 cm., length 21.2 cm.

— *Ethnology Division, British Columbia Provincial Museum*

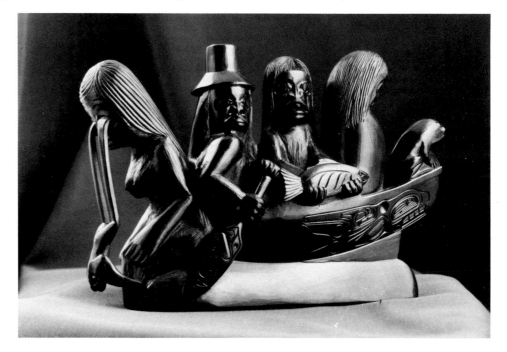

The artist, Emily Carr, sensed the mystique attached to many aspects of Haida life. She had an excellent opportunity to experience it " on location," as it were, in gripping solitude. In 1912, she visited the abandoned village of Chaatl on the west coast of the Charlottes, where the Pacific surf with its "awful boom, boom"

could be heard constantly yet was not seen. She had been taken there in a gasoline-driven boat by a Haida she called Jimmie and his wife, Louisa. Jimmie pitched her tent to one of the many tall, carved, wooden poles which still stood then against the forest background at Chaatl. Watched by the great faces on the poles, they began to talk about "ghosts and supernatural things," of drums that beat themselves, animals that spoke like men . . . It was a memorable night for the deeply sensitive Emily Carr, one that took her to far ranges of the human mind. "Everything about Cha-atl was so vast and deep you shrivelled up," she wrote.[4]

For all Haida, the surf beats in the distance, firelight plays on epic carvings, and timelessness takes hold. Moments stretch into hours, and during ceremonials hours stretch into days. But these are not times of tedium. Legend telling is the idle-hour awakener, the exerciser of the mind when the body relaxes from the drama of existence. What follows is just such a story, measured and leisurely, made only for those who have ample time for listening. Henry Young of Skidegate told it to the United Church minister Lloyd Hooper on April 7, 1954, and Hooper in turn passed it on to Douglas Wilson in 1977, thus returning the legend to a member of Young's family.

NCLESLIAS-NI — Ancient One who is born again as Raven-that-walked-the-earth

In the beginning the world was all water, dark brooding water with no land and no life except for one lone Todla (Tō—tl, the loon) swimming around all by itself. After a long time, it looked up into the sky and there in the air above, the loon saw a Haida house, suspended and motionless. Todla flew up to the house, settled on the front porch, and there removed his loon skin and feathers and took on the form of a man. Stepping up to the door, he looked in and saw, in the middle of the room, a fire burning between two crystal-clear stones, like an electric arc. It was as if the ends of the stones were burning yet they were not consumed by the fire. On the far side of the fire an ancient one was dozing. There was no one else in the house.

Todla slipped into the room and took up a position opposite the ancient one and gazed down on him. The ancient one seemed so oblivious to his presence that Todla feared to speak lest he startle him, and so went outside to announce his arrival. There he "hallooed" as loons do even today on the lonely waters. He returned to his place beside the fire, and still there was no sign of life and movement from the sleeping ancient. After a time, Todla thought he would try again and, stepping outside into the empty world, echoed again the lonely cry: "HALLOO-OO!" Nothing had changed when he resumed his place in the room. As the shadows of evening came, Todla again sent his loon's cry into the darkening skies but still the ancient one did not open an eye. All night long Todla repeated his "Halloos" and all the next

day, and there was still no sign that the ancient one had heard anything.

The evening of the second day, the ancient one roused and said: "Why are you making all this hullabaloo?"

Todla replied: "I keep saying this because there is no place for people to dwell."

The ancient began in a slow, dignified way to rub his stomach upward with the fingers and palms of his hands as he reclined before the fire. After a while, a little boy appeared in his hands, sat up and then stood up. Placing his toes over those of the boy and taking the boy by the arms, the ancient one stretched him up until he was the full height and girth of a grown man. He turned him around, and there he was — perfect in every way.

The ancient one then sent the newly-incarnated man to fetch a box for him from his private room behind a front partition such as are found in the Haida houses. The box was where he had said it was, and the new man brought it out and set it at the feet of the ancient one. It was an inverted stone box, a cube measuring about the length of a blueback (a young salmon).

The ancient then lifted up the box and behold, there was a smaller box inside. He lifted this up and still there was another box inside. He did this a total of five times until he came to a small wooden box. From this he took a black stone about the size of a man's thumb tip, and gave it to Todla. Then, dipping again into the little wooden box, he brought out a larger black shining stone and this too he gave to Todla, saying: "Take these back to earth with you. Drop the little one into the water but be careful not to breathe on it too much. But when you put the big one in the water, blow on it and blow on it, and when you tire, you must still blow on it. Then you will have the land and a place on which the people can dwell."

Carrying the two stones carefully, Todla stepped out, donned his loon skin and feather dress, and flew back to the water of the earth, and did as the ancient one had instructed him. The little stone became the Queen Charlotte Islands (*Haida-Gwai* — hither land) and the big one, helped with much blowing, became Canada or North America (*Kwagaqui* — yon land). The born-again man then stepped down from the house in the skies to become the Raven-that-walked-the-earth to bring forth mankind (the Haida people) and to teach them all that man needed to know.

It is told that when he came down with his hands spread out, he pointed with one hand toward the bushes of the island and with the other to a great stone. Mankind came from the bushes and not from the stone, and it is believed that had they come from the stone, they would have been immortal.

There were any number of such legends, and each was private property. A legend was jealously guarded by its owner, but it was

shared on certain occasions in the "telling" and passed on to an inheritor at the right time. The more legends a person owned, the more he or she was respected. So important were they that the reputation of a village could rest on the multitude of its legends. The people of Ninstints and Skedans were supposed to know more stories than any others, or so the American ethnologist John Swanton was informed.[5]

Some legends told of ancestors such as Foam Woman of the Ravens or Djila'qons of the Eagles, founding figures to whose offspring families could trace their origin. Other legends told of the experiences of supernatural beings, like the loon of Henry Young's story. Still others told of dramatic events. The following story of how a town on the north shore of Cumshewa Inlet was destroyed by fire was related to Swanton:

> Five men went on a fishing expedition. At their campfire, frog came, and one of the five who was full of mischief (literally "without ears" — one who does not listen) put it in the fire. It exploded repeatedly, yet each time sat as before. The next day, as the men were paddling off, someone called and predicted the death of each of them in turn, the last living just long enough to tell the story when he got home. The prediction came true.[6]

Legends were told in song, dance and speeches. They were told again and again, in exact and minute detail, during the long winter nights after the Haida had returned to their permanent villages. And, as more lasting reminders, legends were recorded in artistic designs in various mediums.

In Philip Drucker's words, the whole art of the Northwest Coast native peoples "was aimed at the depiction of the supernatural beings, in animal, monster, or human form, who according to lineage or clan traditions had appeared to some ancestor, or, in some instances, had transformed itself to human form and become an ancestor. In either case the descendants of that ancestor, in the proper line, inherited the right to display symbols of the supernatural being to demonstrate their noble descent. Whether painted or carved, the motifs are often referred to as 'crests' . . ."[7]

These motifs do not "read" like a written script. Rather, figures from various legends stand in freely interflowing relationship to one another. They reflect a companionship with the past that the artist, and those who know what he is saying, share. It is a symbolism that bridges time. Like other Haida artists, the argillite carver demonstrated that he could do full justice to the symbolic past.

Part 2
This
Strange
Slate

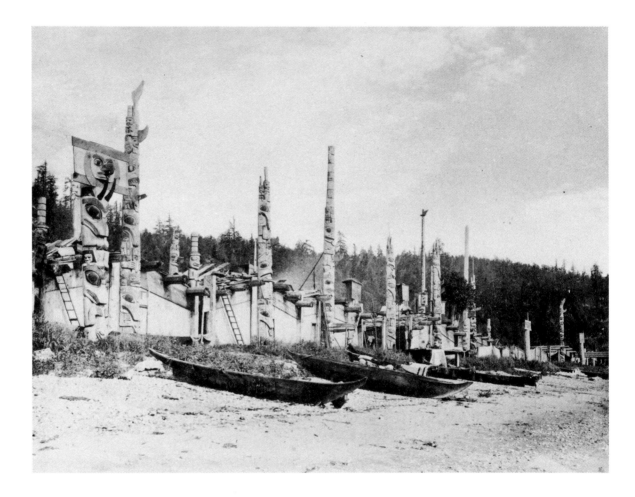

Skidegate village, photographed by George
Dawson in 1878
— *Provincial Archives, Victoria, B.C.*

Western man has taken such giant leaps through space in this century that his earlier discoveries here on earth give the impression of having taken a terribly long time. It now seems almost beyond belief that in his search for the fabled Northwest Passage, Captain Cook missed the mouth of the Columbia River, and that Captain George Vancouver failed to discover the mouth of the Fraser River or to recognize the Skeena as a river. The process of discovery was also slow in the Charlottes. The islands were first sighted by Europeans in 1774. Yet not until 1853, with a survey by the paddle sloop-of-war *Virago*, was it officially established that the Queen Charlotte Islands consisted chiefly of two large islands, Graham and Moresby.[1] The Haida however, had long known Skidegate Inlet as the divider. It was their great throughway. They had paddled its waters and camped at its coves for centuries. They also had a trail or trails running from Masset Inlet to Skidegate Inlet.[2]

This is important to our story, because we shall now concentrate on a single spot on southern Graham Island — a narrow, uninhabited valley with a creek that tumbles into Skidegate Inlet. This is the Slatechuck, the mysterious source of the Haida carvers' slate called argillite. There, on a steep slope, lies the deposit which has been a King Solomon's mine to the Haida. From this lode they developed their art of argillite carving, which is as unique as the substance itself.

The word argillite (derived from argillaceous, *argil* meaning clay), is invariably applied to a dark, shaly, well-consolidated rock found in many places, including the Charlottes and southeastern Alaska. The Slatechuck argillite, however, is different from the other argillites in having no quartz and feldspar, and in being composed of a series of clays with a highly complex organic matrix. It is a geological freak.

Geologists say that between 200 million and 160 million years ago, between the late Triassic and late Jurassic ages, when dinosaurs and winged reptiles roamed other parts of the earth, submarine basalts erupted to form the base, the building block as it were, of the Queen Charlotte Islands. Later, in the Cretaceous age, during the greatest flooding of the continents, when most of the great building stones of the world were laid down, sandstones and shales were deposited in shallow seas. A certain band of these shales lay close to an evolving mountain chain which was to form the spine of the Queen Charlottes. It was an unusual shale made entirely of kaolin (a fine clay) and an abundant fine carbonaceous matrix.

During another major volcanic episode in the early Tertiary period seventy million years ago, the shale layer baked in the heat of a nearby vent, and in doing so hardened a slight degree. The grains of kaolin and organic matter metamorphosed in an odd manner, to form the unique argillite.[3] "It looks similar to a lot of other shales superficially, but when you examine it under a high-powered microscope you see it's quite different, with unusual textures and excessive organic matter," says Dr. Atholl Sutherland Brown, chief geologist for the British Columbia Mineral Resources Branch.

4.
Gift of the ages

After baking, erosion followed in a cooling climate. From the last great volcanism forty million years ago until the onset one million years ago of the Pleistocene age, the most celebrated glacial period of the earth's history, a large part of the island chain was exposed and was probably hospitable to life. But in the several hundreds of thousands of years that the Pleistocene age lasted, the islands lay under a deep ice sheet. Actually, two ice sheets converged — the Cordilleran flow from the continental mainland met a locally-spawned sheet from the mountains of the Charlottes. Far to the northwest, in the region of the Bering Sea that today separates Alaska from Siberia, something else happened in the Pleistocene period. According to the fossil record, a land bridge emerged on one or more occasions. Over millenia, it is believed, that bridge brought nomadic people to the North American continent.

On the Queen Charlotte Islands, the ice sheets withdrew and approximately 10,000 years ago the tooth-shaped archipelago woke up from its terribly long, cold sleep. Animals, including wandering man, began to inhabit the islands. On southern Graham Island, ice had gouged one of many small valleys and in doing so had exposed on one of its slopes some of that peculiar gray slate. In an unknown time, in the valley of Slatechuck Creek, creative man and carvable slate came together.

We can only speculate on how and when the meeting occurred. A lone hunter, perhaps, pursuing his quarry, loses it, becomes weary, sits down on a slope to rest. After a while, he picks up a chunk of slate dislodged by a slide higher up the slope. He takes a hunter's blade and begins cutting into the slab. He likes the feel of the slate, its cold softness. He realizes it is different from anything else in his island world. He would not have kept his secret long; rare objects always become generally known, sooner or later. Next, he or some-one else discovers that when this slate is hand-rubbed, it turns black and shines in sunlight. At that moment it becomes something special.

In a journal kept by the unhappy John Jewitt, survivor of the crew of the ship *Boston*, after he was captured by Chief Maquinna at Nootka Sound in 1802, it was noted that Maquinna and other prominent chiefs would strew on their faces, after painting them, a fine black shining powder which glittered like silver in the sun, and which was valued very highly. It was brought in bags by a fierce people he called the Newchemass (probably Nimpkish Kwakiutl) and who also supplied a superior kind of ochre.[4] The shining black powder was probably mica. It is quite different from argillite. But Jewitt's account, if it is true, could indicate that shiny black substances were widely esteemed.

Unquestionably, black *is* beautiful to the Haida, who were originally a black-haired, black-eyed people. Strong black is one of the primary colors of their painting on wood. A lustrous black had fond associations in nature. It was the color of the raven. A glossy blackness reflected off the coat of the sea otter, the mammal that had attracted the first whites to the Charlottes, with consequences fatal to the sea otter itself. This dark, glistening fur, called the most beautiful fur known to man, robed the Haida chiefs who greeted the first European arrivals.

Whatever the associations it may have evoked in the collective memory, argillite would definitely have gratified the tactile senses of Haida carvers. Here was slate so soft as to surrender readily to a blade or graver in the hands of a people who were already capable carvers of wood. Their cedar creations ranged in size from massive houses, carved posts and painted screens, to huge team-manned canoes, to storage boxes, masks and rattles, down to the smallest of facial ornaments. Other native people of the Northwest Coast were skilled wood carvers, too, of course. But this new material, which the Haida called *ʔGaʔGal* (black rock), was apparently exclusive to the Haida. It had to be used.

From that beginning, whenever it may have been, the Haida and argillite have enjoyed a long and happy association. For gold, other men have murdered. For precious stones, they have killed their brothers. But the slate called argillite has roused none of the lusts that make a bitter-sweet mockery of most treasures. Instead, the Haida have kept it to themselves, to express their own private sense of beauty.

Over the years, it has also become the single staple of a highly-select "cottage-industry" providing a steady, if irregular, income that has tided carvers and their families over many a lean year. Although the Haida wonder whether the supply will diminish or whether the quality will be maintained, geologists say the deposit is inexhaustible. The product goes to market by a splendidly direct route — from source to carver to buyer — with no high-powered advertising, no Madison Avenue marketing, no corporate controls. How many other native industries can claim such freedom today?

— *Stephanie Quainton Steel*

5.
The Slatechuck

Whatever is hard won is doubly prized. By an accident of geology, the soft slate called argillite was deposited in a lofty, obscure setting. It lies high up in a steep, narrow mountain valley where eagles soar. The trail leading there rises an estimated 300 meters in five kilometers, almost straight up from sea level at Skidegate Inlet. The seeker of raw argillite must be patient, sturdy, and sure-footed as a mountain goat.

It is a semi-secret place, visited only by Haida carvers who quarry this slate that they alone know how to select. Interestingly enough, although this prodigal stone has traveled around the world in the finished form of beautiful black carvings, most of their owners would be at a loss to pinpoint the source on a map.

The Haida would prefer to keep them in ignorance. "They do not appreciate questions about it," a long-time white resident of the Charlottes, a collector of argillite carvings herself, once remarked. The reasons for secrecy are plain enough. Too many whites have poked around in the past, the Haida feel. Besides, it is their resource, one they can still call their own, and they intend to protect it. We shall abide by their wishes by not specifying the exact location here. All Queen Charlotte Islanders respect the Slatechuck as the private property of the Haida and do not visit it except by invitation.

Over the years, the only unescorted whites who have visited the deposit have been for the most part prospectors or surveyors and their assistants, like Charlie Hartie, an oldtimer of Queen Charlotte City, who first saw the deposit shortly after the turn of the century. Newton Chittenden, on his 1884 exploration, reported that "the deposit is evidently an extensive one, the exposures covering several acres."[1] Next, it shows up fleetingly in government mining reports. One, in 1909, stated that investigating prospectors believed the quarry had possibilities as a source of slate for mantels, and that attempts had been made to slake it. There is actually a 1906 report for the Geological Survey of Canada stating that a quarry had been opened by a Victoria company, and that the material was being shipped to Victoria "and there manufactured."[2] Any commercial use by whites could not have lasted long. The Indian Affairs Department asserted protective control during the term of its first resident agent on the Charlottes, Thomas Deasy, appointed in 1910. By the 1920s, department correspondence clearly shows the department was determined that if any mineral licences covering the property were to lapse, the Haida would still be allowed to obtain whatever quantities of the slate they required.

On September 12, 1939, the land surveyor J.A. Rutherford blazed his way to the deposit. It was the same week that Canada entered the Second World War, a momentous event of which he made not the slightest mention in his diary. Wrote Rutherford: "We followed an old coal mine trail, densely overgrown, for one mile; then followed a very poorly defined trail for the remaining distance of two miles." On reaching the deposit, he found "about seven places where the Indians have extracted the Black Slate; the two most recent workings show up a well-defined body of slate . . ."[3]

Rutherford's survey, commissioned by the Surveyor General of Canada, enabled the government to set aside the forty-four acre

Newton Chittenden (seated right) with photographer Richard Maynard.
— *Provincial Archives, Victoria, B.C.*

Black Slate No. 11 reserve on behalf of the Haida. At the time, Canada was tightening its control over mineral resources that might be vital to the war effort. Although argillite was not in this category, it seemed a convenient time to safeguard the Slatechuck deposit as well.[4] A British Columbia Order-in-Council dated May 7, 1941,[5] provided for the sale to the federal government of the land "containing a deposit of black slate for use and benefit of the Skidegate Indians." The argillite deposit was thus placed firmly and squarely in Haida hands in perpetuity. For the carver, this has effectively cut out all competition for the resource.

Today, being practical people, the Haida usually muster a work party to pack out a supply of argillite that will last a carver a year or more. Aged carvers hire younger Haida to make the expedition for them. The veteran carver Lewis Collinson regretted in 1963, when he was over eighty, that he was no longer spry enough to fetch his own slate. What hurt, too, was that he had to pay $100 to the younger men who were willing to do the job for him.

Since the difficult, even dangerous trip to the Slatechuck is one that few lovers of argillite are ever likely to make, it seems only fair that they should be given a chance to take part — at least in the imagination — in a typical modern mining expedition to this age-old deposit. The trip will differ only in minor detail from those made by countless ancestors of the present-day Haida, a century or more ago.

It is a sunny day in late September. Seven young men have set off in the early morning from Skidegate, pointing their fiberglass-hulled motorboat in the direction of Slatechuck Mountain, rising high above inlet waters. The boat glides along noisily past islets, startling a flock of cormorants perched like black watchmen on a nearby rock. Had this boat been a canoe, such as the men's forefathers once used, the birds would scarcely have turned their craggy heads. In no time at all, it seems, the boat eases into a greenwater cove rimmed with spruce trees. This is Kagan Bay, the jumping off point for the onerous trek to the quarry itself.

The men — two brothers who both carve argillite and five of their nephews — haul the boat up the beach beyond high-tide mark. They remove their packboards, now containing only their lunches, and strap them on their backs. By the time they return here, these packboards will be loaded with 500 pounds of argillite, a year's supply for one of the brothers, who lives on the mainland. The men are lightly clad and wear knee-high rubber boots.

There is no one else for miles around, and the stillness of the Slatechuck is almost overwhelming, even to people accustomed to silence. They start hiking into the bush at a slow, even pace, reserving their strength for the hard climb ahead. For a while, the trail follows the Slatechuck River, partly in its gravel bed and partly through woodland within view of the river. Its waters are benignly low at this time of year. It is much more a creek than a river. Soon the men plunge into dense rain forest, climbing steeply over ground riddled with fallen logs, spruce roots, mudholes, boulders covered with moss a foot thick. They stop every so often to catch their breath, then struggle on.

After nearly an hour, they reach the floor of the Slatechuck

Valley. The region was logged at one time, and still shows the signs of stumps notched for springboards. The men pause briefly, amid the dense new growth which has sprung up after the logging. Anyone unfamiliar with this wild terrain could easily become lost here, deep in the mountains, but these men know exactly where they are going, and now they brace themselves for the final ascent.

One by one, keeping out of each other's way to avoid being hit by falling rocks, they climb almost straight up for 100 meters, clambering hand-over-hand for the last stretch. Hot and tired, they finally reach the "mine."

It is simply an 80-degree, pockmarked slope with overhangs and ledges. Anything looking less like one's idea of a conventional mine could hardly be imagined. There are no weatherbeaten buildings, no cast-off machinery, no timber portals, no tailings dump. The only visible tailings consist of moss-coated rubble from old excavations, strewn over the lower reaches of the slope. Pitched at this steep slant, the argillite source does not even resemble a quarry. It is certainly the cleanest mine in British Columbia, and one of the oldest. That so much beauty could come from such an unspectacular hand-dug perch on a mountain seems almost impossible.

A couple of the men pick their way through debris over to an old rotted stump off to one side of the slope. Beneath it lie tools they had cached on a previous trip — a shovel, a crowbar, a sledge hammer, a handsaw, a long steel wedge, and an eight-foot pole for leverage.

Armed with these, the group is ready to go to work. They bypass a level where a few young fellows made the mistake of setting off dynamite in the 1950s, leaving behind a body of slate flawed with hairline cracks. Instead, they inch up to a higher level, a perilously-narrow ledge where a new seam was opened in the 1960s.

Here, where previous workings have created a grotto-like gallery, they select what looks like the "cleanest" slate — that which seems most fresh and fault free. They look for lines of cleavage and then, using a steel wedge and a sledge hammer, they split out a slab of slate weighing roughly 500 to 600 pounds. Each man knows precisely what is expected of him; they have all been coming here since childhood. As soon as one has fractured a big block, another inserts his shovel blade and eases the slab out of its position while a third helps with the crowbar. When the slab finally comes free, two or three men wielding the long pole pry it out onto the ledge. Once dislodged and in the open, the block is ready for trimming. Its color is dark gray dusting to black. Its surfaces are dull and uneven.

After sawing off several squared blocks, the men stop for lunch. It is now past noon, and their salmon sandwiches and Coke are more than welcome. After half an hour they resume work, hand-sawing the blocks into smaller slabs that will fit easily into burlap wraps on their packboards. The slabs, each weighing between 50 and 100 pounds, are duly loaded, one to a packboard, and one by one the men start off down the slope toward the trail. The tools are stashed away beneath the stump for the next expedition.

The ascent was more arduous than dangerous. But now, on the descent, with loads averaging more than 70 pounds on their backs, the men must take care not to overbalance or trip. More than one

Artist Bill Reid, sawing a slab of argillite at the Slatechuck deposit in 1954. The photo was taken by Wilson Duff.
— *Ethnology Division, British Columbia Provincial Museum*

packer has fallen and injured himself in the past, so they follow the trail down slowly. Fortunately, on this trip they have found the waters of the Slatechuck River lower than they have ever seen them before. All have known times when the river, swollen by autumn rains, was hazardous to cross; when laden packers, with water swirling up to their waists, had to make a superhuman effort to keep their balance.

When they reach a certain place along the trail, the men stop to gather and chew roots of the licorice fern. Legend has it that the fern roots make a person strong, and certainly their sugar content restores flagging energies. The flavor refreshes the mouth. This little ritual on the trail is one that generations of argillite packers have performed.

In truth, the past is ever present on this secluded route. The scene is one of eternal peace and changelessness. Mossy boulders. Licorice fern. Dark glades illuminated by shafts of sunlight. Pungent rain forest scents. Nothing has altered since argillite packing began; when the old ones came by canoe, trundled up the trail barefoot, hacked out the slate with simple wedges, and toted it out in woven cedar-bark slings. The process is supremely basic. All it takes is hard human effort. But then the burden is always lightened by the thought — the vision — of the beauty that will emerge when the raw slate undergoes transformation.

Packing a load of argillite.
— *Stephanie Quainton Steel*

Question: "So you have been commissioned to carve a mask in slate. Where will you begin?"

Carver: "I will carve it a hundred times in my head."

The physical properties of argillite explain in large measure what has commended it to generations of Haida carvers. In hardness, texture and fracturing quality, it is remarkably similar to catlinite, the Minnesota pipestone that American Plains Indians made into ceremonial pipes. Both rank at about 2.5 on the Mohs scale of hardness,[1] midway between gypsum and calcite. The specific gravity is about 2.90. When fractured, both split into conchoidal or shell shapes; they do not cleave flatly like most slates. The only real difference is in their color. Argillite is gray-black from its carbon content; catlinite is reddish owing to its iron oxide content.

Even the color difference may not be as great as it sounds, for there is always the enduring mystery of a few carvings of so-called red argillite which exist in museum collections. Their colors range from a pinkish-red to red-brown. In 1929, when he was employed at the British Columbia Provincial Museum, William Newcombe received a chunk of red slate which was said to have been found further up Slatechuck Creek from the main argillite deposit. "This material is far harder to work than the black," Newcombe commented, adding that the piece sent to him was the only large piece he had seen or heard of, "though it might be the source of the material used in making the red stone labrets."[2] A very fine bird carving of red argillite belongs to the University of British Columbia Museum of Anthropology in Vancouver. The previous owner once heard that the deposit had been mined out. Several Haida today say they have heard of a deposit of a reddish-colored argillite across the Slatechuck Valley from the main lode. Some claim to know its whereabouts. However until it comes to light, the source of the rare red argillite must remain an open question. There is even the possibility of catlinite itself having reached the Charlottes, traded all the way from what is now the state of Minnesota.[3]

6. Transformation

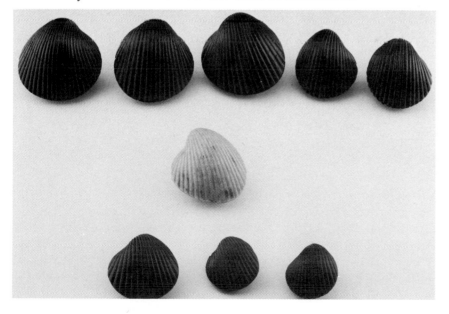

A unique collection of cockleshells carved in black argillite (top row), ivory (center), and red argillite (bottom row). From the Jelliman collection purchased by William Newcombe. Museum Nos. 10626-10628. The largest are 5 cm. in diameter.

— *Ethnology Division, British Columbia Provincial Museum*

Normal argillite, the one and only kind used by carvers today, also has a chemical composition very similar to that of catlinite. A high clay content makes them almost identical in texture and carvability. An analysis done for James Richardson of the Geological Survey of Canada more than 100 years ago revealed the content of argillite as: silica 44.78, alumina 36.78, peroxide of iron 8.46, water 7.15, carbonaceous matter 3.18, and traces of manganese and lime, for a total of 100.35. A 1978 analysis produced a lower figure for alumina.

That water content is important to the carver. He retains the moisture, as much as possible, by wrapping his raw slabs of argillite in burlap sacking and burying them in the ground until he is ready to saw off pieces for carving. Or, in lieu of burial, he glazes the surfaces with Varathane to seal in the moisture and prevent a crust from forming. A carver likes to be assured of the feel of "fresh" argillite which to him means that it is moist throughout. Such argillite, Douglas Wilson explains, responds to a blade by cutting the way it should. Dried-out argillite, while definitely carvable, is less predictable in behavior. "You do not press your luck with it. You might gouge too much in one place instead of what you want. You can also get a flaking effect. You can tell when you have got a really dry piece. It has got a different sound. When you saw into it, you can hear when there is a crack, even though you cannot see it. You get so used to hearing it you know it is there. I tell my nephew this and he does not believe me, but it is true."

Douglas Wilson carves a pole in argillite. Having pencilled his figures on the sawn and sanded oblong of raw slate, he scribes the main outlines.
— *Alex Barta*

After cutting along the scribe lines with a coping saw, Wilson begins to rough-shape the figures.
— *Alex Barta*

Like any sculptor, the carver begins by cutting his raw material to the approximate size of the object he intends to make. With argillite, this can be done with a carpenter's handsaw. Having sized the piece, his next step is blocking out the carving, and here the greatest challenge is to make the design conform to the grain of the slate. For a platter, the grain must run horizontally for ease in carving; its longest length must conform with the direction of the grain. Con-

versely, if the carver intends to make a pole, the grain must run vertically.

Frequently, if the carver is to ornament in high relief, with sharp edges, he will be obliged to work against the grain. The upright figures sometimes seen on dishes, and the high-relief figures on the sides of boxes, defy the grain, assuming, of course, that they are an integral part of the material. Here the carver will have battled against the grain and won. More often he will carve the protruding figures separately, and attach them with glue. In working against the grain, the carver may find the slate flaking badly, which means he must modify his plan. Cross-grain carving can also inhibit deep carving. The novice carver who overcomes the problem of grain, who realizes that he must make it work for and not against him, is well on the way to becoming a skilled craftsman.

While it is not always possible, the creation of an argillite carving from a single piece of slate has always been a criterion of the carver's capability. Naturally, the larger the carving, the greater the risks from faults in the grain, so most tall poles, for instance, have been made in separately-carved sections pieced together. Joints are visible to the trained eye.

Panel pipes, with their delicate connectors and acute proportioning, are regarded by most carvers today as the most ambitious works in the medium. Next, in descending order, come bowls, then group figurines, then boxes, then poles. Plates are considered the easiest to carve of all the sizable works. We are talking now of

The finishing touches. Here the carver refines an ovoid with a round-ended blade. The raven's projecting beak has been attached separately; the base will also be added.
— *Alex Barta*

Sculpturing of the figures with a chisel.
— *Alex Barta*

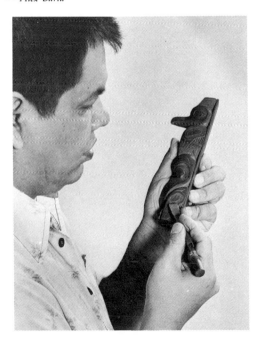

straight carving, not the designing, which can take a great deal of time.

Having roughed out his raw slate, the carver now refines the silhouette with a scriber, then begins gouging with a chisel, turning the piece over and over in his hands, smoothing and rounding its surfaces, his mind's eye constantly on the symmetry. Some carvers use templates to fix the design patterns; others draw a few guide-

lines in pencil directly on the slate. Beginners may do much more measuring than experienced carvers. Both will resort to a geometry divider now and then, but most veteran carvers rely solely on their eyes to guide their hand.

"You train your eye to do the measuring," one carver explains as he sits at his basement workshop bench, refining the contours of a bowl. He works under a bank of fluorescent lights. In the distant past, daylight would have had to suffice, and in the not-so-distant past, kerosene or coal-oil lamps. Electricity did not come to Skidegate homes until the early 1950s. Our Skidegate carver is making a beaver bowl, and is shaping the beaver head which constitutes the forward end of the bowl. He "peels" off a sliver of slate from one side of the head, then holds the bowl up to see how much more to shave off. He does this repeatedly, after each blade stroke. "You've got to keep looking at it," he says. "If you let your eye wander, a carving can be ruined." This man carves toward himself, bracing the bowl on his chest now and then for a closeup view. This is the old style of carving, with inward hand movements, not outward which is the style that has been adopted by almost all young carvers today. His overalls, as a result, are coated with slate dust. He does not mind. The carving is coming along nicely.

In pole making, Douglas Wilson finds that the bottom figure takes the most time. This is the key figure against which all the other figures wil be proportioned. Keeping the pole straight, and mating each half of the faces or figures from the vertical center-line, severely test the carver's skill. So, before he begins to carve the pole, he levels its base on a sandpaper board.

The tools for "sculpturing" are the regular files for sharpening saws, their tips reshaped by the carvers. Basically, they come down to three types: one, a V-shaped scriber with sharp edges for incising; two, a flat file for fast removal of the dead surfaces, and three, a round-tipped file that can be maneuvered into nooks and crannies for fine finishing. Files of high-tempered steel are preferred to those of lesser quality. The shaping of the file's working end is done by the carvers themselves heating and grinding until they achieve the tip they desire. Some produce extremely sharp, curved blades that look like surgical instruments. For engraving, the file shaft is held like a pencil; for gouging, it is held in the palm of the hand.

A set of basic argillite carving tools.
The shafts are served with twine to give a
firm grip for control in carving.
— *Alex Barta*

After the carving comes the smoothing of the surfaces. The carver today rubs them with sandpaper, then fine steel wool or emery paper. Some carvers use a tool, a fine file, for example. In the past, dried sharkskin, or a dried sponge known locally as the sea potato, served the purpose of sandpaper. For glue, the oldtime carver chewed and boiled fish skin to produce a sticky substance that was quite adequate for bonding. According to the late Walter Russ of Skidegate, the skin of the smoked dog-salmon (chum) was commonly used.

Now for the final finish. Many early carvers seem to have been content with a dull surface. They left the slate its natural gray, or gray shading to black, green or brown. The great majority of carvers in the last hundred years have chosen to give their works a rich, jet black, glossy finish which has become a hallmark of argillite. Unlikely though it may sound, this lustrous black finish comes from hand rubbing. Sweat and natural oils from the pores of the skin do the trick. It is accomplished in part during the carving process every time the carver turns the object over in his hands, exercising that famous eye for proportioning. For a high black polish, he simply rubs a thumb or forefinger over each part of the carving, bit by bit, until the whole thing is uniformly polished. Lamp black and loggers' chalk have also been applied for darkening the slate. Petrolatum and shoe polish have sometimes been used, but oily substances like these tend to attract dust which can dull the finish in the long term. The degree of polishing is purely a matter of individual taste. Some carvers today apply such a high polish that the argillite looks like obsidian or black opal. Others avoid a super-gloss, claiming it looks artificial. Still others will leave the surfaces virtually untouched. A dull gray finish may be appropriate for a particular carving.

Argillite carving is not the cleanest occupation in the world. A thin layer of dust from all the gouging, chipping and sanding settles on the carver and everything surrounding him. Slate dust lies thick on every carver's table or workbench. One of the master carvers, Charles Edenshaw, made a practice of tacking up a flannel sheet in the background whenever he was carving, to prevent particles from spreading around the house.

In their own closely-knit circles, the Haida are great cooperators. They like to work in pairs, exchanging ideas and equipment. Through the long history of argillite carving, artists have teamed up from time to time, learning different techniques from one another and thus aiding each other. Tom Price and John Cross were two who carved together in Victoria. Each had something to teach the other on how to be a better carver. But, some secrets are not divulged. George Young was an expert polisher who never disclosed his method; others paid him to do their polishing.[4]

One of the joys of argillite is that it gratifies the sense of touch. One must feel argillite to really appreciate it, run one's fingers over the cool, smooth surfaces, and revel in the sensation. A blind man would realize the tactile beauty. Visually, of course, the finished product, deep blue-black like Raven's wings, is enormously appealing. In this connection, it is interesting to see how many artists beyond the Haida domain were captivated by argillite carvings. The

American painter George Catlin was one, the Canadian painter Paul Kane, another. (Two slate carvings that Kane collected are in the Royal Ontario Museum in Toronto.) Other artists include the Canadian poet, Duncan Campbell Scott, and the British Columbia painter, Emily Carr.

Old Henry Young of Skidegate used to say that an argillite carving looks best by firelight.[5] That is how the Haida of long ago saw argillite, held before the light of an open fire, catching the glow and casting moving shadows. Henry Young was speaking after the fires had gone out. "For a pole to look best, put a candle beside it," he recommended. Against a dark background, the flickering light dances dramatically and the carving begins to come to life. It is entirely appropriate that argillite, born of fire, should be its most seductive when seen by the light of naked flame.

Part 3
Out
of
the
Past

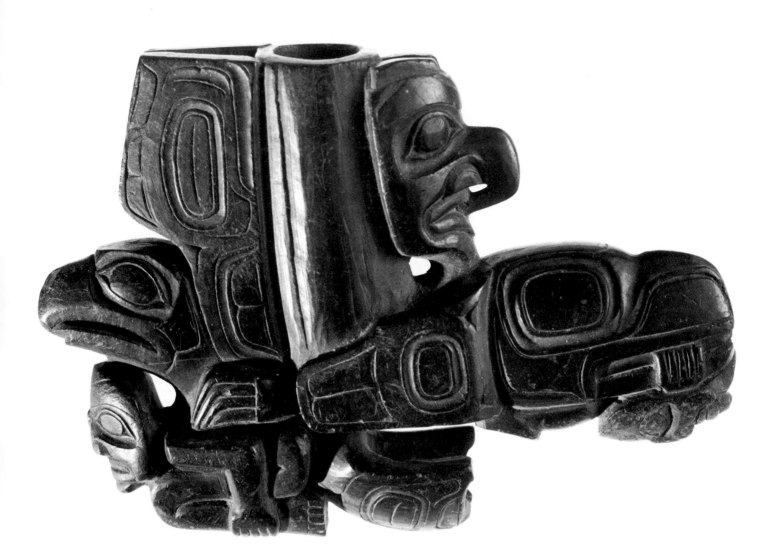

One of the earliest argillite carvings on record, this pipehead was the property of fur-trader Roderick McKenzie prior to 1819. At right: Thunderbird back to bowl, and below, whale holding man in mouth; at left, raven with man in front. Raven's tail is broken off; it once reached up to end on underside of whale's chin. Museum No. 95-20-10/48404. Length 12 cm., height 8 cm.

— *Peabody Museum, Harvard University. Hillel Burger Photo.*

By the time we first hear of argillite carvings, they are already in circulation. Most of the first carvings that show up in quantity are not little rough-hewn trifles. They are pipes of one type or another, some wreathed in Haida legend, technically brilliant, sophisticated in concept. Usually in tracing the origin of an art form we can find a forerunner, something indicative of the shape of things to come. But in the case of these pipes we search in vain. Yet the Haida made them — in wood, clay and slate — especially slate. And they seem to have come out of nowhere. We have to ask ourselves why. What led up to them? Why were they made?

Before we contemplate what the Haida did with their peculiar slate, let us see what other peoples used slate for carving. We find that almost everywhere in the world it has been known, used and cherished as a structural and art medium. The earliest slate carvings, we are told, go back as far as the Egyptian dynasties. The Palette of King Narmer in the Egyptian Museum in Cairo was made in 3100 B.C. The ancient Chinese knew and used slate ornamentally. Native peoples elsewhere in North America had also discovered it. Several tribes north of Mexico had used the typical slates of their region to make utensils, implements and ornaments. One of the best-known sources was the Appalachian Mountains, in the present-day states of Vermont, New Hampshire and Pennsylvania.

Even the Haida's mainland neighbors, the Tsimshian, made so-called "slate mirrors" — slabs of slate cut into something resembling the shape of hand-mirrors, then sanded smooth. George Thornton Emmons who wrote a monograph on those mirrors, said the Nishgan people of the Nass River Valley claimed to be the originators, and that their slate came from a ledge on the north bank of the Nass. The mirrors were very much a product of the Tsimshian, Emmons decided, and if known to the Tlingit, Haida or Kwakiutl were not used by them.[1] By territorial right, the distinctive slate from the Slatechuck called argillite, assuming it had been known, would in any case have been exclusive to the Haida.

In academic circles, argillite carving has long been thought to have begun after the white man arrived, and only now is this being questioned. The Haida were seashore dwellers, not mountain people. Yet George Dawson in his 1878 survey of the Charlottes, was informed of the existence of a trail running from Masset Inlet to Skidegate Inlet via the valley of the Slatechuck. After canoeing up the Yakoun River, he wrote, the Haida were able to walk across to Skidegate "in half a day, reaching that inlet by the valley of the Slate Chuck Creek."[2] It would seem more than likely that someone would find the argillite deposit. Then, all that would be needed were tools — and these the Haida had.

When the first "iron men" — the foreigners in strange ships — arrived in the late 1700s to change forever the native way of life, they were surprised to find that the people already had iron knives. Men of the Dixon expedition speculated that the iron had been obtained from the Russians. "Their (native) knives are so very thin, that they bend them into a variety of forms, which answer their every purpose nearly as well as if they had recourse to a carpenter's tool-chest,"[3] it was reported. The Haida also had blades, adzes and wedges made of basalt and nephrite, which were used for working

7.
The birth of an art

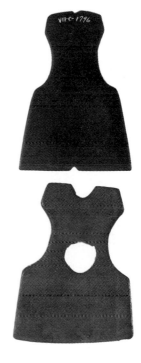

Slate mirrors, height approximately 12.5 cm.
— *National Museums of Canada, Ottawa*

materials much harder than the yielding slate from the Slatechuck. Their stone implements were proof.

However, there can be little doubt that iron supplied by the white man would have encouraged the carving of argillite and other native materials. The fur-trading expedition of George Dixon, which could scarcely believe its good fortune in purchasing 300 prime sea otter pelts in less than half an hour at the place he named Cloak Bay, had satisfied its customers with "toes" — iron adzes — the article most in demand by the Haida at that time. When toes became plentiful, the Haida no longer wanted them. Later they asked for more refined, "precision" tools.

Today, at least one archaeologist supports the Haida in their belief that use of the peculiar argillite goes back beyond the coming of the whites. He is Knut Fladmark, assistant professor in the Archaeology Department at Simon Fraser University in Burnaby near Vancouver. "There is no doubt in my mind that it was worked in prehistoric times," he says. He bases his opinion on a discovery he himself made in the course of a dig in the Charlottes during the summers of 1969 and 1970. He also bases it on other "small pieces of evidence" and a feeling that people who had occupied this not-so-big land mass for centuries must have known and taken advantage of all its resources.[4]

Fladmark's discovery was made at Tlell. He and his team were trying to develop a prehistoric (pre-white) cultural sequence for the area. In 1970 his attention was drawn to a historic Haida house-pit site "notable for its lack of heavy vegetational cover and ease of access." As the definition of a historic Haida artifact assemblage would be advantageous for the study of prehistoric components, Fladmark chose the house site, calling it the Richardson Ranch Site. Actually, it had been spotted by George Dawson in 1878. "A ruined Indian house, which must have been very large, stands about three miles south of the mouth of the river . . ." he reported.[5] The site is a beautiful one, scarcely changed over the years. Close by is the road, ahead lie sand dunes opening onto the sea, and behind are fields of an island's landmark, the Richardson Ranch, built by pioneer white settlers.

In the shallow buried remains of the big Haida house, which he estimated had been occupied from 1810 to 1830 or 1840, Fladmark and his crew unearthed several fragments of plain elbow pipes made of argillite, with evidence of their use — a pronounced layer of carbon residue was in the bowl. They also found one superb, complete pipe of argillite. Now in the Queen Charlotte Islands Museum at Skidegate, this pipe is ornamented with human faces on the bowl sides, a sea creature on the stem, and three names etched in an old-fashioned English script. It could be as old as the earliest examples of the argillite art in museums in western Europe and North America. These date from around 1820.

What was more significant than the dating was how the pipes had been made. On examining the whole pieces and fragments, the scientists came to two conclusions. Here at Tlell, Haida carvers had used the ancient percussion-flaking method of shaping the slate. "Apparently natural pebbles or cobbles of raw argillite were roughly shaped by light percussion flaking — the stone is sufficiently

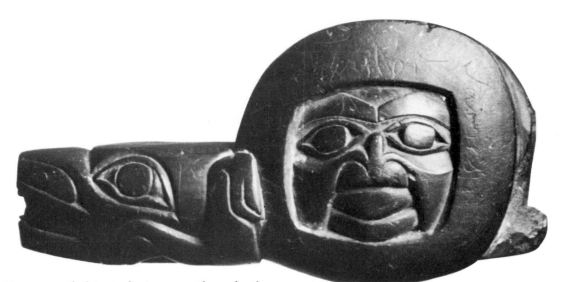

The Tlell pipe.
— *Dr. Knut Fladmark*

fine-grained to allow the use of this technique — then further shaped by sectioning, whittling, and abrasion," Fladmark reported. There were no signs of metal saws or files having been used. Moreover, these pipes had apparently been made for a specific purpose. The context in which they were found suggested a tobacco feast associated with a Haida funeral. They had been made for smoking — from one durable material available locally — argillite. Fladmark decided then and there that the presence of the pipes "must throw considerable doubt on any theory suggesting that argillite carving began solely as a response to commercial opportunity."[6]

In one short summer, science had pushed back a time barrier. Earlier there had been only a few tantalizing hints that argillite might have been used very early, perhaps even before it was used for tobacco pipes. Labrets and amulets of argillite had shown up in unexpected places. And at least one investigator, albeit an amateur, had formulated the opinion at least fifty years ago that the use of argillite predated the white man's arrival. William Newcombe of Victoria, generally regarded as the most knowledgeable person of his day on Haida artifacts, told the Canadian ethnologist Marius Barbeau in 1928:

> "I don't suppose that Haidas made any of the totem poles, circular dishes & group carvings until the whites arrived, creating the demand, but I feel certain they used it (argillite) for carving of charms and trinklets (sic) for personal use before that date. I have one specimen here & have seen others, of the same type as the lovely bone & ivory charms as used by the shamans."[7]

Archaeology has barely scratched the surface of the Queen Charlottes, but, as Fladmark pointed out in conversation later, waste argillite (and occasionally a carved piece) shows up in quantity at the few historic sites that have been investigated. No argillite has been found in any excavations of prehistoric sites of a datable age, which leads Fladmark to believe that it was not used extensively in those days, but very few such sites have been explored. (Incidentally, the oldest stone artwork from the Charlottes is 4,000 years old.) Asked to elaborate on what he meant by "small pieces of evidence" sug-

gesting the use of argillite in pre-white times, he cited an argillite labret found on the east coast of the Charlottes on the surface of a site dating back 2,000 years — and the existence of that trail linking Masset Inlet and Skidegate Inlet by way of the Slatechuck.[8]

Fladmark does not rule out the possibility that both the knowledge of smoking and the idea of stone-pipe manufacture came initially from the fur traders. Virtually every fur-trade fort ever investigated in northwestern North America has produced evidence of the local manufacture and use of stone-pipes by the fort's personnel. In addition, he says, fur traders exported vast quantities of pipestone to the northwestern regions (to meet the native demand) from such famous sources as the Minnesota catlinite quarry.

Let us now consider the role of smoking in the Haida life of long ago, and what connection it may have had with those incredibly beautiful panel pipes of Haida motif.

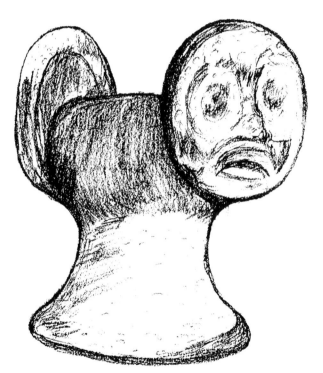

This stone pestle was dug up in a garden at Port Clements. Both handle ends are decorated.
— *Drawing from photograph by F. W. M. Drew*

Gul is one of the Haida words for tobacco, and both the word and the substance were on their lips a great deal at one time. They had two kinds of tobacco — smoking tobacco initially introduced by white fur traders, and a native tobacco, a mystery plant which both the Haida and Tlingit cultivated. Observers reported that the native plant was not smoked but was mixed instead with a small quantity of finely-ground clamshell and then chewed. This "Indian tobacco" came to the attention of George Dawson during his 1878 survey of the Charlottes. "Its cultivation is now entirely abandoned except at Cumshewa, where a single old woman continues to grow it," he wrote, "some of the older Indians still relishing it."[1] A few visiting mariners, dating back to the British trader George Dixon in 1787, took samples of the plant. Some of them are still preserved in England and fairly recent studies have suggested that the plant may have been a variety of *Nicotiana quadrivalvis* cultivated by native peoples of the American West but not known to have existed north of the Columbia River. It was apparently an annual, growing up to two and a half feet high in a season, with seed pods which were bean-sized but round, and leaves from one to eight inches long.[2] With the death of the old woman at Cumshewa, the plant seems to have vanished from the face of the Charlottes.

8.
Pipe dreams

Two sketches of native tobacco, drawn by Captain Kloo in 1897 for C. F. Newcombe.
— *Provincial Archives, Victoria, B.C.*

At the end of the last century, however, Haida oldtimers could still recall the plant. In 1897, its leaves and round seed pods were drawn from memory by a Skidegate man called Captain Kloo, for Dr. Charles F. Newcombe of Victoria. Five years later when Newcombe was visiting Kasaan, Alaska and chatting with "Chief Edensa," he scribbled these recollections of the chief's: The native tobacco was grown in gardens used exclusively for that purpose. The gardens were owned by individual women and their size was in proportion to the owner's rank. For security against dogs and people, the gardens were fenced with stakes of crabapple lashed with cedar bark. When the plants reached the right age, they were pulled up whole and arranged on slat frames of split cedar over small fires made of alder. Old women took turns keeping the fires going day and night and sought to avoid too great a heat, in order to properly cure the tobacco.[3] From another source, Newcombe learned that the plant had been in regular cultivation at Old Masset in 1820-1830.[4]

If we knew more about the properties of that native tobacco, how narcotic it was, and what functions it had in Haida life when cultivated, we would have a better idea of whether it had some

connection with the production of argillite pipes. It may have been smoked as well as chewed. A Russian explorer at Sitka in 1863 reported that the native people around there both chewed and smoked the native plant.[5] What we do know is that the Haida grew tobacco, that they traded an extract of either it or a poppy-like plant to the Tsimshian,[6] that they also traded their slate pipes to the Nootka,[7] and that there is a striking similarity between foliate designs on early argillite pipes and the plant as depicted by the Haida Captain Kloo.

On the other hand, we do know that smoking of imported tobacco was a valued luxury among the Haida. Comforting, warming, perhaps euphoric, this tobacco was smoked by men, women and children. American traders brought tobacco that had been grown in Virginia, Maryland, Carolina and Kentucky. The British usually obtained theirs at home from the same former colonies, or Brazilian tobacco shipped to the British Isles via Portugal. The leaves were bound in pressed form in what were called carrots and twists. To the trader, they were essential cargoes for gifts and as a medium of exchange for furs and services.

The Haida were by no means alone in developing a strong liking for the "weed." Native peoples all over the continent shared their enthusiasm for tobacco. The American frontier traveler and artist George Catlin observed in his wanderings among American tribes that the natives were excessive smokers. They seemed to be smoking for half their lives. "As smoking is a luxury so highly valued by the Indians, they have bestowed much pains, and not a little ingenuity, to the construction of their pipes," he wrote.[8]

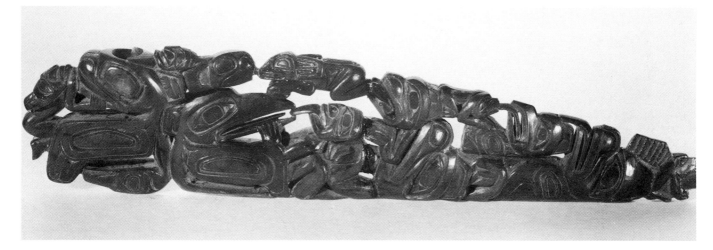

Pre-1832 panel pipe collected by George Catlin. Bowl is located at top left, and stem hole at extreme right. Museum No. 1/9272. Length 35 cm.

— *Museum of the American Indian, Heye Foundation, N.Y.*

Catlin had not only an artist's eye. He was also a dogged explorer. Early in his eight years of wandering among tribes of the American West — from 1832 to 1839 — he kept hearing reports of a mysterious, forbidden source of the red stone from which the Plains Indians — and native peoples far and wide — made their smoking pipes. Finding it became an obsession with him. To the eastern Sioux it was sacred ground which, as far as he knew, no white man had ever been allowed to visit.

In 1835 he set out from St. Louis to find it. Accompanied by a

footloose Englishman named Robert Serrill Wood, he journeyed east to Buffalo, across the lake to the Falls of St. Anthony, and then struck 480 kilometers due west on horseback. En route, the two men were challenged by the Sioux, asked what business they had at the sacred place, and were told to turn back. Despite the threat, they went on.

Eventually Catlin found the forbidden place, the "fountain of the red pipe," located on high ground in what is now Pipestone County, in the extreme southwestern corner of the state of Minnesota. "This place is great, not in history, for there is none of it, but in traditions and stories," Catlin wrote. "Here, according to their traditions, happened the mysterious birth of the red pipe, which has blown its fumes of peace and war to the remotest corners of the Continent . . ." Legend had it, wrote Catlin, that long ago . . .

> . . . when all the different tribes were at war, the Great Spirit sent runners and called them together at the 'Red Pipe.' He stood on the top of the rocks, and the red people were assembled in infinite numbers on the plains below. He took out of the rock a piece of red stone, and made a large pipe; he smoked it over them all; told them that it was a part of their flesh; that though they were at war, they must meet at this place as friends; that it belonged to them all; that they must make their calumets from it and smoke them to him whenever they wished to appease him or get his goodwill — the smoke from his big pipe rolled over them all, and he disappeared in its cloud; at the last whiff of his pipe a blaze of fire rolled over the rocks, and melted their surface . . .[9]

Block-and-tackle type panel pipe collected by George Catlin. Museum No. 1/9271. Length 36 cm.

— *Museum of the American Indian, Heye Foundation, N.Y.*

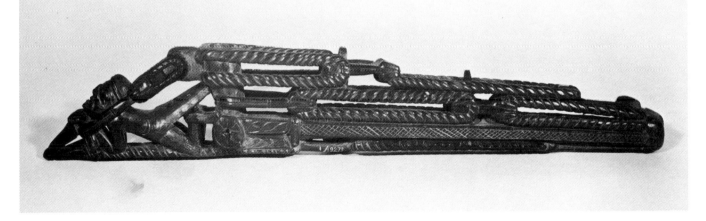

Ancestors of the Oto and Iowa Indians are believed to have first used the quarries more than 400 years ago. For years tribespeople had trekked to the pipestone source, traveling up to 1,000 miles on foot. The stone was widely traded. In 1937, Pipestone National Monument was created by an Act of Congress, and the exclusive right to quarry the pipestone was granted to the American Indian.

The red pipestone came to be called catlinite after its "discoverer." Though he was not the first white man to visit the area, Catlin was the first person to describe the quarries in print, and his

pipestone sample was the first to be studied. It is easy to imagine how thrilled Catlin was to reach the secret place. Anyone who hikes into the Slatechuck quarry today feels the same sense of excitement — the feeling that "this is it — the source." But while 200,000 tourists call at the Minnesota quarries each year, the lofty, exclusive Slatechuck hears only the occasional hammer blows of a few Haida carvers.

Catlin collected several hundred pipes of native manufacture during his roamings from 1832 to 1839, including two argillite pipes which are now in the Museum of the American Indian, Heye Foundation in New York City.[10] Since he did not go near the Charlottes on those travels, he is presumed to have acquired them from Yankee or British traders in the Northwest. Catlin was therefore one of the first minor "collectors" of argillite. He was also the first person to picture argillite in a book. Rough sketches of his slate pipes appeared in his popular *Manners, Customs, and Condition of the North American Indians*, published in 1841.

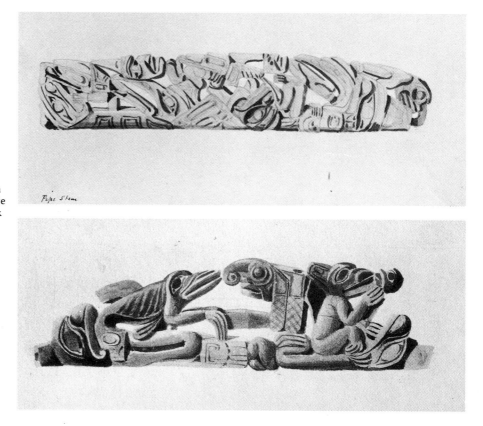

The Canadian artist Paul Kane (1810-1871), an admirer of George Catlin, painted these argillite pipes. The original watercolors are in the Stark Museum of Art in Orange, Texas.
— *Stark Museum of Art, Orange, Texas*

Argillite reached Catlin. Pipestone could have reached the Haida. However, the resourceful native people of the Charlottes were not committed entirely to the use of slate. They made pipes of wood — several specimens in wood exist in museums. And they used clay.

The presence of one clay pipe of early provenance came to light only in 1977-78, in a European museum. Christian Feest of the Museum für Völkerkunde in Vienna had sent the authors a photograph of one of several of his museum's panel pipes of black argillite. He noted at the time that it was reddish in color "but

otherwise in the style of black argillite carvings." Later, on examining it, he thought that its weight and texture differed as well. So he subjected it to laboratory tests which indicated it was not stone but more likely made of clay. "Why in the world should a piece which certainly predates 1867 be made of clay?" he asked.[11] The clay could have come from almost anywhere. It is found in the Charlottes — there is a deposit close to Skidegate village.

Haida wooden pipe of European-American motif with abalone shell and ivory inlays. Pipe bowl and mouth end are rimmed with brass. Museum No. de W. 74.403.10 Length 29 cm.
— *Berne Historical Museum, Ethnography Department, Berne, Switzerland*

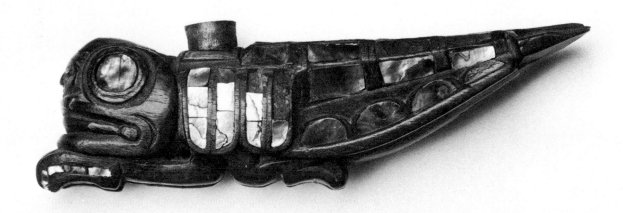

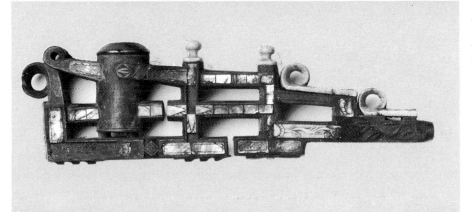

Another wooden pipe with abalone inlay. Bowl is a small metal cylinder. Museum No. de W. 74.403.11. Designated as Tlingit. Length 17.5 cm.
— *Berne Historical Museum, Ethnography Department, Berne, Switzerland*

Panel pipe carved from a single piece of wood, with iron bowl inserted. Museum No. de W. 74.403.1. Length 38.5 cm.
— *Berne Historical Museum, Ethnography Department, Berne, Switzerland*

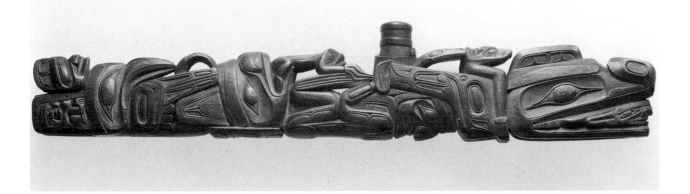

Most academic students today subscribe to the theory that argillite carving did not start, at least in earnest, until after the white man arrived. No mention of argillite carvings appears in early journals, they point out, whereas other accoutrements of Haida culture *are* described, often in great detail, in those journals that have been widely circulated. Furthermore, they maintain that when argillite carving did begin — in the first two decades of the 1800s — it did so in response to the demands of trade with whites. The sea otter hunter's bonanza years were over. The Haida needed another commodity to take the place of sea otter pelts, and turned to the carving of argillite pipes for trade.

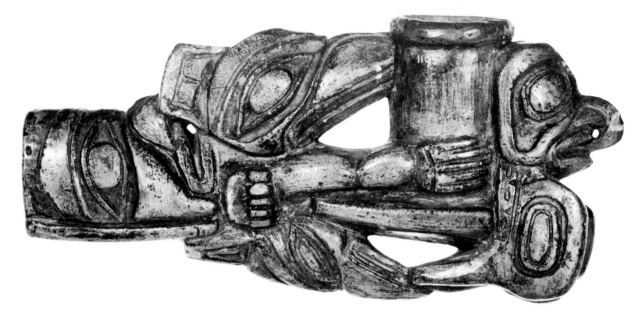

Once thought to have been carved from reddish slate, this pipehead was recently found to be made of clay. It came from the collection of J. G. Schwarz who had never visited the Northwest Coast and who died in 1867. Museum No. 11958. Length 10.9 cm., height 5 cm., thickness 2.2 cm.

— *Museum für Völkerkunde, Vienna*

Haida students of argillite history, relying more on their own oral history, think differently about the rise of argillite carving. Because argillite carvings are not mentioned in the journals is no reason for thinking they were *not* there, they say. Most early visitors came in the summer months, not in the winter when ceremonials took place. They contend that the trade aspect of early argillite has been over-emphasized. They do not dispute that a number of argillite pipes would indeed have been made to be exchanged, either with other native people or with visiting sailors, for tobacco, liquor, ammunition, or clothing. But the goods received in exchange would have meant so little in the self-sustaining Haida economy of the early 1800s as not to warrant argillite production on the scale indicated by the large number of pipes that survive from the period.

The educated Scotsman Dr. John Scouler noted as much. He visited the Charlottes in 1825 as surgeon aboard the Hudson's Bay Company supply ship *William and Ann*, the first HBC ship to take part in the maritime fur trade, and commented that for the few things the Haida had to sell they demanded "such exorbitant prices as convinced us they were in no want of European goods."[12] At that time, the main manufacture for trade continued to be the canoe, the staple that was traded to the Tsimshian for oolachan grease, which

was not only a much-relished food but which may also have been a dietary necessity. No, we must look elsewhere for the inspiration behind some of the argillite pipes of the period, in particular the exotic panel pipe of Haida motif, the most elaborate of the early pipes, which were then coming into full flowering. That source, we suggest, lies in the dark recesses of shamanism.

No first-hand accounts exist of shamanistic practices among the Haida other than those of healing, but a German scientist named Aurel Krause, sent out on a research expedition for the Geographical Society of Bremen in 1881, wrote in considerable detail of what he found among the Tlingit. Krause spent three and a half months at the trading post of Chilkoot at the head of the Lynn Canal, and one of his sources of information in his lonely winter of 1881-82 was a Tsimshian woman who had lived among both the Haida and the Tlingit. Krause wrote in painstaking detail about Tlingit customs and manufactures. He described Chilkat blankets, for instance, and went on to tell of small ornaments, models, and toys carved from a variety of materials such as stone, bone, shell, or wood. And, interestingly enough, he said that nephrite and "other hard silicates like marble and alabaster and a softer black slate from the Queen Charlotte Islands are all worked."

Tlingit shamanism, he found, consisted of a belief in spirits which interfere with the lives of the people and whose power can only be broken through the knowledge of a few, the shamans.

> The shaman, called *ichta*, is recognized by his wild, dirty appearance, with hair loosely hanging in strands, or bound in a knot at the back of his head, but never touched by scissors or comb . . . A shaman has in his possession all kinds of decorative objects, such as carved bone spikes, face masks, rattles, drums, etc. . . . The conjuring of a spirit consists of a wild dance around the fire during which violent contortions of the body take place. The shaman cures the sick by driving out evil spirits, brings on good weather, brings about large fish runs and performs similar acts. For these services he collects good pay and in fact always gets it in advance.

Then, quoting from Ivan Veniaminoff, a six-foot-three Russian priest who was transferred by Baron Wrangell to Sitka in 1834 so that he might familiarize himself with the Northwest Coast people through the Tlingit (Veniaminoff was later elected bishop and served at Sitka until 1850), Krause goes on to say that not everyone who wished to could become a shaman — only those who obtain spirits and have entered into a rapport with them.

> Whoever wishes to become a shaman goes alone into the forest or the mountains far from human contacts for a period of from one week to several months, during which time he nourishes himself only on the roots of (devil's club) The shorter or longer period in the wilderness depends on the appearance of the spirit. When he finally meets the spirit he can count himself among the lucky if he gets a land otter in whose tongue is contained the whole secret of shamanism. The land otter

goes directly to the would-be shaman who, as soon as he sees the spirit, stands still and exclaiming four times a loud "oh" in various pitches, kills him. As soon as the land otter hears this sound he falls on his back and dies, with his tongue protruding. The shaman tears the tongue out, saying: "May I be successful in my new calling, may I conjure and dance well," and putting the tongue in a basket which he has prepared for this purpose, he hides it in an unapproachable place, for if an uninitiated person should find this (otter's tongue) he would lose his senses.

The ability of a shaman depended on the number of spirits under his control. Moreover, the great shamanistic performances were given only in the winter during a new or full moon. "The shamans call ceremonially upon their spirits so that they may bring luck and ward off illness for the village," and at the conclusion of the performance the guests were served with tobacco and all kinds of food until dawn.[13]

Among the Haida, according to Krause, the influence of the shaman was stronger than that of the village chief. His description of how a Tlingit became a shaman, while more detailed, follows closely the "severe course of initiation" outlined by George Dawson for the Haida shaman or sGaga. His hair was long and tangled, neither cut nor combed, Dawson attested. The office was not, like the chieftaincy, hereditary, but was "either chosen or accepted in consequence of some tendency to dream or see visions, or owing to some omen."[14]

The scholar Andreas Lommel, who has investigated shamanism in various parts of the world, has found certain common denominators. He distinguishes between the shaman and the ordinary medicine man. The shaman, he tells us, works only in a state of trance. He sends himself into this state by the repetitive sounds of rattles and drums, or by dance movements. The trance is then transmitted to his audience, becoming as it were a plane of communication. The audience experiences "a process of transformation — a catharsis — a purification and ordering of the psyche, an increase in self-confidence and security. All this renders them better able to stand up to the dangers of everyday life."

The intellectual outlook of the world of hunters, he says, is the view that "a living creature, every living creature, is divided into a physical and a spiritual being," and that from the particular parts of the body and the "souls" linked to them a creature can be repeatedly brought back to life. Attempts were made, in the form of the trance, to penetrate and influence the spirit world.

The period of preparation for shamanism, he continues, is frequently preceded by a mystic experience in which the shaman gives up his personality in order to be born again into another individuality. Helping spirits, in various shapes or in the form of large animals, show themselves to the shaman in visions and are at his beck and call. "The increase in psychic power which he acquires in the course of his development is described in all accounts by the concept of the 'helping spirits'."

According to Lommel, shamanism is not, as is often supposed, a religion, but a psychological technique which, theoretically, could

appear within the framework of any religion. An important means by which the shaman influences his fellows is by his ability as an actor, his use of theatre and drama, his almost complete identification with the "images" in and through the trance. "When the animal spirit has entered into the shaman he has to behave outwardly in conformity with the animal"

The shaman's experiences, he goes on, give him special abilities which afford him his social status. "Not simply the experiences, of course, but their artistic transposition into dramatic action." The shaman is not only the influencer of fortune but also the poet and artist of his group who molds its spiritual world into impressive images and who gives fresh life to the images that live in his group's imagination. "The shaman is able to influence the psyche of his group, to give it fresh life, to render it creative and restore its healthy, productive equilibrium more effectively than any modern psychotherapist, artist or man of the theatre, and also more effectively than any celebrant priest."[15]

The shaman's status, both social and artistic, is worth noting because the most exotic of Haida pipes in argillite, the dream-like panel pipes of Haida motif, would have been entirely appropriate for his use. The artistry lavished on the finest of these panel pipes is such as to suggest, indeed demand, a specific use by someone of high rank. At least one person in fairly modern times stated that Indian "doctors" held them in their hands, while dancing. He was Indian agent Thomas Deasy who lived and worked among the Haida from 1910 to 1923. When Deasy referred to argillite pipes that showed the "Egyptian style" of carving,[16] there can be little doubt that he meant what we now call panel pipes of Haida motif. Although their iconography is totally different, these marvellous pipes do bear a vague resemblance to an Egyptian frieze.

Just how and why the shaman used them we do not know. Were they to call up his helping spirits? Did he wave a panel pipe before a fire, that it should glitter, or that it should cast eerie shadows? Was it possible, with those that are fully equipped with bowl and pipe-stem, to blow a puff of smoke at the right moment? We may never know the answers to any of these questions. All we do know is that these pipes were among the first argillite productions to show up in quantity in the collections being formed in North America and Europe. For, as we shall soon see, these incredibly intricate carvings exerted a strange fascination on the pale-looking visitors who were now beginning to turn up in increasing numbers on the secluded shores of the Haida homeland.

A fine example of a panel pipe in argillite, well-proportioned, combining strong yet intricate carving. Every component is integrated. Accession No. 37.2982. Length 44 cm., maximum height 10.5 cm.

— The Brooklyn Museum, Henry L. Batterman and Frank Sherman Benson Funds

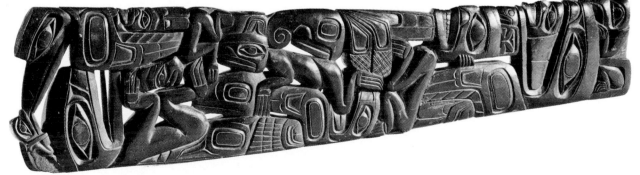

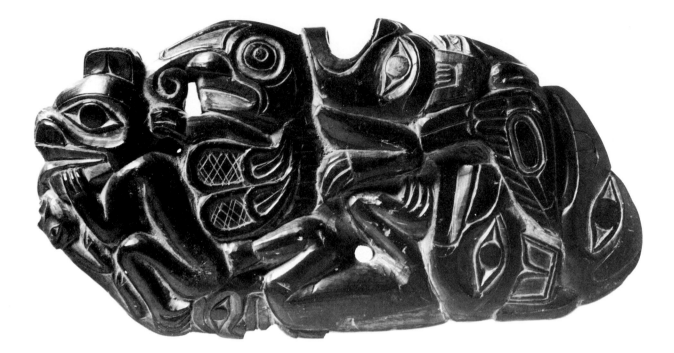

Pipe from the Etholén collection, showing
butterfly, raven, bears and humans, facing
outward in a circle. Very little openwork.
Museum No. VK 56.

— *National Museum of Finland, Helsinki*

9.
Into the world

Argillite carvings, in the form of pipes, first began filtering into the western world around 1818. Whether they existed before that time we do not know, but assuming they did and that they were connected with shamanism, it is unlikely that they would have been seen by white eyes.

For safer, easier navigation, most ships called during the summer months and since the majority of secret rituals took place during the winter in the permanent villages, white men would probably not have been admitted to these rites even if they had been around. For a long time, British and American traders and their ships' crews kept their distance from Haida villagers as a whole. Many of them had come to regard the Haida as unpredictable in behavior, friendly though they had been in greeting the first comers. Most shipmasters refused to allow them on deck. Likewise, fearing capture, few traders ventured ashore. Those who did usually took a chief's son as hostage to guarantee a landing party's safety should a dispute arise. At the same time, relations between some white traders and certain villagers became less than cordial.

In June of 1791 at Ninstints, on Anthony Island, near the southern tip of the Charlottes, a notorious incident occurred which was to become typical of the hostile trading relations between the Haida and those fur traders known as the "Boston men," the New Englanders. Hoya (Raven) was the leading chief at Ninstints at the time. The Yankee captain, John Kendrick, arrived in the *Lady Washington*, and while the ship lay offshore, some of Hoya's people pilfered Kendrick's personal laundry hanging above decks to dry. Either in a fit of temper, or in a deliberate move to obtain furs at the price he had set, Kendrick retaliated by ordering the seizure of Hoya and another man and bolted down their legs in a gun carriage until the stolen laundry had been returned, along with all the furs in the Indians' possession. To the proud Hoya this was a grave insult, degrading to him as a chief. He set about taking revenge. When Kendrick arrived again a few weeks later, "in liquor" that day and careless, Hoya and his people swarmed aboard and commandeered his vessel. "Now put me into your gun carriage," he declared. Kendrick stalled for time, then rallied a counterattack. Forty to sixty Haida were killed and Hoya himself was wounded. In 1794 Hoya took part in the capture of two other ships. "No other Northwest Coast chief was involved in so many attacks on ships," Wilson Duff observed. Hoya apparently met his death in 1795 in an attempt to capture another American ship.[1] Kendrick had died earlier, in the Sandwich (Hawaiian) Islands — the victim of a ball fired accidentally from a British vessel while saluting him.

Strongarm tactics like Kendrick's were not forgotten by the Haida. As late as 1878, a Haida shaman, on coming face to face with the Canadian scientist George Dawson in a lonely spot, asked whether he was a Boston man or a King George man — even though by then George III and George IV were long dead and Queen Victoria had been reigning for just over forty years. The shaman, an elderly man with his mass of gray hair rolled up behind his head, was in a canoe with his assistant, along with several other Haida, salmon fishing in Masset Inlet. On being assured that Dawson and other members of his party were King George men and not

Americans, he replied "very good."[2]

Word of the Ninstints incident spread quickly among the Bostonians, who were gradually gaining control over the Northwest trade. Many of them adopted stern measures. If the natives seemed unfriendly, the rule of thumb was to use brute force — seize a chief or two, clap them in irons, and ransom them for furs. It was also acceptable to exploit any animosity between tribes and villages, and to practice deception shamelessly. At the slightest sign of opposition, any alert captain worth his salt sent men into the rigging with blunderbusses ready to fire indiscriminately on the men, women and children in the canoes below. The natives, whose own code of conduct demanded an eye for an eye, reacted in the only way they could. They became as wily as the whites in their dealings by avenging wrongs at the first opportunity. Opinions differed as to who got the better of whom. The Scottish ship's doctor, John Scouler, commented that "with respect to atrocity, they (the Americans) can outdo the Indians."[3]

Luckily, not all the intruders were alike. The very summer that Kendrick humiliated Hoya, a completely different calibre of white man could be found in the northern Charlottes — members of a French expedition led by Etienne Marchand. Its officers were mentally equipped to take a relatively objective look at the Haida. The Marchand expedition claimed to be the second around-the-world voyage for the French. Louis Antoine de Bougainville had been first, followed by Jean Francoise de Galaup, comte de La Pérouse, who had actually visited the Charlottes in 1786, but had since vanished. Not until 1826 were the La Pérouse ships found wrecked in the New Hebrides, far off in the South Pacific.

Marchand's ship, *Solide*, was fitted out for scientific studies as well as for trading, and her officers at least were literate and reasonably knowledgeable men. They spoke well of the American traders they encountered. They found the Americans had sociable dispositions and mild, easy manners, and noted that when they dressed in the English fashion — cloth jacket, petticoat trousers, round hat — "they might have been taken for Thames watermen." The Frenchmen went ashore at North Island, explored Haida houses, and marveled that architecture, sculpture, painting and music were united and "naturalized" under the Haida.[4]

But these were educated men, as different from most traders as cognac from raw corn whisky. The average Yankee — and for that matter the average British trader of the period — was uneducated in the arts and cared little for the beauty of native artifacts. Such a trader had only one mission — to pick up as many pelts as possible in the shortest time and get away with his ship intact. He was accountable to no one but the ship's owners thousands of nautical miles away. Between 1800 and 1820, during the Napoleonic Wars, educated European visitors were almost non-existent. The Yankees dominated the trade in those years and continued to do so until the Hudson's Bay Company, under George Simpson's direction, moved into the field in the 1820s and 1830s. Even then, ship visits were less frequent than in the sea otter bonanza years around 1800.

Significantly, what could well be the very first illustration of a Haida pipe was drawn by a man who apparently went nowhere

near the Queen Charlotte Islands. The artist was Ludovic (Louis) Choris, who accompanied the world voyage of the brig *Rurik,* led by Otto von Kotzebue in the years 1815-1818. Choris included the illustration in his *Voyage Pittoresque Autour du Monde* (An Illustrated Journey Around the World) published in Paris in 1822. It shows an elaborate inlaid pipehead, but does not say of what material it is made. The only information is contained in the caption: "Illustration pipe des îles de la Reine Charlotte à la Côte Nord ouest d'Amérique dans la collection de Son Excellence le Maréchal duc de Reggio."

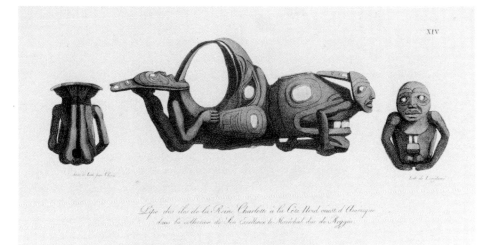

Illustration of a Haida pipe in *Voyage Pittoresque Autour du Monde 1815-1818,* published in Paris in 1822.
— *Provincial Archives of British Columbia*

Russian-born Choris had studied drawing at the gymnasium in Kharkov and at St. Petersburg before being invited to join the voyage of the *Rurik.* Upon returning to Europe, he prepared his book, received recognition from scholars and artists in Paris, continued his studies in France, and then in 1827 left for Mexico and other parts of the American continent. He debarked at Veracruz on March 19, 1828, only to be killed four days later on the road to Mexico City. He was thirty-three years old. Where he could have seen that Haida pipe, whether on his earlier voyage or in Europe, is anybody's guess. The *Rurik* was at San Francisco, Unilaska and Hawaii — that was the closest she came to the Queen Charlotte Islands. But while Choris was at Bodega Bay just north of San Francisco, a Russian fur-trading party from Sitka was there also, busy catching sea otters.[5]

His illustration is a fascinating one. It clearly shows how sophisticated Haida carving could be at a time just before the first pipeheads of argillite were reaching the western world. Whether the pipe was made of wood or argillite is almost irrelevant. Much more important is its capability in design and execution, that awesome quality seen in argillite pipes of a "later" period.

The Russians were probably the first Europeans to encounter Haida traders, not in the Charlottes themselves, but in Tlingit territory or beyond. The Russians, after all, were the first Europeans to enter the North Pacific. In the latter half of the 1700s they explored eastward in pursuit of sea otter pelts, rounding up native peoples as hunters. Their word for the all-too-friendly animal with

the coat warmer and denser than the best Russian sable was *bobr morskoy*, meaning sea beaver, which was also James Cook's word for it.

In the Russian sweep, incidentally, another aquatic mammal was wiped out. This was the sea cow of the North Pacific, which was slaughtered to sustain Vitus Bering's shipwrecked men on Bering's Island.[6] The sea cow was similar to the dugong of mermaid legend, a possible antecedent of mermaid representations that occasionally appear in argillite carvings.

The Russians could have met roving Haida almost anywhere along the great bight of the Gulf of Alaska. Links between the Russians and the Haida, although tenuous, were nonetheless strengthened in 1799, the year Alexander Baranov established New Archangel (Sitka) as the furthermost outpost of the Russian empire. For both the Haida and Tsimshian, Sitka fulfilled a role as a major trading center with the whites, a role that was not challenged until sixty years later by Victoria. Sitka lay in the heart of Tlingit territory, and the Haida had maintained cultural and trade ties with these people. The Kaigani Haida on Prince of Wales Island formed an enclave in Tlingit territory.

One of the first, small collections of argillite went out via the North Pacific route to eastern Europe, and was assembled by a Finnish trader in the service of the Russian American Company. Arvid Adolf Etholén, known in North America by the name Etolén, which is the Russian spelling of the originally Swedish name, was born in 1799 in Finland, the son of Carl Gustaf Etholén, a merchant. When still a boy, he entered the Russian navy, as Finland then belonged to Russia. In 1817 he joined the Russian American Conpany, rose in service and in 1833 became chief administrator of the Russian colonies in America.

Arvid Adolf Etholén (1799-1876).
— *National Board of Antiquities and Historical Monuments, Helsinki, Finland*

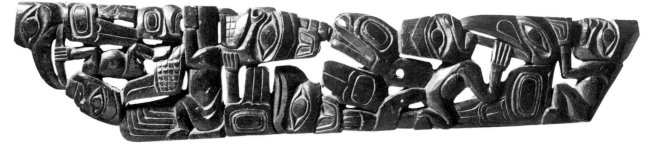

Nine-figure panel pipe of Haida motif collected by A. A. Etholén in Russian America (Alaska) 1830s-1844. From left: Raven, man, raven, grizzly bear holding pipe bowl, raven, killer whale (note hole in fin), man, raven, bear. Museum No. VK 58. Length 34.5 cm., height 7.3 cm.

— *National Museum of Finland, Helsinki*

Etholén, later Admiral Etholén, during his residence at Sitka and his journeys along the Northwest Coast and Bering Sea regions, picked up various artifacts of the native cultures and sent two collections to Finland.[7] The earlier collection, dating to the 1820s, was destroyed by fire. The second collection arrived in 1847 and is today the property of the National Museum of Finland at Helsinki. The museum has four panel pipes in argillite from that acquisition. Exactly how they found their way into Etholén's hands is not known. But we do know that during his years at Sitka he started an annual fair for the Tlingit and other fur-supplying people, attracting them from as far as Yakutat and Vancouver Island, to feast, sing, dance, and show off their crafts.

Earlier than this, argillite carvings trickled in the other direction, one by one, into the western world. They went by land and by sea to the other side of North America. Museum records indicate that individual examples were reaching the hands of fur traders who were penetrating the endless uncharted plains and valleys of the Canadian West from Lower Canada. At least one prominent fur trader contrived to obtain more than one example. He was Colin Robertson, a tough trader who worked for both the North West Company and its successor, the Hudson's Bay Company, and helped negotiate their merger. In 1833 he gave five argillite pipes to Perth, Scotland. He had probably collected them several years earlier. Meanwhile, officers and men of Spanish, British and American ships picked up slate carvings — along with numerous other artifacts — either from the Haida themselves or from other native peoples with whom the Haida traded. Slate carvings were "curiosities," something to take home as a souvenir of a dangerous voyage, to show family and friends. They were status symbols, proof that the owner had been to the ends of the earth.

Colin Robertson (1779?-1842), oil painting c. 1821 attributed to G. S. Newton. Negative number C-8984.
— *Public Archives of Canada, Ottawa*

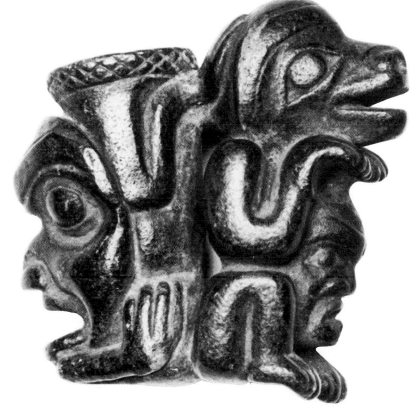

Ornamental yet functional, this pipehead with bear face (upper right) and two other faces, was donated to Perth, Scotland in 1833 by Colin Robertson, along with four other pipes. Museum records state that they were collected at "Frasers River, Gulf of Georgia." Museum No. 1978.469. Width 7.5 cm., height 7 cm.
— *Perth Museum and Art Gallery, Perth, Scotland. John Watt Photo*

Etholén qualifies as a collector. But for every man like him there were hundreds of sailors who shuffled curiosities around — and lost them. The ocean floors are probably littered with argillite. The National Museum of Denmark in Copenhagen has an argillite pipe found at the bottom of the harbor of St. Thomas in the Virgin Islands. And, wonder of wonders, Merseyside County Museums, Liverpool, own an argillite bird carving found in a field in England.

Information about the fugitive interest eighteenth century sailors took in native artifacts comes from no less an explorer than Captain

Cook. On his second world voyage, in 1774, when his ship *Resolution* was visited off the New Hebrides by hundreds of natives willing to trade their belongings, he wrote:

> Indeed, these things generally found the best market with us, such is the prevailing passion for curiosities, or what appeared new. As I have had occasion to make this remark more than once before, the reader will think the ship must be full of such articles by this time. He will be mistaken, for nothing is more common than to give away what has been collected at one island for anything new at another, even if it is less curious. This, together with what is destroyed on board after the owners are tired of looking at them, prevents any considerable increase.[8]

Not until the 1820s do we find evidence of visitors actually seeing slate carving on its home ground. One of the first reports comes from the Scottish ship's doctor John Scouler, who traveled across the Atlantic and around Cape Horn in the *William and Ann*, in the company of botanist David Douglas of Douglas fir fame. The *William and Ann* coasted along the Charlottes in 1825, visited Skidegate, and there Scouler made this observation of the Haida: "They fashion drinking-vessels, tobacco-pipes, and so on, from a soft argillaceous stone, and these articles are remarkable for the symmetry of their form, and the exceedingly-elaborate and intricate figures, which are carved upon them."[9] The last could only be the beautiful panel pipes.

An elaborate panel pipe of pure Haida inspiration, and one of the earliest acquisitions recorded anywhere, from ship's surgeon Dr. John Scouler's 1825 visit to the Queen Charlotte Islands. Several of the eight figures from legend are open to various interpretations. White lettering, added later, appears on butterfly proboscis. Museum No. 79.5.4. Length 21.3 cm., height 11.2 cm., thickness 3 cm.
— *Musée de l'Homme, Paris*

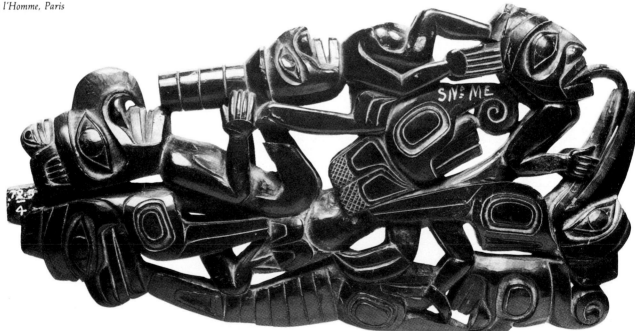

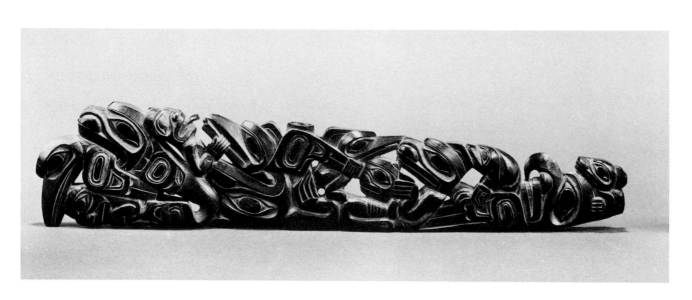

Four years later, an American called at the Charlottes and made note of the slate pipes. Rev. Jonathan Smith Green, the first Protestant minister to scout for mission prospects along the shores of what became British Columbia, visited Skidegate in 1829, and was impressed by Haida industriousness in making hats and baskets, dishes, masks, war canoes and "curious stone pipes." Green came as a passenger in the trading barque *Volunteer*, under the auspices of the American Congregational Church. His exploratory tour of the North Coast on behalf of the church was an episode in a life devoted to missionary work in the Hawaiian Islands. Throughout the journey he was on bad terms with the *Volunteer*'s master, Captain Charles Taylor, who resented among many other things his lecturing the crew on Sabbath-breaking. Green was the epitome of missionary fervor. One historian described him, on the basis of his letters, as uncompromising, lacking in imagination, and "tactful as a porcupine."[10] The Haida, Green commented, "possess a kind of independence, which scorns everything like restraint" and were the keenest traders of sea otter pelts — by that time scarce. Skidegate, with its carved poles and houses, seemed to the missionary "almost enchanting, and, more than anything I had seen, reminded me of a civilized country." He made note that "their pipes, which they make of a kind of slate-stone, are curiously wrought."[11]

Curiously carved . . . curiously wrought. These words appear again and again in the first accounts of argillite from people who actually visited the Charlottes. Yet no one asked why the Haida were carving their intricate panel pipes, or what their symbols meant.

This elaborate panel pipe (note bowl to left of center at top) was given to its Cambridge donor, Col. H. W. Fieldon, in 1846. According to museum records, it was obtained from a ship's carpenter who got it from natives at New Archangel (Sitka). Museum. No. 1897.17. Length 35.5 cm.

— *University Museum of Archaeology and Anthropology, Cambridge, England*

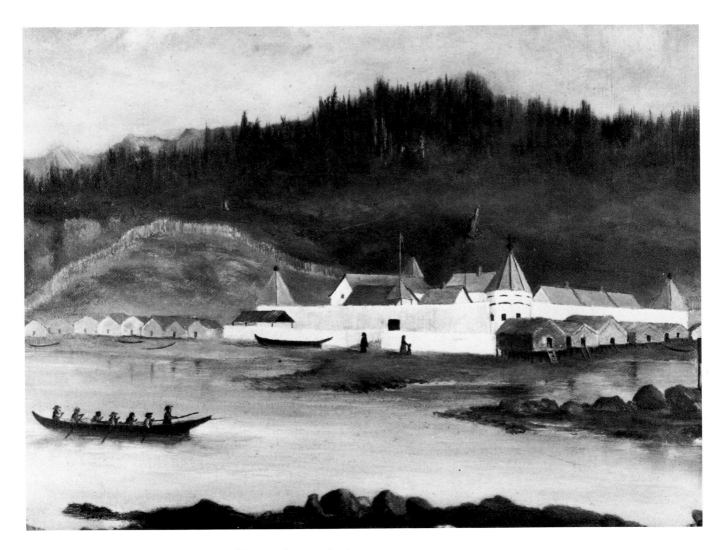

Fort Simpson — copied from a photograph taken
by a Metlakatla native, Benjamin A. Haldane, of
an oil painting by Gordon Lockerby, who painted
from watercolor sketches of the fort-trading post
in 1863.
— *Provincial Archives, Victoria, B.C.*

Very early in the 1800s the Haida way of life began to change, and that change, as we shall see, affected the slate carver's art. The sea otter which had attracted the white man to Haida shores became scarcer as relentless killing wiped out each new hunting ground, with the result that fewer ships called. Haida villagers began growing potatoes, adding these to the goods they traded across the strait to the Tsimshian, obtaining in exchange oolachan grease. A rendering of a smelt-like fish called oolachan or candlefish, this flavorful and nourishing grease is called *taow* — rhyming with how — and is relished to this day by Northwest Coast native peoples.

The Haida still moved about their ocean, as restless as ever. They continued to visit the Russian trading base at Sitka, and their own relatives, the Kaigani Haida. They went by canoe to whatever harbors were visited by those vessels still engaged in the maritime fur trade, almost all of them American. By about 1812, the sea otter trade shifted to the coast of California. It was conducted by vessels which usually had their winter headquarters in the Sandwich (Hawaiian) Islands, and whose practice it was to sail from there in the spring to Alaska to gather crews of native hunters, then swing south to reap a harvest in pelts off California, and return to Honolulu. Kaigani hunters were employed in this trade, and probably more than a few of their kinsmen from the Charlottes. The memory of those expeditions lingered as late as 1902. In that year, a Mrs. Yeltatzie of Kasaan could recall that her maternal grandfather used to go to California to hunt sea otters, and that he brought back abalone shell.[1]

Broader horizons were opening to the Haida. But at the same time potentially harmful inventions were being introduced — firearms and liquor. By 1825 the Haida were quite familiar with imported tobacco and snuff. Their leaders, it seems, were also discerning drinkers. The same Dr. John Scouler who visited the Charlottes that year also called at Nootka on Vancouver Island's west coast and noted that most of the people there were "in a happy state of ignorance of rum and tobacco" and that the old chief was the only exception: "He was much pleased with a little rum and water, which a Queen Charlotte Islander would have rejected with contempt and demanded wine."[2]

In the period from 1830 to 1840, replacing the sea otter-oriented deep-sea traffic, came coastal trading for pelts of a variety of land mammals — marten, land otter, bear and beaver. The Hudson's Bay Company had gained control over the fur trade, and to consolidate its efforts, built strategically-located posts at which the furs could be collected and put aboard its supply ships.

Up to this time, argillite had filtered out to a few mainland localities. Close to home, one of the transaction centers, for instance, was the west coast of Banks Island, directly across the strait. This was neutral ground on which the Haida had long dealt with the Tsimshian. But now, with the Hudson's Bay posts, there were new, permanent trade outlets.

The first and most important to the Haida because of its proximity, was Fort Simpson, founded initially in 1831 and then moved to a better location in 1834. Fort Simpson covered the northern territory. Then came Fort McLoughlin (1833-1843) on Milbanke Sound

10.
Fading of the light

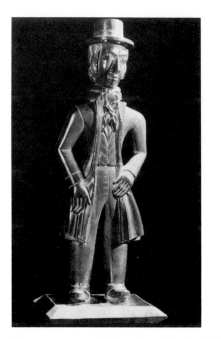

The man represented here is said to be Sir James Douglas. Museum No. 6672; donor Joseph Carter Moon. Height 37.5 cm.

— *Ethnology Division, British Columbia Provincial Museum*

near Bella Bella on the central coast, covering trade from Fort Simpson south to Fort Langley on the Fraser River. At the southern end was Fort Nisqually at the head of Puget Sound. It was founded in 1833 as a depot for coastal ships to deposit furs or pick up supplies without having to go around to Fort Vancouver and risk the notorious Columbia River bar. Later came Fort Victoria (1843) and Fort Rupert, both on Vancouver Island. The Haida would have bartered argillite carvings at these and other posts. Having paddled great distances, they would stay at each trading center for several days, dickering over transactions and generally making a social event of the occasion.

Of the individual carvers of the period we know nothing. To the whites they were faceless individuals, it seems. Only the argillite record speaks for them, and here something curious happened. The panel pipe of Haida motif lost favor with carvers. Instead, they produced panel pipes that reflected images of the white man — ships and sailors — and sometimes a combination of "western" and Haida motifs. They also enlarged the slate repertory, venturing into other forms. They began to carve standing figurines of Europeans and Americans, dishes, the odd bit of cutlery, and "flutes." The potential of argillite as a profitable souvenir had become obvious to the Haida, and from this time forward they would exploit it to the utmost.

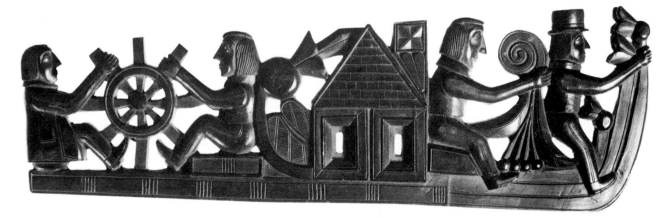

Panel pipe ship-type. Two mariners turning a ship's wheel, pod-mushroom? link, shingled "deckhouse," two more white men, between them native tobacco leaves and pods extending from scroll design. Museum No. 2-19083. Length 35.5 cm.

— *Lowie Museum of Anthropology, University of California, Berkeley*

The principal outlets were the Hudson's Bay Company posts on the mainland and the company vessels that put into the Charlottes. Then, in 1851, came the first white exploiters of mineral resources, in the form of company gold miners. They did not stay long. The strike, at Gold (Mitchell's) Harbour was a poor one and the Haida harassed the miners. But it did mark the start of a series of ventures, all relatively short-lived, that brought whites for brief periods — copper exploration, coal mining at Skidegate Inlet not far from the source of that other black substance, argillite, and later fish extraction plants. It could not be long before whites would be forming settlements in the land of the Haida.

82

Political domination began with one swift stroke in 1852. James Douglas of the Hudson's Bay Company, and governor of the crown colony of Vancouver Island, annexed the Queen Charlotte Islands in fear of an American takeover arising from the gold strike episode. Hundreds of American adventurers were reported en route to the Charlottes but, as it turned out, the gold rush collapsed.

In the home villages, the influence of encroaching whites began to penetrate deep into the fabric of Haida society. Western dress began to be adopted. Young Haida, especially women, were persuaded to leave for places like Victoria for long periods of time, often against their elders' wishes. The departure of women disrupted the system of matrilineal descent. Disease and alcohol started to take a serious toll in health and lives. Haida ceremonials, upstaged by new distractions, gradually lost their meaning, and Haida class structure lost its sharp definition. The Hudson's Bay blanket, which had replaced the fur or cedarbark cloak as the Haida coat, was the new medium of exchange. Personal wealth was counted in blankets. "Upstarts" could amass impressive numbers of blankets, much to the displeasure of some of the noble families. The west coast explorer Robert Brown had a sharp reminder of how much one chief still valued "gentle blood and long descent." Brown made the mistake of disputing a Skidegate chief's opinion of another Haida, saying the latter had as many blankets as the chief. The chief replied: "I don't doubt that; chiefs are always the poorest men, they have to give so much away; but what matters his blankets? His father was nobody."[3]

James Douglas (1803-1877).
— *Provincial Archives, Victoria, B.C.*

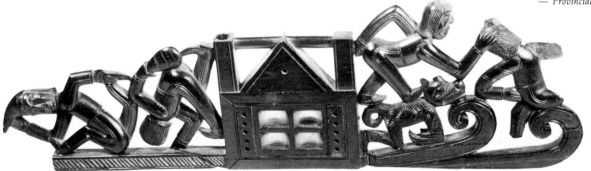

Much as he and other hereditary chiefs could take comfort in pride, the fact remained that the old social order was crumbling. City lights beckoned the younger generation. In the summer of 1858, Victoria blew up from a quiet settlement of less than 300 whites to 6,000 following the discovery of gold on the mainland. The Haida and other northern natives descended in hundreds. They had come before, but never in such numbers. Governor Douglas had been worried by their visits. In 1856 he wrote: "I have used every means in my power to prevent their annual visits to the white settlements, both British and American."[4] Douglas, whose wife was part-native, knew from long experience the harm of mass mixing of native people and white riff-raff, in this case rough miners from California and the assorted hucksters who move into any boom town. He was in the unenviable position of having to

A caprice of a European-American or ship-type panel pipe. Four seamen in acrobatic postures with curly-tailed dog (?) on each side of "deckhouse" having inlays for windows. Fine spatial sensitivity, flow of movement. Museum No. A62.62.49. Length 35 cm.
— *Glenbow Museum, Calgary*

maintain order, with pitifully small police resources, amid a boom that had the explosive combination of guns and liquor. He wanted desperately to avoid a repetition of the California brand of lawlessness that had all too often turned on the native population, reaching its worst in bounty hunting.

A sketch of Victoria in 1862.
— *Provincial Archives, Victoria, B.C.*

From the Benjamin collection of argillite, acquired in 1861: Pipe, length 23.5 cm., No. 1057; cup, diameter 8.5 cm., height 6 cm., No. 1062.

Those were his problems. The Haida, camped on the outskirts of town in crowded quarters, had theirs. But craftsmen among them suddenly found new opportunities. For the first time, a great many potential purchasers existed, all in one place. Visitors of every description were arriving daily by steamer. One of them, a Jewish historian, came from Europe on an extraordinary quest.

Benjamin II, whose real name was Israel Joseph Benjamin (1818-1864), had married young, engaged in commerce, lost a modest fortune, and then taken up a new career. Adopting the name of Benjamin of Tudela, a famous Jewish traveler of the twelfth century, he set out from Europe in 1844 to search for the Ten Lost Tribes of Israel. He traveled through the Middle East, into Afghanistan and India, then to North Africa, then in 1859 headed for North America.

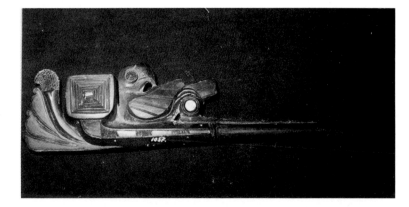

Despite a limited purse, he reached Victoria early in 1861 in the steamer *Panama*, noting as he did so that most of the steamers plying between San Francisco and Victoria were unseaworthy ("I would not trust the life of a faithful dog, let alone a human being, to a ship that goes to Victoria") while at the same time expressing

gratitude for free passage.[5] During his brief stay, Benjamin visited several Indian encampments around Victoria, especially those of the Haida and Tsimshian, and recorded the names of three Haida chiefs — Wyhaw, Kaneho and Stiltah.

"I met with the friendliest and most courteous reception," he wrote. "Their delicacies, to be sure, with which they wished to regale me, dried fish and dried bear's meat, tempted my palate little. With much trouble I succeeded in making them understand how grateful I should be to have some of their ornaments and articles of clothing. These had, naturally no real value in themselves, but all the greater value for a collector of curiosities. I succeeded, partly by purchase and partly by gifts made to me, in forming a not unimportant collection of Indian objects."[6]

Benjamin did not continue north to Sitka, as he had hoped to do, but instead returned to San Francisco, having concluded that West Coast Indians did not qualify as one of the lost tribes. On his return to Europe he published his *Drei Jahre in Amerika* in Hannover in 1862. His "not unimportant collection" went to the King of Hannover and from him to the Niedersächsisches Landesmuseum in Hannover the following year. Eight argillite carvings — two pipes, two panels, two flutes, one plate and one cup — survive. It is an important group illustrative of the diversified production in the brief period of Haida flirtation with Victoria.

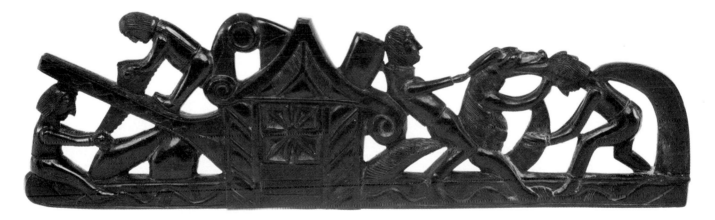

The Haida craftsmen who made Victoria a second home, as it were, were by no means limited to making curios. New, substantial buildings were going up all around town. Wrought iron was in high fashion for ornamentation. Foundrymen needed carved wooden molds in order to make iron castings. Who should be hired but the versatile Haida craftsman?

One talented, "urbanized" Haida who apparently found employment in the industry was called Waekus (the name is sometimes spelled Wacas or Wakus.) He worked in Victoria around 1860, and since he was also an argillite carver, his name is important in our story. He is the first slate carver to be mentioned by name. Our informant is Robert Brown again. Brown, like so many other educated whites, was of the opinion that the Haida excelled all other of

This ship-type panel pipe depicting strenuous activity (wood-sawing, horseback riding) was among Northwest Coast artifacts displayed at the London exhibition of 1862. Museum No. 1906.459. Length 30 cm.

— *The Royal Scottish Museum, Edinburgh*

the "American races" in artistic skill. He marveled at their "beautiful pipes, statuettes, and so forth, made of slate...as well as jewelry...and when we consider that all the tools they had to work with were probably a broken knife and a file, their execution is really wonderful, as well as the aesthetic taste displayed in their design."

He went on to tell of a man called Waekus who "made out of gold coin a pair of bracelets, for the wife of the English Admiral on the station, of such beautiful design and execution, that they were universally admired. The same man afterwards designed the cast-iron railing now (1860s) ornamenting the balcony of the Bank of British Columbia, in Victoria. He could scratch a fair portrait on ivory, and I have seen a bust of Shakespeare executed by him in slate from an engraving."[7] We would love to know what happened to his works. The banks still stands on Government Street in Victoria but its railing is gone. And what became of the bust of Shakespeare we do not know.

Waekus could have been the same artist whose work was seen by Lady Franklin, widow of the lost Arctic explorer Sir John Franklin, when she visited Victoria in 1861 accompanied by her niece, Sophia Cracroft. The two women visited an iron foundry in Victoria West for the express purpose of seeing some very remarkable carvings, in wood for castings, by an Indian. "They are admirable — copied from drawings, and show wonderful power of imagination," the niece wrote. The foundry owner gave Lady Franklin a plate of slate on which was carved in relief his name (Macdougall) and designation, for casting. Lady Franklin promised to send it to the London Exhibition of 1862, "together with a most wonderful piece of carving also in slate, copied from a picture, by an Indian in Queen Charlotte Island, given her by the Governor."[8] The 1862 exhibition was the attempt by Prince Albert, Queen Victoria's consort, to revive the glorious spirit of the Crystal Palace exhibition of 1851. Argillite carvings were displayed at that exhibition, but whether they were the ones presented to Lady Franklin we do not know.

The celebrated Waekus, meanwhile, disappeared under tragic circumstances. He returned to the north from Victoria, only to be shot by his chief in a drunken quarrel. He would have known a great deal about the argillite art, but apparently no one was interested enough to ask him and set it down in writing. Of anything else he produced in slate, nothing is known. He could well have been a carver of some of the beautiful panel pipes.

His death is a dramatic instance of how the Haida culture was breaking down at this period. Conflicts fueled by liquor were costly in lives — and talent. And those annual excursions to Victoria, besides leading the Haida into vice and prostitution, were depopulating villages back home. The captain of the man-of-war H.M.S. *Alert* got a clear indication of this when he toured the Charlottes in 1860 on a peace-keeping, anti-slaving mission. At each village he told the chiefs to refrain from raiding other tribes, especially those living on northern Vancouver Island. He told them to trust to the white man's laws for redress in case of wrong, when any of their people were living in Victoria. The message was received sympathetically. At Skidegate, Chief Nestacaana suggested that all his people should be compelled to return home. He had wanted to

build a large house that summer, but could not find enough men to help him. Nearly all of them were away in Victoria.[9]

In Victoria itself, the clamor for expulsion was growing louder. In the spring of 1861, the newspaper, *The Daily British Colonist*, railed editorially against the annual influx. "Every year since 1858, the town and country around Victoria has been overrun by Russian, Queen Charlotte's Island, Fort Rupert, Fort Simpson, and Northwest Coast Indians," it declared, going on to say that on their canoe trips to and from Victoria they had terrorized settlers at Salt Spring Island and Nanaimo, and that Victoria residents had been subjected to their noise, feuding, stray bullets, drunkenness, larceny, and prostitution. "The only thing we receive in return for these monstrous crimes are a few, very few furs, and some whistles, pipes, or trifles carved out of carbonized slate and occasionally a day's labor from the vagrants." None of the northerners, the editorial writer added, should be allowed south of Cape Mudge. "If they are to be taught to cultivate the soil, build school houses, erect churches, and substitute peace for bloodshed, the school-master and the evangelist must go to their Northern homes — away from the scum and vices of civilization — then some good may be effected."[10]

Vagrants indeed, in their own country! However, from behind its lace curtains, the Victoria establishment must have applauded the editorial outburst.

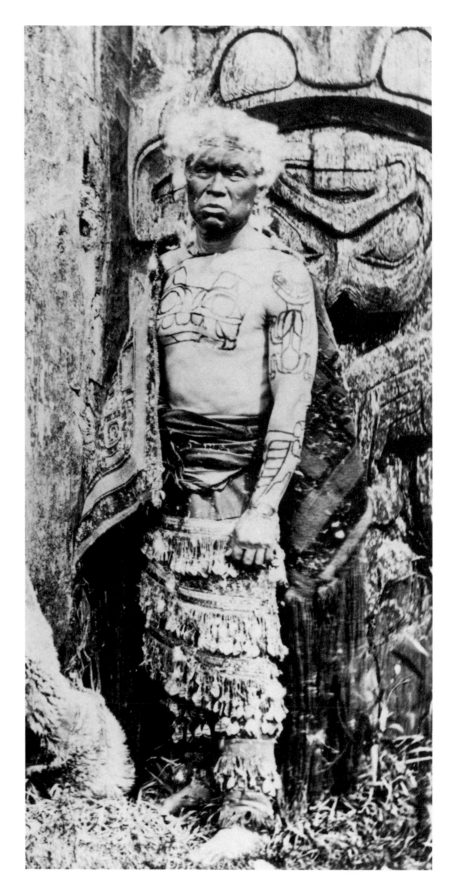

A rare photo of a Haida shaman, from the early 1880s, showing his tattoos, Chilkat robe, and fringed skirt and leggings.

— *Provincial Archives, Victoria, B.C.*

If the roving Haida had known what would happen a year later they would have been only too glad to stay home. No one, not even the wisest shaman, could have foretold what form expulsion would take. It was the spectre of disease, which has often changed the course of history, and it led a fiery dance of death.

The smallpox epidemic of 1862 has been described by Wilson Duff as the most terrible single calamity to befall the native people of British Columbia. It is said to have started with a white man who had the symptoms when he arrived in Victoria from San Francisco in March. Within days, the disease began to spread into the crowded native encampments on the outskirts of town. By April it was into the Tsimshian camp. By May it reached the Haida camp. Because Governor Douglas was away on the mainland at the time, the authorities were slow to act. Douglas's son-in-law, Dr. John Sebastian Helmcken, did the best he could by vaccinating 500 natives, but these represented only one-quarter of the total. Deaths occurred so rapidly that corpses lay in the huts with the dying. At last, realizing the enormity of the outbreak and anxious to prevent the disease from spreading to the white population, the police expelled the northern natives. By this time many of those left had contracted smallpox. As they struggled north in their canoes they passed the disease to uncontaminated native settlements. Soon virtually every village along the route was engulfed. Smallpox had broken out before, as early as the 1700s, and was much feared, but never had it come on such a devastating scale as this.

In the Haida homeland, once-thriving villages were depopulated beyond recovery. On the southwest coast of the Charlottes complete villages died almost overnight. In those that somehow managed to survive, observers commented ruefully in later years on the scarcity of children. George Dawson noted that the disease was invariably fatal to the Haida. He could learn of only one instance in which recovery had occurred.[1] From a population estimated at nearly 7,000 in 1835, the Haida dwindled to a mere 800 by 1885, largely because of smallpox. A chief summed up the despair in these words: "Now the fires have gone out and the brave men have fallen before the iron man's sickness."[2]

Total disorder followed. Surviving villagers banded together with kinsmen in villages that had suffered less severely. Some villages struggled on, if they had the spirit and the manpower, but not for long. Ultimately all the survivors were drawn into two villages, Old Masset and Skidegate. From Yatza to Ninstints, from Chaatl to Cumshewa, one by one, families were forced to relocate over the next thirty years among the Massets and Skidegates. With only two villages left, there ceased to be the diversity in village character which had been one of the strengths of the Haida culture.

The loss penetrated deeply. Only missionary admonitions and government edicts would inflict comparable wounds. It was not simply a matter of people having to leave behind their village traditions. The epidemic did not discriminate between rich and poor, talented or untalented. It did not spare story-makers, story-tellers, masters of ceremonies, singers, dancers, artisans. Among the first victims would have been the shamans, called upon to attend the sick and dying. Nor did smallpox spare those who

11.
The smoldering fires

ordained that ceremonies should take place. Without guests to invite or heirs to receive property, the potlatch fell into disuse.

One village after another fell silent with only their great cedar columns and painted houses left to creak a protest. In those villages there were no more house-raisings or any other events to be commemorated. Of necessity, ceremonials became fewer and fewer in the surviving villages. Their occupants had a hard enough time fending for themselves without giving feasts. Only a few villages — Tanu (Kloo) was one, Cumshewa another — had enough people to rally ceremonial functions in the years leading up to consolidation. And it had been the ceremonials and feast occasions, bringing people from other villages, which had constantly refreshed the arts. Here the legends had been told which, under the impact of dance and drama, inspired artists who worked in other mediums, among them the slate carver.

In Old Masset and Skidegate, of course, potlatching could still go on. At least it had every chance of doing so but for the arrival of the missionary. He had been coming closer and closer. The same year that the epidemic struck, William Duncan, the Anglican lay missionary, was building his New Jerusalem across the strait at Metlakatla, among the Tsimshian people. The Church Missionary Society in London had been prevailed upon by the deeply religious James Prevost, the British naval officer, to send a missionary to the North Coast. On the Charlottes, Catholic priests had been driven off by the Haida.[3] But where the Catholics failed, the Protestants with their beachhead at Metlakatla succeeded.

The Christian presence arrived permanently in the person of the Anglican William Henry Collison. He came on November 1, 1876 with his family as the Charlottes' first resident missionary and chose Old Masset for his mission headquarters. It was then the largest northern village except for Yan, which he would have preferred as a site if access had not been difficult in bad weather. Within three months, he was reporting on his work by letter to the Church Missionary Society. In passing, he mentioned the great number of totem poles in front of every house, "fraught with meaning to the people themselves."[4] He also remarked that since the establishment of a Wesleyan mission at Fort Simpson, "Mr. Crosby (Rev. Thomas Crosby), who is the missionary at that post has induced them to take them all down and destroy them."[5]

Collison was not slow to take "reform" measures himself. He set about putting an end to dancing, that vigorous Haida tradition which had a spinoff effect on other Haida arts. By 1878 he was able to inform the Church Missionary Society: "Dancing, which was carried out every night without intermission during our first winter on the Islands, has been greatly checked. Several, including two of the chiefs, have given it up entirely. The medicine men have informed them that those who give up dancing will die soon. They are well aware that the abandonment of this practice will weaken their influence and hence their opposition."[6]

With remarkable defiance, some native people on the Northwest Coast, Haida included, resisted for a good long while the peremptory end to their dancing. A Kwakiutl chief told the ethnologist Franz Boas several years later: "If you are come to forbid us dance,

begone, if not you will be welcome to us."[7] The same thing happened after the dominion government prohibited potlatching in 1884. The Haida were too far away for effective enforcement of the ban and continued to hold them. Missionaries opposed them vehemently. Collison considered them obstacles to cultural development and "barriers to industry."

With sublime inconsistency, however, churchmen were not above preaching at potlatches because there they had captive audiences. Instances of the ambivalent attitude of the missionary toward native customs and arts never cease to amaze — and amuse — the Haida. In 1978 one charming, elderly Haida woman told us that an Anglican minister in the Charlottes had taken to wearing vestments that incorporated Indian designs. She smiled at the irony. She could also recall hearing that one of her great-grandfathers had once been fined $10 or $15 for holding a potlatch. She could not remember the exact amount, but she did know it was "a lot of money then."

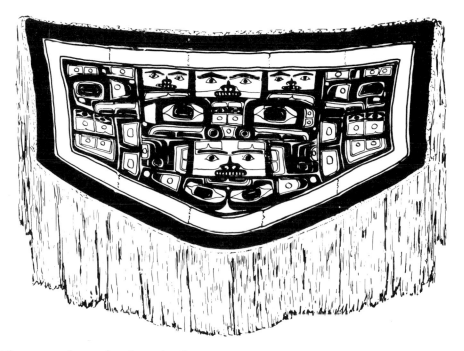

Chilkat blanket drawing.
— F. W. M. Drew

The Haida have not forgotten. They may have forgiven in the spirit of the Christianity they have been taught, but they still remember what happened to their culture in the years leading up to 1910 when they came completely under the control of the white man. Their names, the most personal possessions of all, remind them every day. With the missionary came the rites of baptism, requiring registration by names the whites could spell and pronounce. Haida names were blandly disregarded. Symbols of a person's prestige, history, and individuality, each name had a life of its own that the missionary blissfully ignored. More importantly, Haida names had been passed on according to the matrilineal system. The new namings forced adherence to a conflicting patrilineal system. Anglo-Saxon surnames were imposed, names like Gladstone, Shakespeare, Smith, Jones, and the anglicized Eden-

shaw. In the communication gap of the period, brothers could sometimes receive different surnames. If names were often given unfeelingly, they were also appropriate now and then. A fifty-year-old Kitkatla man was christened Peter Bell by an Anglican bishop at Metlakatla in 1885. It identified him immediately, as though he needed it. He was the man who rang the church bell.

The Anglicans had hoped to serve Skidegate from their Masset mission, but the distance between the two points proved too great. When the Skidegates asked for a teacher, the church made the mistake of sending them a Tsimshian. That wouldn't do. The Skidegates wanted a white mentor, same as the Massets had. In 1883, the Canadian Methodist Missionary Society stepped in obligingly, and after that the Anglicans confined their activities to the northern Haida.

The two denominations operated rather differently, mainly because of the differing persuasions of the men in charge. The Methodists were the sterner of the two. With the support of converts of high rank, they set about instilling the work ethnic much more vigorously than the Anglicans at Masset.[8] They clamped down hard on shamanism, potlatches, drinking and gambling. The Anglicans who succeeded Collison at Masset were slightly more tolerant in these and other matters. Nonetheless, both dictated what they considered best.

The shaman was an early target. His medical practices were assailed first of all. Against competition from vaccines, chemical drugs and rules of hygiene applied by the missionary, he rapidly lost face and favor among his own people. By 1885 his influence was practically nil at Masset. He was even helping the Anglican clergyman by supplying him with medicinal herbs. Nothing is so revealing of his plight than one or two photographs of shamans taken in this period. They show him glaring resentfully, defiantly, at the cameraman, glaring at a world that has stripped him of his powers.

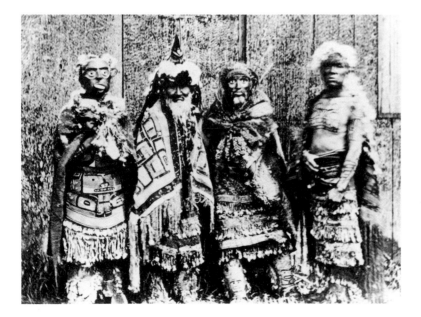

Glowering shamans with masked companion at left. They are sprinkled with feathers and down.
— *Provincial Archives, Victoria, B.C.*

Meanwhile, the distinctive symbols of the Haida culture vanished one by one. Finally, the greatest symbols of all — the magnificent cedar memorial poles — were taken down. They had long stood for family genealogy and honor. Now they too went, first at Skidegate, then at Old Masset.

Throughout the destruction, the churches had worked closely with government officials. Soon officialdom took the upper hand. The North Coast Indian Agency had been set up at Metlakatla in 1883, but the agent seldom visited the Charlottes. However, in 1910, the cultural cutoff date, a separate agency was instituted at Masset marking the start of Canadian domination of the Haida. It represented the relative end of Haida aboriginality. A Catholic, Thomas Deasy, became the first agent. Control gradually shifted from the church to the state in education, medical care, social assistance.

In their zeal for running other people's lives, churchmen and bureaucrats alike gave scarcely a thought to what they were doing to a very old, self-respecting culture. What was at stake was cultural integrity. They had struck close to its heart, but they hadn't known exactly where that heart lay. They had never listened long enough to find it. They had never tried to understand the Haida — his ways of expressing himself, his thought processes, his values.

Had they tried, even after all the havoc, they would have been in for a surprise. Many Haida, elders especially, still retained their intense pride and their long memories. As we have already mentioned, they had new names, but they still knew and used their Haida names. They kept their language. Somehow they managed to retain their quiet sense of humor. They salvaged what they could of legends and songs. And, of crucial importance in our story, they continued to create from the natural resources of the islands.

Argillite art flourished in the 1880s and 1890s. The missionary considered it harmless, unrelated to "paganistic" rites, and even encouraged carving as a source of profitable work and revenue. The revival attended the appearance in the Queen Charlottes of travelers and scientific investigators. Their interest in the disappearing "pristine" Haida culture stimulated purchasing of historic and contemporary argillite samples.

As well, there were internal encouragements. Displaced Haida settling in Skidegate and Masset took up argillite carving. Apparently they found it as satisfactory a medium for expression as the wood they had carved in their home villages. The origins of several slate carvers who were working at the turn of the century convey a picture of the talent that infused slate carving in Skidegate during the roundup of survivors of the depopulated villages: Robert Miller,[9] formerly of Tasu; George Smith from Cumshewa, whose family could trace roots to Hippa Island; Henry and Joseph Moody from Skedans, who owned mountain goat, grizzly bear and wasco crests. It can be assumed that almost every one of the carvers of the 1880s and 1890s was adept in several different mediums, especially wood, like Waekus before them. Johnny Kit Elswa, for instance, a prominent argillite carver of the 1880s, was also a tattooist. In the use of all the mediums, design capability was of utmost importance.

Design was one thing. The *form* that argillite carvings took was

another. At about the time of the smallpox epidemic, for reasons not at all clear, the form took a radical turn. The panel pipe of European-American motif — the ship-type panel pipe which had delighted visiting mariners — died rather suddenly. In its place as the new favorite rose the miniature pole, modeled after the giant cedar poles that would soon disappear. Perhaps subconsciously, artistic vision foresaw the end of the big cedar pole. Later, argillite poles would not be models at all, but original inventions.

In relationship to the panel pipe, the pole marked a distinct swing from a horizontal to a vertical form. Instead of the flowing, multi-figured carvings came a more rigid argillite form with fewer figures. The number of figures on three-dimensional works has further diminished through subsequent years until today we have the two-figure pole and the free-form carving. The trend can be traced directly to the turning point of the 1860s when ceremonials began to die, and with them the legends that enriched the art. The old art forms, like the old culture, changed in a time of crisis. An age-old culture was breaking apart, its more ambitious youths scattered to the four winds, drawn by the white man's ostentatious wealth and beguiling ways. Yet old men went on carving, and a few children sat at their knees watching. For these men carving was a satisfying pastime. Besides, with a bit of luck, it earned them money.

Indeed, by the last decades of the 1800s, the stay-at-home carver no longer had to wait for occasional buyers off ships. Steamer traffic to Alaska began operating more or less regularly just after the mid-1880s and the carver could send his winter's output there, or south to the rising towns of Seattle, Victoria and Vancouver.

Tourists bought eagerly. The Victoria photographer Richard Maynard, who was later to accompany the Chittenden expedition to the Charlottes, visited Sitka in 1882 and wrote in his diary: "Got passengers ashore — crazy after Indian curios."[10] Soon both sides of Lincoln Street in Sitka were lined with natives, their wares spread out before them. Shops with fancy names like the Indian Bazaar displayed slateware. And, as missionaries and settlers moved onto the British Columbia north coast, outlets developed close to home. The cooperative store at Metlakatla, the Cunning-ham trading post at Port Essington, and Hudson's Bay Company stores at Port Simpson and Masset bought and sold countless pieces as did curio shops in Wrangell, Juneau and Sitka. The Sheldon Jackson Museum in Sitka today owes almost its entire argillite collection to the foresight of the college museum's namesake, Alaska's pioneer missionary-educator Sheldon Jackson (1834-1904). He bought them in a single day. On July 6, 1887, he stopped off at Metlakatla, and at the co-op store William Duncan had founded, bought twenty-five carvings for $130, an average of $5.25 each. The carver could sell for cash or barter for goods. Debts were paid in argillite. Several modern collections owe their formation to busi-nessmen who bought direct or took carvings in exchange for mer-chandise. So, fortuitously, one aspect of Haida culture was show-ing all the signs of revival.

The words from the Etienne Marchand expedition of 1791 drift across the years: "Here every man is a painter and sculptor." So it was one hundred years later. The Haida artist was equally multi-

The bill of sale for the 25 argillite carvings which Sheldon Jackson bought for $130 at Metlakatla, in 1887.
— From the collections of the Presbyterian Historical Society (MSJ137, V. 26, p. 198)

talented in the 1890s, working in wood and slate, in silver and gold, in copper and iron. Almost every one of the early argillite carvers was a skilled craftsman in other mediums. When James Deans of Victoria, an ardent amateur archaeologist and folklorist, assembled an exhibition of native art in 1892 for the World Columbian fair in Chicago, among the wonderful custom-made productions were wooden models of Skidegate houses, scaled down to about three feet, complete with their house poles. The makers of some of these models were John Robson, David Shakespeare, George Dixon, George Young and John Cross — all argillite carvers as well.[11] For such men, the making of art objects was as natural as eating, sleeping and breathing. Carving was also a means of escaping the trauma of change, a way of recapturing a past that seemed to be fading rapidly. Among the artists was a man of high birth who was determined to save all he could of the Haida artistic heritage. His name was Charles Edenshaw.

These are some of the models in wood of the Skidegate houses, exhibited in much the same way as they were at the Columbian Exposition.
— *Field Museum of Natural History, Chicago*

One of the few photographs of Charles
Edenshaw carving, taken about 1906.

— *Provincial Archives, Victoria, B.C.*

When Emily White, Charles Edenshaw's eldest daughter, attended the *Arts of the Raven* exhibition at the Vancouver Art Gallery in 1967, the first thing she saw as she entered was an enlargement of a photograph of Edenshaw at work, carving argillite. She called his name and rushed forward as if about to embrace him. She was old then, and the portrait of her famous father as she had known him in her youth suddenly brought a flood of memories so vivid that for all the world he was there in the flesh, though he had been long dead.

As he appeared to Emily White at that exhibition, so he is in Northwest Coast art — its larger-than-life embodiment. The accumulated detail of how he achieved fame is not easy to piece together now, sixty years after his death. But the achievement itself is quite clear: Edenshaw more than anyone else established Haida craftsmanship as art in the eyes of the international community. This implies recognition, and Edenshaw brought that recognition on himself. By his own example, he compelled the outside world to acknowledge all Haida artists. His output was immense, versatile, constant in quality.

During his most productive years — from 1880 until his death in 1920 — drastic, long-term changes swept over the Haida people. Whites began settling on what had been Haida lands. Church and state were applying controls with a heavy hand, silencing songs, stilling dances, smothering cultural identity. Edenshaw saw that at a time when the performing arts were being extinguished, the plastic arts had to be promoted as never before. Cultural preservation was at stake. By organizing his work within a time frame, he demonstrated that a white way could be turned to Haida advantage. He learned white commercial practices, and in this sense became the first modern carver. He was the first to be fully aware of the need for sustained excellence, streamlining of production, and publicity. Happily, he could command respect without resorting to aggressive business tactics. By all accounts he was mild-mannered, gentlemanly, unassuming. His personality would be at odds with his achievement but for one thing: Edenshaw was a leader by birth. His entire accomplishment was rooted in a worthy desire to live up to a noble ancestry.

His uncle was Albert Edward Edenshaw (1810?-1894), head chief of the Stastas, one of the Eagle divisions. Stastas chiefs were ruling chiefs with extensive land and sea properties, Kiusta being their main village. Near there in 1788, an Edenshaw predecessor had greeted the British fur trader Captain William Douglas in the *Iphigenia*, just a year after Dixon's arrival. The two men exchanged names ceremonially.[1] In addition to village chieftainships in the northwestern Charlottes, the Edenshaws had extensive family lands to the east, mostly around Rose Spit. Albert Edward, named for Queen Victoria's eldest son the Prince of Wales, later Edward VII, was himself said to have been born near Cape Ball on the east coast. By the 1840s he was piloting New England trading vessels and Royal Navy ships visiting Queen Charlotte waters, and being commended for his service. He was ambitious, and he knew what was expected of him as a ship's pilot.

In the course of that career, in 1852, Albert Edward became the

12.
The flame of Edenshaw

central figure in a celebrated incident. He had been hired to pilot the American schooner *Susan Sturgis* from Skidegate north toward Langara Island. On September 26, shortly after he guided the helmsman around the perilous sand bars of Rose Spit, canoe loads of Masset Haida, followers of another chief named Weah, suddenly drew alongside and attempted to seize the schooner. Albert Edward, his wife, and two or three of his men who happened to join the fray in a small canoe, staved off the attack for seven hours. He later bargained for the safety of Captain Matthew Rooney and his crew. "He saved my chronometer and several other things which he brought to Fort Simpson and gave to me without ever asking for remuneration," Rooney wrote in commendation. "I hope if this should be shown to any master of a ship, that he will treat him well for he deserves well at the hand of every white man."[2] Weah, whom Rooney blamed for the incident, was later to drown when his war canoe overturned in Hecate Strait.

When officers of H.M.S. *Virago* investigated the *Susan Sturgis* incident in 1853, they heard conflicting testimony from several Masset Haida who claimed that Edenshaw had designs on the schooner himself. *Virago*'s commander, Captain James Prevost, was unable to attach blame to any group but suspected Albert Edward of complicity. Of his capabilities as a pilot, though, Prevost had no doubts whatever. He said Albert Edward not only knew the anchorages but also had a greater understanding of the operation of a large ship than any other native he had met.[3] Newton Chittenden, who met Albert Edward in 1884, described him as the highest ranking chief of the Haida, the one who had erected the largest number of carved poles, given the greatest feasts, and made the frequent and lavish potlatches. "Though about seventy-five years of age, he is still quite vigorous, and being well dressed in a suit of broad cloth, would easily pass for a younger man," he said.[4]

The story goes that Albert Edward took young Charles Edenshaw into his household, as was the maternal uncle's responsibility in the upbringing of the nephew who would succeed him. Within a few years came also children from leading Kaigani Haida with whom the upper-bracket Stastas Eagles had traditionally maintained formal links by marriage. Among them was a girl named Isabella, whose parents had died in the smallpox epidemic.[5] It was thus the usual big Haida household. One of Albert Edward's own children, Henry, although younger than his cousin Charles, was to be his lifelong friend.

Charles was not a strong boy. According to word passed to his granddaughter, Lavina Lightbown, he had tuberculosis which was cured by Indian medicine. Whether this illness led him into sedentary occupations is uncertain, but he is believed to have begun his training in crafts at an early age. His teacher was his influential uncle, Albert Edward, who was noted as an ironworker, coppersmith, jewelrymaker, and carver of big wooden poles, and who was more than likely an argillite carver also, although no pieces have been definitely assigned to him.

From his uncle, Charles learned the basic techniques of designing, carving and painting. By the 1870s he was undoubtedly an able craftsman in several mediums, experienced both from assisting his

uncle and by creating his own works. From his mother and her eminent brother, whose heir he would be, Charles gained crests and legends of the Stastas Eagles. Through his father's family at Skidegate he had easy access to argillite, which was brought by relatives and slaves.

By 1890, in middle age, he was well established as a full-time carver, supporting a wife and young children. He had married Isabella, the orphaned, high-born Kaigani Raven who had been adopted into his uncle's household. On Albert Edward's death in 1894, Charles became Chief Edenshaw. The surname, which he had taken at his christening ten years earlier, was an anglicized version of the old family name Edinso or *It-in-su*, meaning "so be it." In effect, his word was law. But to the quiet, dignified Edenshaw, chieftainship meant not so much prestige as responsibility. He was obligated to look after the well-being of all the members of his lineage throughout the islands. This he did.[6] He also spared time for the questions of visiting scientists and government officials. And all the while he carved unremittingly.

In his art, design was all-important. He had abundant ideas to be translated into designs, and this superceded any general preference for the materials he used. For one design purpose he would use argillite, for another, wood, for yet another, metal. Whatever basic design material, however intractable, could best convey his design message, would be his choice of the moment. In wood, he produced a great many carvings large and small, including poles. He painted designs on houses, on canoes, on woven hats and on baskets. He carved ivory handles for walking sticks. He made jewelry.

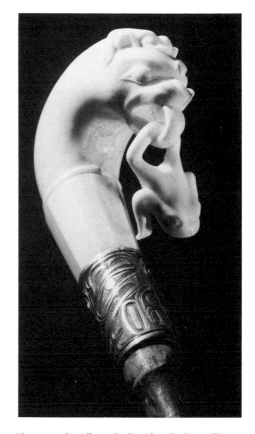

The ivory handle and silver band of a walking stick made by Charles Edenshaw. Raven design on band. Formerly in the Jelliman collection. Museum No. 10677.
— *Ethnology Division, British Columbia Provincial Museum*

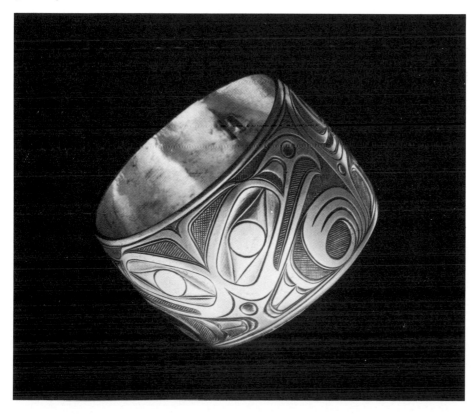

Silver bracelet attributed to Charles Edenshaw by Wilson Duff, Peter Macnair, Bill Holm. Split eagle design. Museum No. 13046.
— *Ethnology Division, British Columbia Provincial Museum*

If his range was remarkable, even more astonishing was his consistent quality. A gold bracelet by Edenshaw is like no other gold bracelet, which is not to demean the work of other Haida goldsmiths. It has the pure Edenshaw touch of splendor. It is substantial in weight, richly designed and deeply engraved. As he swept up all the various mediums for design expression and made them his, so, in argillite, he produced one object type after another. Chests, poles, compotes, bowls, dishes, panels, model houses and probably more. Many of them were sizable, high-relief works, like his chests. Everything was balanced and harmonious. He paid scrupulous attention to detail. "It's not the amount so much as the beautiful proportions, the beautiful finishing," his granddaughter Lavina Lightbown says. "I don't ever remember seeing anything of his that looked unfinished. Maybe it was the educational process that he went through and the strict rules he followed." She also recalls hearing that he used to travel a great deal, visiting trade centers such as Sitka and giving carving demonstrations. Reputedly he was a very fast carver. Now and then he actually held speed-carving contests with the young and brilliant argillite carver Isaac Chapman.[7]

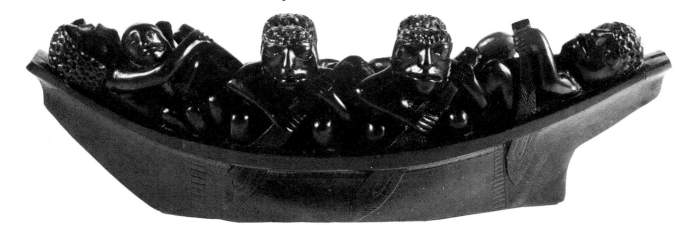

Six-figure canoe group attributed to Charles Edenshaw. Museum No. AA 2326.

— *Centennial Museum, Vancouver*

With all this information available, one might reasonably assume that Edenshaw's major works in argillite would be fully documented, even though he did not sign his pieces. Regrettably, this is not so. Only a few carvings can be attributed to him with any certitude and what remain are innumerable and often questionable pieces. Here we run into the great paradox of Edenshaw. While he was well-known in his lifetime, the recognition due him as a carver did not come until after his death. The scientists who pumped questions at him were more anxious to buy his family heirlooms than argillite, the mere trade goods thought to be of white derivation, and even his commissioned presentation of exhibition pieces were seldom recorded as being from his hand. Within his family, his work was taken for granted. Gift bracelets were kept, but not argillite.[8] And by the time the Canadian ethnologist Marius Barbeau, the first person to take a serious interest in the history of argillite, arrived in the Charlottes, Edenshaw was dead. For attributions, Barbeau had to rely on secondhand and often doubtful information.

However, among nearly forty argillite carvings now in the National Museum of Man in Ottawa which were bought from the Victoria pawnbroker and curio dealer Andrew Aaronson in 1899, there are a few carvings listed as being by Edenshaw. There is also a brief, amusing commentary on a file card. This notation says that according to a letter from Dr. C.F. Newcombe of Victoria to the museum's Dr. Edward Sapir in May, 1911, "the catalogue of the Aaronson collection was made by the late James Deans of this place (Victoria); mostly from guesswork." The guessing game has gone on ever since. The reader can engage in similar speculation by examining the four pieces.

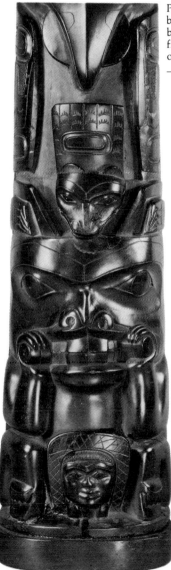

Photo enlargement of bottom section detailing beaver with Raven's son in center of tail. Note bear cub between ears and raven's tail, both filling space and skilfully linking the two figures of beaver and raven.
— *National Museums of Canada, Ottawa*

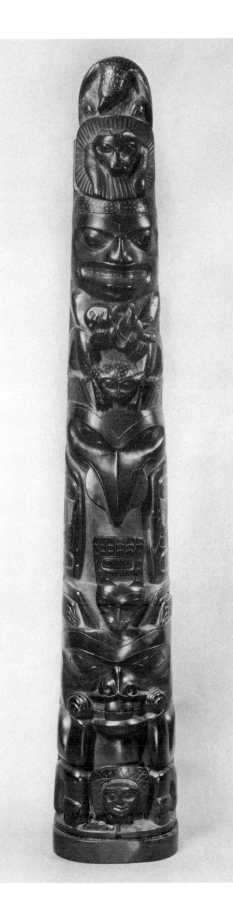

An exceptionally fine Edenshaw story pole, hollow-backed and tall (63.5 cm.). The figures from bottom: beaver, with Raven's son in center of tail and bear cub between ears, gnawing stick held in mouth; raven with disc in beak and frog about head; labreted woman holding Raven as a child who in turn holds the moon; bear in den, and eagle at top. Well proportioned, with strong, simple lines. Museum No. VII-B-792.
— *National Museums of Canada, Ottawa*

Eagle forms the complete design on this platter
of conflicting attribution. Eagle's head is at top,
wings flow around the center oval, and the three
elaborate tail feathers create a bear-like mask.
The beautifully-carved motifs, with complex
ovoids and salmon-trout's head designs, fine line
work and matching are by a master carver.
Wilson Duff thought he was Edenshaw; Marius
Barbeau said Tom Price. Museum No. VII-B-826
(841). Collector: Andrew Aaronson. Dimensions:
41 cm. × 25.5 cm. × 5.2 cm. — *National Museums of Canada, Ottawa*

The first pole and the platter are from the Aaronson collection and stated as Edenshaw's; the second pole is a fairly recent attribution, and the second dish has conflicting attributions. Notice that all four are richly embellished, and that the design elements, therefore, must be closely scrutinized. A fondness for emphasis through compounds is apparent — U-shapes within U-shapes, and ovoids within ovoids. We also see double-lining, the use of closely-parallel raised lines. Other carvers adopted these design elements, but not to the extent Edenshaw did. And there is a distinguishing hallmark of Edenshaw: U-shapes doubling back into the U differently on one side.

The second plate is attributed to Edenshaw by the late Wilson Duff, in a pencilled note on the National Museum's catalogue card. Barbeau attributed the plate to Tom Price, the Skidegate master whose flat-surface work equalled or surpassed that of Edenshaw. We would agree with Wilson Duff's opinion in this case, on the basis of the foregoing features. At his death in 1976, when he was a senior faculty member of the Anthropology Department at the University of British Columbia, Duff was working on a biography of Edenshaw.

With someone less versatile than Edenshaw, preferences in figures can sometimes be a guide to the carver's identity. But in his case this cannot be applied. His own crests, according to John Swanton, seem to have been eagle, frog, beaver, raven and killer whale, and possibly cormorant, dogfish, whale, sculpin, halibut, cumulus cloud and the "T" of the copper — horizontal and vertical bars that divide the lower portion of a shield-shaped copper. He may also have adopted crests from the Ravens of his wife's and his father's families, adding, for example, grizzly bear, thunderbird, wolf and the moon. With such an array, in addition to the use of figures from legend, it becomes obvious that his style of carving can be the only valid means of identifying the master's work.

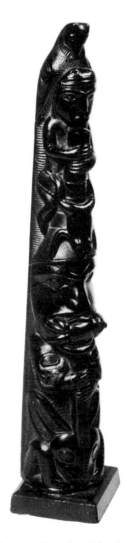

This pole has been attributed to Edenshaw. Figures from top: Raven, man wearing frog headdress and holding DzeLarons' hat; frog on front of hat; DzeLarons holding cane; killer whale head down. DzeLarons holds in her mouth her child who is dead, killed by man holding her hat, and her children are the frogs. Raven is the main crest of man and DzeLarons killer whale is his sub-crest. Museum No. A62.62.22. Height 32 cm.

— Glenbow Museum, Calgary, Alberta

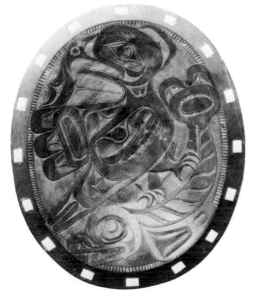

Small platter, probably by Charles Edenshaw, depicting eagle clutching whale. Collected by Andrew Aaronson and received in 1899. Museum No. VII-B-824. Length 23.5 cm.

— National Museums of Canada, Ottawa

Even this can be risky, because it is difficult to reconcile his output with the increasing demands made on his time and talent. Among poles attributed to him are a few bearing only one or two of his characteristics and lacking a total Edenshaw "look." These may be explained by the fact that in later years he acted as an intermediary for other carvers and the buying public. Every winter he and his friends made ten argillite carvings, and in the spring he would open a roomful of pieces to potential purchasers. To facilitate completion of the showroom, he himself may have done the finishing of more than a few pieces before they went on view. He was, after all, a very astute businessman.

Edenshaw died on September 10, 1920. Relatives and friends from Alaska and British Columbia attended his funeral in the Anglican church he had helped to build nearly forty years earlier. The Prince Rupert *Daily News* published an obituary, but in Vancouver his death went unnoticed. The honor he richly deserved did not come until years later, when the international art community became aware of Northwest Coast art in general and found that he had been a major contributor. Ultimately, he was acknowledged as one of Canada's foremost artists, and on one occasion he was hailed as THE original artist of Canada.[9] As museums began to take stock of their holdings, Edenshaw attributions came thick and fast. Nevertheless, because no single collection containing any significant number of his argillite pieces has emerged, positive and reliable attributions have been difficult for the non-carver. The process of recognition is still going on and will continue to do so until cataloguing becomes more complete. A few museums, one in New Zealand, have what appear to be Edenshaw argillite which has not been recognized as such.

Vitality, dedication and allegiance to high standards were at the heart of Edenshaw's achievement. His family life was full and happy. In old age, the personal sorrows he could look back on were the deaths of three of his children. A seventeen-year-old son, Robert, drowned in Rivers Inlet on the mainland coast; a daughter, Alice, died when she was twelve, and a second son died in infancy. His four surviving daughters were Emily White, who died in 1972 at the age of ninety-six; Agnes Yeltatzie Jones and Florence Davidson, still in Masset, and Norah Cogo, who lives in Ketchikan, Alaska. Among Edenshaw's descendants shines a glowing pride in family and skill in Haida arts.

Edenshaw's granddaughter Lavina Lightbown, is one of the few Haida women to take up argillite carving. When we visited her, she was living in an apartment on Robson Street in downtown Vancouver. It was a temporary home; she and her family intended soon to move back to the Charlottes. She is a slender, elegant woman with flashing black eyes. Her Indian name is T-How-Hegwelths, The Sound of Many Copper Shields, which she interprets laughingly as "the sound of money." She gesticulates often in the course of a conversation which jumps from Haida land claims on which she is resolutely working, to the Haida language ("I think in Haida and speak in English; I talk backwards"), to Edenshaw ("The thing that strikes me about Grandpa's work, even his jewelry, is his balance, his proportion"), to the current state of the argillite market ("Buyers

Lavina Lightbown, 1978.
— *Douglas Wilson*

are still not educated enough to differentiate between good and bad; they still buy by the inch, not by the art content"), to her own sons who are argillite carvers — Henry White, of a previous marriage, and Greg and Bill Lightbown ("Shane will be carving too.")

When Lavina Lightbown began carving in 1962, an elderly relative chided her: "A lady doesn't do that." But she is an activist and went ahead — not only with argillite but also with silkscreen prints. She has not done many carvings, but this seems to be related more to her faculty for self-criticism than anything else. She started a free-form raven once, from a piece of slate that revealed an unusual white fleck on one of the raven's wings. Then she saw a similar carving by Bill Reid, for whose work she has the utmost admiration, decided she could never do as well, and promptly set aside her own raven. If one comments on a particularly fine carving she has completed, she says: "Yes, but the killer whale could have been better."

On this day in Vancouver in 1978, an argillite plate she was making lay on a table directly in front of a window. She contends that natural light is by far the best light to carve by. The plate is plaque-like, about the size of an average saucer. From the flat, circular inner surface, in four-level relief, rises *mamačiki*, the dragonfly. Its form is complete, and on the raised wings she has drawn pencil guidelines for graving the conventional split-U decorations. The set of wings will be perfectly balanced. It is a strong yet delicate creation. Charles Edenshaw, one feels, would thoroughly approve.

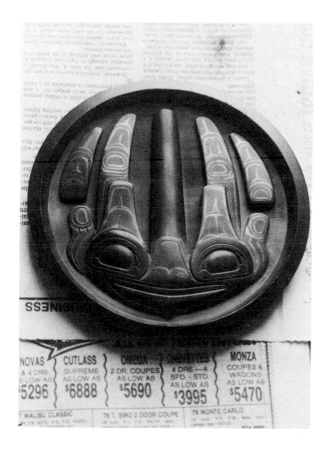

Lavina Lightbown's dragonfly plate, showing pencilling of the design on wings.
— *Douglas Wilson*

Marius Barbeau (1883-1969)

Today, as Charles Edenshaw would be glad to learn, argillite art is in excellent health. Contrary to reports of imminent death over the last seventy years, it has not only survived but flourished. The Haida creative spirit saw to its survival. The rate of production, however, has depended to a great extent on economic conditions.

Distance from markets, a factor which has dogged many an attempt at individual, small-scale commercial enterprise in the Charlottes, has never inhibited the production of argillite carvings. Here an old, natural industry, inseparable from the culture, has shown it can do what new, superimposed industries cannot do. Farming is one example of the latter. The scarcely-visible remains of what were once farms, whether at Kumdis Slough or at Cape Ball, bear mute testimony to the struggles of many white settlers who one by one came to the sad realization that the islands lay too far from major population centers. The argillite carver had no such problems in marketing. With a portable commodity, he could overcome the obstacles of geography. If he was unable to transport his carvings himself, he could mail them or ask a traveling friend to take them to outside markets. Economic conditions, though, were something he had no control over.

A key indicator of the marketability of argillite is the price record through the years of that most staple of items, the pole. For a long time the cash price for poles was calculated by the inch. During the first decades of the twentieth century, 25 to 50 cents an inch was the going rate, regardless of how tall the pole or how capable the carver. Many long-time North Coast residents remember buying poles from the carver at that price. The National Museum of Man at Ottawa has a seven-and-a-half inch pole bought for $3.50 in 1905. Incidentally, a ten-inch pipehead in the same collection was purchased at about the same time for $4. By the 1920s the pole carver was getting as much as 77 cents an inch.

With the Depression, the Haida artist was caught in the same predicament as other British Columbians. Argillite carvings could scarcely be given away. Alfred Adams, the Haida proprietor of Alfred Adams & Sons, general merchants, of Old Masset, who bought and sold Haida crafts, wrote in 1934: "Business is absolutely dead . . . and I have closed up for two winters now, no cash in circulation."[1] The same year, M.J. Williams of M.J. Williams and Son general store at Skidegate was importuning William Newcombe of Victoria:

> We will be pleased to supply your needs in the way of totem
> poles, Indian bracelets, rings gold or silver, baskets, slate
> and wooden totem poles. Slate up to 24" and wooden up to
> 30 feet, old or new. Slate is also made into various novelties
> such as ink wells, smoking pipes, candle holders, ashtrays
> and book ends and trays. We do not stock all above articles
> but we are in a position to procure them very reasonably for
> you, as we trade them for groceries and other necessities,
> where others are obliged to pay for cash . . .[2]

The barter system had taken over.

In those bleak days, the Haida could still eat. Breakfast was still as close as the seashore. But there was no money for buying more than the barest essentials. Andrew Brown of Masset, a prolific carver,

13.
Struggling back

Rev. Lloyd Hooper.
— *Douglas Wilson*

knew how hard it was to sell argillite during the Depression. So did Lewis Collinson at Skidegate. Young and even middle-aged carvers today, who have known only a rising economy, have little idea how tough those times were.

With the Second World War, the cash flow improved in the Charlottes but argillite production remained low for another reason. Several carvers abandoned their art for occupations related to the war effort, especially the logging and shipping of Sitka spruce used in aircraft manufacturing. A number of Haida men and women went off to fight in the Canadian Armed Forces. A limited market for argillite carvings sprang up with the establishment of an air base at Alliford Bay on Moresby Island, across Skidegate Inlet from Skidegate, but most of the artists who stayed home earned better money as loggers and fishermen than as carvers. Only a few old men continued to carve during the war and for several years afterwards, leading one magazine writer to report in 1952 that the craft was "nearing its end."[3] The writer underestimated the resilience and strength of the argillite carving tradition.

What is true is that until recent years the rate of payment for argillite work was controlled by profit-oriented dealers, which forced native carvers to devote much of their time to supplementary occupations.

"Buy cheap, sell dear" is an unwritten law in dealers' circles and the individual Haida artist, selling on his own, was often exploited in the marketplace. For example, poles that brought the carver 77 cents an inch in the 1920s were passed on to the eastern United States at $2 an inch.[4] As recently as the early 1950s, Prince Rupert commercial buyers were paying 30 cents an inch for poles they were retailing for $5 and upward.

Lack of appreciation and poor economic returns were the two factors that stifled production for years. Capability was not wanting. Indian agents deplored what seemed to them lack of interest in carving on the part of young people. "Sitting for days carving does not appeal to the rising generation," one wrote to his superiors in 1918.[5] He was speaking in very broad terms. Even in the 1950s, when argillite art was at one of its ebbs, there were still carvers who, while not profuse in output, nevertheless regularly fulfilled orders from far-sighted customers. Because they were not publicity seekers, they were little known outside the Charlottes. Norman Pryce is such a carver. Now middle-aged, he is an extremely able craftsman who took up his carving tools intermittently while engaged in logging. Tim Pearson of Skidegate was another. At the same time, Claude Davidson, a grandson of Charles Edenshaw, was one of several part-time carvers at Masset. In both villages at any season, but especially in winter when regular jobs were scarce, someone could be found chipping at a block of slate. And, equally important, young people would be watching and listening.

One person who almost singlehandedly brought about the payment of fairer prices in the post-war years was Lloyd Hooper, a United Church minister. Young, active, intensely interested in native customs, he lived with his wife in the mission house during the term of his pastorate at Skidegate, from 1952 to 1956, and became a good friend of many Haida families. He realized at once

what was wrong. He says, speaking of the origins of carving: "The Haida and Kwakiutl were the most industrious people on the coast; they couldn't have sat at home all winter and done nothing." Lack of opportunity for sales frustrated ambition. A few buyers existed in the Charlottes, such as hotelkeeper Bessie Piper at Port Clements who paid fair prices and, in fact, built a large private collection, but such enthusiasts were few and far between. At Prince Rupert, a combine of local dealers kept prices down.

"I had no faith in the buyers at that time," Hooper recalled. "They would tell the Haida carvers that their poles had been broken in shipment. The ones I mailed out for them never broke." Hooper came to the conclusion that a cooperative arrangement founded on a scale of criteria including volume, and time spent in preparation and carving, plus a premium for originality, was necessary to maintain fair prices. He underestimated the Haida desire for independence. But he did help carvers with marketing and bonus payments were indeed made. He recruited stores in Vancouver and Victoria as regular buyers, thus circumventing the Prince Rupert price-fixing. In no time at all, the carver was receiving a new, unheard-of return of $5 an inch. Ten years later it was $10 an inch.

In the 1970s the standard of pricing shifted from the inch to the figure. Today, in the spiral of inflation, a competent carver expects to receive $400 for each figure on a pole. Dealers apply markups ranging from 100 to 300 per cent.

How a person assesses prices will depend on whether he is a carver, an impartial bystander, a collector, or a dealer. The main point is that argillite carving has at last been placed on a sound economic footing — and this has given rise to the professional carver.

The professional regularly holds exhibitions in cities like Vancouver, Victoria and Seattle, demonstrating carving techniques and selling previously-made works at the same time. He sells to select stores. Carving steadily, he will earn a comfortable living. His annual production will be made up, say, of twenty two-figure poles, three or four major works like platters or boxes or standing figures, and as many as 200 small pieces such as medallions. Only the most outstanding and dedicated artists reach and maintain professional status.

This professionalism did not come easily, or entirely on its own. It was encouraged by formal training in the 1950s and 1960s. Informal instruction had always been available. An adult carver would teach any interested child in a loose apprenticeship system, allowing the youngster to saw slate and rough out carvings, then instructing in the carving process itself. In the late 1950s and early 1960s, a more organized training system came into vogue voluntarily. Carvers such as Rufus Moody at Skidegate and Claude Davidson at Masset conducted classes for children in their respective villages. By that time, on every carver's workbench lay a well-thumbed copy of one of Marius Barbeau's books on argillite. Writings of the last thirty years have bestowed a new dignity, raising the craft's integrity to an art in the public mind and encouraging the collector as never before. Barbeau more than anyone else drew public attention to argillite.

Quebec-born, a Rhodes scholar, ethnologist and folklorist, a senior staff member of the National Museum of Canada, Barbeau undertook the first scientific study of argillite carving. He first visited the Northwest Coast in 1915 to study the Tsimshian, and his interest in totem poles of wood led him into research into the legends behind the poles and into slate carving of poles. He paid two visits to the Charlottes, in 1939 and 1947, and there gleaned much of the information that appeared in his *Haida Myths in Argillite* (1953), *Haida Carvers in Argillite* (1957), and *Medicine-Men on the North Pacific Coast* (1958). For the first time, the public could see argillite carvings en masse, for his books were abundantly illustrated.

Carvers treasured their copies of the Barbeau publications. Turning pages blackened with slate dust, they studied the reproductions for hours on end and read and reread the legends told to Barbeau. A few critical carvers complained that he had interviewed their elders through a Tsimshian interpreter, William Beynon, when he could haved hired a Haida; and that he relied heavily for information on Alfred Adams, who was mainly an argillite dealer and silversmith, who put his own family's interpretation on some of the legends. Academic researchers[6] have since shown that in attempting to bolster his personal theory that cultural development of the Northwest Coast peoples was much more recent than is now believed, Barbeau confused the record in respect to early argillite. One of them goes so far as to say that most of his attributions are erroneous.

Nevertheless, Barbeau's writings on argillite, published under government auspices as anthropological bulletins, have run into several printings, and have remained the only book-length publications available on the subject. He will always be credited with pioneering the field. He alone was sufficiently interested to compile biographies of various carvers. The voluminous data he gathered will be sifted, sorted, and analyzed by researchers for years to come.

Other publications, often in the form of exhibition catalogs, dealing with Northwest Coast native arts in general, have also brought argillite to the attention of a wide readership. Magazine articles, film strips, television programs introduce it to more North Americans each year. As a result, the carver today finds himself something of a celebrity.

Claude Davidson is a handsome, heavy-set man with lank black hair that flops over his brow. From his rugged appearance he looks more like a Haida fisherman — which he was as a young man — than the stereotype of an artist. He belongs to the argillite carving generation that took up the art in the mid-1950s. Marius Barbeau's books full of illustrations of argillite from the past were just reaching the Charlottes, and these helped guide the hands. However, Claude Davidson also had the resources of a family with a grand heritage.

Born in the village of Haida (Old Masset) in 1924, he is a grandson of Charles Edenshaw. His mother, Florence, is a daughter of Edenshaw. His father, Robert Davidson Sr., was a noted canoe-builder as a young man. Claude Davidson grew up in the Charlottes. As a young married man, Davidson lived for several years among relatives in Hydaburg and Ketchikan, Alaska. His first wife, Vivian, who drowned in a boating accident in Masset Inlet in 1972, was a Kaigani Haida. He began carving in his thirties, using yellow cedar first, and turning to argillite a year later.

14.
Time changes everything

Claude Davidson's version of a legend of the origin of the Haida people, Raven coaxing the people out of clamshell.
— *Alex Barta*

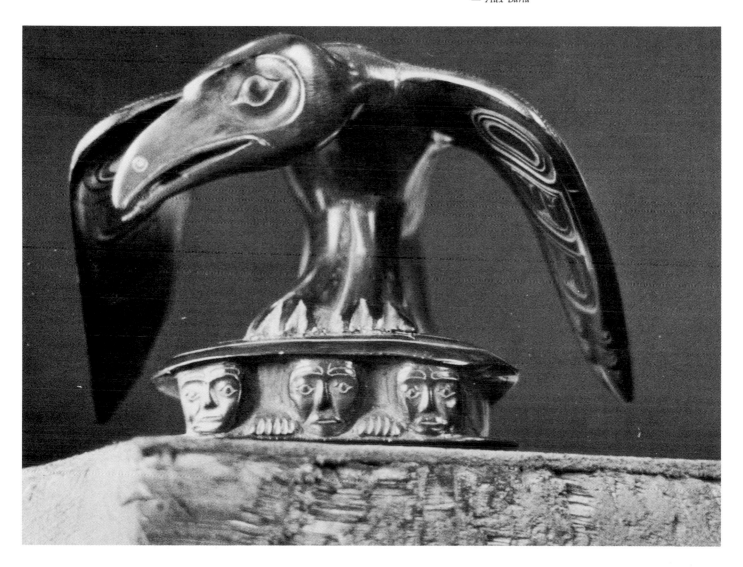

He has carved most of the "conventional" works of argillite — poles, dishes, boxes — in the "conventional" manner, but he has not been afraid to innovate. Several of his ventures into modern free-form carving, such as his raven carving which has been exhibited in Germany, have been much admired. "He keeps an eye on what's going on," a friend says. "He also buys a lot of carvings from younger guys, even poor ones, to sell for them, to encourage them. If they get a few bucks and know they can sell to somebody, it can make all the difference. It gets them going." Davidson himself now makes a comfortable living from argillite carving and printmaking.

On November 25, 1977, he and his wife Sarah took off on a holiday trip to Hawaii, a welcome break from the Charlottes' rainy season. On the way they stopped at the home of Sarah's mother at Deep Cove, north of Victoria, and there Claude was interviewed by Douglas Wilson.

Claude Davidson's fascinating account of how he made a pole after a stormy incident that took place at Masset in 1964 reveals the slate carver's inclination to commemorate major events affecting his people's lives. His words also reflect two Edenshaw characteristics — a strong desire to please the customer and an acute awareness of the value of money.

* * *

Wilson: Do you have any memories of when you were really young?

Davidson: When I was about three or four years old I used to go out with my Dad hand-trolling. We'd go from Masset to Langara Island (what we used to call North Island). We'd use a rowboat and three-pound lead, and troll all day, and then we'd anchor up when we figured the tide was right, and fish halibut. We'd get halibut and a few springs (salmon) as well, and then we'd go home with our catch for the day. Packers, seine-boat type, used to pick up our salmon; we'd sell it to them, and they'd take it over to Rupert. Then, later on, my Dad got a boat which was about thirty feet long, double ender, and we'd do the same thing — troll, till the tide was right for catching halibut, and then do the same thing we'd done before. And then sometimes we'd tie up to another boat, cook a meal, and enjoy it together. During the time we were on the rowboat...we used to have a lot of hand-trollers then, there must have been at least ten or fifteen hand-trollers...we'd all go up to shore and make one big fire and cook up a meal. Somebody would have a big pot, another guy would have another pot, and we'd cook up a big pot of either salmon or deer. We used to have great times. When Dad and I would go out halibut fishing in the rowboat, strictly halibut, we used to get 3 cents a pound. So now what do they get? $1.70 a pound? We'd get at least a thousand pounds a day and that's $30 a day. That was big pay for halibut at that time. We thought it was. If you get a thousand pounds now, you get close to two thousand dollars.

Wilson: How do you think a carver learns to carve?

Claude Davidson, 1978.
— *Alex Barta*

Best wishes to you.
Claude Davidson
(83)

Davidson: Well, for myself, I more or less picked it up. I was working on one of Sam Simpson's boats, and there was this yellow cedar . . . we were burning it for steaming. One day I thought, well, I'm doing nothing here. I've worked four hours already for the day, and it only takes you five minutes to eat your lunch, and then you got another twenty-five minutes before you go back to work, and you got to do something. So naturally I figure, what the heck am I wasting time for? I could be doing something. So I picked up this yellow cedar and that's how I started.

So I cut off a piece and planed it, sided it, and started working on it. Then I brought it to my Dad when I was halfway through, very rough. He laughed like heck at me, and said "I suppose you think that's pretty cute". He wasn't making fun of me. But he told me the mistakes I'd made, because he was carving then. Instead of correcting my mistake on this wooden pole, I started another one. I tried to improve. Then after I finished that and brought it to him it was the same thing again. He laughed real hard, and after he got through, he told me my mistakes again. So I left that, then I tried a big one. I don't think I brought that to him. When I finished the fourth one, then the fifth one, that's when I started argillite.

I brought this one to him. He thought it was alright, though he said there's some mistakes there yet. I sold that one for $49 — they were selling for $7 an inch and it was a seven-inch pole. He thought that was pretty good. Then I made another one, and I worked at it, worked at it, and in the meantime I'm working in the cannery, working on the house, and carving at the same time trying to make a few dollars extra. I sold this one to Gordon Jolliffe[1] and he just laughed and says "You're making a mistake here, the eyes are not forward enough, they're too much to the sides." So it took a white man to tell me my mistakes, besides my Dad. I didn't learn everything on my own. I was still learning from the book as well. I got a copy of *Haida Myths in Argillite*, Marius Barbeau's book, from my Dad. I started looking at the designs in that book, and started to go by it.

I think my Dad was urged on by Andrew Brown[2] to learn how to carve because he says there's good money in it. Like my Dad, he was a boat builder and house builder and carpenter, and could do practically anything, so Andrew Brown told him "You better start carving." In 1944 we went up the Slatechuck to pack argillite for my Dad — my brother Alfred, Paul Hill, myself, who else? — five of us, anyway, and Dad came up. I think he was about sixty years old when we first went up Slatechuck. Old as he was, he went up there with us. The road wasn't too bad then because logging was taking place at that time. After so many years that Dad had this argillite buried, Andrew Brown kept asking him, "Why don't you start carving?" Finally Dad went to him to see what kinds of tools he was using. Dad decided to make his own tools, by hand, and then he started carving. Andrew Brown himself carved until about two years before he died.

I've also done a lot of teaching. I had sixteen students, and out of them, four carried on. So it's possible to learn either on your own or from a teacher. It's just an urge and something pushes you into it. I pushed Robert, my son, into carving. But now he's had a lot of experience, and his hands are more or less guided to what he can do. Often when he goes to bed he will think of a design. So he gets up, sketches it out in a hurry, and the next morning he gets up and, oh boy, there it is. The design all comes back to him, so he draws the whole thing. We all got different ways.

Wilson: Do you use any specific crests when you carve?

Davidson: In the olden days, they didn't allow a person to carve someone else's crest; he could only carve his own crest. Same as we couldn't get married within our own clan. Like as a Raven, I couldn't get married to a Raven. But nowadays everything's so modern — a Raven can marry another Raven, but we're so distant in relationship that we're able to do that. And now we do the same thing with totem poles. As you know, in the past if I were building a small totem pole, I couldn't carve an Eagle on it, whereas nowadays I can. Before, if people ordered it, we had to get consent from our opposite clan in order to build the totem pole that's not in our crest. But now we can go ahead and nobody says nothing.

Wilson: Which crest do you carve the most?

Davidson: I carve mostly Eagle on top, because everybody seems to like Eagle. I've made a few pieces with a double-headed Eagle. Sometimes I put Raven and Eagle on a totem pole because that way nobody can kick...

Wilson: What do the crests mean to you?

Davidson: My crest itself I think a lot of, and yet I think a lot of other crests as well. They can be very important, depending on who you're carving for and what the crest represents. I like to put in my whole spirit, my whole soul, just to prove to the people that even if a white man has bought it, I expect him to treat it with loving care. And I really appreciate it when a buyer comes along, and then he writes back to me once in a while to let me know where my carving is. That way we know how much our artwork is appreciated. So each crest is very valuable to me.

Wilson: Do you make your poles, say, with a story in mind?

Davidson: I made one story one time over a dispute that we had in Masset with the cannery. The dispute was over this man who drove this truck and dumped a whole bunch of people and one got killed.

(Davidson is referring to the Fred Steel incident which roused strong emotions among the Haida in 1963-64. Steel, a white man, was a senior employee of Queen Charlotte Canners Ltd., at Masset, and had good friends among the Haida. On the morning of October 4, 1963, he was driving a company truck transporting Haida people to their jobs at the cannery. The truck left the road and one young Haida man was killed and several others were injured. Steel was fined for driving without due care and attention. The United Fishermen and Allied Workers Union threw its weight behind the Haida,

114

and Steel became the central figure in a full-scale labor dispute between the union and the company. When the cannery was about to reopen next spring, Haida shoreworkers and fishermen refused to work until Steel was dismissed. He was finally voted out of his job by the cannery workers.)

Davidson: This guy (Steel) had been adopted into one of our clans, so I made a figure representing him at the bottom of the pole.[3] Then the next figure was the union man that came in. He was adopted into another clan, so I made his figure. And then another guy (unionist) came up and he was adopted into the clan as well, so I made these three different figures. We'd been getting telegrams from different union locals on the whole coast, and the man who'd been getting all the telegrams — I carved him holding all the telegrams in his hand in front of him, similar to Raven holding beaver lodge.[4] And the very top figure is the business agent, because he's the top man in the union. I don't remember their names. But I at least carved them as my own. That's one totem pole that I made on my own.

Wilson: What do you think of when you're carving?

Davidson: Girls. (A pause, then laughter.)

Wilson: Do you make a good living carving argillite?

Davidson: So far, we've been more or less getting by on what we make. Within the last three years I've been doing quite well, enough to travel with, get a holiday once in a while. With the help of Sarah selling her jewelry as well, we make enough money for two to travel.

Wilson: Do you always go up the Slatechuck to get your own slate?

Davidson: Yes, we go up there every year, usually in June, and pack about three or four days, a year's supply probably.

Wilson: Have you heard any stories from your mother about your grandfather, Charlie Edenshaw? What sort of person was he?

Davidson: My mother never talked too much about him. Mother always talked about our grandmother. Aunt Norah, she likes to talk about Charlie Edenshaw. She always thought that he was one of the best fathers that ever was created. She talks highly of him all the time. And that's all I heard about him, besides all the carving he's done and what's been recorded and all that. Other than that, I don't know him. My brother, he's talked about him, and how he used to make glue.

Wilson: Do you remember what he said?

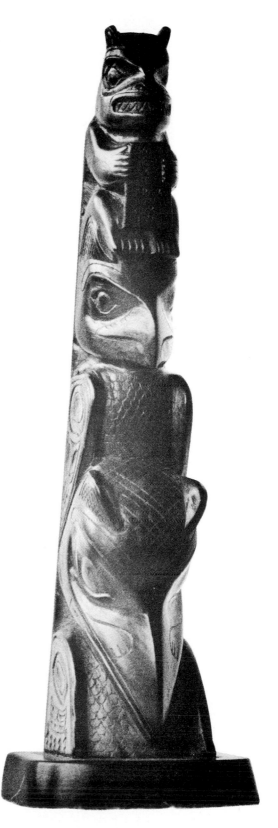

This pole, now in the Vancouver offices of the United Fishermen and Allied Workers Union, is the one Claude Davidson carved in commemoration of the Fred Steel incident. The figures represent leading personalities in the incident. Top figure holds a representation of the telegrams, and on the tablet Davidson inscribed the words "Telegrams from south."

— *Douglas Wilson*

Davidson: Alfred told me they used to dry these big halibut during the summer. In the wintertime they'd chew the skin up, just chew it up and chew it and chew it, till it got soft in the mouth. And they'd spit it in a pot, mixed with saliva. As soon as they got enough they'd boil it and boil it until it got tacky. Then they'd glue together whatever he was working on. And the glue still holds! It's a miracle how they used to do those things.

Wilson: Do you try to make your work as good as Charlie Edenshaw's?

Davidson: The best way I can explain it is that I'm trying to do what he can, especially on carving. Right now I'm making a copy of a box of his that's in the Centennial Museum. I don't know if it will be as good, but I'm trying my best.

Wilson: What do you think is the most difficult part of carving?

Davidson: Selling it. (Davidson and his interviewer both chuckle.)

Wilson: Do you think that any Haida can carve argillite, that we all have an inborn talent?

Davidson: Well, say if you didn't have the talent but you had the urge, the interest to want to do it — put those two things together and you *will* learn. Willingly you will go on to learn.

Wilson: How do you think Masset people view Skidegate people?

Davidson: The same as the Skidegate people think of the Masset people — they love one another. At any mourning, or when something bad has happened, they will try to do their best for one another. Both sides are the same; part of Skidegate is part of Masset. I have quite a few relatives in Skidegate. There's no way one person can hate another person.

This brings to mind the time when we used to live on North Island. Dadens is our summer fishing village, and in the next bay was Henslung, the Skidegate fishing village, and we used to go there in the summertime. All the young boys, when I was young, we used to go and fight one another. We'd attack one another just like big war time, and I remember Rufus Moody was the worst one for starting up a fight. He never used to come forward with the rest of the bunch; he'd kind of stand back. He was the one that used to start everything. But now, today, he and I are the best of friends. Time changes everything.

What are you crying for?
Do you cry for Skidegate Inlet?

— translation from a Haida song.

15.
A glimpse
of the future

Time does indeed change everything. While Claude Davidson remains an active carver and an eloquent spokesman for craftsmen of his generation, a new generation has sprung up with different values and different ideas of what can be accomplished in the argillite art. To a large extent, its inspiration came from Pat McGuire. His work told novices that they had to set high, almost unattainable standards if they were ever to satisfy themselves. His life told them they should make haste.

As a young man McGuire was slender and tall, with a finely-chiselled face. He spoke very softly. He seldom laughed but often smiled. It was a faint, wan smile. His manner was gentle, almost apologetic. His hands were long, sensitive, agile. He listened to the music of Bach on a stereo set he himself had built. Those who knew him realized long before he reached manhood that Patrick Samuel McGuire, the loner, was an artist. He liked to draw, even as a child. To his schoolmates he was a quiet kid who drew Haida designs on his desk, much to the teacher's annoyance.

He was one of five children of a Haida Eagle mother and an Ontario-born father of Ojibway-Irish stock. The father, Sam, had joined the Royal Canadian Air Force in 1939 at Thunder Bay, Ontario, and had been posted to Alliford Bay in 1941, as a leading aircraftsman first class. There Sam McGuire met and married Nora Tulip of Skidegate, who was related, by the way, to Charles Edenshaw. The two remained in the Charlottes among her people.

Pat McGuire's early years were spent entirely in the peaceful atmosphere of Skidegate. He listened and absorbed Haida stories told by his uncle, Joe Tulip. He watched slate carvers at work — Ike Hans, Lewis Collinson, and his kinsman Charles Gladstone — and learned from them. Soon he began applying himself daily to drawing, slate carving, and jewelry making. He sold to Berta Brown of

Pat McGuire.
— *Reg Ashwell*

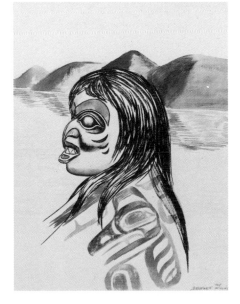

Watercolor painting by Pat McGuire, 1969.
Museum No. 13973.

— *Ethnology Division, British Columbia Provincial Museum*

117

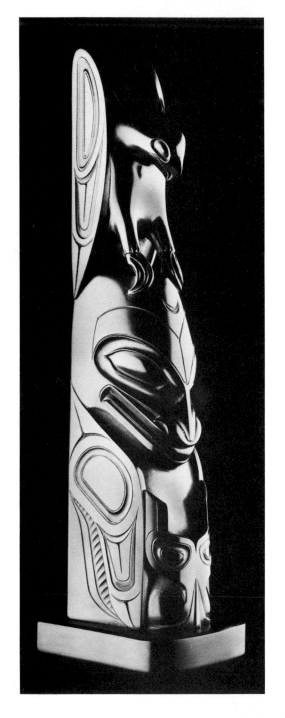

A superb pole by Pat McGuire.
— *Reg Ashwell*

Brown's store in Skidegate, to Hilda Kendall, postmistress at Skidegate Landing, and to storekeeper Gordon Jolliffe of Queen Charlotte City.

Eagle and killer whale were his principal crests. He used them in silver and gold bracelets, in his designs for ink paintings, and in making slate poles, platters and medallions. He, more than anyone else, made the medallion a popular item of jewelry. He fished the pools of Haida legend and retrieved the blind halibut fisherman and the woman shaman of false powers. Very rapidly, he exhibited a genuine style different from that of any of his fellow carvers — freer in concept and form, dead-sure in line, harmonious. In the early 1960s the word went around collectors' circles in Prince Rupert and Vancouver that McGuire was the carver of the future.

He handled raw slate lovingly, one interviewer reported, turning it over in his hands, studying the contours. Then, speaking so softly as to be almost inaudible, he would confide that hidden under the surface, "awaiting release," was the carving.[1] He possessed the Haida mystique of birth and rebirth. Carving was a ceremonial act, with McGuire in complete control. He himself was far too modest, too self-questioning, ever to acknowledge this. Yet to others, everything he released from the raw slate radiated the confidence of a craftsman who had thoroughly mastered the medium.

As he matured, a change came over McGuire. Cloud shadows flickered across the sunlight of encouragement. "It was good news indeed, to me, to hear of your good intentions, and I do hope, Pat, that you will remain steadfast, and allow no one to influence you against carrying them out," Gordon Jolliffe wrote him in 1961. "I would, so much, like to see you excel in the art you are capable of

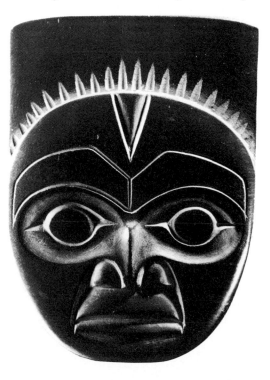

Exquisite detail of McGuire's carving is shown in this brooch. Museum No. 13885. Height 4.9 cm., width 3.5 cm.
— *Ethnology Division, British Columbia Provincial Museum*

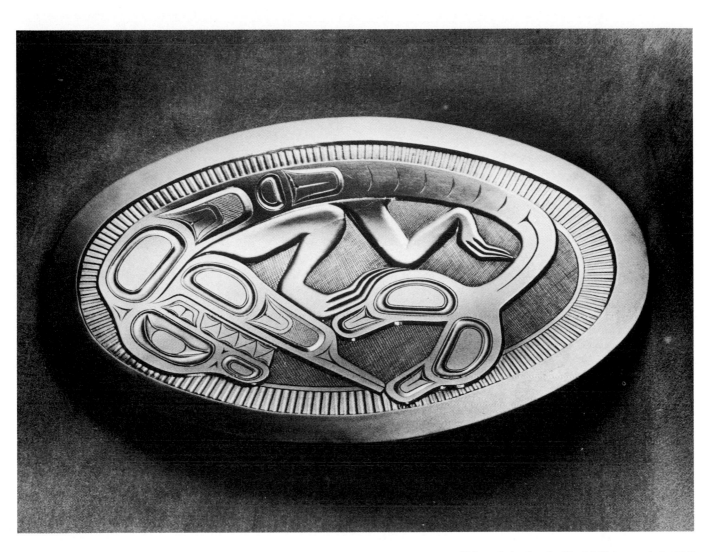

Killer whale plate by Pat McGuire, made in 1963.
Dimensions 23 cm. × 15.2 cm.
— *Alex Barta*

developing, and thereby prove yourself worthy of the faith and trust that I, and many others, still have in you. Success and happiness are within your reach — just waiting for you to grasp. Do not let either slip from you."[2]

If Jolliffe knew McGuire's potential as an artist, scarcely a soul knew the inner person. Even his first cousin, Amelia Hughan, found he was hard to get to know — "you never knew what was going on in his head most of the time." His life became less secure, more diffuse, increasingly confusing, and he retreated inward. He had taken to alcohol, and then to other drugs. The realm of artistic creation became his real world. The other one that impinged on him every day was full of horrors — laws, police, institutions. Every time he landed in a hospital, feeling like a caged animal, he walked out. The whole scene was inimical to the young artist who, as a child, had listened to waves lapping on the shores of Skidegate Inlet. Deep down, though, there was an irony to his situation that could not have escaped his sensitivities. McGuire, master of slate carving, came under the brutal thumb of a succession of insatiable masters that ran his life relentlessly.

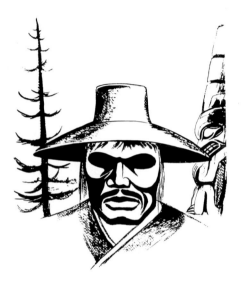

The blind halibut fisherman by Pat McGuire, 1969. Red on white. Drew collection.

"He was almost continuously under the influence of drugs," a partner in a Vancouver craft shop who knew him later on in the 1960s recalled. "He would carve when he was wiped right out." McGuire had chosen to live in Vancouver where drugs could be obtained more easily than on the north coast. "He had difficulty getting argillite, and as a result he'd make thirty brooches for $500 rather than one big piece. You'd get a storehouse of promises from him. He was a great guy. A complete charmer."

McGuire charmed argillite off the folks back home. "I am completely out of slate," he wrote Herb Hughan from the Driard Hotel on West Pender Street in 1965. "You can go about getting it through Charlie Williams, Walt Russ or Joe Tulip . . . There is no worry about the Skidegate council objecting because I secured their permission a couple of years ago."[3] He offered $200 a load. The cost of his art supplies, though, was negligible compared with other expenses. McGuire was forever broke and he knew why. "All that money gone to waste — up my arm," he once said. The waste, of money and a life, ended on a late December day in 1970. In the cold phrase of a medical report, he died of an overdose of heroin. He was twenty-seven.

His life was short, but during that brief time he produced work of extraordinary vitality, a living memorial to his genius. To see what made McGuire's work different from that of previous carvers, we must examine it closely alongside the work of others. His distinctive style is readily apparent. He knew precisely what could be coaxed out of a curve. The arch of his killer whale's back, for example, conveys a naturalistic impression of the animal in motion. Besides giving an extended sweep to the main figure and sometimes others, he elongated various design components to reinforce the sense of fluidity. Eye ends are lengthened, ovoids are especially elongated, and hands end in long tapering, slightly-curved fingers. All give an effect of grace and movement.

He lovingly hand rubbed his carvings until they took on a supersoft, glare-proof finish. They receive and reflect light uncannily. By carving inner ovoids in relief, McGuire would often create additional reflecting surfaces. But a prerequisite of that splendid sheen was an absolutely smooth surface, and here McGuire was also a perfectionist. Every surface, even in niches difficult to reach, is uniformly smooth. He was as careful with engraving as he was with finishing.

At the same time, he carved very quickly. Lavina Lightbown noticed this. Watching him at work, she noticed that he used both hands, turning the object with one hand while carving with the other. This increased the speed of his carving and gave him dual control.

McGuire's best work was done for cherished friends. But even his work for the general buyer was magnificent. However ill he was, however urgently he needed money, he still gave his best to every carving. He could do this because he was the sternest critic of his own work. He seemed never to be satisfied. He was always going to do better. He would destroy a carving before he would sell something that failed to come up to his standards. Because he carved rapidly, he left behind him a substantial body of splendid pieces. Most of them are privately owned. Those who recognized

his genius and bought directly from him would be reluctant now to part with his work at any price. North American museums own scarcely a handful of McGuires, among them the British Columbia Provincial Museum and the Museum of Northern British Columbia at Prince Rupert.

McGuire profoundly influenced the new generation of carvers by both his life and his art. He established a "school" of carving distinguished by its sweeping lines and clean finish. He taught technique to several carvers, among them Alfred Collinson, Ronald Russ and Douglas Wilson. His standards of artistic excellence were something to emulate, much as in his personal life he stood at odds with society. More than anyone else, with the possible exception of Pat Dixon, another excellent contemporary carver, he laid to rest the notion expressed by more than one magazine writer of the 1950s, that slate carving was dying. He confirmed what the Haida had felt all along. Sooner or later there had to be a Pat McGuire.

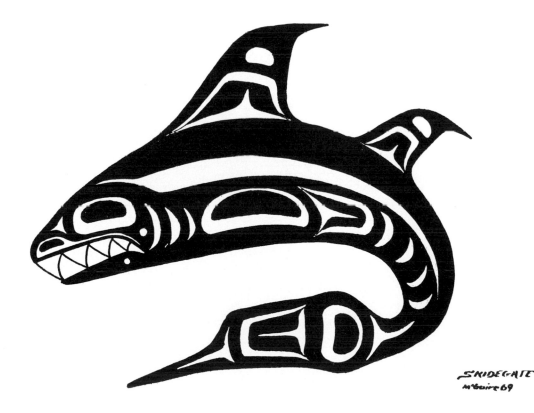

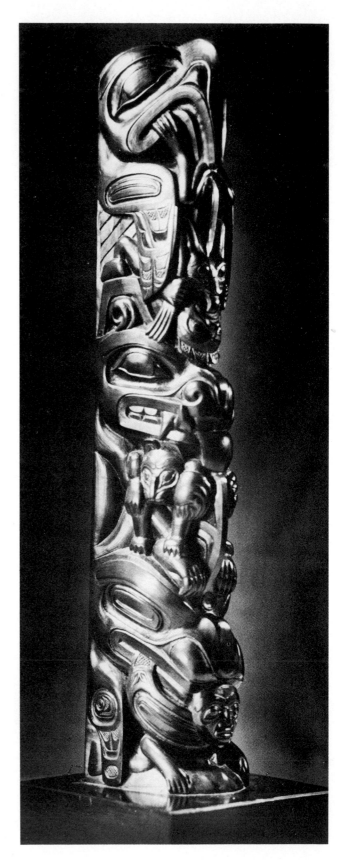

Bill Reid's carving of this complex, multi-figured story pole is in the finest tradition of the old master carvers.

— *Alex Barta*

The recognition which took so long to come to Charles Edenshaw came much faster to Pat McGuire. Such is the nature of our accelerated world. The young carver of today is acutely aware of this phenomenon. From the example set by his distinguished predecessors like Edenshaw, Tom Price, and McGuire, he realizes he must produce a substantial number of first-class pieces in order to become known and thus sought-after. The modern carver also has two living exemplars, both Haida design experts of national and international reputation, Bill Reid and Robert Davidson.

Reid's name has been carved in jewelry. Yet he is also a brilliant artist in slate, the old word he much prefers to "argillite." Like a composer who writes a fugue before tackling a symphonic tone poem, he has created masterful panel pipes and legend poles in slate, and thus demonstrated the strength of modern classicism. Davidson, like Reid, works in various mediums, and has produced outstanding argillite carvings.

16. The enduring art

Bill Reid.
— *Photo Reg Ashwell Collection*

Robert Davidson.
— *Photo Reg Ashwell Collection*

Reid's stated guiding principle — innovation within the framework of tradition — is shared by most young argillite carvers today. It is not a contradiction in terms. It means, for one thing, renewal — the revival of classical Haida thematics. The carver continues to explore age-old Haida legends for source material, and in the process, as George Yeltatzie explains,[1] he gains a greater understanding of his culture. In the Charlottes, such renewal is still possible. The carver gleans information by talking with his elders and by visiting his abandoned villages. When Yeltatzie's brother, Harold, began argillite carving in 1972, he looked to Yan for ideas. In that long-silent village across the inlet from Masset his mother's people had their roots, and there remnants of wood carvings lie greening amid strangling new growth.

Innovation within traditional forms is also tangibly evident. The major works of several young carvers today reflect a structural freedom that was not present twenty years ago. The free-form carving has undergone dramatic development. Killer whale dis-

ports in a buoyant, spirited fashion, mounted on a slender metal rod set in a rough-hewn base. Instead of standing four-square, a shaman figure kneels in an expressive, offertory attitude. Sea dog, again as a single figure, displays a new, muscular strength. Yet their decorative details remain unchanged. In his designs, the carver still adheres to tradition. Lavina Lightbown firmly believes the time-hallowed design elements will endure. When asked how she envisages argillite carvings of the year 2050, she replies: "We'll never lose that beautiful eye."

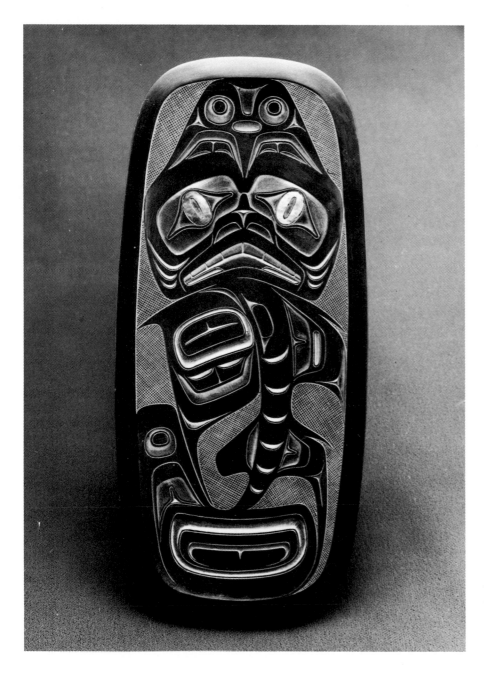

Dogfish platter by Robert Davidson, eyes inlaid with abalone shell. Purchased by the museum in 1974. Museum No. 14529.

— *Ethnology Division, British Columbia Provincial Museum*

124

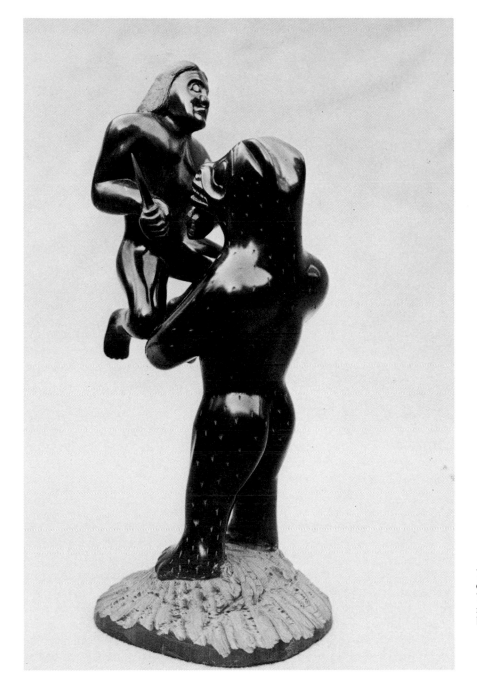

There are many stories in Haida legends concerning men in personal combat with bears. The contemporary carver John Yeltatzie has recreated one of them here. Height including base 20 cm. Lightbown collection.

Most modern carvers agree that the opportunities for displaying argillite to advantage have never been greater than they are now. This has come in part from the changing role of museums as repositories of the past to "living" places of the present. In the permanent or special exhibitions of today, argillite is usually displayed in the context of Northwest Coast art in general, but even so, it arouses great interest in its own right. One has only to stand aside and listen to the comments from viewers. Most of them would like to see much more argillite included.

Carvers also give public demonstrations at museums, gift shops, university seminars, and at events such as the Pacific National

Ron Wilson.
- *Alex Barta*

Pat Dixon.
- *Alex Barta*

Exhibition in Vancouver, just as oldtime carvers like Arthur Moody used to do at fairs in British Columbia and Alaska, except that crowds are bigger now. Small groups of carvers will also rent hotel space in British Columbia centers for public showings. Wherever they appear, they make themselves known, sell the carvings they have on hand, and pick up fresh orders. While doing so, they share ideas with one another, and with Haida artists in other mediums. A goldsmith and an argillite carver will exchange information on marketing opportunities, potential buyers, new techniques, and works of other artists.

They monitor each other's work closely, watch it in progress, and now and then help one another at the workbench, one carver blocking out the slate while his friend carves. They also keep an eye open for markets developing beyond the borders of British Columbia. Latterly, when they became aware of a rising potential in the oil-rich province of Alberta, several carvers lined up stores in Calgary and Edmonton as buyers.

To the carver who lives in the Charlottes, keeping in touch with the market involves travel — something he has always enjoyed, but in this case also a necessity. He journeys often to Vancouver, grumbling about the $80 one-way air fare as he does so, and taking his latest carvings with him. He will carry perhaps three pieces worth a total of $4,000, the result of two months' labor, delivering them either to private purchasers or to stores that handle his work by prior arrangement.

Not all carvers, however, live permanently in Skidegate or Old Masset. Several full-time carvers have chosen to reside in Prince Rupert, Vancouver or Victoria. Being based in these centers can benefit these carvers both financially and artistically. They can keep up to date regarding the market. Also, they are the first to hear of impending contracts, such as government commissions. And, perhaps because he can look objectively from a distance, the urban Haida may be more keenly motivated to preserve his cultural heritage than his Haida counterpart who stays home. On the other hand, urban living is more expensive, and for this reason the carver living away from the reserve believes strongly that he is entitled to a decent price for his product.

If dealers combine to depress prices, as Lloyd Hooper found them doing in the past, the carver now knows how to open markets elsewhere. In recent times, several carvers have withheld quality carvings rather than sell low. Carvers have also resisted attempts at government intervention in marketing. Operating independently, they have in effect controlled the market so as to ensure fair prices. One result has been that canny investors are coming more and more to recognize argillite as a good hedge against inflation.

Inflation is, of course, largely responsible for current prices. But another factor must also be taken into consideration. Over the last thirty years, Northwest Coast native arts have increasingly captivated the public's imagination, especially in North America. Beautifully-illustrated books on the subject, published from the 1950s to the present day, have reached a wide, enthusiastic readership. Further encouragement has come in recent years from Canadian government aid to the publishing industry. Argillite carvings have

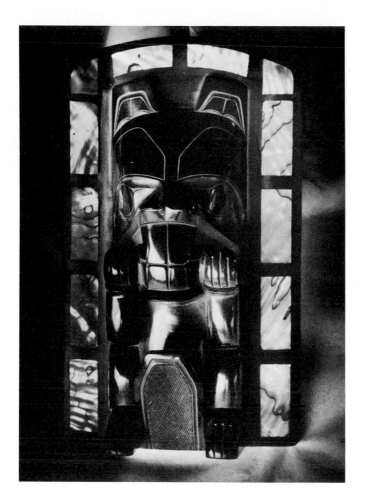

Deeply-carved argillite frontlet of the beaver crest with border of inlaid abalone shell, by Pat Dixon, in the Centennial Museum Gift Shop, 1979. Dimensions approx. 22 cm. by 12 cm.
— *Douglas Wilson*

A fine example of the work of contemporary carver Fred Davis. The figures, from top: eagle, bear, killer whale with human face on tail. Height 38 cm. Lightbown collection.

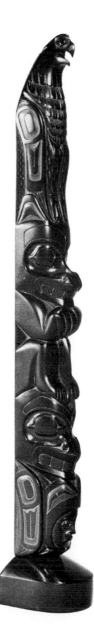

been illustrated in many of these books, as well as magazines, and for the specialist there have been reprintings of Marius Barbeau's publications on the subject.

At the same time, an affluent middle class has begun to collect modern native art, including argillite. Conscious of tax benefits, corporations and foundations have entered the field as well. Museums, on the other hand with their emphasis on conservation, combined with limited budgets for contemporary work, have tended to concentrate on buying pieces from the past, very often as part of a general collection of Northwest Coast material. Only recently have they shown interest in purchasing any contemporary argillite.

With Canadian museums, by and large, jostling in an increasingly-restricted market for old argillite, the present-day carver must perforce find his biggest market among private buyers. Here, fortunately, he is well served. Commissions come in regularly from business and industrial executives and from doctors, lawyers, accountants and other professionals, not to mention many blue-collar workers who have acquired a taste for this most expressively indigenous of British Columbia native arts. For the most part, the private collector is a knowledgeable person who can afford top-quality argillite and demands it.

127

The future of argillite carving depends, of course, entirely on its quality. The demand will continue as long as the standards set by the front ranking carvers remain high. And there is no reason why they should not, as long as the Haida continue to honor their traditions. The exclusive nature of the art — unique, hard-to-obtain slate, the concentration on individual sales, and the indisputable fact that there are only a few first-class carvers at any given time — guarantees protection against over-supply.

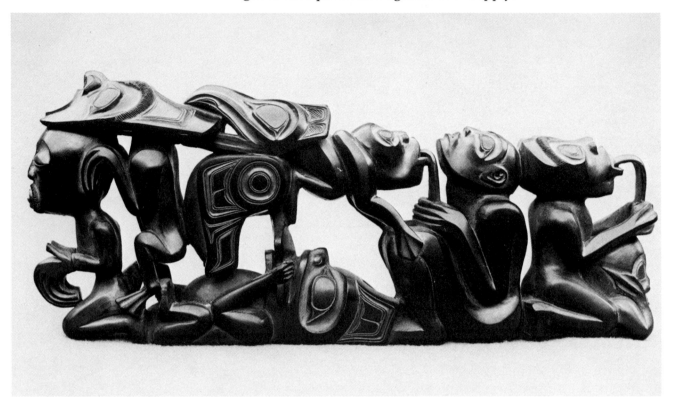

Greg Lightbown's modern version of the early 19th Century Haida-motif panel pipe — this as a panel. The figures, from left: old chief, supernatural frog, raven, bear (lying on his back), traditional frog, human, supernatural human and supernatural otter. Length 25 cm., height 10 cm. Lightbown collection.

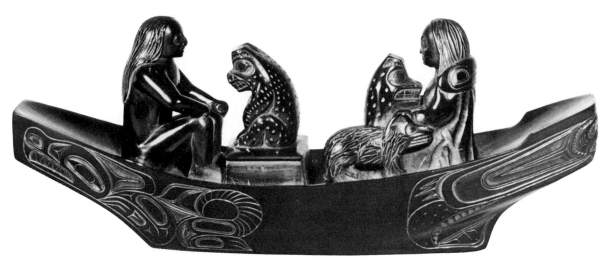

Henry White's modern depiction of part of the bear mother legend — the brother returning home with the woman and her offspring. Length 28 cm., height 11.5 cm., width 7 cm. Lightbown collection.

Part of seven-piece model village in argillite, carved in about 1976 by Alfred Collinson, including two longhouses both with frontal poles; one family pole which is a copy of the last old cedar pole standing in Skidegate; one burial pole (at left) and a canoe. The tallest pole here is 42 cm. Lightbown collection.

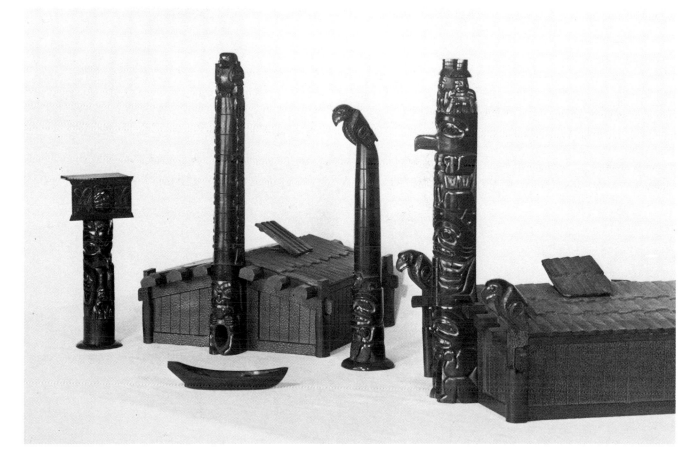

Part 4. A Legacy of Legends

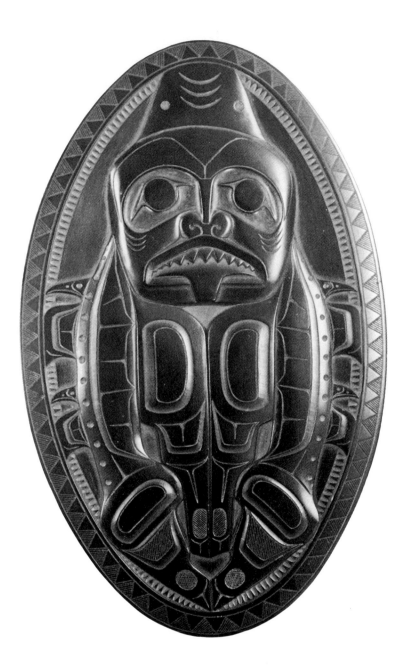

Shark in split design on a platter by Pat Dixon.
Dimensions 20 cm. by 13 cm. Lightbown
collection.

Stripped of their aesthetic content, most argillite carvings could be described as parades of Haida crests. Indeed, some of them are just that and nothing more. The carver presents his personal crests, like monograms or heraldic devices, in an arrangement agreeable to his design purposes. Thus, some knowledge of these crests and their significance is essential if we are to appreciate his finished creations.

Carvings of crests are the basic elements that go to make up the familiar Northwest Coast wooden pole. For the pole owner, crests were markers of identity, indicating personal inheritance and symbolizing the family's wealth, position and honor. Pole crests could also serve as homing devices, almost as street addresses. A storm-blown canoeman, taking shelter in a strange village, could locate kinsmen immediately by glancing up at the phalanx of poles in front of him and recognizing crests connected with his own family. In big-pole format, being stacked vertically and larger than life-size, the crests can be deciphered fairly easily by anyone.

The big pole of cedar, whether a memorial pole, frontal pole or mortuary pole, has a rigidity exceeding its physical aspect. It was made to order, and carved to certain rules. The person erecting it hired a master carver for the job, a specialist who was instructed in what was to be depicted, the precise crests to be used, and how they were to be positioned.

The argillite carver was under no such restrictions. He was his own man, and any rules were of his own devising. He could carve his material to whatever shape or size he desired. He could turn from amulets to pipes to poles to bowls, working on more than one at the same time. He carved the crests as he alone visualized them, through them related the stories he wished to tell, and, in the case of the shaman's panel pipes, displayed the powers he wished to summon.

This freedom of choice, a built-in survival factor for argillite art, was exercised vigorously in motif selection. He could use personal and family crests, and he could "borrow" crests. Animal and bird figures that cannot be assigned to either the Raven or Eagle crest omnibus today, may represent stories that have disappeared, along with their owners. The scope for depiction at one time seems to have been virtually limitless. As one native commentator observes: "The native artist had a whole world out there, and he dipped into it liberally." Thus equipped, the early argillite carver was off into his cerebral exercise, calling up an individual, dream-like past and giving it artistic expression.

Crests embody the personae of a legend or remembered incident. We shall discuss legends later, but Claude Davidson has already explained to us how he reconstructed in argillite one incident memorable to his people. Story-teller was in a sense also story-maker. Crests and other symbols were combined into stories spelled out by the speaking slate.

In the simplest argillite carvings, the crests stand as distinct entities. As with the big-pole crests, they are relatively easy to discern. In more complex carvings, crest figures intertwine, and because of this, may be difficult to recognize. Limbs of one crest figure may be interlocked with those of another, posing anatomical

17.
Crests and other symbols

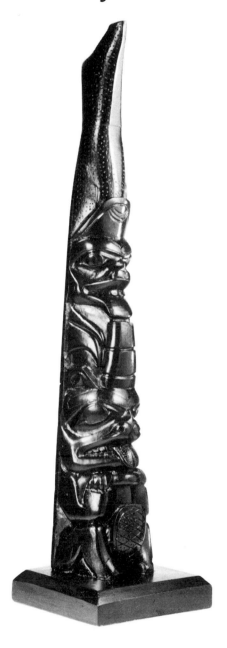

Shark is depicted at the top of this shark and beaver pole, acquired about 1900. Museum No. 569. Height 38 cm.
— *Milwaukee Public Museum, Milwaukee, Wisconsin*

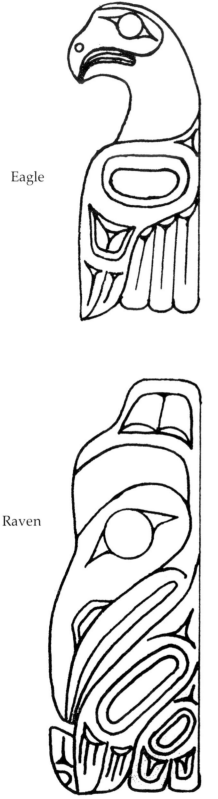

Eagle

Raven

riddles. As well, a figure may be in the midst of transformation, having half or part of the characteristics of one "personality" and half or part of another. Again, owing to a slight variation in styling, one crest figure may be mistaken for another. For example, if a carver chooses not to give ears to a bear crest, it can look rather like an otter. The relative size of the actual animal from which the crest is derived has no bearing on its size in representation. Even the most capable zoologist will be baffled at times, because the artist's licence has enabled him to shift levels of realism. Contemporary Haida carvers will disagree among themselves on crest identification. Resorting to legends is usually of little help because of the infinite number of versions that exist for every legend. Besides that, the basic legend may by now be forgotten. This, of course, is the great tragedy of Haida art — so much has been lost, irretrievably.

What makes the identification problem doubly frustrating in the case of argillite is that we can see the carver's symbols very plainly. The features have not been eroded by weather, unlike many of those on the giant cedar poles carved in the last century. In argillite carvings, irrespective of age, the crests are beautifully preserved, clear-cut as the day they were made. We feel they should tell us everything we want to know. Yet the closer we look, the wider seems to grow the distance between us and the carver's mind. Only long and intensive study can begin to bridge the gulf.

Every Haida was, and is to this day, born into either the Raven or Eagle moiety, membership depending on the mother's moiety affiliation. Each Raven or Eagle family owns and has the right to display certain crests. The right to a crest could be earned, given by an elder, or inherited. The crests themselves are figures of animals or legendary human beings, sometimes manifestations of nature, such as rainbow, or, in a few instances, man-made objects such as coppers. They could be used for display on poles, house paintings, tattoos . . . argillite carvings.

According to the ethnologist John Swanton, a great number of crests were obtained from a Tsimshian chief at Kitkatla, especially through a Haida chief at Skedans who was his friend.[1] Some of the accounts Swanton was given of how these crests originated are delightful. For example, one of the Chaatl Ravens found the first sea lion, and used the skin taken from its head as a hat. Later, wooden war-helmets were carved into the same shapes. Another account refers to the chief of all supernatural beings in the woods, who appeared dressed as the rainbow. Because the chief was a Raven "power," members of the Raven moiety took the rainbow crest from him.

Swanton learned that the killer whale, oldest of all Raven crests, was owned by every Raven family without exception, while the eagle, oldest of all Eagle crests, was similarly owned by almost every Eagle family.[2] A Haida today takes it for granted that he is known to be either a Raven or Eagle. If asked which he is, he will more than likely name his principal crest, say Killer Whale or Eagle. Town and family chiefs, Swanton remarks, were always striving to reserve certain crests for their exclusive use. If any chief learned that one of his crests had been usurped by a chief of a family of lesser rank, he would put the usurper to shame. By giving away or

destroying more property than the other chief could muster, the rightful owner forced him to abandon the disputed crest.

The accompanying illustrated table gives some of the crests that commonly appear in argillite, together with their identifying characteristics. The order does not necessarily coincide with their importance in the crest system, or with the frequency with which Swanton found them to be used by Haida families. In addition, a few crests were owned by both Raven and Eagle moiety members. Swanton suggested that this was accidental; a crest could be acquired by one family in ignorance of the fact that it was already in use by the opposite moiety elsewhere. And, as Swanton noted, why Raven should be an Eagle crest was as much a mystery to the Haida as it was to him.[3]

RAVEN CRESTS

Note: Some or all of these attributes may be present.

Raven:	Head down, beak long or short, tapered to a point. Long, folded wings.
Killer whale:	Snub-nosed, mouth showing teeth, dorsal fin, two pectoral fins, fluked tail with two ovoids split. May have blow-hole.
Grizzly bear:	Fully-rounded nostrils; large upturned mouth showing two canines. Tongue often protrudes. Block ears. No tail.
Black bear:	Much the same as Grizzly but without the two canines.
Hawk:	Round face. Sharp downturned beak incurving toward mouth.
Moon:	Human face set in broad-rimmed circlet.
Wasco:	Bear face, pectoral fins, fluked tail. Similar to Eagle wasco, except for the tail.
Dogfish (shark):	Large domed forehead representing shark nose. Downturned mouth showing triangular teeth. Two or three gill marks may appear in dome or on cheeks. When shown with human face, this is supernatural dogfish.
Snag:	Human-like yet supernatural face. Hook may extend in arc from top of head to below mouth, or there may be a spike on shoulder. Sometimes holds a stick in front, representing driftwood or "deadhead."[1]

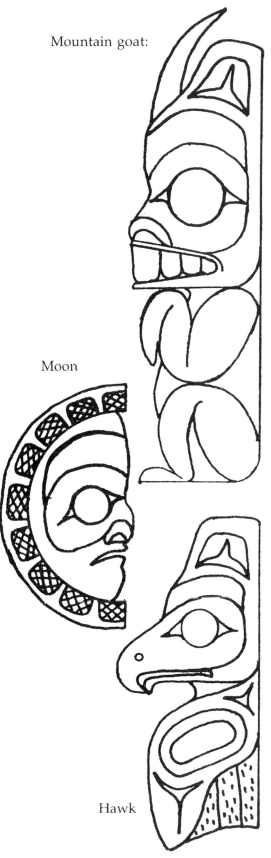

Mountain goat:

Moon

Hawk

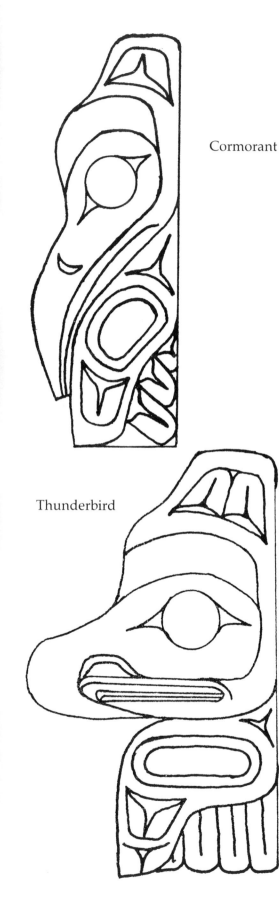

Cormorant

Thunderbird

Thunderbird:	Hooked beak, thicker and more massive than Eagle's.
Mountain goat:	Two horns jutting up from forehead. Often confused with sculpin.
Wolf:	Bear or dog-like face but with sharp, pointed teeth. Nose longer, more slender than bear's.
Skate:	Representational.[2]
Rainbow:	Human face with deeply-arched head-dress extending down each side of face.
Worm:	Grub-like face with sucking mouth.[3]
Sea lion:	Similar to seal but has whiskers.
Horned owl:	Representational.
Cumulus cloud:	Indistinct semi-circles, like puffs of smoke.

Notes:
1. Snag was a personification of driftwood, sometimes called "tide-walker."
2. A skate is a species of flatfish.
3. A worm to the Haida was anything that wiggled, had few or no fins, and no "arms" or "legs."

EAGLE CRESTS

Note: Some or all of these attributes may be present.

Eagle:	Strong, curved, pointed beak less prominent than Thunderbird's. Usually has rows of wing feathers at sides. Often has talons.
Beaver:	Two prominent incisor teeth center front. Flat, cross-hatched tail. Usually holds gnawing stick or scroll horizontally in upright front paws.
Wasco (sea wolf):	Animal face of fierce expression. Obvious wolf tail. On poles, the wolf tail is curled up in front.
Hawk:	Round face. Sharp downturned beak incurving toward mouth.

Five-finned Killer Whale:	Same as Killer Whale except for five dorsal fins.
Raven:	Head down, beak long or short, tapered to a point. Long, folded wings.
Frog:	Representational, with wide mouth, no ears, teeth or tail.
Blackfish:	Very wide mouth. Flukes. No ears.[1]
Dogfish:	Similar to Raven dogfish.
Cormorant:	Long, flat, block-ended beak, not tapered like Raven's.
Sculpin:	Two horn-like feelers over forehead. Round eyes. Upturned mouth.[2]
Halibut:	Flat halibut shape, often with two eyes on upper side of face. Appears most often on flat surfaces of dishes and boxes.
Skate:	Similar to Raven skate.
Dragonfly:	Double wings. Big bug eyes. Broad mouth. Segmented body. In early representations has curled proboscis.
Heron:	Long, arched neck. Long beak. Stilt legs.

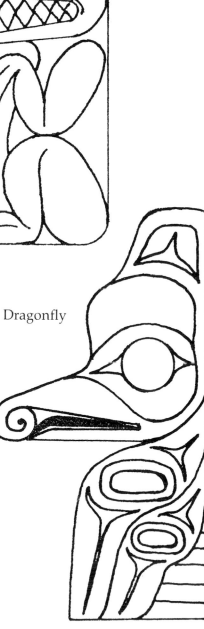

Wolf

Dragonfly

Notes:
1. The blackfish is the Pacific pilot whale.
2. The sculpin is sometimes called a bullhead, member of a family of fishes with large, spiny or armored heads and short, tapering bodies.

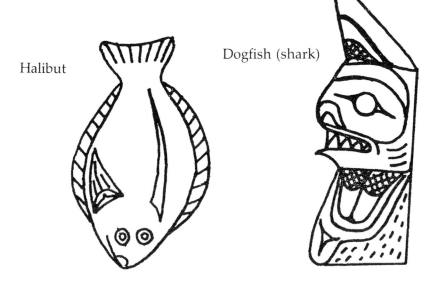

Halibut

Dogfish (shark)

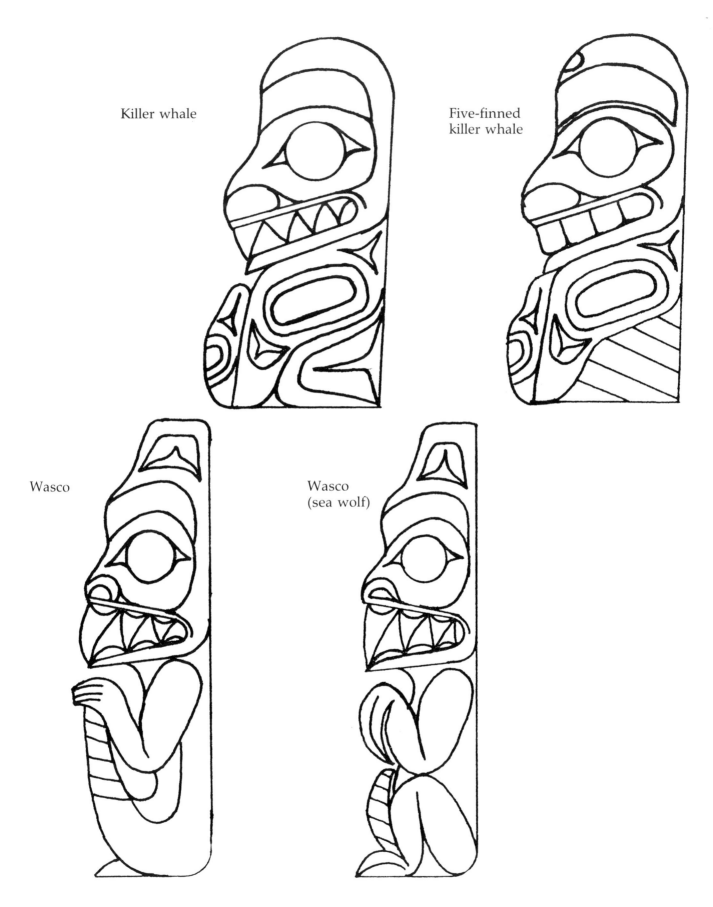

Killer whale

Five-finned
killer whale

Wasco

Wasco
(sea wolf)

138

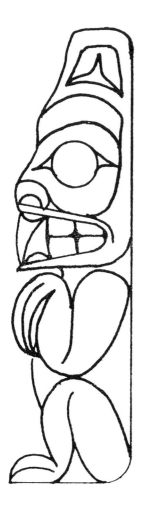

Grizzly bear

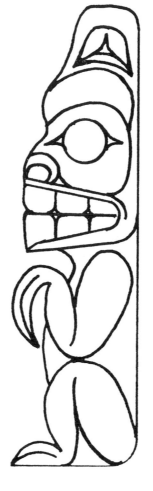

Black bear

How a carver designs his crests will naturally depend on the shape of the object he is making. If it is round, he "sculptures" the crest. If it is flat-surfaced, he engraves the crest design in high or low relief. In the following illustrations, wasco is "sculptured" on a pole and engraved on a platter:

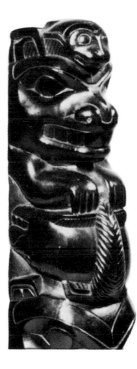

Wasco at the top of a pole, clutching whale, his tail curled up in front. Whale on his head.

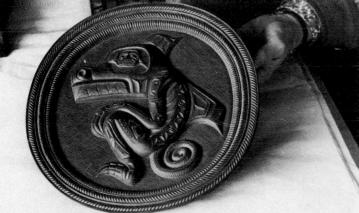

Wasco in profile on a plate by Ed Russ in the Centennial Museum Gift Shop, Vancouver, in 1979. Note fins and tightly curled tail.

— *Douglas Wilson*

139

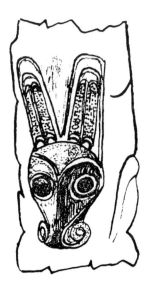

Drawings of butterfly on a pole, and the same creature in profile as represented on a panel pipe.

In another comparison, butterfly (a non-crest figure) is depicted on a panel pipe and a pole.

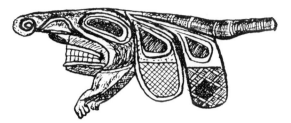

In adjusting to the flat surface, the device of "splitting" the crest figure has been used, opening it up much as one would prepare a fish for filleting. Artists skilled at house painting, tattooing and decorating cedar boxes were particularly adept at flat-surface designing in argillite. The customary options to the split form are face-on or profile representations.

Other figures, apparently from Haida legend rather than the crest lexicon, also appear in slate carvings. Some of these may actually have been crests at one time, although they are not mentioned in the lists Swanton compiled during ten months of research in the Charlottes in 1900-1901. The following are among the "non-crest" figures:

Mosquito:	Small face, long, pointed proboscis. No body.
Butterfly:	Animal face. Segmented body. Two hatched wings with smaller overlaid wings. In some early representations, a little human face appears on the head.
Seal:	Seal-like face, flippers.
Octopus:	Long tentacles. Sometimes the suction cups appear as a row of circles.
Mouse:	Representational.
Woman:	Distinguished by ornamental labret in lower lip.
Skil:	Segmented cylindrical object, a symbol of property and status.
Watchmen:	Two or three human-like guardian figures, side by side.
Clam:	Entirely representational.

These are some of the foregoing names, in the Skidegate dialect:

RAVEN		EAGLE	
raven	x̲uya	eagle	Gud
killer whale	sGana	beaver	ʔciŋ
grizzly bear	xuʔaĵi	wasco	wasco
black bear	tan	raven	x̲uya
moon	guŋ	frog	ɬkyan q̓usʼtan
wasco	wasco		(wood crab)
dogfish	q̓ax̲ada	blackfish	qun
wolf	Guts	halibut	x̲agu
cumulus cloud	yánʌŋa	dragonfly	mamaciki
		seal	x̲ud
octopus	nʌw		

Note: For pronunciation guide see page 13

What could be taken for crayfish, otters, geese, oyster-catchers and sandpipers also show up in early argillite, but are not listed by Swanton. Creatures which could be construed as weasels, flickers and hummingbirds *are* on the Swanton crest lists. But because no positively-identifying characteristics have been recorded, we cannot ascertain exactly what they are. In addition, there are some creatures which simply defy identification by modern eyes.

In circle, winking face on a group carving. Museum No. 56.25.794. Length 26 cm., height 19 cm.

— *Merseyside County Museums, Liverpool*

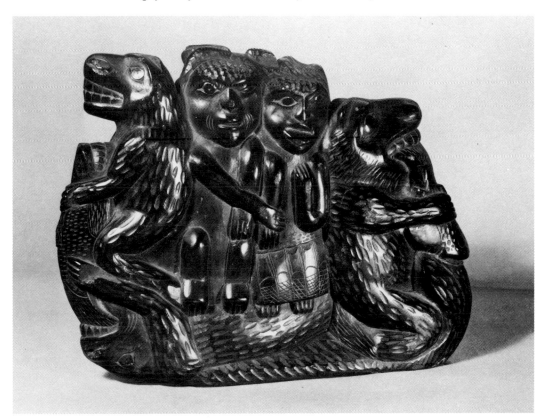

Sometimes a carver gave facial expression to his crest and non-crest subjects. A human face may be open-mouthed in fear, horror, anguish or incantation. A face may have both eyes shut, signifying sleep, blindness or death. Now and then, a human face on a group figurine will be seen to be winking. A wink has a metaphorical meaning within Haida culture, not necessarily in the commonly-accepted Euro-Canadian sense of sly knowingness. For instance, Master Carpenter or Master Canoe-Builder, a "supernatural being" who belonged to the Eagle moiety, could reputedly build a house in a single night, and it was said that his carving was so life-like that the eyes of his creatures seemed to wink.[4]

Carvers today, especially the young ones, spend hours poring over illustrations of argillite carvings to see how their predecessors carved a particular figure. They exclaim over the beautiful mouths that an artist like Tom Price gave to his bears, or the graceful arch that another carver bestowed on killer whale. Changing their focus, they will examine the way in which figures have been linked to unify the whole and make the story-line "flow" in the narration of legends and historical incidents.

From the Haida point of view, the term "historical" is a misnomer. The Haida, recognizing the limitations of the written word, consider their legends as well as their remembered incidents to be valid historical accounts. Though their ceremonials were suppressed, their story-telling lived on. The argillite medium became one of the messages.

The distant origins of crest use are often more sensed than realized. A perceptive carver today, seeing a fellow carver's predilection for a particular crest, will sometimes say: "That's probably one of his crests and he doesn't know it." The expression is spontaneous, suggesting that the argillite medium may be a message for carvers themselves as much as for other people.

18. Stories in slate

Since the morningtime of the human race, legends have been invoking the spirits of the founders of every culture, glorifying deeds, enshrining heroes, and even directing codes of conduct.

In their wind-swept corner of the globe, the Haida and other Northwest Coast people created countless legends. Here, where Etienne Marchand's expedition found that "every man is an artist," legends were told constantly by speakers, singers, dancers, carvers, painters, tattooists and dress designers. Less formally, family legends were taught to children by their elders. As they grew up, they could watch and listen to enactments of legends at winter ceremonials. All year they were surrounded by visual legends in the form of house decorations. Legends were everywhere to be seen and heard. Most city people in the late twentieth century find it hard to imagine the influence that legends play in their own lives, let alone the Haida village of long ago. To many of us a legend is no more than the key on a map.

Legends as told in songs and stories tell us of a people's values and behavior. While in some ways Haida legendry resembles those of other cultures, there are significant differences. Most Haida legends are not concerned with noble warriors going into battle, as one might expect, but with Haida origins, with a search for roots, and of men who perform great feats of strength, and of mystical unions between human beings and supernatural powers. In fact, Haida legendry is very much concerned with supernatural relationships between human beings and the rest of nature.

The wanderer — and what happens to him on his travels — is a central figure. A woman out berry picking is carried off by a Bear because she has insulted the Bear People. A man goes beneath the sea in search of his wife. Raven flies off to a distant place to find a valuable object. After the wanderer's exploits, there is the homecoming. Setting forth and coming home, two great events in Haida village life, echo through the legends. Whether journeying by land, sea or air, the wanderer has one strange experience after another, moving on like a person in a dream. He encounters other animals in the cloaks and masks of disguise, who lead him on to other experiences. The wanderer himself may undergo a metamorphosis. He accepts the change as being natural. Transformations come swiftly as black clouds on a clear day, or sunshine after a storm.

Panel pipes of Haida motif are legend-laden circles of change. In subtle ways, they convey the sense of the mystical interchangeability of all physical forms and beings. A figure is depicted in the midst of metamorphosis, displaying characteristics of what it has been and of what it is becoming. Although we may have no idea of what was in the carver's mind, figures in transformation indicate that a legend is being told.

Supernatural hawkman by Greg Lightbown. He is in the process of transformation into hawk. Height 15.5 cm. Lightbown collection.

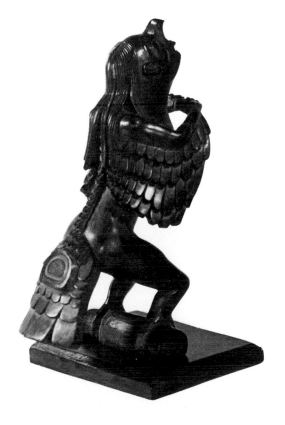

An extraordinary feature of early argillite is tongue-linking, the connection of one figure to another by an extended tongue. This device goes beyond the mere unifying of design elements. One-and-one depictions, as modern art historians have noted, are almost universal. Their connotations are sensual rather than sexual, conveying the idea of a cycle — something that has no beginning and no end. Moreover, to the early Haida — and the shaman especially — the tongue may have been the direct means of transfer of a power, an ethos, from one creature to another.

The Vancouver Island west coast native artist Ron Hamilton, of the Opetchesaht tribe, whose knowledge of design spans the complete spectrum of coastal native art, speculates that tongues may have been considered messengers from another world. "I know that at home tongues of animals like sea otters used to be really highly-prized things for Indian doctors. They were considered to contain powers. The tongue is obviously what you talk through, or speak through, or sing through, and these (in argillite) imply a sucking power indicating where a song came from . . . or may indicate physically the transfer of a story, a song, a name, knowledge — whatever it was that was given."[1]

Whatever the origins of tongue-linking, we can take to mean, at its most straightforward, the transfer of a power, a strength, a capability for transformation or reincarnation. It is a recurring symbol in panel pipes of Haida motif. The tongue of one figure extends downward or across into another's mouth and presumably into the throat. The two figures are inextricably bound together in an act of transfer.

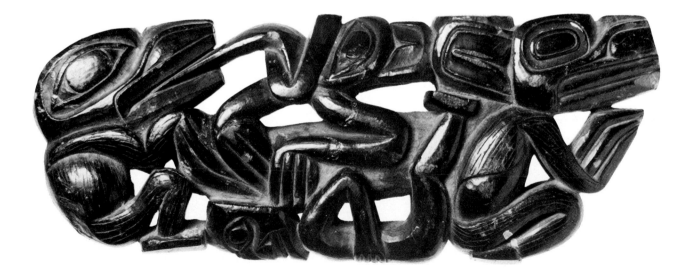

Tongue-linking is clearly depicted at top left in this panel pipe.
— *Museum für Völkerkunde, Berlin*

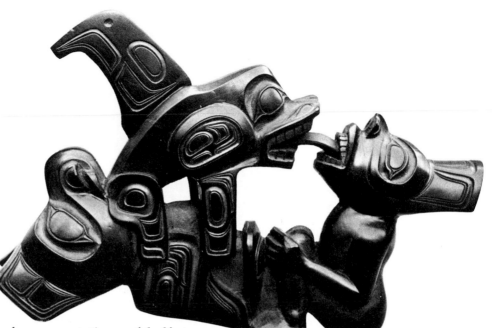

Tongue-linking in a modern panel carving by Greg Lightbown. The figures are thunderbird (lying on his back), killer whale, and human. Length 16.5 cm., height 10 cm. Lightbown collection.

Aside from tongue-linking and representations of half-stage metamorphoses in legend depictions, crest figures by early argillite artists are less uniformly styled and more difficult to discern than the crests on later carvings. Several crests or figures on a single carving may defy identification. We have no way of knowing precisely what legend the carver was relating. Legends varied from village to village, from family to family, from person to person. Carvers today convey legends tersely. A single figure often suffices to represent the legend.

We have selected a few legend themes that recur in argillite. Even though they are much abbreviated, they will give an idea of the roles of the leading "personalities." Raven will be seen as the paramount figure, the great provider for the Haida people, and at times a prankster. Swanton observed that all Ravens of the northern end of Graham Island had the right to use the raven crest at potlatches, because Raven was their grandfather, but they did not consider it a true crest. As used by the Eagles, it was a true crest, just as their eagle crest was. When there was going to be a death in the village, "the raven would call for some time." When it ruffled its feathers and made itself look big, a death would soon take place.

The supernatural beings always hunted at night and were careful to return before the raven cried, or death would overtake them.[2] The personified Raven was commonly called Nankilslas — He-whose-Voice-is-True, because whatever he predicted came true. At Skidegate, Eagle would be Raven's companion, whereas at Masset, his place was taken by Butterfly. Other legendary beings such as Killer Whale and Wasco had their own attributes, which again could vary according to the village and lineage division.

The following, then, are a few examples of legends told in argillite carvings:

The primal clamshell:

 In one of many different stories of how Haida people originated, a clam symbolically gives birth to several human chil-

dren. In one version, Raven is the seed bearer. A few carvings of a single clam or cockle exist from the past in argillite. On dishes and boxes, a row of little faces appears in the shell opening — the children.

Raven, Butterfly and Bear:
While looking for suitable land for the Haida, Raven takes Butterfly on his flight as an escort and scout. Butterfly informs him that where bears live, there also is good land with salmon and berries.

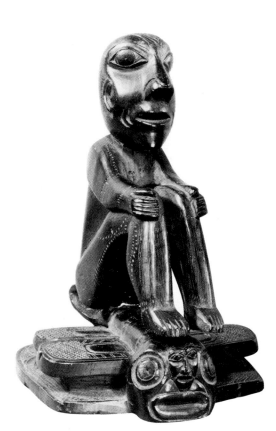

Raven-man with butterfly companion, a carving collected by Israel Powell and received in 1879. Height 13.7 cm., width 9.2 cm.
— *National Museums of Canada, Ottawa*

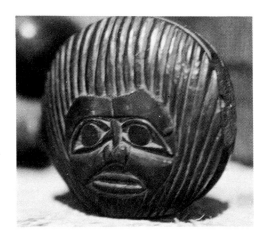

Oval pipe representing a cockle, with a human face on each side. The pipe is resting on the bowl rim. This carving was found in a yard at Skidegate.
— *Queen Charlotte Islands Museum, Skidegate*

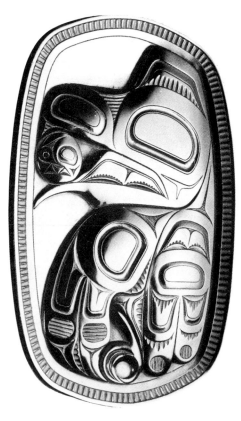

Platter by Pat Dixon showing moon in raven's beak, carved in deep relief. Length 20.5 cm., width 13 cm. Drew collection.
— *Alex Barta*

146

Raven and the mosquitoes:
 Raven hears the cries of people being molested by giant mosquitoes. He sends Butterfly, enemy of Mosquito, to investigate and report. When Butterfly returns and informs him of the people's plight, Raven sends Mosquito-hawk to gobble up the offending mosquitoes.[3]

Raven and the moon:
 On his travels, Raven finds a chief who keeps the moon hidden in a box in his house. By changing into human form and deceiving the chief, Raven obtains the moon, flies out the smoke-hole in the roof, and places the moon in the sky. Raven is sometimes shown on slate poles with a disc in his beak representing the moon, or with a box panel in his beak.

Raven and whale:
 Raven the dissembler could enter a whale and drive it ashore as food for Haida villagers. His feat accomplished, he would change back to raven form and fly off for another adventure.

Raven and fisherman:
 Raven repeatedly goes down to the sea to steal bait from a halibut fisherman's hook. The exasperated fisherman finally catches him, and pulls off his beak in the process.

The bear mother:
 A woman out berry-picking one day insults a bear. Angered by her insult, he follows her until she becomes separated from her companions, then shows himself to her in human form and leads her to his village. They mate, and she gives birth to twin cubs. Years pass, and her youngest brother, who has been waiting for her to return, finally sets off in search of her. He finds his sister and her family. Bear husband teaches his human wife his death song, and lets her brother kill him. All return to her village, but her sons are uneasy; they don't feel as though they belong. On questioning their mother, they learn the truth. The sons want to return to their father's village. All return there, and the mother, seeing her sons' new-found joy, realizes they must part — that her sons must live their own lives and that she must go back to a new husband in her own village. There is a tearful parting. The supernatural cubs begin a new tribe, and their mother raises a family that claims the grizzly bear as its crest.

A woman captured by killer whales:
 A man's wife is abducted by killer whales and taken to their village beneath the sea. The husband goes in pursuit and eventually finds her. In one version, he meets a man mending a canoe, who turns out to be Heron, a watchman for the killer whale community. The husband befriends Heron who leads him to his wife.

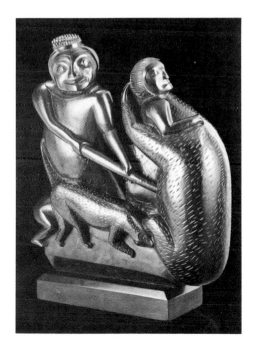

Bear mother story is told in this group figurine. Brother of woman who became bear mother stabs her bear husband. Bear husband embraces his grimacing wife as he dies. Her brother is accompanied by his hunting dog who nips bear on his hind leg. Intense feeling in the spear-thrust and the wife sensing her mate's death. Traditional hair dress on brother. Museum No. 248. Skidegate Oil Company gift, 1889. Height 34 cm., length 25.5 cm., thickness 7.5 cm.
— *Ethnology Division, British Columbia Provincial Museum*

Woman and dogfish:
> A woman is carried off by the dogfish and becomes one of them. In one story, her metamorphosis is symbolic of a change in weather.

Wasco and whales:
> Wasco hunts black whales at night, bringing them home in the morning as food for his wife's family. Wasco often appears in argillite holding his catches. In a Skidegate legend, a woman shaman has promised her hungry villagers that whales will appear in a certain number of days. But a hero of legend traps Wasco, dresses as him and thus becomes Wasco. He is then able to go to sea and catch the promised whales. He thus "unmasks" the woman shaman, who dies of humiliation.[4]

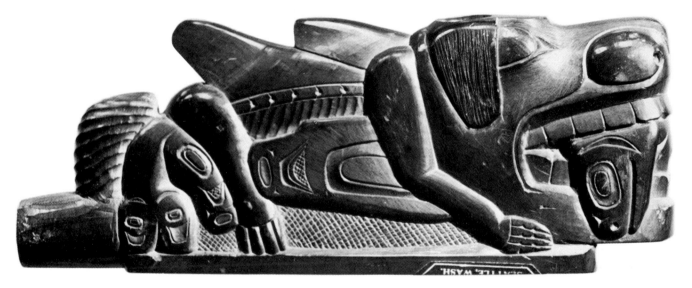

Wasco bringing in whales, in his mouth and in the curl of his tail, illustrated in a late trade pipe. Length 19 cm.
— *Cranbrook Institute of Science, Bloomfield Hills, Michigan*

The unexpected in voyaging ripples throughout these legends. Today, in the relative safety of boats equipped with electronic navigational aids beeping reassuringly, we can scarcely comprehend the uncertainties that the original canoe-going Haida faced. Skilled handler though he was, his craft was a mere speck on seas that could turn from dead calm to tempestuous fury in an incredibly short time. Misfortune and death were always at hand, far too close for complacency. Deliverance, if possible, was around the next corner. In addition to, and perhaps because of, the environmental risks, he was liable to encounter phenomena that might be natural or supernatural. Thus, the thin line separating real life from legend tended to blur. At times, the two merged completely in the Haida consciousness. Their fusion is reflected in all Haida art, and nowhere more clearly than in the argillite art.

Part 5
Forms
and
Figures

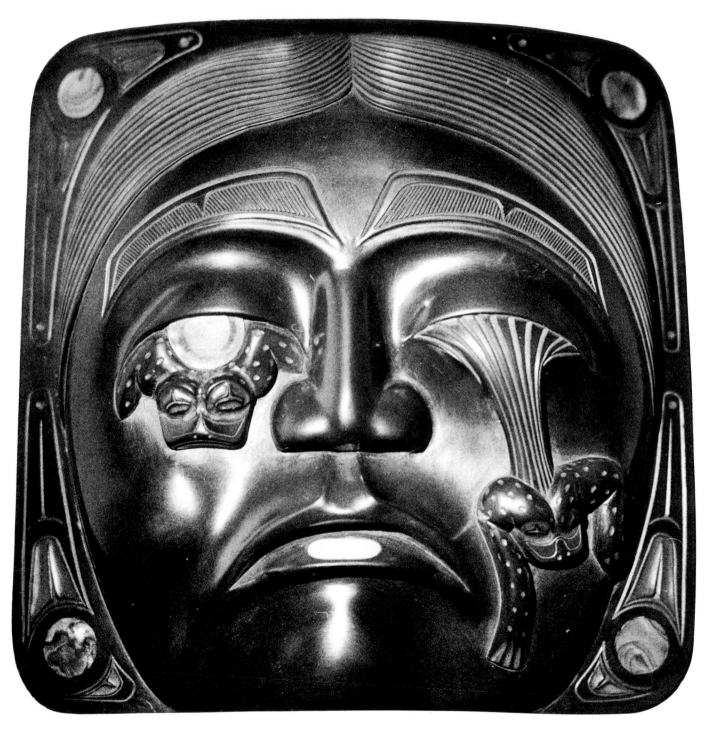

Contemporary carver Henry White used abalone
shell and ivory for inlays in this impressive mask
which interprets part of the Tanu legend of
frogs thrown into a fire which led to the
destruction of a village by a bolt of fire. Frog
woman, depicted here, who is weeping for the
frogs, has a red abalone shell eye suggesting the
ball of fire. Height 19.5 cm., width 19 cm.

— *Museum of Northern British Columbia, Prince Rupert*

No artist, however revolutionary he may be, sees the world through the eyes of an innocent. His perceptions have been culturally coded. His vision is informed by previous art and borrows from one or more cultural banks. The argillite carver is no different. At first, he drew from the form and substance of what all Northwest Coast native peoples created in wood and stone, especially from the legacy of his own people. This was all he knew. It was all he needed to know.

Almost all forms of commonly-produced objects in argillite have closely related forms in either wood or stone accoutrements of Haida culture. In its trapezoidal shape, the miraculous panel pipe of Haida motif appears to be one notable exception, although it too was sometimes made in wood. Slate amulets have their counterparts in amulets made of ivory or bone, bowls in stone mortars, platters and bowls in wooden feast dishes, single figurines in Haida "dolls" of wood or stone, boxes in cedar chests, poles in the obvious cedar totem poles. In size and purpose the slate object may be different, but the essential forms were already there and needed no modification.

So the slate carver hewed to known forms, manipulating some of them for his prime purpose — design display and story-telling. Later, as his horizons expanded, he explored the new language of forms brought by the white man. He acquired new construction aids, making perfectly round plates, for example, by using the navigator's pointed divider to describe the arcs. Later, he saw the elegant compote, a form from a foreign culture, and carved his own version in slate. Otherwise, he was largely faithful to the forms of his own culture.

The following table gives the major form-types of objects produced in argillite. The sequence is not chronological throughout:

● The oval pipe, short, oval in profile, can be called a pipehead since it appears to have required the insertion of a stem for smoking. One type of oval pipe is carved as a curled animal, the other as a clamshell.

● The elbow pipe has a long, plainly visible stem, ending in a bowl. Elaborate versions have figures surmounting the stem and embracing the bowl.

● The panel pipe is frieze-like with elaborate openwork. Its components are secondary to, and frequently concealed by, the ornamentation. The longest of all pipes, the panel pipe is trapezoid, oblong, or slightly-curved oblong.

● The panel pipe has three design types: Haida, "ship-type" or European-American, and those of mixed motifs, combining the two previous types.

● The late trade pipe, which has an exposed stem like the elbow pipe but is heavily ornamented toward the bowl end with conjoined figures.

● The "flute," more accurately a recorder, with a mouthpiece at one end.

● Single figurines may be of human beings, white or Haida; birds, or animals. Of the human figures, the earlier type depicts Americans or Europeans, the later type a Haida chief or shaman. They stand on small bases.

19.
The shape of things

• Group figurines are composed of clusters of people, animals, or both, on a single base.

• Dishes, the circular type defined as plates and the oval or oblong ones as platters. Early plates show the use of dividers for geometric designing. Platters may be rounded at their ends, squared, or tapered.

• Bowls, like platters, are some of the biggest works in argillite. Identical in form to bowls of wood shaped as a crouched animal. Bowls are deeply hollowed, as distinct from shallow dishes.

• The compote, a decorative plate on a pillar, is of European-American derivation.

• Poles are often referred to as totem poles or model totem poles. "Model totem poles," the designation of many museums, is misleading, as most argillite poles are not models of the much-bigger memorial poles, house poles or mortuary poles of cedar.

• Boxes modeled after much-larger wooden chests in which the Haida kept their valuables, or after mortuary boxes.

• Personal ornaments:
— Amulets, small, irregularly shaped.
— Labrets, oblong studs worn in the lower lip.
— Medallions worn as pendants.
• Models of Haida houses.
• Household knick-knacks of European-American form.

A limited number of argillite carvings including copies of stone artifacts from other cultures, cannot be slotted into these form categories.

In the 1800s, the carver often left his slate unpolished. Amulets, a great many pipes, and simple bowls, retain the untouched slaty-green, slaty-gray or gray-black color of the raw material. Later carvings were polished and rubbed to glossy blackness. Their facets catch the light, and on objects such as the panel pipes, the open-work admits light to dark surfaces and casts shadows. To the Haida eye, accustomed to subtle shadings of light, they must have had tremendous appeal.

An instance of early use of abalone shell for inlays, this is one of five pipes which Colin Robertson gave to Perth in 1833. Museum No. 1978.472. Length 23 cm., height 9 cm.

— *Perth Museum and Art Gallery, Perth, Scotland. John Watt Photo*

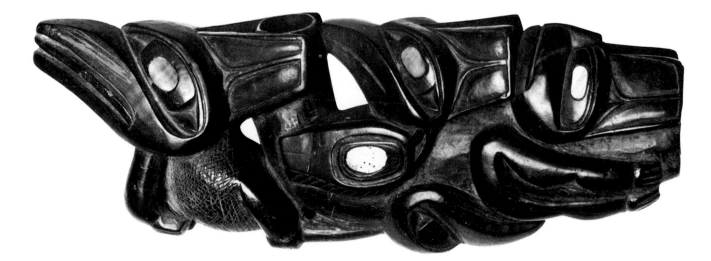

For color contrast and design emphasis, the carver may apply inlays of shell, ivory, bone, or metal. In most instances, these have been used judiciously on carvings large enough to carry them successfully without detracting from the designs. One of the earliest examples of inlaid argillite is a panel pipe pre-dating 1833, now in Perth, Scotland.

Abalone, which has an opalescence complementing the sheen of polished slate, is the shell most frequently used. Fragments are sawn off, filed and sanded to the desired shape and then inset with glue. In the 1800s, the preferred abalone shell was the California green, acquired by whites as a trade item for the North Coast native peoples. The pinks, reds, pintos and blacks were not used, for the same reason that the abalone shell found in waters off the Charlottes *(Haliotis kamchatkana)* was spurned — it does not possess the desired blue-green outer layer. Because it would remove the desirable outer layer, many of the old inlays of abalone shell were not filed or sanded flush with the carving as is done now.

For bowl rim inlays, another popular "shell" used in the 1800s goes by the name of operculum, a Latin word meaning cover or lid. This is actually a horny appendage of the red turban snail *(Astrea gibberosa)*, common to seashores of the Charlottes. Ivory in color and a chunky oblong of about finger-nail length, the operculum is attached to the mollusk's foot and when the animal retracts its foot, the operculum wholly or partially closes the aperture and seals the mollusk inside. The snail itself grows up to three inches long and its flesh, like that of abalone, is good eating.

Dentalium shell was used for inlays on rare occasions. Prized above all other shells for personal ornamentation, this delicate mollusk shell is curved and tapered like a tusk, with openings at both ends. Indians living on the west coast of Vancouver Island swept dentalia from shallow ocean beds and traded the shells as currency and for ornamental use throughout the Northwest. By 1878 the mollusk was rare in the waters of the Queen Charlottes, according to George Dawson.[1]

Decorations of ivory and bone appear as often as abalone shell. The ivory was cut from walrus tusks traded from the north, and the bone from a variety of sources on the Charlottes — whalebone and the teeth of killer whales, sharks, otters, bears, beavers and dogs. Whalebone, commonly used for inlays in the last half of the nineteenth century, can be recognized by its grainy appearance. Bone of a different sort — tooth bone — can scarcely be distinguished from ivory when inlaid. The enamel of large mammal teeth, which is much thicker than the enamel of human teeth, could (and did) serve as an acceptable substitute for the scarcer ivory. In color and lustre they are almost identical, which is why many museum catalogers guardedly describe an inlay as being of "ivory or bone."

Copper, a metal worked by the Haida long before the white man landed on his shores, has also been used for inlays, but infrequently. The only other metallic inlays are found on argillite pipes, and these are of lead or pewter introduced to the Haida by Europeans.

The following are the main inlay materials and the manner in which they have been used:

Abalone: Carved into thin rounds, ovals, squares or triangles for

inlays on dishes, and for eyes on designs on dishes, bowls and poles and other carvings. It is still used by some carvers.

Operculum: Inset whole at intervals on nineteenth century bowl rims. It is not used today.

Bone: Used in the last century for inlays on ship-type panel pipes, flutes or dishes, and for faces on figurines depicting white people. Also used as boat ornamentation on group figurines.

Ivory or tooth bone: Of nineteenth century use on ship-type panel pipes, mouthpieces of late elbow pipes; on bowl rims; for teeth on figures such as beaver, on bowls and poles; for inserts as nose-pieces and piercers on shaman figurines; for the faces of whites on figurines. Seldom used today.

Copper: To give a burnished look to an eye, or for buttons on a uniform. Used rarely.

Lead or pewter: For mouthpieces and stem designs on elbow pipes and flutes. Not used today.

To establish a chronology for early works is far from easy and only recently have serious attempts been made — both by American researchers. The first study was undertaken by Carole Natalie Kaufmann of the University of California, Los Angeles, as a doctoral thesis, published in 1969 under the title *Changes in Haida Indian Argillite Carvings 1820-1910.* Next came a comprehensive, penetrating study of pipes by Robin Kathleen Wright of Seattle in a 1977 thesis published in support of a master of arts degree from the University of Washington. She acknowledged the assistance of Bill Holm, curator of Northwest Coast Indian Art at the Thomas Burke Memorial Washington State Museum and professor of art history at the University of Washington, for sharing his collection of more than 500 slides of argillite pipes and his notes on their museum records.

The riddle of dating arises first from the fact that not until this century did carvers sign or date their works. Secondly, the acquisition records of museums, even of long-established ones in the United States, the British Isles and Europe, cannot be entirely accepted as chronological guides to a given type of carving's manufacture. Early specimens could have taken years to reach a museum. Their provenance, if stated at all, is often vague: "from the mouth of the Columbia River," "Stickeen," "Nootka Sound," indicating nothing more than the locality to which the carving had been traded.

The earlier the period, the more difficult the dating. However, from clues as fragile as a yellowed, handwritten label stuck to a carving, by tracing the movements of donors, and from isolated references to slate carvings in the journals of nineteenth century visitors to the Northwest Coast, it has been possible to build a chronology indicating when the majority of certain form types were made. When the unknown artists began custom-carving, producing works such as the panel pipes of European-American motif, one can assume that these reached the outside world quite quickly — certainly within a few years of their being manufactured.

The chronologies we offer here are based in part on the Kaufmann and Wright theses. In light of the discovery of percussion-flaking of argillite at the Tlell house excavation, and because of the lack of archaeological investigation at ancient village sites on Skide-

gate Inlet close to the Slatechuck itself, we have left the starting dates for several form types open-ended. In one or two instances we have allowed considerable latitude in approximate starting and finishing dates, mainly on the basis of data from European museums. We have included all pipes of the elbow type in a single form category, from the Tlell pipe to the ornate bird-figure elbow pipes, separating only the late trade pipe.

PIPES: Estimated periods of main form types

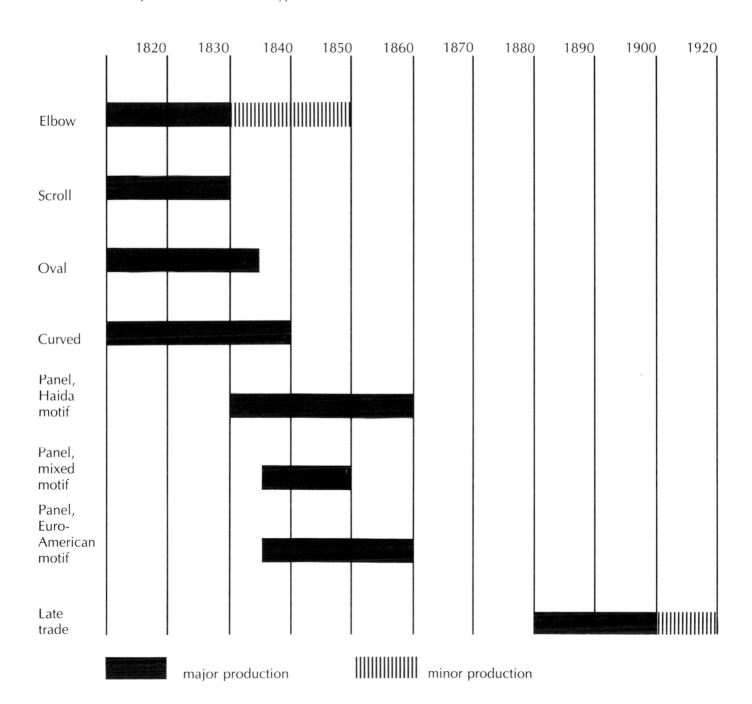

OTHER ARGILLITE CARVINGS: Estimated periods of main form types

	1820	1830	1840	1850	1860	1870
Amulets & labrets						
Bowls						
Boxes						
Figurines: Euro-American singles						
Haida singles						
Groups						
Free-form						
Medallions						
Plates & platters: Euro-American, mixed motifs						
Haida motif						
Poles: House post type						
Multiple-figure						
Double-figure						
Single-figure						
Recorders						

major production

156

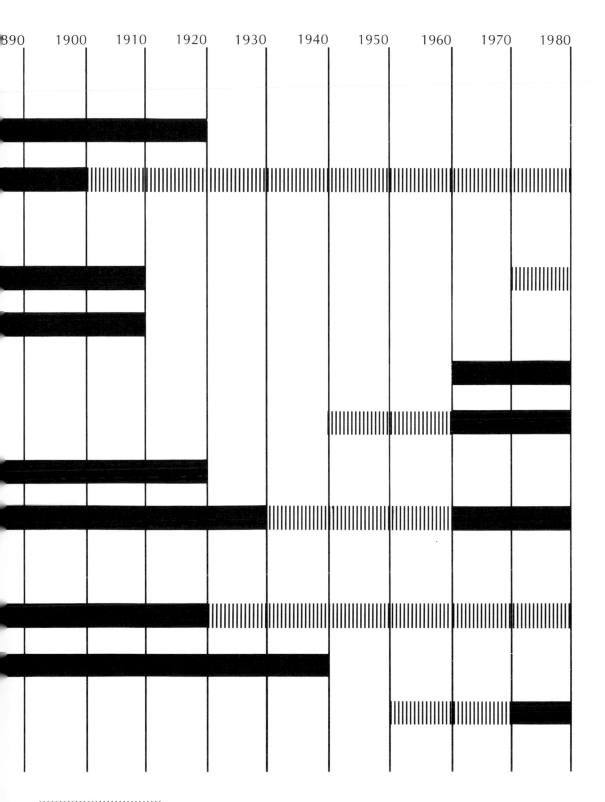

|||||||||||||||||||||||||| minor production

An old and very beautiful oval pipe representing shark, its fin breaking the inner space. Gill slits on cheeks, and closed-eyed human face on forehead. From the Bragge collection. Museum No. D.e. 15. About 8 cm. in diameter, 3 cm. thick.

— *British Museum*

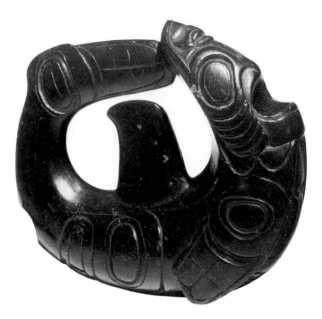

An early pipe in clamshell form, the foot carved as an animal head. Bowl opening at the valve. Museum No. D.e. 17, from the Bragge collection. Length 9 cm., thickness 2¾ cm.

— *British Museum*

The traditional carver lavished his craftsmanship on argillite pieces within several major categories — pipes, plates and platters, figurines, poles, and so on. And since the pipe is the earliest specimen of his art known to us today in any significant quantity, it seems only proper that attention first be given to the varieties of this ubiquitous object.

Nothing is simple when it comes to argillite pipes. Like a creature from Haida legend, one form changes into another, losing some characteristics and gaining others in the process. The oval pipe, the elbow pipe and the panel pipe are first cousins in different guises. All are known to have existed in the first part of the nineteenth century. All were capable of being smoked in one fashion or another, except of course, those panel pipes which are mere panels and were never drilled to provide a passage for smoke.

The oval pipe, in its most clearly defined form, is similar to the European pipe called a "nosewarmer," and would have been equally effective as a handwarmer since it fits snugly into a cupped hand. Being stubby, it did not require much drilling. The carving envelopes most of the bowl and these early oval pipes, so called because of their profiles, are not at all common. A few delightful examples come in the form of clam or cockle shells and at first glance look rather like fossils. They may well be illustrations of a legend of the birth of Haida people by Raven out of clam. Others, thicker but still less than eight centimetres long, depict an animal curled up, or two or three creatures interlocked. So small are their bowls and stems that very little tobacco could have been inserted for smoking. The Tlingit, the only other Pacific Northwest Coast people who cultivated the native tobacco, also made oval pipes, but of wood.

By contrast, the elbow pipe is identified by a long, straight stem not incorporated into the ornamental carving, with the bowl extended upward from one end. Perhaps the earliest type is the Tlell pipe, bearing a round face that also appears on many prehistoric images in stone.

20.
A century of pipes

One of the earliest pipe types — the billet-head scroll, acquired by the museum in 1824. Museum No. IV B 62. Length 9 cm., depth 6 cm.
— *Museum für Völkerkunde, Berlin*

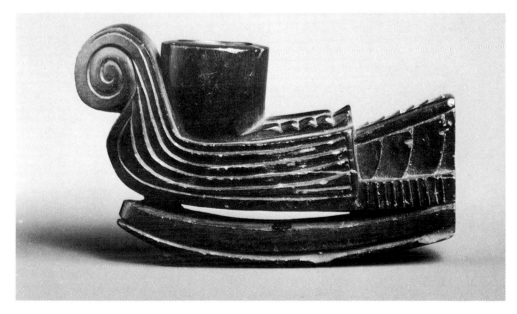

Another very early variety of elbow pipe, more a pipehead than a full pipe, has been called the billet-head scroll type. It is said to have been derived from a sailing ship's head, though the scroll could also have been a Haida design derived from nature — the young fronds of fern, fosil patterns, snail shells.

In the early elbow pipes there is an elusive "division" between those that appear to have had a functional purpose and those seemingly made for ceremonial use. In its most practical form, the elbow pipe took on a distinct European-American look. In these much more common examples, the stem is long and the bowl is carved as a human head, face thrust forward, a "modern" face reminiscent of ships' figureheads or maybe even actual portraiture.

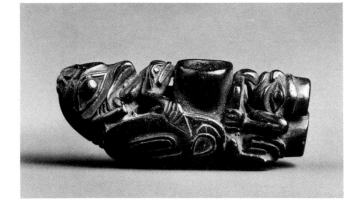

Another early pipe, acquired by the museum in 1839. Animal head with wings, frog in mouth, and human figure with tongue extended, between bowl and stem. Museum No. IV B 99. Length 8 cm., depth 3.5 cm.
— *Museum für Völkerkunde, Berlin*

A simple elbow pipe, with tobacco leaf and scroll designs on the bowl. Museum No. VK 635.
— *National Museum of Finland, Helsinki*

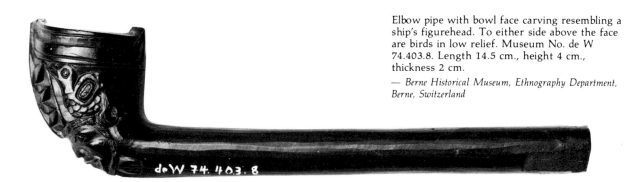

Elbow pipe with bowl face carving resembling a ship's figurehead. To either side above the face are birds in low relief. Museum No. de W 74.403.8. Length 14.5 cm., height 4 cm., thickness 2 cm.
— *Berne Historical Museum, Ethnography Department, Berne, Switzerland*

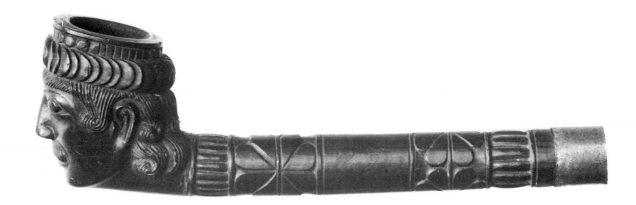

In pipes of a more ceremonial form, the innovative carver seemed not content with a mere decorated bowl and plain stem. He balanced figures on top of the pipestem, sometimes spanning them almost from mouthpiece to bowl, and he added figures in counterpoint to the upright bowl. A goose or heron perches calmly on a stem. Raven may be backed against the bowl, facing a frog which is positioned close to the mouthpiece. A goose beak will be divided down the middle to its point of contact with the pipebowl, so that the view in profile is unimpaired from either side. Human figures appear in expressive attitudes. The carver was well aware that the long slender stem called for delicacy. His supplementary figures never overburden it.

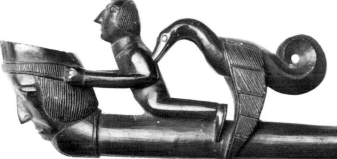

A fine example of an elbow pipe with the stem surmounted by figures. The bird here is split-headed. Museum No. de W. 74.403.6. Length 23.7 cm., height 4.2 cm., thickness 2.3 cm.
— *Berne Historical Museum, Ethnography Department, Berne, Switzerland*

Ornamental pipe unusual for its square bowl. Man holding tail of oystercatcher (?) which holds tobacco leaves in beak. Donor Mrs. Charles Harrison. Museum No. AA38. Length 29 cm.
— *Centennial Museum, Vancouver*

161

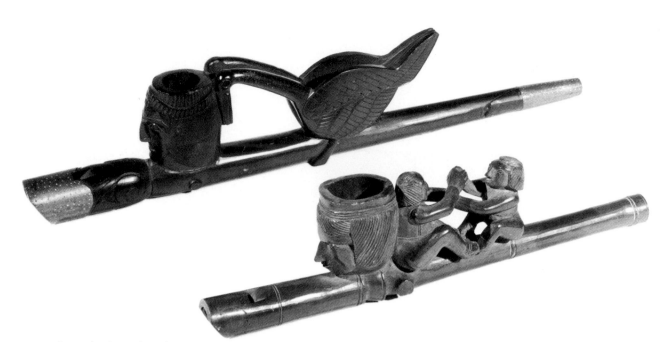

These rare pipes combine whistles and smoking-pipe elements. Pipe mouthpieces are at right and whistle holes toward left end on each. Bird in split design may be oystercatcher. Museum No. Q 72 Am 65 (top), length 26.25 cm., from the Bragge collection; No. 1911.4-6.153 (bottom), length 19 cm.

— *British Museum*

Marius Barbeau saw a similarity between bird-decorated pipes and wooden bird rattles.[1] On the rattles, however, only the bird's head and back are presented. With argillite elbow pipes, on the other hand, the birds are often complete, with their legs and feet planted firmly on the stem, and are an integral part of the total carving.

In economy of design and in proportioning, the best elbow pipes from the early period are of a high order artistically. They invite one to hold and admire them, as do the panel pipes.

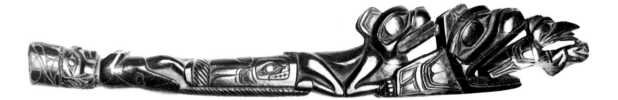

A delicate, beautifully-carved panel pipe with many open areas. Museum No. S.719. Christy collection. Length 47 cm., height 12 cm.

— *British Museum*

This one-level-carving pipe is tending toward the curved form. Note extraordinary dress on man at mouthpiece end. Museum No. 1978.467. Length 33 cm.

— *Perth Museum and Art Gallery, Perth, Scotland. John Watt Photo*

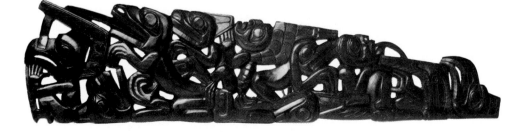

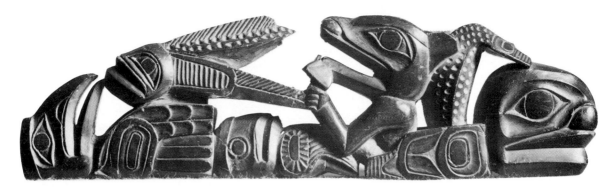

Five-figure panel pipe of Haida motif. From left:
Raven, dragonfly, owl? at center baseline, bear,
and whale with tail curving up to touch head. A
strong carving style. Museum No. 38631. Length
17.5 cm., height 5 cm., thickness 1.7 cm.
— *Ethnographical Museum, University of Oslo*

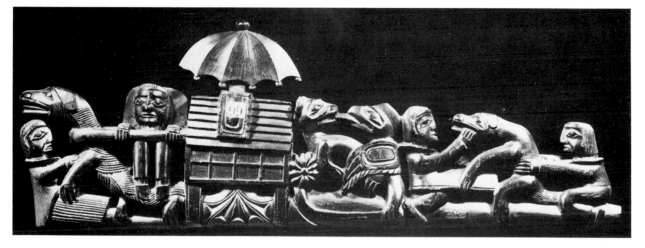

Predominantly a ship-type or European-
American type panel pipe, first presented to a
museum in 1855. Museum No. 49.208. Length
29 cm.
— *University Museum of Archaeology and Anthropology,
Cambridge, England*

Panel pipe combining Haida and European-
American motifs. Four men with two dog-like
animals and tongue-linked bear-like animal and
eagle. The umbrella seems incongruous, but
viewed upside down the pointed double-curve
design of Haida tradition appears in the ribbing.
Museum No. 99H. Length 35 cm., height 12 cm.
— *Anthropological Museum, University of Aberdeen*

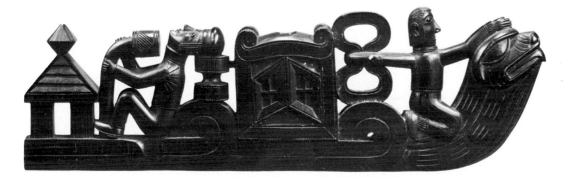

As with the rare musical recorder in argillite, the mouthpieces of elbow pipes were sometimes made of lead or pewter which the Haida could obtain from shipwrights and bosuns. Some have bone tips and the odd pipebowl has a copper liner. Occasionally, lead inlays appear on the stems in indefinite patterns suggesting that the metal may have been used as a strengthener, if not actually to mend breaks in the slate.

Finally, the late trade pipe must be mentioned. Here the carver heavily embellished the pipehead with crest and legend figures. Often he chose companion figures — Raven and Killer Whale, Bear and Man, twining neatly around or behind the bowl. Multi-figure elbow pipes of this kind closely resemble three-dimensional group figurines, just as some elbow pipes wander off into the panel form.

The late trade pipe of argillite can be an object of great charm, effective and vigorous in its portrayal of legends. Because it is bulkier than both the earlier elbow pipe and the panel pipe, it is sometimes considered less artistic. However, there was a good reason for heavier construction. These pipes were made for a souvenir-buying public that entered the Pacific Northwest after the completion of the transcontinental railways and the start of regular steamer service to Alaska and the northern coast of British Columbia, and consequently had to be strong enough to withstand the rigors of luggage loadings and unloadings. They stood up remarkably well. An examination of the argillite pipes in museums readily shows that the late trade pipes suffered less from chipping and breakage than their more delicate predecessors.

A well-balanced group of figures on a trade pipe, portraying the doctoring of a seal or sea lion by raven, a shaman and a Haida woman. Raven and the shaman, heads up and mouths open, appear to be chanting over seal, whose eyes are closed. The pipe bowl is in the woman's head. Museum No. 1954 W. Am 5 1019. Length 28 cm., height 7.75 cm. Wellcome collection.

— *British Museum*

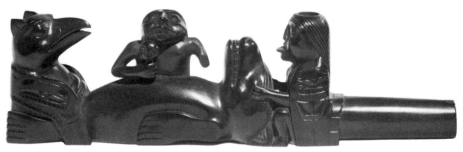

Late trade pipe, probably from 1880 to 1900. Haida portrait head. Stem figures depicting a legend and including sharkwoman and bear on top, and shaman and frog beneath. This pipe was obtained by the museums from Norwich Museum in 1956. Museums No. 56.25.644. Length 24 cm., height 7.5 cm.

— *Merseyside County Museums, Liverpool*

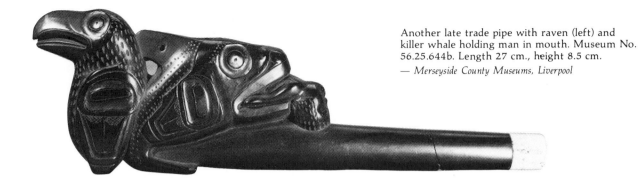

Another late trade pipe with raven (left) and killer whale holding man in mouth. Museum No. 56.25.644b. Length 27 cm., height 8.5 cm.

— *Merseyside County Museums, Liverpool*

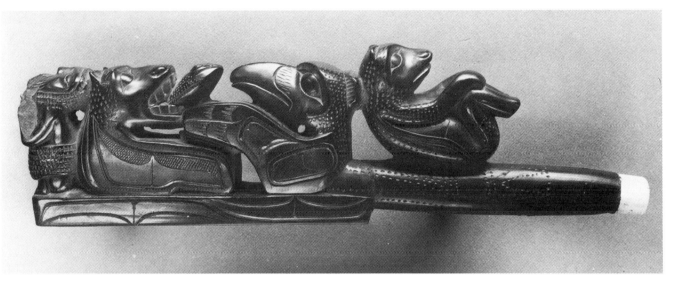

In this late trade pipe, stippling, dashing and hatching give textured effect, especially in the Haida bark skirt at extreme left. Bear facing raven holds a frog in his mouth, and another bear balances on pipestem. Museum No. 39.27.1. Collected 1910. Length 31 cm., height 8 cm., thickness 3 cm.

— *Musée de l'Homme, Paris*

The technique of hewing any of these marvellous pipes from raw slate calls for great skill and patience. The craftsman starts with a rough block of argillite. On this he marks the outline of the pipe he intends to make and then saws to form a "pipe blank." The piece is usually drilled at this stage, so that little work would be lost if the stone were to split during the operation. After drilling, the pipe is shaped with files, rasps and knives, and sanded smooth.

George Catlin's description of how the Minnesota pipestone was worked may provide a further clue to the Haida method. Catlin found that the American Indian craftsman shaped the bowl from solid stone using nothing but a knife, then made the hole for the bowl by drilling with a hard stick trimmed to the desired size, along with a quantity of sharp sand and water kept constantly in the hole. This involved, he noted, "a very great labor and the necessity of much patience."[2]

Patience, in the timelessness of early Haida life, would scarcely have been a problem. It was the art that mattered. Even so, in our clock-driven society we must imagine that it took a carver many long hours to make an elbow pipe. That masterwork, the panel pipe, could well have taken weeks. Slips were made now and then.

The British Columbia Provincial Museum has one piece apparently damaged in manufacture. A close examination indicates that during the sculpting, the carver's blade struck too near the underlying pipe tunnel and took a slice out of the wall.

Most examples of argillite pipes in museums show no signs of charring or discoloration from having been smoked, which may have led Wilson Duff to declare panel pipes "unsmokeable."[3] Yet there seems little doubt that, with or without liners, they could withstand the heat of lighted tobacco.

In a thermal analysis conducted for the authors in 1978 by Dr. Martin Hocking, associate professor in the University of Victoria Chemistry Department, argillite samples were heated for twenty-four hours at four different temperatures ranging up to 610 degrees Centigrade (1130 degrees Fahrenheit) which corresponds to what ceramicists call a dull red heat. The samples tested at 100°, 280° and 380°C. resisted thermal decomposition very well, Hocking observed. The sample subjected to the peak 610°C. test changed color, turning from black or dark slate gray to a pale beige throughout. But to his surprise, this sample was still well consolidated and sound. It could not be broken readily and had not gone to a friable powder as he anticipated it might. Since aluminum melts at only a slightly higher temperature, and potters' kilns are normally fired at between 720° and 800°C., Hocking felt confident that the highest temperature applied in the test would be equal to or greater than the heat an argillite pipe would be subjected to in smoking. "I would say that this material would stand up to the rigors of smoking quite adequately," he summed up.[4]

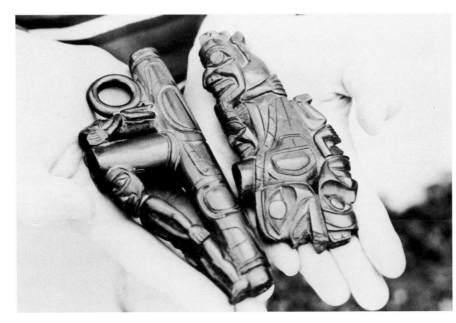

The pipes Richard Holway finds "very satisfying to smoke".
— *Richard Holway*

Many of the simpler argillite pipes, such as pipeheads, which are fairly common in the early repertory, could have been smoked by inserting a reed of bone or wood. Indeed, we know of two antique pipes that are almost in the panel form, both of which have been used for smoking. In 1978, a Californian, Richard Holway, sent us

photographs of his argillite pipes, which he smoked regularly. He had this to say:

> Those Indians sure knew about oral gratification. My two pipes are carved so as to be very interesting in the mouth. The general idea is a protruding part with another part to brace the lips against. The ones I have are more complicated and interesting to the mouth, but that is the basic idea. They are very satisfying to smoke, more so than English pipes, though you have to hold onto them while you smoke.

Whether the very long, Haida-motif panel pipes that have complete passages were used for smoking is debatable. The custom-made panel pipes of European-American motif probably were not smoked. Although we can assume the panel pipe of Haida motif played a role in shamanism, its specific use is unknown. But there is one indication that pipes which had been used for smoking were in demand among fastidious collectors early in this century. In 1907, C.F. Newcombe, writing from Victoria, tipped George T. Emmons to the existence of an old Haida pipe that might be for sale. Emmons, a knowledgeable collector, replied: "If (the slate pipe) is an old piece and particularly if it has been in use as a pipe I would like to have it . . ."[5]

The pipes, of whatever variety, marked a full flowering of argillite art. Once the form had been established, it blossomed into virtuosity. The Haida artist had to demonstrate palpably to everyone just how brilliant he could be in the use of his peculiar resource and devoted all his prodigious talents to this end. Luckily, as we have already seen, his creations — already respected among other native peoples — became increasingly marketable as the white man moved into his territory. Slate pipes began to show up at the first white distribution centers — Hudson's Bay Company forts. Company traders and visiting officials picked them up. Many early pipes existing today in museums in Scotland and England can be traced to men who served the company in the Northwest from 1820 to 1860. Explorers and adventurers, like the artist Paul Kane, were guests of the Hudson's Bay Company on their travels, usually having no-where else to stay but at the company posts. Here they encountered Haida pipes. At Fort Vancouver, scholar Robin Wright tells us, a small museum was actually maintained in the Bachelors' Hall which probably contained a variety of the Haida slate pipes.[6]

The early Haida pipe is a wonderful union of the practical and the beautiful. Above all, it has an air of gaiety. The little men astride the pipestems appear to be in high spirits, jaunty, outward-looking. They seem to be trying to glimpse new ships on the horizon, new ideas to comprehend. They appear to be eagerly awaiting whatever the next day brings.

The prime time of argillite pipe-making, from 1820 to 1850, reflects self-confidence above all else. The Haida was still in control of his land, master of his destiny. How could he know in 1850 that in a few years his whole world would crumble, his ceremonials fade, his treasury of legends be largely forgotten? Yet that is what happened. By 1865 at the very latest, the great era of the argillite pipe had passed.

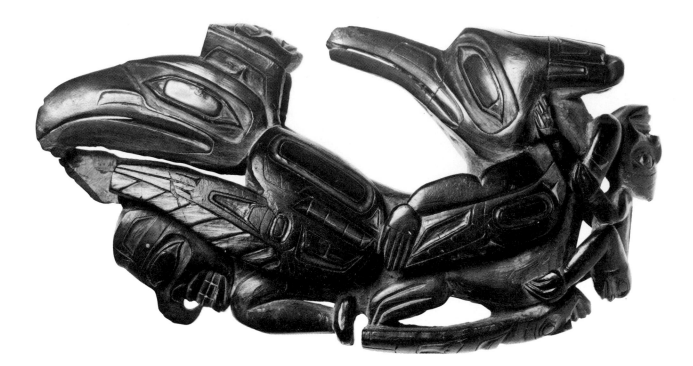

This is midway between the oval and panel form.
Raven at left with thunderbird on chest, with a
face looking up between open ears; kingfisher-
like bird at right above tail, facing back of raven's
head. Museum No. IV A 8116. Length 16 cm.,
depth 8 cm.

— *Museum für Völkerkunde, Berlin*

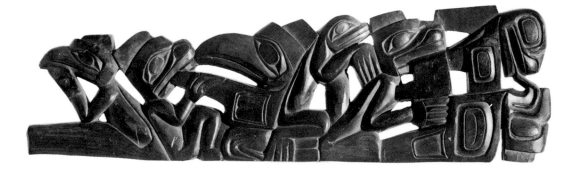

A panel pipe of Haida motif, at its simplest,
acquired by the museums in 1867. Museums No.
Mayer 4466. Length 30 cm., height 9 cm.

— *Merseyside County Museums, Liverpool*

There are three varieties of panel pipes insofar as subject matter is concerned — (1) those of Haida motif, (2) the so-called "ship-type" which draws its imagery from European and American visitors to the Queen Charlotte Islands, and (3) those in which the artist mixed elements of both motifs. The two main classifications stand as historical markers. One is pure Haida image-making. The other shows us, more than anything else created in argillite, a sudden recognition of strangers and their "wonderful" machines and subconsciously, an awareness of the changes they would impose on Haida life.

The panel pipes of Haida motif are the most complex, enigmatic works in the entire argillite repertory. Structurally, they appear to have evolved from the oval pipe. Each is a circle, or oval, of change, with one figure following another in orderly, artistic sequence. The oval pipe has few figures, the panel pipe many. It would be a tidy theory to suggest that the complex panel pipe of Haida motif is an elongated, much more elaborate version of the simpler oval pipe. Yet there is something else in Haida art, not connected with smoking, which the panel pipe resembles much more closely, and that is the curved, carved handle of a horn spoon. Both are black, both have similar carving. Both could have their origins in some ceremonial function since both have a ceremonial ornateness. Both are profound artistic expressions. They do not represent things as seen, but rather symbols of the supernatural.

21.
Panel pipes
of Haida motif

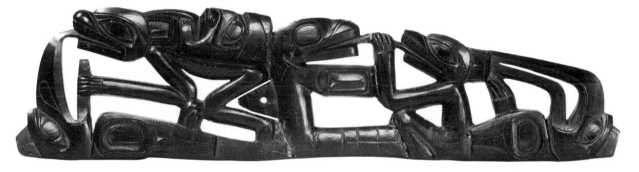

A particular sub-style of the early panel pipe is in a curved, rather than trapezoidal shape of the full-blown panel pipe. It curves upward at the ends and the figures are usually on a single plane. These pipes are thirty to forty centimeters long and carved their full length, with bigger bowls than most panel pipes. Viewed from one end, the body on these pipes is round or oval, not flat and parallel as in the true panel pipe.

These curved pipes show up fairly frequently in European collections. Their shape is reminiscent of Tlingit tusk-carvings and, indeed, of "soul-catchers" made of bone or ivory which were used by shamans among various North Coast peoples, including the Haida. Several examples have a whale with another creature in its mouth at one end, and what appears to be a prominent Haida personality at the other end.

Whatever their origin, the panel pipes of Haida motif are the ultimate creations in argillite. The classical examples are trapezoidal in shape and up to fifty centimeters long. As many as fifteen figures

Another one-level panel pipe in trapezoidal shape, with many wide open areas. The flowing lines give the impression of movement. Museum No. 91.350. Length 39 cm.
— *Staatliches Museum für Völkerkunde, Munich*

coil and overcoil in ravishing tracery, perfectly proportioned. Many of these figures are in transformation and according to whatever legend is involved, turn from bird or animal form into human likeness and back again, with tongues as the primary links that cause one figure to "flow" into another. The tongue, as we have seen, may have had significance as a medium of transformation while long, curving fingers and flippers reiterate this sense of change. Crests such as dragonfly, which disappear from later argillite, convey the richness of symbolism in this early period.

The open-work gives the panel pipe an ephemeral quality. Ratios of space to mass are carefully observed. Sureness of hand makes the whole harmonious, lucid and "right."

Interesting detail in this panel pipe — lines merging and extending. Museum No. 56.6.61. Length 35 cm., height 9.5 cm.

— *The Brooklyn Museum. Gift of A. & P. Peralta-Ramos*

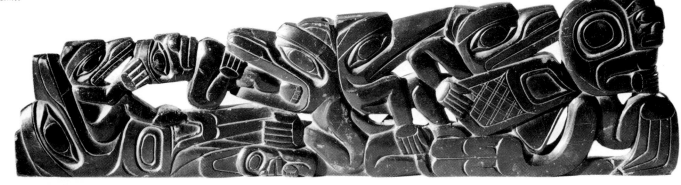

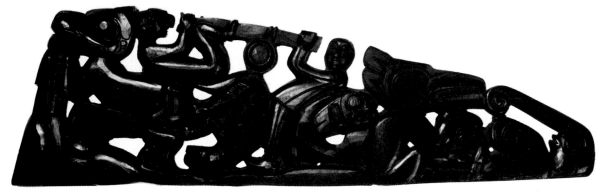

A beautiful panel pipe which is clearly a story depiction. The motifs are Haida except for the white mariner at center. Several of the figures are found only in very early panel pipes. The carving was obtained in Sitka, and given to the Museum der Estlandischen Literarischen Gesellschaft in Reval at the end of the 19th Century. Length 30 cm., height 9 cm.

— *Institut für Völkerkunde, University of Göttingen*

Holding one of these pipes and looking at the intertwining figures, one can easily overlook the underlying pipe component. Usually, a small mouthpiece outlet can be seen at one end of the base, often at the tapered end, and a bowl somewhere along the top ridge, its rim flush with the crown of an animal head. In some of even the thinnest, most intricately-carved panel pipes, the concealed pipe passage will be complete. Others, however, are strictly panels, without the inner pipe.

An exceptionally fine panel pipe from the James Hooper collection (see illustration) was sold in 1976 at Christie's in London to the National Museum of Man at Ottawa. The anonymous carver would probably have spent four or five weeks, working of necessity by natural light only, crafting this masterpiece. Typically, there is no central figure, although bears predominate numerically. It may tell a legend, or it may be a pure abstraction — a two-level parade of those symbols the carver wished to memorialize.

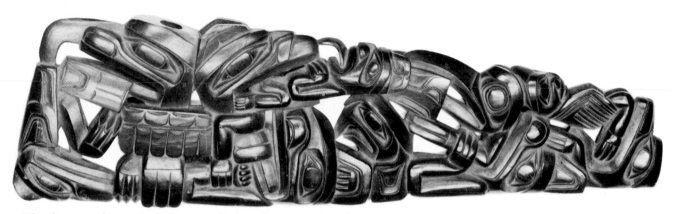

The figures, from the left, are whale at bottom, (head down) with fin and human-type arm and hand; thunderbird at top, facing left, pipehole in head, with six wing feathers above and three tail feathers below them, and claws to the left of the tail feathers. At the top left, back-to-back with thunderbird and facing right is a bear with a bear-human in his mouth; below is a bear of more human features, closely linked with the top-row bear. At the center bottom facing left is hawk with his tail in the mouth of raven, top right. Raven is partly in the mouth of another bear, the second-to-last figure at the bottom right, an unusual configuration. Above this raven-consuming bear is a small, human-type winged figure which may be raven changing into a human being. Finally, at the stem end, is whale, possibly Whale that swallowed Raven. Throughout, there are "throwers," or transformation devices such as odd-shaped noses and tails. Only the unknown carver could explain the meaning of each part of this ingenious work.

The National Museum of Man at Ottawa acquired this superb panel pipe for £3,800. It was originally collected by Charles Beardmore of the Hudson's Bay Company at Fort Rupert in 1848-52. Length 35.5 cm..

Panel pipe of oblong instead of tapered silhouette. Two ravens face the central figure of a chief wearing frontlet-type headdress. Note too that the raven legs end in faces. Raven with human body at left end, bear at right end. From a collection made by J. G. Schwarz. Museum No. 11956. Length 23 cm., height 10.5 cm., thickness 3 cm.

— *Museum für Völkerkunde, Vienna*

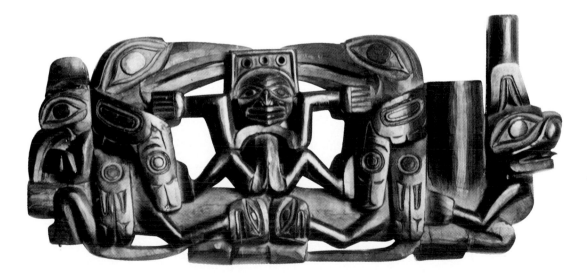

Identifying individual figures on panel pipes of Haida motif does little to solve the mystery of exactly why the pipes were produced. Thomas Deasy's statement that Indian doctors held them in their hands while dancing seems reasonable and support for his statement can be found in museum records. The National Museum of Man at Ottawa, in an old handwritten ledger where its earliest argillite accessions are listed, has this description of a Haida-motif panel pipe collected by Andrew Aaronson of Victoria: "Stone Wand of Doctor." The entry date is 1879.

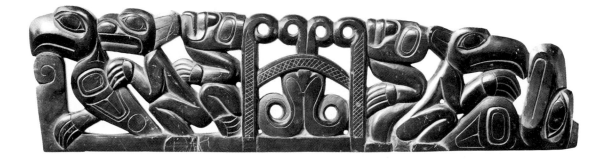

From left, eagle, bear, man, central panel, man, half man half eagle, thunderbird. Two very small holes, one at base of tapered end and other at top center. Museum No. de W 74.403.2. Length 43 cm., height 11.1 cm., thickness 1.5 cm.
— *Berne Historical Museum, Ethnography Department, Berne, Switzerland*

Panel pipes of Haida motif reached the outside world both before and after those two cataclysmic events that spelled the end of shamanism — the smallpox epidemic and the arrival of the missionary. Quite possibly some pipes were gifts to whites or to leaders of other Northwest Coast native peoples. Some may have been stolen and disposed of clandestinely. It seems unlikely that any substantial number of them would have been custom-made for whites, as the panel pipes of ship-type motif clearly were. Indeed, the European-American or ship-type panel pipe may well have been produced in response to a demand that no self-respecting carver would deign to fulfill by providing a "true" panel pipe.

Today, the will-o'-the-wisp panel pipe of Haida motif remains a magical thing, a mystical dreaming in slate. Its beauty is unearthly, as though a recording angel was telling us, dispassionately and lucidly, what Haida vision was really like in the distant past. The pipes seem to be less intentional works of art and more expressions of a state of mind. They bring to mind the words of anthropologist Claude Lévi-Strauss:

> The sculptor of Alaska and British Columbia is not only the sorcerer who confers upon the supernatural a visible form but also the inspired creator, the interpreter who translates into eternal chefs d'oeuvre the fugitive emotions of man.[1]

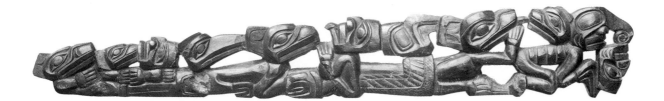

A beautiful single-level panel pipe, received in 1868 from the Smithsonian Institution and previously collected by the American government's Wilkes Expedition 1838-41. Museum No. H.c. 1379. Length 41.5 cm., maximum height 6.5 cm., thickness 1.7 cm.

— *Department of Ethnography, The National Museum of Denmark*

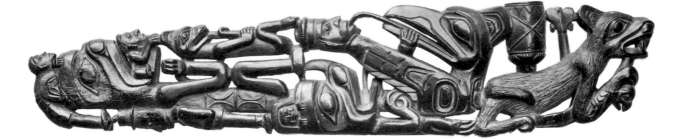

Surely one of the finest panel pipes in existence, the figures integrated ingeniously, and superbly carved. See the close detailing in claws, face in ear at bottom. The pipe stem running from the obvious bowl at right to the left end is all but totally concealed. Wolf at the right end, and snag, with his spike as a nose horn, at lower center. Haida and European-American motifs. Museum No. H.c.601b, entered in 1877. Length 32 cm., height 6.5 cm., thickness at pipe bowl 2 cm.

— *Department of Ethnography, The National Museum of Denmark*

Gently-curving panel pipe with the principal figures looking up from one level. Whale is at left end with seal? in mouth. Museum No. 37.58.2. Length 34 cm., height 5.5 cm., thickness 3 cm.

— *Musée de l'Homme, Paris*

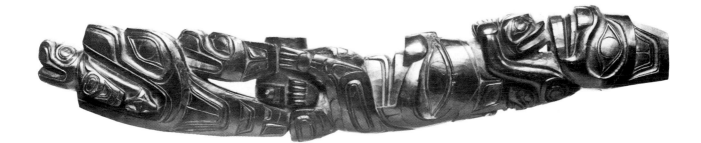

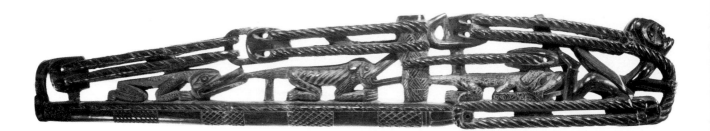

A daring undertaking in argillite, this is a prime example of the block-and-tackle-motif panel pipe, with contorted figure caught in tackle at right end, and three different animals on pipe base. Pipe bowl is in the stanchion. Museum No. Q72.Am63. The original registration number was 37.4-8.1, indicating it was accessioned in 1837. Length 43.5 cm., height 8 cm.
— *British Museum*

Panel pipe of the block-and-tackle variety, drawn from mechanics and nature. Besides roping, screwheads and impressions of a metal strap and ship's grating, there are native leaf designs and familiar U shape. Pipe stem runs through center horizontally. Museum No. H.c.225. Length 31 cm., maximum height 6 cm., thickness 2 cm.
— *Department of Ethnography, The National Museum of Denmark*

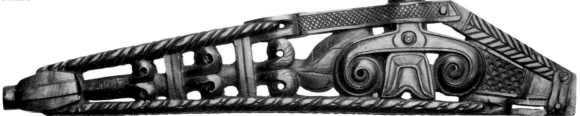

This long, thin panel pipe is unusual for the number of its designs borrowed probably from British trade goods or illustrated magazines. The serpent is almost identical to engravings on the locks of Hudson's Bay Company muskets. The oak leaves, lily, thistle and Tudor rose are all part of British floral heraldic design. One of the two recumbent men is smoking a pipe. Museum No. D.e. 22, from the Bragge collection, collected by Captain Sir Edward Belcher in the 1830s. Length 45 cm., height 6.5 cm.
— *British Museum*

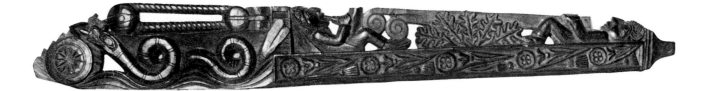

The panel pipe of European-American motif, also called the ship-type, is shaped like the panel pipe of Haida motif but represents a totally different kind of image-making. The genre is unique in Northwest Coast native art. In fact, its like does not exist anywhere else in North American native art. Daringly, the slate artist broke out of his cultural bonds to depict his white "guests" en masse. He encapsulated in argillite the American and British sailors of the mid-1800s and their ships. Impressed by the white man's posture and dress, he reproduced them faithfully — ships' masters in their top hats, officers in their frock coats and Wellington boots, seamen in their short jackets and tight trousers. It was a brilliant innovation that delighted both artist and subject.

By 1820 the Haida were being allowed a good look at what went on aboard barks and frigates. They were taken aboard and could sit around the decks for hours on end, smoking, conversing with crewmen, exchanging souvenirs. The artist made a mental note of what he saw and later translated those sights into both slate and wooden panel pipes, though slate was the preferred medium.

He needed a good memory, but more especially, acute powers of observation. William Fraser Tolmie of the Hudson's Bay Company once commented: "The Indians, keen observers of men as they are, (know) white men better than white men know them, because white men do not take the same trouble to study Indians that they take to study us . . ."[1] Image-making was a serious business, but in the ship-type panel pipe, the slate artist not only dared to depict the visitor but also did it in a lively, humorous way. The uniqueness of the venture and the spirit in which it was done, could only have come from a people who regarded themselves as equals or superiors of the white man.

One category of ship panel pipe seems to reflect Haida fascination with the operation of ships' tackle. The mechanism, after all, was much to be prized. Its weight-lifting capability had been demonstrated onshore occasionally, when a ship's company would help villagers to raise a great cedar totem pole. Blocks and tackle stretch from one end of the panel to the other and sometimes animal figures such as grizzly bear flatten out beneath the roping, almost crushed by it. In a few of these panels, a man is shown with his back arched, as though he is caught in the running gear. These may be remembrances of accidents in which the unleashed power of the mechanism etched itself unforgettably into the carver's mind.

22.
Panel pipes of European-American motif

Thick-stemmed block and tackle panel pipe. Museum No. 1891.91. Length 27 cm., height 4.9 cm.

— *University Museum of Archaeology and Anthropology, Cambridge, England*

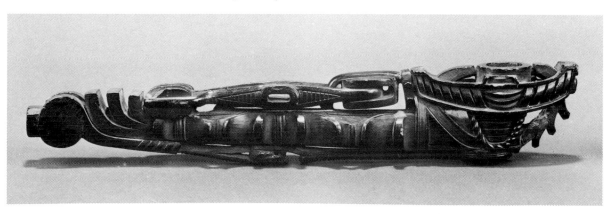

The friendlier and more familiar populated-deck panel pipe is vigorous, full of good humor, and may now and then be poking fun at its subjects. Energetic little European and American men in maritime dress of the nineteenth century are positioned along a deck, accompanied sometimes by dogs, horses and other animals. Certain other features recur in these panel pipes — windowed squares which have been likened to deck houses, cabins or stern galleries, and prows ending in billet-head scrolls. The over-all impression is one of intense shipboard activity. A sense of movement is conveyed in realistic action stances. One man holds a telescope in front of his eyes. Another opens a chest. One mariner grabs another by the neck, probably a depiction of sailors skylarking.

Panel pipe of European-American motif, with so-called "deckhouse" and figures of uniformed mariners. Museum No. 54.106.82. Length 39.5 cm., height 14.1 cm.
— *Merseyside County Museums, Liverpool*

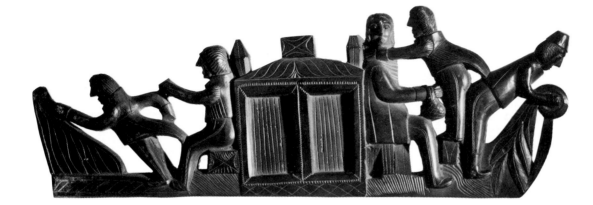

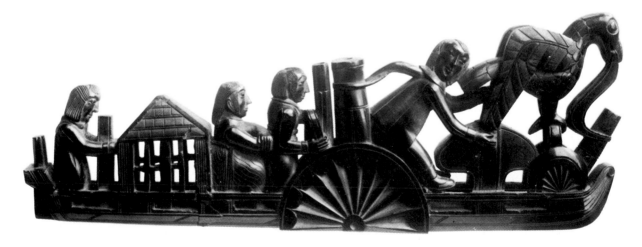

European-American, or ship-type, panel pipe. The tapering outline conforms to the trapezoidal panel pipe shape. Elegant crafting for the half wheels and the five major figures. The carving arrived in the museum in 1868. Museum No. VK 857. Length 37.3 cm., height 13.2 cm.
— *National Museum of Finland, Helsinki*

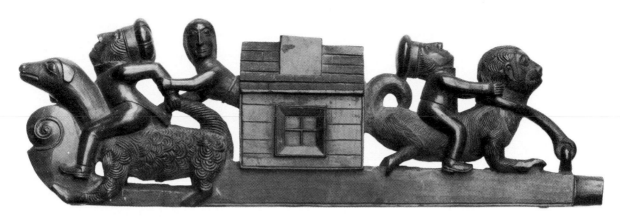

A panel pipe of men in Russian-type dress riding animals, one of the men being seized by a woman leaning from house. This work was acquired in 1853 from a man in Helsinki who had spent years in Russian America, and was probably procured in Sitka. Museum No. H.c. 240. Length 21.5 cm., height 7 cm., thickness 2.2 cm.

— *Department of Ethnography, The National Museum of Denmark*

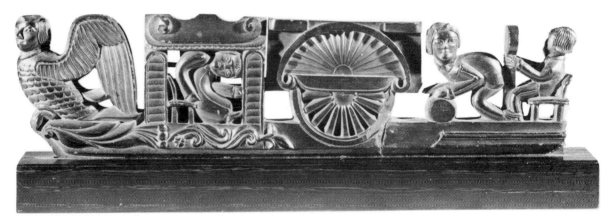

An unusual, intricate panel. Length 32.2 cm., height 11.1 cm. Gift of Arthur Wiesenberger, 1953 (1834.1)

— *Honolulu Academy of Arts, Honolulu*

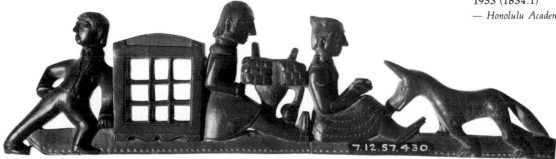

Deckhouse with pierced windows; cradle acts as pipe chimney, between seated man and woman. Dog at right. Collected by a Royal Navy captain and donated 1857. Museum No. 7.12.57.430. Length 28.2 cm., height 7.9 cm.

— *Merseyside County Museums, Liverpool*

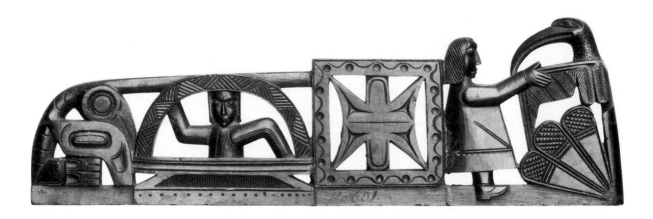

A panel noteworthy for its geometric designing and proportioning. Most geometric designs are static, but here the men and birds bring the carving to life. Museum No. H.c. 601a. Length 32 cm., maximum height 10.2 cm., thickness 1.4 cm. Inscription HAW at base.

— *Department of Ethnography, The National Museum of Denmark*

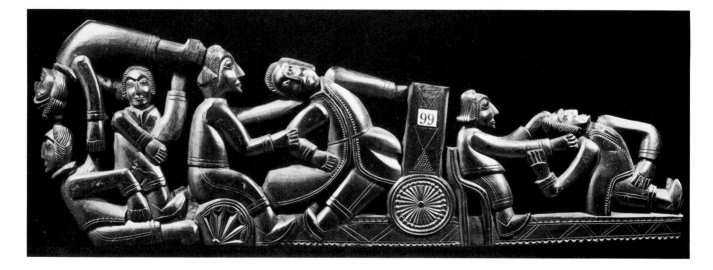

Panel pipe ship-type. Exceptionally animated, full of dramatic movement, this could be a parody of games sailors indulged in during idle hours. Note pod-like boots. Museum No. 99E. Length 36 cm., height 13 cm.

— *Anthropological Museum, University of Aberdeen*

In many of these frieze-like scenes, however, the men do not seem to be performing any practical act of seamanship. They are not hauling anchors, securing ropes around bollards, or mending sails. This bizarre aspect has two possible explanations. First, the actual mechanics of ship operation may have eluded the Haida artist (if not Haida pilots) in the same way that seeing spacemen walking on the moon with their rock-gathering equipment would confound us had we not been told beforehand exactly what they were doing and using. The second possibility, and the more likely one, is that these canoe experts understood perfectly well what was going on, but thought it all rather a waste of energy. "You really are very funny people," the carver of the ship-type panel pipe seems to be saying. "You do so many unnecessary things aboard your ships!"

An excellent example of the ship panel pipe belongs to the Anthropological Museum of the University of Aberdeen, Scotland. It incorporates features that show up in many other examples — cabins or deckhouses, their windows in this instance framed in ivory with actual glass inset, a funnel which is also the pipebowl, and the hull complete with strutted keel and planking.

Panel pipe of European-American motif distinguished by the use of ivory or bone inlays for mariners' heads, "deckhouse" and bulwark. Museum No. 1954 W Am5 999, Wellcome collection. Length 34.5 cm., height 10.5 cm.
— *British Museum*

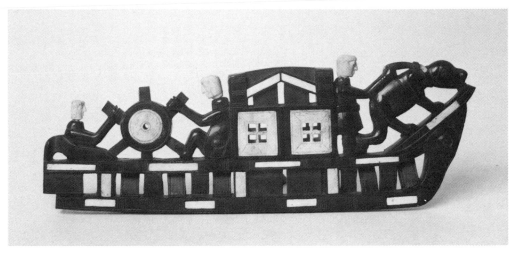

Two other features tell us that this is not just any ship, rather it is the Hudson's Bay Company side-paddle steamer the *Beaver*, the first, and for sixteen years the only, paddlewheel steamer on the Northwest Coast. The paddlewheel is represented by the ivory-inlaid spoked wheel. And to leave absolutely no doubt as to the vessel's identity, the artist carved a stylized beaver, stick in mouth, for a figurehead. The real *Beaver*, 100 feet long and 109 tons burden, went into service in 1836, based at Victoria. Churning through coastal waters and belching smoke, she was a source of astonishment and amusement for native peoples up and down the coast for years after her arrival.[2] She would have endeared herself to those Haida who owned the beaver crest and she probably inspired other models in argillite besides this one.

This ship-type panel pipe is apparently a model of the Hudson's Bay Company side-paddlewheel steamer, the *Beaver*. Note representation of beaver as bow figure. Ivory and glass inlays. Museum No. 101. Presented by Captain William Mitchell who at one time was skipper of the *Beaver*. Length 40 cm., height 12 cm.
— *Anthropological Museum, University of Aberdeen*

Drawing of the S.S. *Beaver* by H. P. Eldridge.
— *Provincial Archives, Victoria, B.C.*

Master mariner Captain William Mitchell (1802-1876) who pre-
sented this panel pipe to Aberdeen, his birthplace, was appointed
first mate of the *Beaver* in 1843 and was probably her skipper at some
period in the 1850s. The pipe could have been made expressly for
him. Mitchell is a fascinating character in his own right. He com-
manded the brigantine *Una* which investigated the first gold strike
in British Columbia, at Gold (Mitchell's) Harbour in the Queen
Charlottes in 1851. The Haida were less than cooperative on that
occasion. Every time the *Una's* men blasted out fresh gold, Haida
men would dash out of hiding, seize them by the legs, and try to
keep them away from the ore, until finally the miners refused to go
ashore any longer.

A bachelor, Billy Mitchell was described as "a regular, rough,
jolly, good-natured, laughing sailor, who disdained umbrellas, and
never wore a great coat, although his red face was blue with cold,
and his waistcoast was always on the fly . . ."[3] He would have been
highly entertained by the model of the *Beaver*, regardless of what he
may have thought of the Haida as protectors of their gold.

His rollicking humor bubbled up on one occasion in the austere
presence of Governor James Douglas.[4] Douglas was annoyed be-
cause Mitchell had not handed in the *Beaver's* accounts. After failing
to get them after repeated requests, the governor eventually went
down to the ship in person.

"Captain Mitchell," he began, "you must hand in your accounts
by tomorrow noon."

"My accounts?" Mitchell replied. "Surely I have none."

"Surely, Captain Mitchell," the governor insisted, "you kept
accounts of your expenditures and receipts."

"Yes sir, I did."

"Well, where are they?"

"To tell the truth, Governor, I kept them in the Bible, and the
damned rats have eaten the book from Genesis to Revelations."

With the *Beaver* sending up spray and smoke, and a flamboyant
man like Mitchell in command, it is little wonder the Haida artist felt
compelled to take up his slate-carving tools.

For sheer surrealism in the realm of panel pipes, nothing can

compare with those that combine both European-American and Haida motifs, in a cross-fertilization of artistic concepts. Another panel pipe from the Mitchell collection at the University of Aberdeen exemplifies the type. It incorporates mariners, what appear to be dogs, an umbrella opening over a deckhouse, and a tongue-linked raven and bear. The symbolism would have been known to the carver; today, unfortunately, it escapes us. But what an astounding object it is.

A most unusual panel pipe. At right, monkey and flamingo-like bird, split-headed; at left, dog with seated woman. Museum No. 99c. Length 39.5 cm., height 11.5 cm. Left side drilled for 18.7 cm.

— *Anthropological Museum, University of Aberdeen*

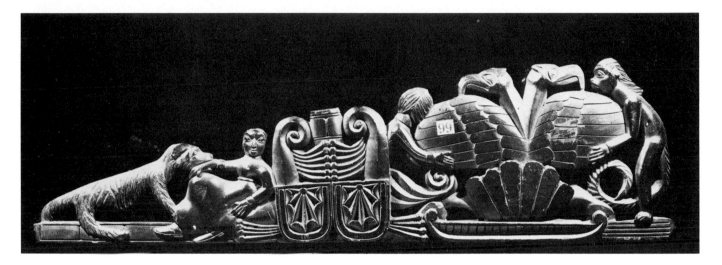

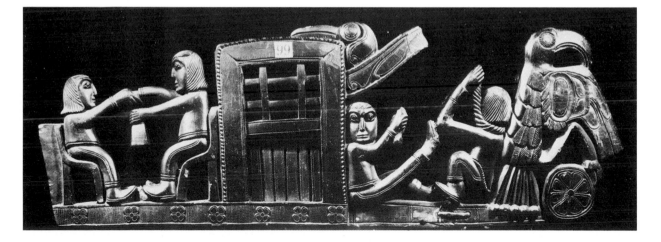

Another panel (more panel than pipe) from the Mitchell collection. No. 99f. Length 34.5 cm., height 11.5 cm.

— *Anthropological Museum, University of Aberdeen*

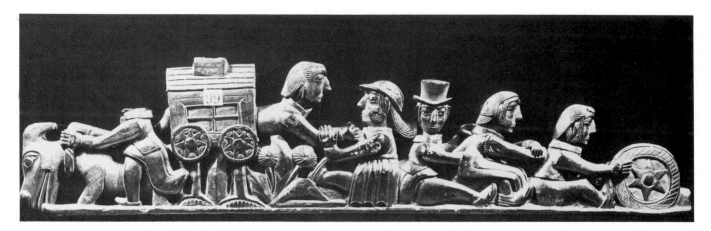

Panel pipe largely composed of European-American male figures. "Deckhouse" appears to be on wheels. Note flowers growing to right of deckhouse. Museum No. 99i. Length 37 cm., height 9 cm. Drilled for 16.3 cm.

— *Anthropological Museum, University of Aberdeen*

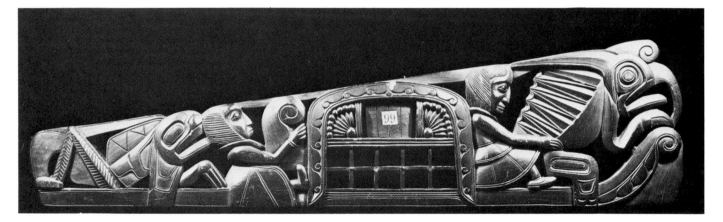

Highly-stylized panel pipe of both Haida and European-American motifs. Museum No. 99a. Length 45.8 cm., height 12 cm.

— *Anthropological Museum, University of Aberdeen*

One design element that has received scholarly attention lately is the "spoked wheel." American scholars, Carole Kaufmann and Robin Wright, who have done the most penetrating research to date on the subject of argillite pipes, regard the wheels as adaptations of the Georgian sunburst designs which were applied to furniture and other fittings of American and British ships, or perhaps of the jagging wheels or pie crimpers which were popular with scrimshanders, or of paddlewheels, steering wheels or compass stars. The Georgian design in inlaid decoration is known as a sunburst when it forms a complete circle, and as a rising sun design in the half-circle.

Not finding anything like these designs in Haida art forms other than argillite, one is tempted to regard them as nothing more than imitations of a Euro-American design. But the Vancouver Island west coast native artist Ron Hamilton considers other possibilities. "The arrangement may have been influenced (by the sight of the foreign decoration), but I think a lot of times these designs were very much Indian things from the beginning," he says.

He then draws on a sheet of paper a distinctive element of Northwest Coast design which the anthropologist Franz Boas described as a pointed double curve, like a brace.[5] It is also called a split crescent. This design, which centers a split U, is employed in a variety of ways. It designates feathers and joints, outlines teeth and nose lines, and defines the limits of formline units. It is a pattern found in nature, one that brings to mind plant seedheads blown in the wind. Hamilton redraws the design, altering it slightly into non-symmetrical forms, and then finally converts it into the radiation of the sunburst design.

Another Mitchell panel pipe suggests Hamilton's final drawing, in the fluted radiation of the partial wheel at lower left. If we look closely at the other wheel on this pipe, we see something else that supports Hamilton's idea. Its "spokes" are tipped with knobs that look very much like representations of the native tobacco seed pod, arranged in a circle. This same "pod" forms the axis for the fluted-tipped partial wheel. We can agree with Hamilton that as much distinctively Haida design may be seen in these circular motifs as what we recognize as Euro-American.

Contemplating the marvellous assortment of objects the carver incorporated into the ship-type panel pipes — Haida crests, umbrellas (a white status symbol), tillers, grinding bowls, bridled horses, a monkey, a mushroom, crown-wearing men, and a great many unidentified objects — Hamilton sits back, takes a deep breath, and says: "It's crazy, crazy, crazy. Great stuff!" A few panels also contain images reflecting Russian America, the most obvious being altar niches with recessed figures. These non-maritime theme carvings are usually presented as straight panels, not as panel pipes.

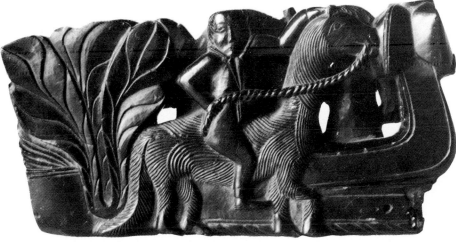

Fractured panel pipe or pipehead with a monarchal figure and attendants on one side, and a horseman on the other side, plus tobacco leaf and pod designs. This was reputedly ordered by a Russian merchant in British Columbia and made in the 1860s according to his wishes.

— *Ethnographical Museum, Budapest*

Essentially, the ship-type panel pipe expresses the Haida society's attitude of the day. The mariners portrayed, with their faces either in profile or turned quizzically toward the viewer, are animated to an extraordinary degree — they seem ready to bounce off the decks, laughing heartily. They tell us that the Haida artist was gazing outward at the world. From his island stronghold, he could look confidently, safely, amusedly, at the strange white men, obsessed with furs and gold, who came and went in their big ships. It may not yet have dawned on him that the white man would soon be coming to stay — and to dominate.

In the storehouse of the British Museum in north London where most of its argillite collection is carefully preserved in deep wooden drawers, each carving swaddled in cotton batting, lie two curious slate pipes. They are styled as elbow pipes, yet each of them, when one blows through the stem hole, produces a whistle from a stop part-way along the stem. One makes a low, eerie sound; the other, carved from a greenish-hued argillite, produces a piercingly shrill whistle. These dual-purpose pipes suggest a ceremonial function.

Instantly, they bring to mind a much better known but nevertheless rare creation in argillite which is strictly musical in appearance — the so-called flute. More accurately, the "flute" should be described as a recorder, since it has a mouthpiece at one end and a series of holes or stops along its long, slender body. Several museums around the world own slate recorders, but seldom more than one specimen which indicates their rarity.

23.
The rare recorder

A beautiful "flute" or recorder, three frogs facing eagle and six finger holes on top, a first-class piece. At one time owned by Emily Carr, it was given by her to William Newcombe, and later purchased by the province with the Newcombe collection. Museum No. 10780. Length 56.5 cm.
— *Ethnology Division, British Columbia Provincial Museum*

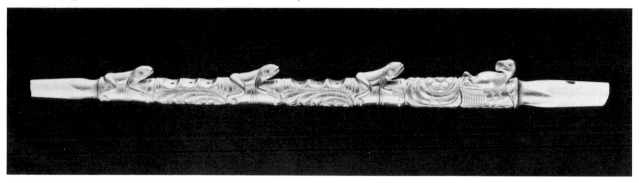

Recorder-making, according to Marius Barbeau, takes us back to the proprietorship of the Slatechuck deposit. At some unknown time, the deposit's ownership descended down the customary Haida matrilineal line, to a prominent Skidegate family named Gunya. George Gunya, an Eagle chief of Skidegate, is credited with making recorders with a specific ornamentation: frogs sitting along the top surface. The frog is one of the crests of the Eagle moiety. Gunya is presumed to have lived in the mid-1800s and evidence of his recorder-making and his rights over the quarry rests solely on information given to Barbeau by an aged daughter of Gunya's, Susan Gray. Gunya is said by Barbeau to have learned to play these instruments.[1]

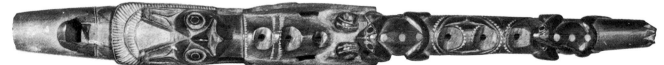

Owl and two frogs decorate this recorder. There are three stops on eagle's chest and three between the two frogs. See also inlays on the frogs' backs, and the lead or pewter tips. Museum No. C 198. Length: 42 cm.
— *Übersee-Museum, Bremen*

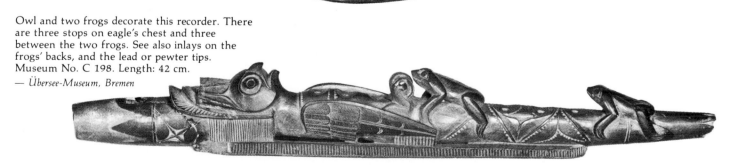

The craftsmanship is superlative in the best of these "Gunya" recorders, if indeed they are his. The carving on each frog-theme recorder is so consistent in quality as to imply that they could only be from the hand of one carver and one alone. The most intricate examples have inlaid, movable keys. A few others, of different motif, may have been made by carvers other than Gunya.

We know that recorders were being made for sale in the early 1850s. Our source is Rev. William Cecil Percy Baylee, who was chaplain and naval instructor aboard the Royal Navy frigate *Thetis*. Based at Valparaiso, *Thetis* was dispatched to the Charlottes in 1852, the first man-of-war to put in an appearance. A Yankee schooner had been reported in the area by men of the Hudson's Bay Company vessel *Una*, following the gold discovery, and this roused James Douglas's fears of an American takeover and brought *Thetis* on the scene. Chaplain Baylee had an opportunity to observe the Haida closely.

He noted that physically and mentally the Haida were "as fine a race of men as can be met with . . . their address most prepossessing and bold, free from that timidity or embarrassment which seem to imply a sense of inferiority." When Haida villagers came on board the *Thetis*, they made inquiries of the use of everything they saw.

> Some helped the men to haul on the ropes, others listened to the band with evident signs of intense admiration; others offered for sale flutes, made out of stone or of slate, and pipes of the same materials with most curious devices carved on them, displaying a degree of skill truly astonishing, when one considers the rude implements, a rusty nail or broken blade of a pen-knife, with which they were wrought out.

One of the lieutenants showed a daguerreotype likeness of his father to a Haida artist, who immediately undertook to make a copy on ivory. He was given a whale's tooth, and in a few days he returned with a bust which, from its resemblance to the original, "excited general admiration." From a book frontispiece portrait of Shakespeare or any other author, a Haida craftsman would also "grave out a bust."[2]

Baylee's mention of the ship's band and Haida flutes, almost in the same breath, is worth noting, because there can be little doubt that the Haida were impressed by musical instruments aboard ships. In later days, when the missionary had started to work among the Haida and Tsimshian, he introduced band instruments and several outstanding native bands were formed. The native peoples were "won over" to Christianity largely by music. Haida argillite carvers were to become band players, among them Arthur Moody. Hornpipes, recorders and mouth organs would have captivated Haida ears from the time the first mariners arrived. At the same time, though, the Haida had wooden whistles of their own which, along with rattles and drums, gave their ceremonials dramatic sound dimensions. The recorder-maker may have been translating into slate something he already knew, something indigenous to his own culture, formalizing it in a European mode with Haida motifs.

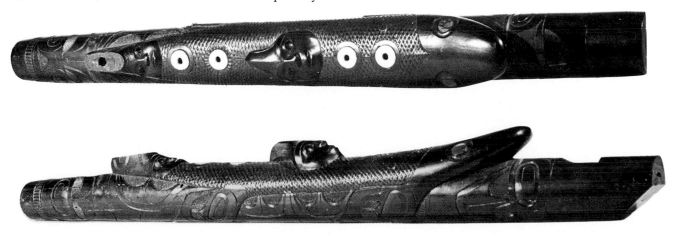

Eagle and two frogs on this recorder. Museum No. 7098. Length 36.6 cm.
— *Bernice P. Bishop Museum, Honolulu*

An extraordinary report that the universal whistle known as the Pan pipe was in the Haida gamut of musical instruments comes from the Marchand expedition. One of the ship's surgeons, Claude Roblet, described as an enlightened observer — in other words an educated man — exploring from Cloak Bay one day that summer of 1791, entered Haida houses and saw "some of those flutes with several pipes, imitating in miniature part of an organ, known among the musical instruments of the ancients, by the name of Pan's pipe . . . He reckoned on some of these flutes as many as eleven pipes . . .". Roblet presumed that "these islanders must have been, or at least that they were formerly, acquainted with an instrument of another kind similar to a harp; and he (Roblet) grounds his opinion on a carved figure, which he examined, having its hands placed on an instrument of this sort."[3]

These Pan pipes could have been of Haida origin, or they may have come from Russian or Chinese contacts long before the Spanish and British probings of the North Pacific. Almost certainly they would have been carved out of wood. Various Haida whistles of wood collected in the 1800s and preserved in museums show great versatility in form. Some are pure whistles, blown like a fife, while others resemble the flageolet. Some have several finger-holes to change notes and some have vibrating reeds. George Gunya's interest in slate recorders may have been based in Haida tradition. The recorder enjoyed a brief spell of popularity among carvers and then, about 1860, vanished from the slate repertory.

Shark-design flute, with four finger holes inlaid with bone. Record card states: "from the collection of Colonel Holmes, it was old when he bought it in 1882." Museum No. J1944.81. Length 51 cm.
— *Museums Department, City of Sheffield, England*

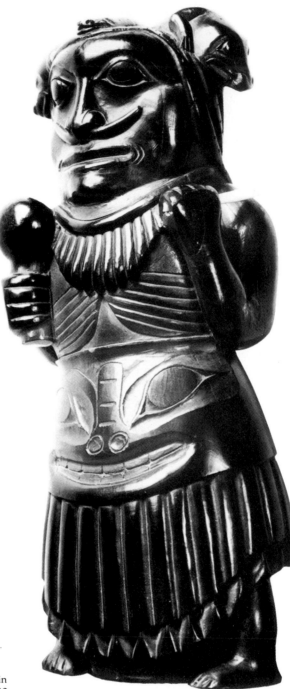

Finely-detailed, expressive shaman figure, collected by George M. Dawson and entered in 1885. Museum No. VII-B-744 (2388) Height 20 cm.

— *National Museums of Canada, Ottawa*

An American sea captain, top-hatted and frock-coated in the style of Abraham Lincoln, stands looking at us imposingly. A Haida chief in ceremonial regalia looks equally impressive. A shaman stands, clasping in his hands the instruments of his powers. A bird takes flight, wings outstretched, from a single base. Sometimes two human figures stand side by side on the same base, or there are small groups of figures — animal or human. These small sculptures range in height from approximately fifteen to fifty centimeters.

In the case of the panel pipes, those of Haida motif were probably produced first, and those of European-American motif later. In the figurines of whites and Haida personalities, it was the other way around. The figurines of foreign sea captains and their wives, of missionaries and government officials, are believed to have been carved, for the most part, between 1830 and 1870. The figurines of Haida chiefs and shamans date from the 1880s.

The most striking feature of these mini-sculptures of individuals, which are entirely representational, is the attention the carver paid to detail in dress. Let us consider first the carvings of whites. Their caps and hats are carefully depicted, as are their neckpieces, the buttons and frogging on their coats, the cut of their trousers, and their boots. The carver took the utmost care to reproduce the costume faithfully. White women were not carved in slate as often as men simply because there were fewer of them, but when they were, the embroidery on their bodices and long skirts received delicate, precise treatment.

With faces, the argillite artist often achieved true portraiture. Haircuts, sideburns, moustaches, beards, are exquisitely detailed. The faces are usually expressionless, as though the subject had been sitting for an oil painting.

One of the finest examples of a maritime figure was offered for sale at Sotheby's in London in 1977, from the collection of Roy Cole of Hamilton, Ontario. Formerly in the Pitt-Rivers collection, it is believed to be an actual portrait of an unknown maritime officer, possibly American. This slate figure is taller than most, more than nineteen inches high (49.75 cm). The catalog description gives the full details.

> He stands on a circular base decorated with fluting, wearing a frock-coat decorated on the sleeves and the back with schematized incised floral motifs on the sleeves and back . . . with more compact floral decoration on the cuffs, the flaps of the coat folded back across the thighs, with braided epaulettes on either shoulder, three brocade ridges on either side of the chest, eight circular copper inset buttons on the front and four on the back of the coat, wearing a six-buttoned waistcoat, a neckerchief and peaked cap, the wavy hair, mutton-chop sideburns and moustache with finely incised lines and with a naturalistic rendering of the face.

The cataloger assigned this piece to the first half of the nineteenth century.[1]

At the same auction, Sotheby's sold an argillite figure of a maritime officer carved in a different style — a style that shows up in at least two museum collections. This is an elongated figure in a

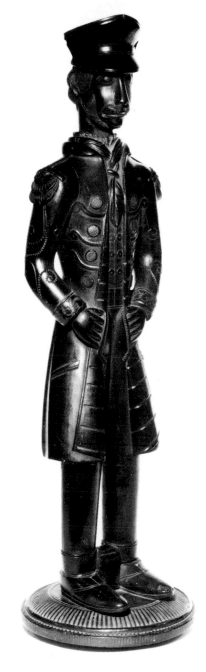

Highly-detailed representation of a maritime officer. Height 49.75 cm.
— Roy G. Cole

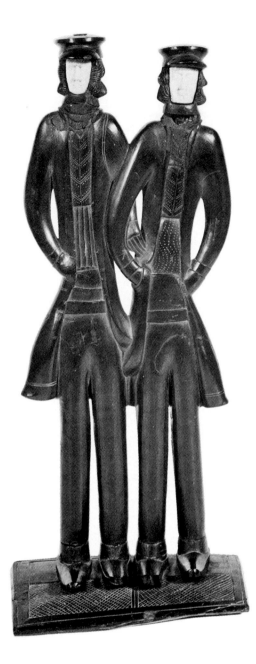

Two New England sailors, in the "thin-man" style, carved from a single block of argillite. Museum No. TM3992. Height 47 cm.
— *Taylor Museum Collection of the Colorado Springs Fine Arts Center, Colorado Springs, Colorado*

frock-coat — a "thin-man" type — with an inset face of ivory clearly indicating a white man. These "thin-man" European-American figures are so alike that they could be well the work of a single carver who, like his subjects, remains anonymous.

The fact that Russian officers at Sitka were popular models is revealed in reports both from the Charlottes and Sitka itself. Carvers showed some of these figures to officers of the Royal Navy steam sloop-of-war *Virago* when she called at Skidegate in May of 1853. *Virago* had come to the islands to do survey work, investigate the gold discovery of two years earlier, and to ask questions about the seizure of the *Susan Sturgis* the previous autumn. While at Skidegate to "wood ship" — stock up on fuel — she welcomed villagers aboard. The people were not surprised to see so large a ship, *Virago's* master George Inskip noted. The *Beaver* had been there, as well as the occasional American whaler, and they were delighted to have an opportunity to barter "furs and masks for old jackets, handkerchiefs, beads, or any other article." Inskip added: "They are very sharp at business, and ask an immoderate price in exchange for their goods." Chief Skidegate was absent at Fort Simpson, "but Captain Bear-skin and his son (the next in rank) came alongside and showed their certificates, which by some strange custom they call 'tea-pots.' "

Inskip further observed: "The men are very dextrous at carving on slate . . . They imitate any pattern exceedingly well, and showed us the figures of many of the Russians at Sitka. They carved the busts of several of our officers in bone; the likeness to the face being remarkably well done . . ."[2]

This quality of portraiture was recognized by the artist Frederick Whymper who visited Sitka in 1865, the year after he had accompanied naturalist Robert Brown on the Vancouver Island Exploring Expedition. Whymper obtained one of the slate figurines, depicting a Russian soldier, during his stay at Sitka. A widely-traveled man, he had come to regard the native peoples sympathetically. "My experience is decidedly this," he wrote, "that the least degraded Indians were those who had least to do with the white man."

As a representational artist, he was intrigued by his newly-acquired carving. He illustrated it in a book about his Alaska travels published after the Alaska Purchase in 1867, and said of it: "Although it may seem a caricature, it is really an accurate likeness of the stolid features and antiquated cut of the late defenders of Russian America."[3]

As history in art, the figurines from Haida life are even more informative today. We know from paintings, sketches and daguerreotypes what a New England sea captain looked like. But before the widespread use of the camera, depictions of prominent Haida personages were extremely rare. By the time photography was brought into frequent focus on the Haida, they had been forced to give up most of their ceremonials that called for full dress. From slate carvings, however, we get a vivid idea of what a Haida chief really looked like — his various types of headdress, his cedarbark roping worn like a sash, even his tattoos.

The shaman figures are believed to have been carved *after* the arrival of the first resident missionary when the shaman was no

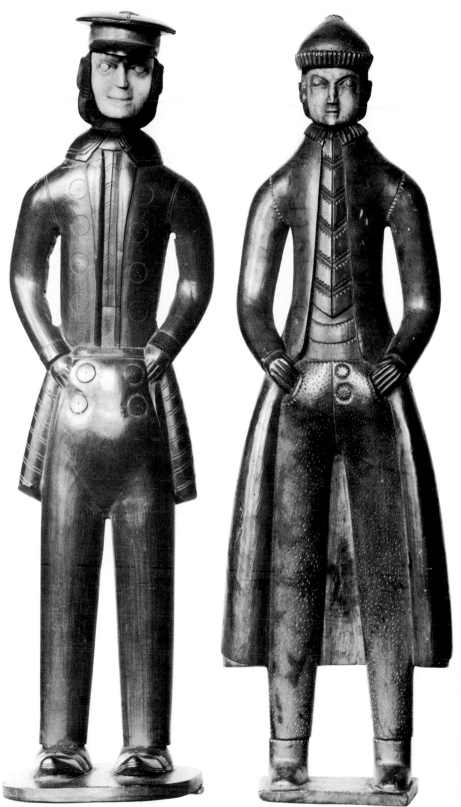

Illustration from Frederick Whymper's *Travel and Adventure in the Territory of Alaska*.

These carvings of maritime officers standing with hands in pockets exemplify the almost microscopic attention paid to details of white men's dress. The faces are inset of bone or ivory. The figure at left (Museum No. H.c. 329) entered the museum in 1857. The one at right (Museum No. H.c. 1380) was collected by the American government's Wilkes expedition of 1838-41 and received from the Smithsonian Institution, Washington, D.C., in 1868. He is clad for cold weather, with toque, great coat, and heavy trousers indicated by stippling. Note also detail in vests and buttons. Height 34.5 cm., width of left figure 10 cm., thickness of left figure 3.8 cm.

— *Department of Ethnography, The National Museum of Denmark*

The carver may have seen this couple, who seem to be quarrelling. Woman's struggle is accented by lines of her dress. This also is carved from one piece of argillite. Museum No. 1954 W. Am 5 1000. Wellcome collection. Height 19.5 cm., width 15 cm., thickness 1.5 cm.

— *British Museum*

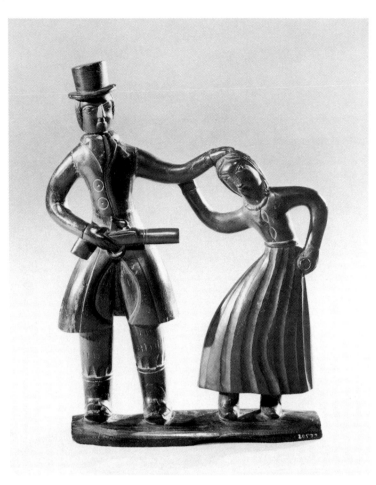

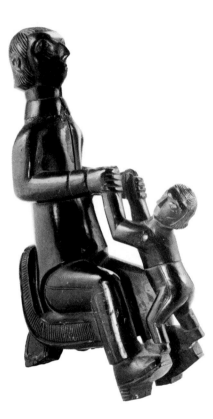

Figure of a man rocking a child. Museum No. 2-4686. Height 23 cm.

— *Lowie Museum of Anthropology, University of California, Berkeley*

longer held in high esteem by the Haida and could therefore be safely depicted.

In slate, the shaman appears just as he was described by Victoria pioneer James Deans, an amateur archaeologist and keen student of the native peoples of the British Columbia coast, who paid periodic visits to the Charlottes from 1869 to the 1890s. A shaman's outfit, Deans reported, consisted of a rattle, a rod or staff of office, pointed bones, one held in the hand and the other worn in a hole pierced through the septum of the nose, and a necklace. He wore an apron fringed with beaks around his waist. The female *sGaga* had a couple of circlets strung with beaks which she held, one in each hand.[4] Long before Deans came on the scene the shamans had other paraphernalia kept hidden from prying whites including, as suggested earlier, beautiful panel pipes for specific ritual use.

Like the carved chiefs in their emblazoned capes and aprons, these sturdy shamans are represented in every last detail with attention paid to their entire person — front and back. So life-like are they in fact, that we almost expect them to begin exercising their powers before our very eyes.

Like all working romantics Haida carvers have their aversions, and some today will not carve shamans, considering them rather spooky. At least one contemporary artist, Alfred Collinson of Skidegate, has carved a shaman. It is a masterful work, bent-kneed rather than standing or seated as the classical shaman figures, and fierce-visaged.

Bird and animal figurines have been carved through the decades although less frequently in the past than today. The early examples — and their dates are uncertain — consisted usually of a bird on a small base, or a bear on its haunches. These are cool, elegant, simple statements. Modern slate artists, in turning to this type of carving, have imbued their figures with a greater tension and movement. The single crest may be killer whale, arched in a stop-action pose, mounted on a slender rod; raven in flight; or wasco crouched, ready to leap forward. These contemporary works seem to owe as much to twentieth century wood carvings of other cultures as they do to traditional Haida creations in argillite.

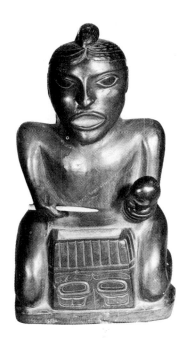

Kneeling figure of a shaman, his box in front of him, seemingly in incantation, and holding his bone or ivory piercer and rattle. Museum No. C 504. Height: 19 cm.

— *Übersee-Museum, Bremen*

Chief in ceremonial dress including frontlet and circlets on each wrist. The face is strongly delineated, and, curiously enough, the eyebrows are depicted by double rows of stippling instead of by broad bands. Museum No. C 502. Height: 23 cm.

— *Übersee-Museum, Bremen*

The shaman figures in this old photograph were once in Indian agent Thomas Deasy's office display at Masset. They became part of the Leigh Pearsall collection, and are now in the Florida State Museum, University of Florida. Museum Nos. from left: P 750, P 754, P 752, P 753, P 755, P 756.

— *National Museums of Canada, Ottawa*

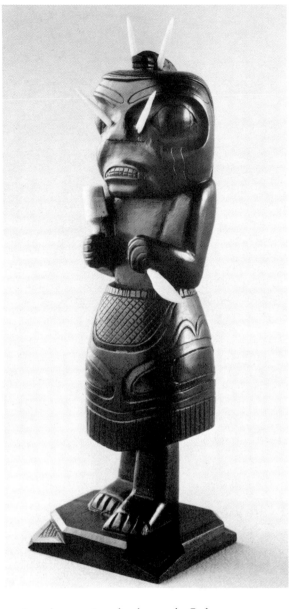

A modern carving of a shaman, by Rufus Moody. Museum No. AA34. Height 14.5 cm.

— *Centennial Museum, Vancouver, B.C.*

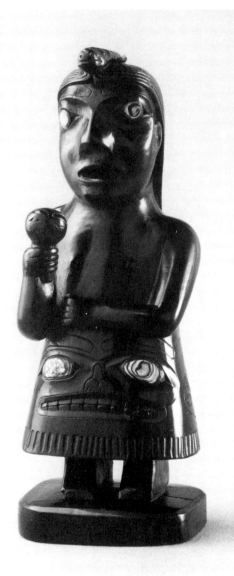

Shaman, attributed to Arthur Moody, from the Lipsett collection. Museum No. AA2323. Height 18.5 cm.

— *Centennial Museum, Vancouver, B.C.*

Like the single chief and shaman figurines, the free-standing group figurines of Haida motif also date from the 1880s. Their carvers reconstructed legends and stories in much the same way that the panel pipe carvers did, but these versions are not nearly so complex. In condensing the story, they are less "peopled," and the component figures heavier, chunkier. The three-dimensionality gave the carver fair scope for movement and expression, and the best of them have a dynamic quality. Bears stand on their hind legs, crowding one or more human or part-human beings. The bear-mother legend is recalled variously and with unusual feeling. The

most famous example is a small carving in the Smithsonian Institution in Washington, D.C. which was finished by Johnny Kit Elswa, if not made entirely by him. Here, the prostrate mother wearing a labret to indicate her high rank, writhes as her half-bear offspring suckles at her breast. It is a highly-imaginative work from a carver of whom all too little is known. (It is illustrated on page 262.)

This group carving was donated by William Van Horne of Canadian Pacific Railway fame. Accession No. 1202. Height 23.5 cm.
— *McCord Museum, Montreal*

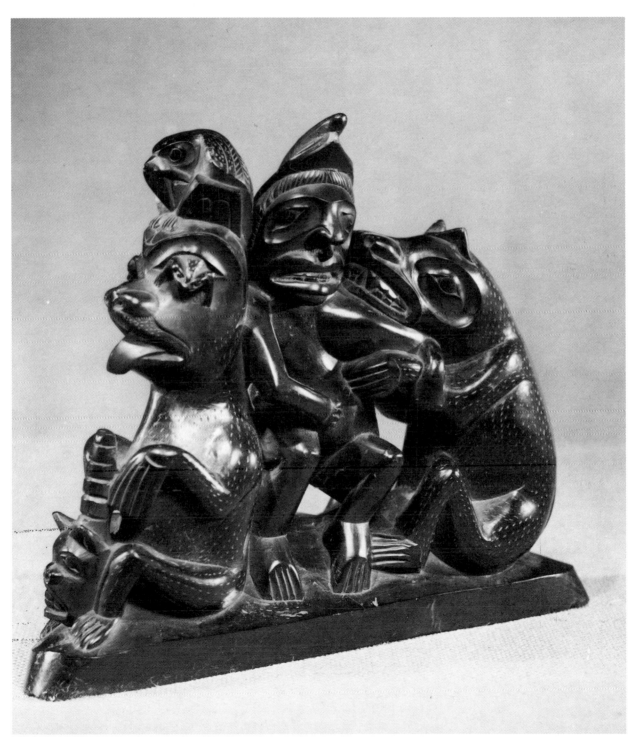

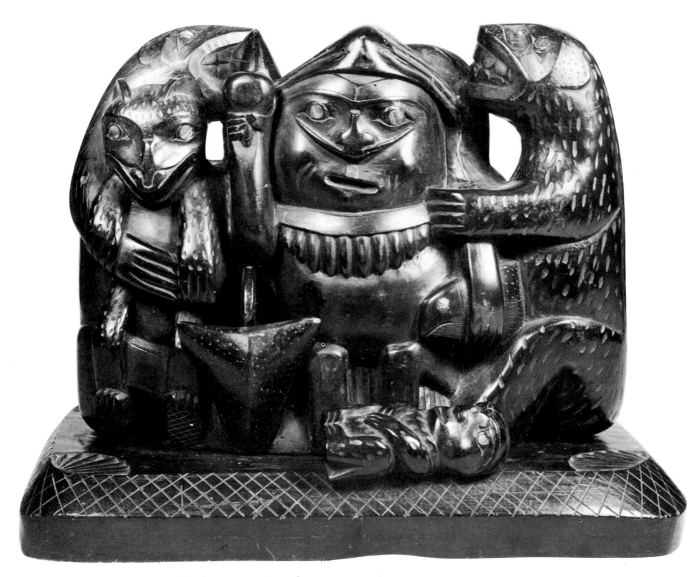

In this group carving, shaman at center is attempting to heal bear cub (lying on base) with salmon as his supernatural helper. Bear wife at left holds cub over her arm. Bear husband at right is watching over shaman.
— *Linden-Museum, Stuttgart*

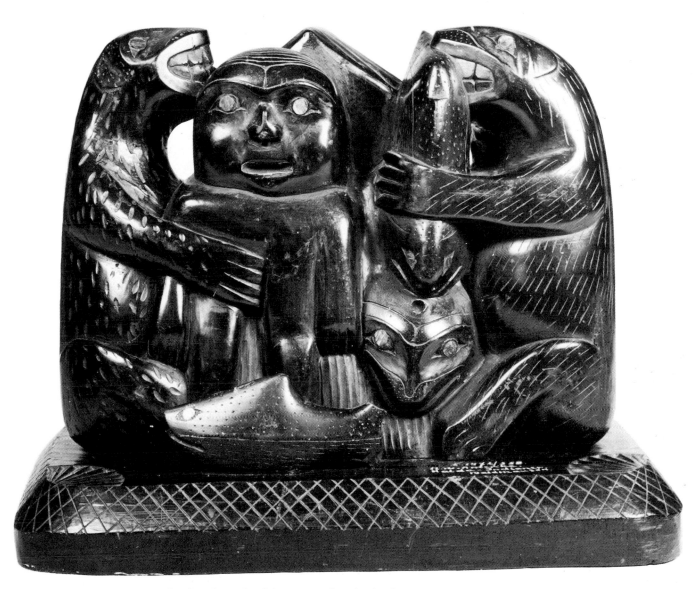

On the other side of this carving, bear husband at left holds woman, salmon is at feet, and at right bear wife holds salmon. Whale's head shows through near bottom. Inventory No. L 1472/358. Height 18 cm.

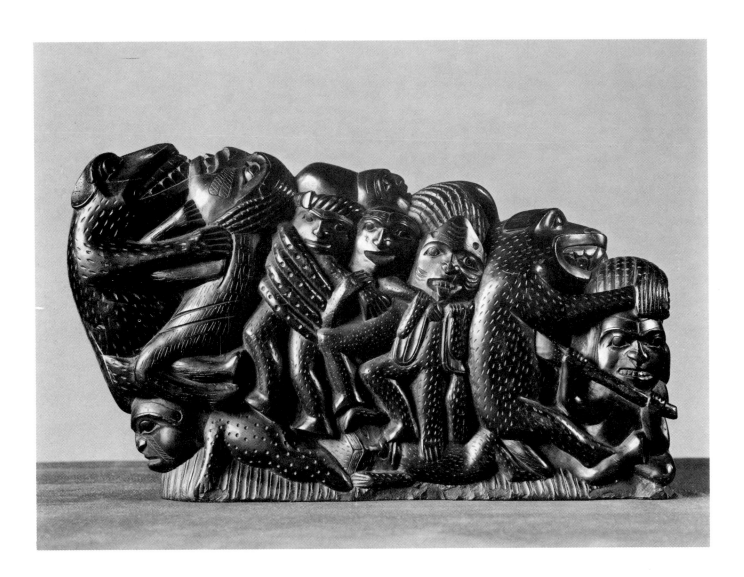

A fine example of a group carving, with stories well clustered. Bear mother legend figures at ends, and in between chiefs and shark. The bear and human female copulate at far left. Museum No. NA 9282. Length 31.5 cm., height 20.5 cm., thickness 5 cm.

— *University Museum, University of Pennsylvania*

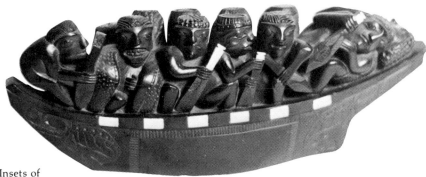

Group of canoe travelers, a story piece. Insets of bone on gunwales and paddles. Museum No. IB 9. Length 37.6 cm., height 14 cm.

— *Sheldon Jackson Museum, Sitka, Alaska*

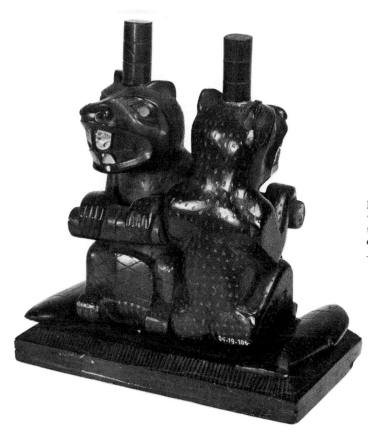

From the Retzius collection, beavers side by side, with inlaid incisors, and a salmon at each end of the base. Museum No. 1904.19.106. Height 18 cm., length 18 cm., width 11 cm.
— *Etnografiska Museet, Stockholm*

In another category of group figurines, people are crammed into canoes or longboats, the keel forming the base of the carving. Here the artist may be depicting either a legend or an actual incident. Sometimes Haida crewmen and white sailors wearing sou'westers labor alongside each other in what appears to be a sealing or whaling expedition. If these canoeloads of people look crowded beyond belief, we should not be unduly surprised. Eyewitnesses in the last century expressed amazement at the number of Haida who packed themselves into canoes and huddled together for warmth on their journeys. Albert Edward Edenshaw told George Dawson in 1878 that in earlier years when setting out for Victoria, he frequently took forty men plus their belongings[5] in a single canoe. So in these compacted people-in-boats carvings, the artist was being quite accurate.

If a select number of these solo and group figurines could be assembled and displayed in one place, they would give us a far more meaningful picture of Haida life 100 years ago than photographs can convey. Each one is a delightfully frank expression of its time. The viewer who is not a Haida can relate to them more easily than to anything else in argillite.

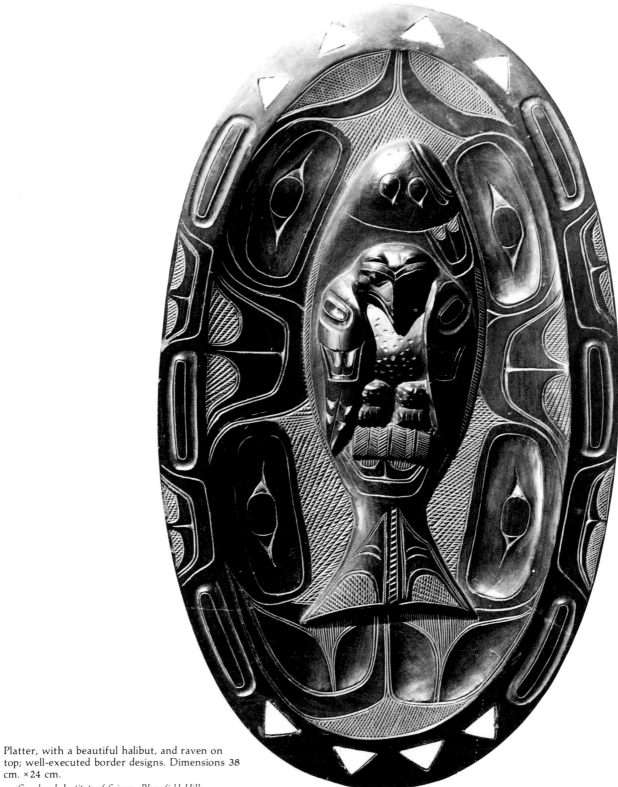

Platter, with a beautiful halibut, and raven on
top; well-executed border designs. Dimensions 38
cm. ×24 cm.
— *Cranbrook Institute of Science, Bloomfield Hills,*
Michigan

Since at least 1830, carvers have produced dishes and bowls embellished either in Haida or European-American motifs. The dishes come in two basic shapes — circular plates, and oblong platters. They can span sixty centimeters and weigh more than thirteen and one half kilograms. It is significant that every known major argillite artist has made dishes, one reason being that the concave surface gave him an excellent opportunity to display his design capabilities. He engraved these surfaces and ornamented them in low and high relief. The rims are decorated so as to contrast the inner design. Haida slate dishes were definitely created for trade. Because they were breakable they were of no practical value to the Haida who, if they used any sort of dish in the 1800s, would have dipped into their own wooden containers or used imported dishes of foreign manufacture.

25.
Plates
and platters

A female shaman in feathered headdress and holding her two circular rattles, is the central figure in relief on this handsome plate. In background design is killer whale. Museum No. 15590. Diameter 35.2 cm.

— Lowie Museum of Anthropology, University of California, Berkeley

In the first slate dishes, the carver exploited instruments and designs introduced to him by visiting mariners. From the magnetic compass, the mapping compass and the compass roses on charts, he saw how geometry could be applied to design, using dividers and calipers. Circular patterns containing spokes that radiate to scalloped edges appear again and again on dishes, often accompanied by representations of the native tobacco leaf for a "naturalizing" effect. Full-spoked wheels and half-spoked wheels were common Georgian designs on pressed glass, furniture and panelling produced by British and American artisans of the period — articles the Haida would have seen aboard ships. They were fascinated with everything that came from ships, and promptly adopted navigational instruments to further their art. Argillite geometric plates bear one unmistakeable sign of the striking of arcs and circles and circumscribing that went on — a small hole at dead center left by the anchoring of the divider point. "It was the handiness and the

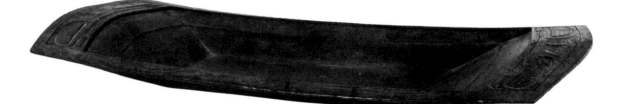

Rectangular wooden feast dish of Kaigani Haida. "Long dish for dried fish at feasts," its collector, C. F. Newcombe, wrote. The ends are decorated. Length 84.5 cm., width 30.3 cm., depth 7.3 cm.

— *National Museums of Canada, Ottawa*

Replica in slate of a wooden feast dish, with hawk or thunderbird at either end, and inlays. Museum No. IB 20. Length 42.2 cm., width 15.8 cm.

— *Sheldon Jackson Museum, Sitka*

stiffness, the ability to change sizes and achieve symmetry instantly with calipers, that made them so nice to use," Ron Hamilton explains.

A few plates reflect an effort on the part of one or two carvers to reproduce English words. One museum example bears the lettering SARSAPARILLO in low relief, apparently an attempt to reproduce lettering seen on a container. Sarsparilla, an ingredient of root beer, was widely used commercially in the nineteenth century.

The carver's fascination with geometrics in dish engraving lasted for at least twenty years, until the devastating smallpox epidemic. Trisha Gessler, curator of the Queen Charlotte Islands Museum at Skidegate, and her husband, Nick, found fragments of slate dishes bearing geometric and native tobacco leaf designs at Kiusta, which is believed to have been abandoned by 1860. Complete specimens in museums have been dated to 1840.[1] It was the Gesslers who pointed out that the plant carved on argillite plates was the native tobacco.

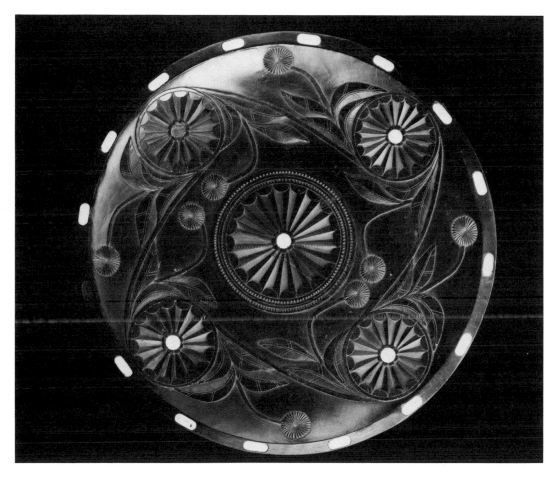

A prime example of geometrics in plate-making. The five sun-burst designs are interwoven with leaves and seed pods. Ivory inlays. Museum No. 12926.
— *Ethnology Division, British Columbia Provincial Museum*

203

Plate in so-called geometric design, with compass-point hole at center. It once belonged to Hawaii's last reigning monarch, Queen Lili'-uokalani. Museum No. 1921.14.99B. Diameter approximately 20 cm.

— *Bernice P. Bishop Museum, Honolulu*

With the revival of interest in Haida designing in the 1880s came dishes of Haida motif, including some of the most spectacular plates and platters ever produced by the slate carver. On their surfaces, stated clearly and vigorously, are all the classic forms and elements of Haida design. In the eye- and U-shapes, the lower portions are one-third the size of the upper portions. The flat surfaces reveal their mathematical "correctness." They enabled the carver to lay out his designs in a more representational manner than he could, say, on a slate pole. A tail appears where a tail is supposed to be, and a head where one would expect to find a head. In the best examples, the complete design fits comfortably within the surface boundaries, uncrowded at the perimeters.

European-American motifs on a platter: on top side, two women and two dog-like animals (note use of ivory inlays to convey space and in border design); on reverse, geometric design. Museum No. 11501. Length 33 cm. Copyright, Bristol Museum and Art Gallery.

— Bristol Museum and Art Gallery, Bristol, England

With the outlying figures, this plate is almost in a class by itself. The outside figures are two bears, face to face, and raven. Diameter 23 cm.

— Cranbrook Institute of Science, Bloomfield Hills, Michigan

Often one crest dominates the entire design. The nineteenth century artist William Dixon, known to have carved dishes, was partial to depicting the octopus.[2] Many Raven carvers chose killer whale. Halibut, eagle, bear or beaver may take the leading role on other dishes. Marine creatures were sometimes presented in relief, near the center as though the carver visualized his dish as the ocean in which they swam.

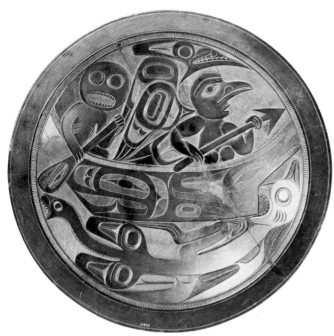

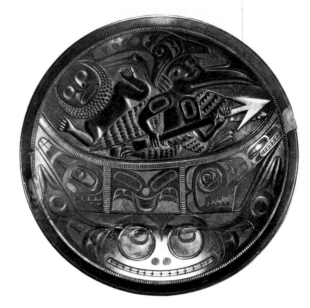

This plate is exceptional for the pictorial quality of the design and engraving brilliance. Two supernatural beings, one holding a paddle and the other a harpoon, ride in a wolf-design canoe which is being attacked by a sea creature. Round-eyed figure in stern is open-mouthed in horror. Museum No. 17952. Received as a gift in 1894. Diameter 35.2 cm.

— *Field Museum of Natural History, Chicago*

The design of this plate illustrates the same theme as the Field Museum's plate, and has several characteristics of the work of Charles Edenshaw. Note different stylings of each component. In this plate, greater emphasis has been placed on the transformation aspect of harpoon-holding, supernatural figure upper right. Museum No. 1894:704. Diameter 31.8 cm.

— *National Museum of Ireland, Dublin*

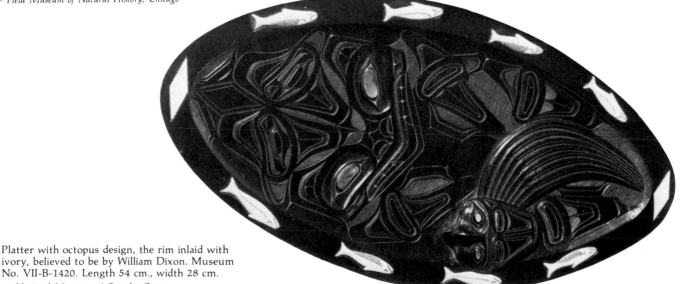

Platter with octopus design, the rim inlaid with ivory, believed to be by William Dixon. Museum No. VII-B-1420. Length 54 cm., width 28 cm.

— *National Museums of Canada, Ottawa*

206

Now and then a carver embellished a dish with three-dimensional figures. A fisherman wearing a conical hat and holding a harpoon rises out of the hollowed dish surface. Invariably, the carver's artistic sense told him to place the fisherman somewhat off-center. On a few dishes, scrupulously spaced bears poke their heads over the rim.

Round or oval, the dish surface lent itself admirably to story-telling. The master dish-maker, Tom Price, like several unknown carvers of the nineteenth century, demonstrated how effectively that surface could be used by incorporating every feature of a legend — main figures and auxiliary ones alike — each following the other in a sequence reflecting their importance.[3]

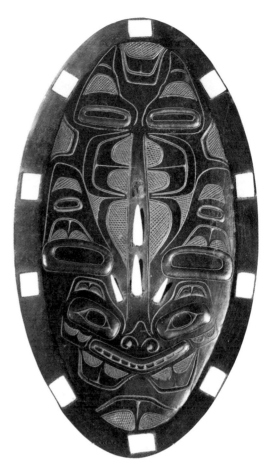

A Skidegate master, Tom Price, made this superb platter for Thomas Deasy, and it was at one time in the Axel Rasmussen collection. It is said to relate an episode in the life of Stone-Ribs, a Haida strong man of legend who was capable of transforming himself into other creatures by wearing their skins, in this instance halibut. The main crest is five-finned killer whale, a crest of Ninstints where Price came from. The halibut which is Stone-Ribs is inside whale. An eagle standing on whale's head pursues another halibut. Also part of the story are the three canoemen, and to the left is a man with bow and arrow and to the right a baby in a thonged cradle. The rim has eight triangular inlays of whalebone cleverly set so as to point to and highlight the design, and abalone shell is inset in whale. Museum No. II-B-824. Length 36.2 cm., width 24.1 cm.

— *Alaska State Museum, Juneau*

A sculpin platter; bone inlays for sculpin's spine (one missing). Length 32.8 cm., width 18.5 cm. Gift of Mrs. Philip E. Spalding, 1931 (3079)

— *Honolulu Academy of Arts, Honolulu.*

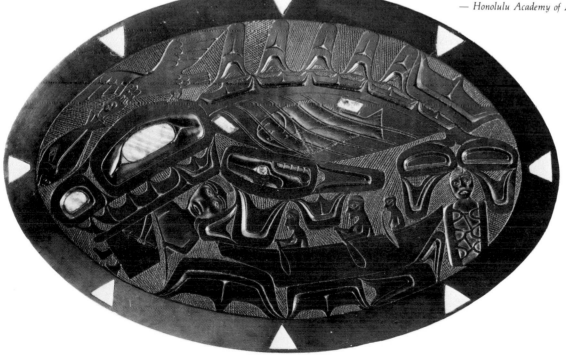

In some dishes, as in the case of a crab platter in the Leigh Morgan Pearsall collection, a single figure sufficed. Thomas Deasy, who sold the dish to Pearsall, related this legend about the Crab of Naden Harbour:

> In the early days when birds, animals and fish were very large, a crab took possession of the entrance to Naden Harbour, and the giant crab devoured all mammals and other fish attempting to enter the harbor. It devoured whales, halibut, salmon and any living thing in the water. The entrance is narrow, with numerous sand bars outside. The Haidas knew of this destructive crab, and made up numerous devices to exterminate it. At last they decided to dress a slave in the skin of a halibut, and send him into the harbour. They caught a huge halibut, skinned it, dressed the slave, and cast him overboard from a large canoe at the entrance. The incoming tide carried the slave along till he reached the place where the crab resided. A battle took place between the "halibut" and crab. The slave won, tore the crab to pieces, and scattered the claws and body in all directions. Every part of the crab took on life, and became smaller crabs.[4]

It was perfectly logical that Naden Harbour should give rise to a crab legend such as this. According to Deasy, it was the best crab-fishing ground on the Pacific Coast. In a single day there, he reported, one Indian with crab nets caught more than 500 large crabs.

Crab platter from the Pearsall collection, high relief with abalone shell inlays around rim and for eyes of crab. Halibut tail visible on the right. Length 22.5 cm., width 12 cm.

— Florida State Museum

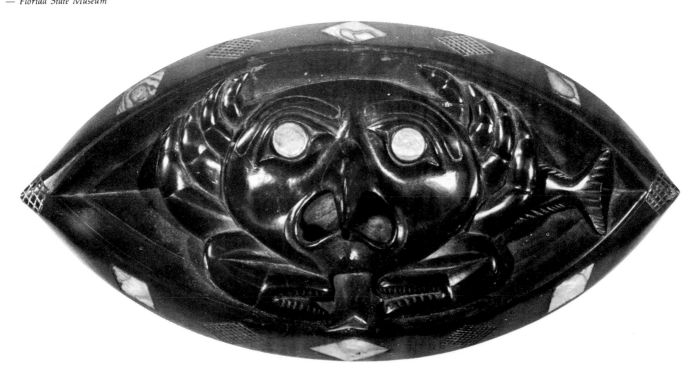

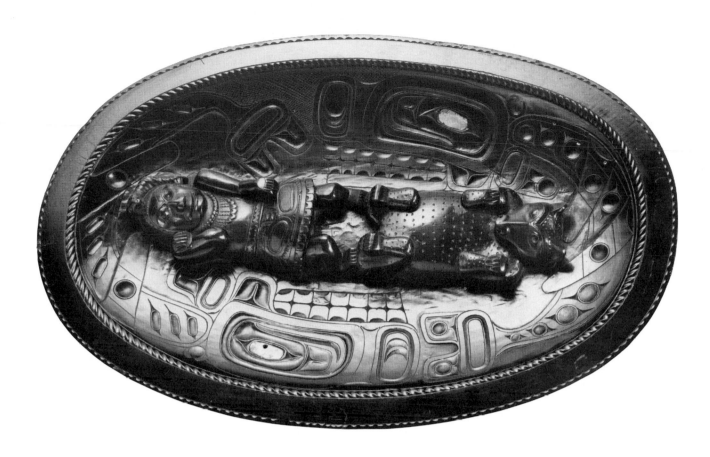

Bear and woman shaman platter by Arthur Moody, from the Lipsett collection. Shaman has woodworm on her head, and two-finned sea monster comprises background design. Abalone inlays. Museum No. AA1608. Length 50.8 cm., width 34.2 cm.

— *Centennial Museum, Vancouver*

The shapes of platters are diverse. Conventional shapes include oval or round-cornered oblongs, or oblongs with angled ends or tapered points. In small ones today, carvers exercise considerable freedom of choice. The rims of many nineteenth century platters are decorated with bone or shell inlays, and the edges may be gadrooned or "roped." Applying this finishing touch, the carver was usually careful not to detract from the central pattern.

The oblong slate dish was a smaller version of wooden Haida feast dishes which often reached epic sizes. George Dawson saw one such wooden platter in Albert Edward Edenshaw's old house on Parry Passage. Pointed at the ends and decorated, it measured five feet six inches in length.[5] In the largest dishes in slate, the artist endeavored to regain the grand scale of feasting remembered by his people.

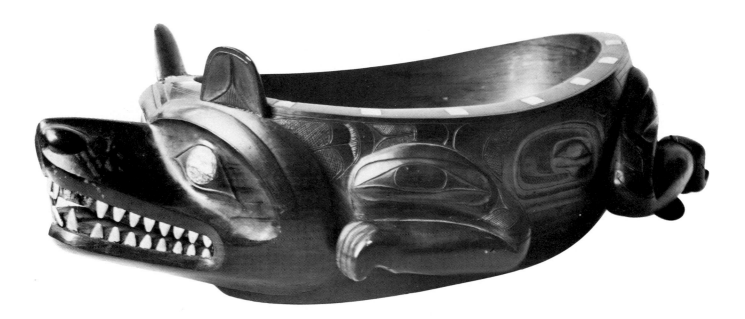

Bear bowl with squares of ivory evenly spaced around the rim and ivory teeth inset. The eyes are of inlaid abalone shell. Museum No. 14830.

— *Field Museum of Natural History, Chicago*

Argillite bowls made their appearance before dishes. They are simple, adroitly balanced, and often substantial — the largest requiring two hands to hold them. The earliest examples of bowls, however, are small — not much longer than the average woman's hand — and they date from the 1820s and 1830s.

At their most conventional, bowls depict an entire single crest. The complete bowl may represent beaver, or bear. The head is carved at one end and the hindquarters at the other, with the bowl section hollowed out from the back of the crouched torso. Some bowls carry two allied crests, their faces at either end and the bodies intertwined at the center underneath the bowl portion.

26.
Bowls

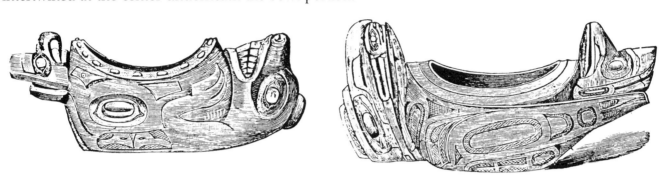

In both size and shape, these "conventional" bowls bring to mind the wooden grease bowls once common in Haida households. They also resemble the much larger cedar mortuary carvings which were family crests placed at graves in the days before tombstones. In the case of the slate bowl, the carver had to present the crest in a fully-crouched position in order to maintain the bowl shape. Yet another antecedent of the slate bowl is the ancient stone mortar used for pulverizing roots and berries.

Sketches from the Dawson Report of 1878, published in the Geological Survey of Canada *Report of Progress for 1878-79*, showing Haida household and ceremonial equipment.

— *Geological Survey of Canada*

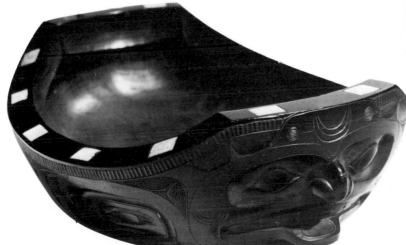

Bowl, expertly carved, with sharkwoman at end facing and shark at other end. Museum No. 5801. Christy collection. Length 28.65 cm., width 20.7 cm.

— *British Museum*

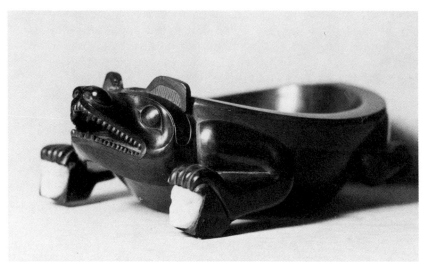

Bear bowl, with bone faces inset in forepaws. Museum No. IB 12. Length 24.7 cm., width 14.5 cm.

— *Sheldon Jackson Museum, Sitka*

Slate bowls vary greatly in size. The smallest are only a few centimeters long; the largest weigh nine kilograms. Prime examples of large bowls from the last century are usually in remarkably good condition, indicating the care taken in handling the weight. Bowls seem to have been carved at almost every period in the history of argillite art.

Just as he does when making a rattle, a wooden bowl, or a canoe, the artist carves the figure first, then hollows it out using any convenient gouging tool. Because of argillite's softness, his labor is infinitely lighter than that of the stone mortar maker. Nonetheless, the carver of large slate bowls in the last century would have chipped away for hours, eventually smoothing the inner surface with dried fishskin or a sponge called the sea potato.

Grizzly bear bowl, pointed at the tail, elaborately carved; the main bear face at end facing, and hawk at tail end (not visible), small human faces of bone inset in bear's ears and two more human faces on forepaws. Bear's teeth are of inset bone, his eyes of abalone shell, and the rim is embellished with operculum shell. This bowl was formerly owned by C. P. Smith of Victoria. Museum No. A 62.62.53. Length 35.5 cm., width 21.6 cm., height 14 cm.

— *Glenbow Museum, Calgary, Alberta*

Eagle bowl. Accession No. 1199. Length 25 cm.

— *McCord Museum, Montreal*

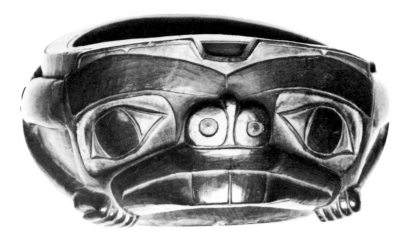

Beaver bowl, front view. This early bowl was acquired by Colin Robertson pre-1833. Museum No. 1978.518. Length 18 cm., width 14 cm.

— *Perth Museum and Art Gallery, Perth, Scotland. John Watt Photo.*

A side view of the Perth beaver bowl.

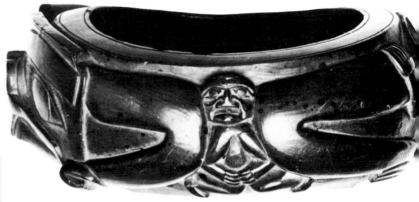

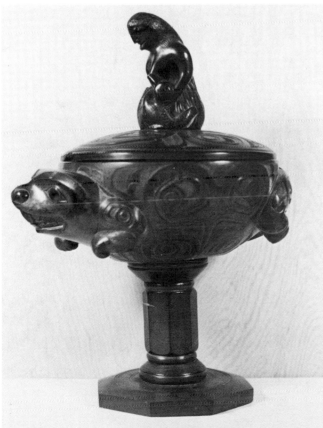

Beaver compote, the lid surmounted by bear mother nursing her cub. Probably by Charles Edenshaw. Museum No. IB 11. Height 35 cm., maximum width 27.8 cm.

— *Sheldon Jackson Museum, Sitka*

A fair number of bowls have bone or shell ornamentation on their rims. These inlays are particularly effective on large bowls. The eyes of the beaver, frog or bear may also be accented with abalone shell.

Few names of bowl carvers have come down from the past. The Skidegate carver Joshua Work was noted for his bowls and when he carved the beaver crest it was characteristic of him to give it rounded incisors.[1] George Smith of Skidegate, as well as Charles Edenshaw, were also bowl carvers.

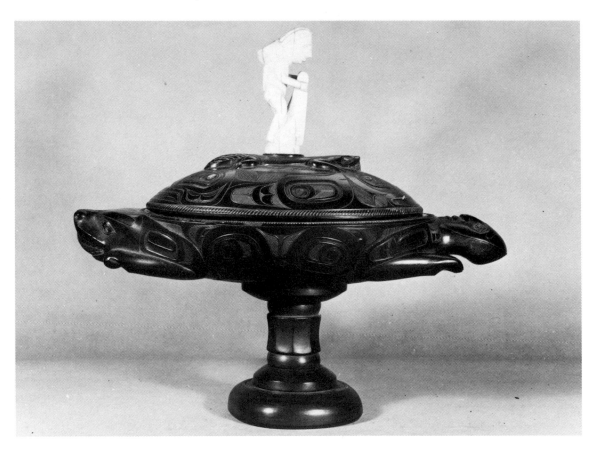

Magnificent compote consisting of an oval bowl with domed lid, on a two-part stand. The entire bowl represents beaver, his head and tail forming the handles. A human face is carved on the top of beaver's tail. The lid represents sculpin or killer whale, and on his back is another beaver in bas-relief. From this beaver rises an ivory figure of a man clasping the ivory fin of killer whale. Looking down on the compote lid, we see the head of the ivory figure standing on the bas-relief beaver, and then the flat-surface design of killer whale. Eyes inlaid with abalone shell. The double-lined split U's and concentric ovoids hint that this work could have been Charles Edenshaw's. Certainly the composition and execution were by a master carver. Ex-Norwich Museum. 57.16.

— *Merseyside County Museums, Liverpool*

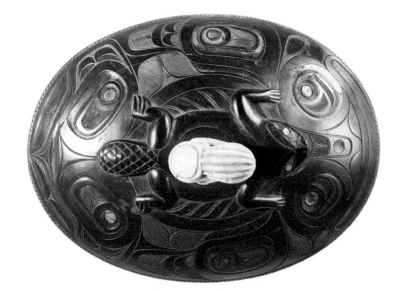

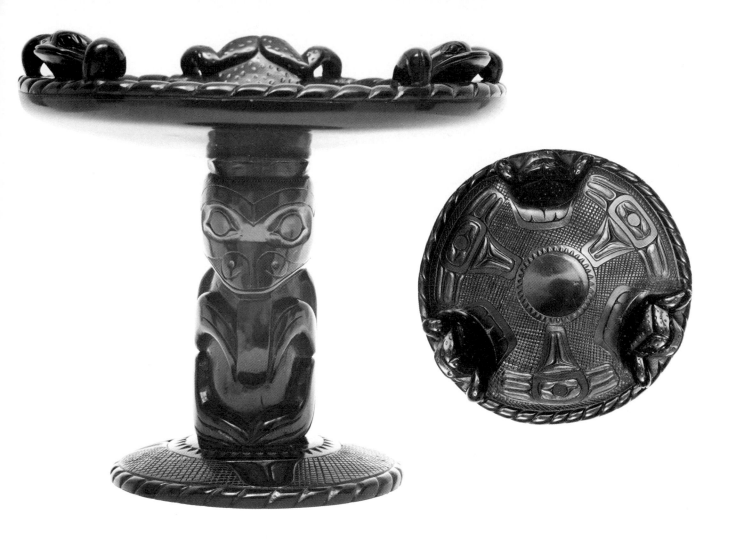

Compote by Gingeda (Melvin Hutchingson), three frogs on plate, bear on column. Plate diameter 13.7 cm., height 11.5 cm. Drew collection.

— *Philip F. Graham*

Bowls are among the rarer works in slate and compotes are rarer still. Compotes are ambitious undertakings in that the carver has much to decorate. Base tops, stems, bowls, and lid tops will be embellished with skill bcing lavished equally on each surface. Without exception, compotes in slate are marvels of proportioning.

The Haida had no known prototype for the compote, yet when turning to a kind of vessel new to him he did so with verve and elegance. Instead of carving handles he extended the main crest figure so that its head and tail could be grasped. Tiny frogs may appear on the rim, or evenly-spaced bear cubs clamber over the edges. Usually, the figure of a human or a bird surmounts the convex lid, splendidly proportioned in relation to the whole. As self-imposed tests for design and proportioning a few contemporary artists have tried their hand at carving compotes — the results have been thoroughly successful.

Early, wide-style pole with bearded man on top of bear and house entrance hole, all well proportioned. "Reminds me of house entrance pole at Tow Hill," Richard Wilson comments. Museum No. +1616. Christy collection, previously Bragge collection. Height 30 cm., width 8.5 cm.
— *British Museum*

Another of these wider-than-usual poles. Museum No. 1933.3-15.34. Height 31.5 cm., width 10.5 cm.
— *British Museum*

"If a museum in a remote spot in the world has one piece of Northwest Coast art, it is more apt to be argillite than almost anything else," anthropologist Erna Gunther once remarked.[1] She might have added that the lone piece would most likely be a totem pole.

Thousands have been produced by Haida slate artists over the last 100 years. Miniature thickets of poles crammed curio store counters from Seattle to Alaska in the last years of the nineteenth century and the early years of this century. In vintage argillite collections they are by far the most common article. They range in height from three inches (7.5 centimeters) to six feet (approximately two meters), although "big" is not necessarily equated with "best." Some of the smallest poles can be masterpieces of carving technique, while some of the largest are of interest solely because of their size.

Large poles (not the exhibition giants) are far from common because of the widely accepted standard that a pole should be carved from single block of slate. By this standard, only the base may be made from a separate piece. In the old poles the shafts were sometimes secured to the base by means of a square dowel carved at the bottom of the shaft. It was then set into a matching square hole carved in the base slab and the two pole parts were finally cemented together with fish glue. In a few instances, the oldtime carver placed a bird or fish at the top of a pole, separate from the main carving, and again attached this top figure with the glue. In affixing his bases, the modern carver has the benefit of instant-bonding glues which are thinner and stronger than the homemade substance and can thus make his joins almost indiscernible. The majority of poles range from six to fourteen inches (approximately fifteen to thirty-five centimeters) in height. Any pole over twenty inches (fifty centimeters) can be considered a large pole.

Despite numerous museum guides that use the term "model totem pole," the slate pole is not in fact a replica of a big cedar pole, except in some early instances. Instead, it is either a story depiction or a display of the carver's own crests, even borrowed crests. Invariably the major crest will be at the top of the pole. The descending crests are adroitly aligned, their tails, fins or flippers either tucked into the sides symmetrically or drawn up neatly in front. The matching of both sides of a face from the center line calls for inordinate skill — a fact not always recognized by the inexperienced observer. Similarly, the "blocking" (proportioning of figures) of the sides of a pole imposes a severe test on the carver's capability.

Once a carver has mastered the basic technique of pole-making he begins to develop a distinctive style. Although he follows a standard mode of crest depiction, he subconsciously or consciously places his own inimitable "signature" on each pole. He may shape his faces differently from other carvers. His beaks may be extra long. He may fold his wings a certain way. He may double-engrave ovoids. These may seem like minor details, but they can be extremely revealing of an artist's style. As well, there may be distinctive personal touches in pedestal trims, in the finishing of the sides of the pole, in the positioning of the crests against the shaft, and, most especially, in the shape of the pole itself.

27.
Miniature poles

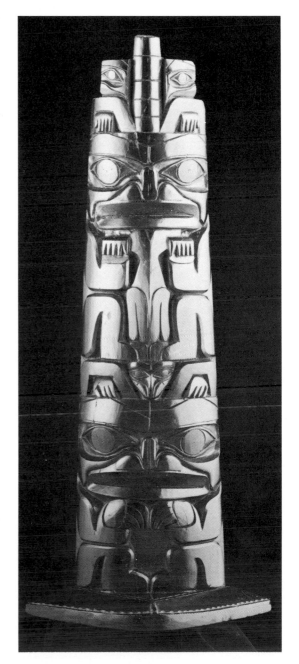

Early pole, finely done. Museum No. 6695. Height approximately 35 cm.
— *Ethnology Division, British Columbia Provincial Museum*

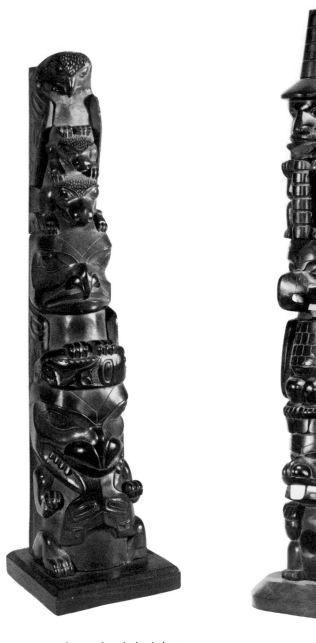

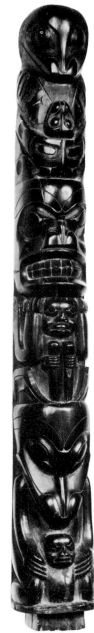

Exceptionally fine early pole, hollow-backed, with hole close to base. Figures from bottom, beaver, hawk or thunderbird and human female (Dzelarons), with skils of status. Note ivory inlays. This carving was collected by James Swan of Port Townsend, Washington Territory, in 1873, and acquired by the museum in 1876. Museum No. 5091. Height 47.5 cm. excluding base.

— *Museum für Völkerkunde, Vienna*

Eagle on top, two bears, thunderbird clasping whale, grizzly bear with whale in mouth. Gift of Foster B. Dickerman. Museum No. 5009. Height 41.2 cm.

— *Taylor Museum Collection of the Colorado Springs Fine Arts Center, Colorado Springs, Colorado*

Separate engraved base fits into flanged end of this pole which, like some others of the period, could have been copied from a house front pole of cedar. Six-figure legend depiction. Collected by Adrian Jacobsen in 1881 and accessioned in 1882. Museum No. IV A 493 a & b. Length 55 cm., with base.

— *Museum für Völkerkunde, Berlin*

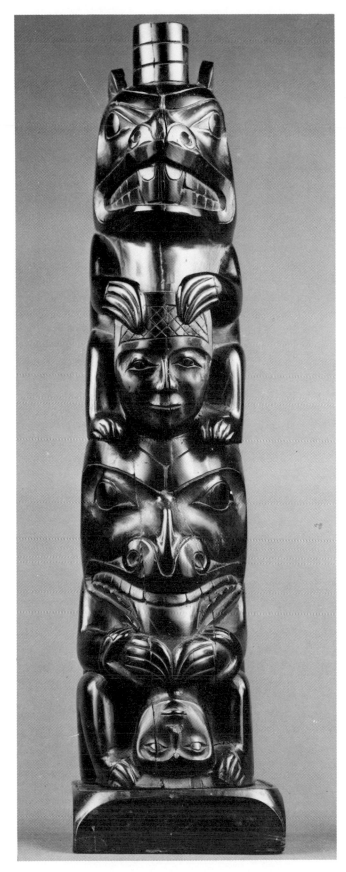

Pole, from top: beaver wearing skil, crest of chief whose face is shown on beaver's tail; grizzly bear holding human figure upside down. Museum No. 59.275. Height 33 cm.

— *University Museum of Archaeology and Anthropology, Cambridge, England*

A beautiful work by a master carver. From top, beaver, grizzly bear, black whale. Hollow-backed. Detailing includes notched lower-brow lines on beaver and grizzly bear, cedar rope around beaver's neck, abalone shell eyes on grizzly, and bone teeth. Museum No. 97-8. Christy collection. Height 54 cm., depth at base 9.5 cm., width at base 10 cm.

— *British Museum*

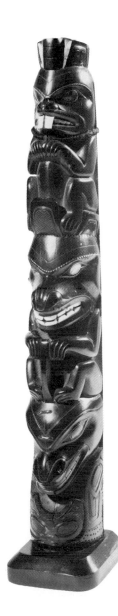

Each pole has a certain geometric conformation which is best seen by looking down on an upright pole from above and, observed this way, it appears as an arc. Looking down on several poles at the same time, it can be seen that some are deep and some shallow in the arc. The depth of the arc, plus the degree of tapering of the shaft, can characterize a particular pole-carving style.

1855-1870

1900-

The fashion for pole-making began shortly before 1860 at a time when carvers were turning away from the panel pipe. Conceptually, in relation to the panel pipe, it involved a ninety-degree shift from a "flowing" horizontal form to a more rigid, vertical form. Above all, it marked the beginning of the end of the carvers' fascination with European-American motifs and an irreversible return to native Haida motifs.

If, as we have suggested, argillite art had its birth within shamanism, by the late 1800s it was obediently following the dictates of western commerce. During the 1860s and 1870s when Haida villages lay numbed by the shock waves of disease, little argillite work was produced.

In the 1880s things began to look up. A surge of economic confidence swept through British Columbia. It was an era of steamer travel to the North Coast. A summer tourist trade opened up and Haida artists responded with, among other goods, the argillite pole. Here was an object that could be explained to customers much more easily than a panel pipe.

By the 1880s, Haida villagers were no longer erecting their giant cedar poles. At the urging of missionaries, the poles that had stood for years at Skidegate and Old Masset were being deliberately destroyed by overly-zealous Haida converts. In its small way, the slate pole helped to fill a void. It was acceptable to the missionary with his Protestant work ethic, for the same reason that big-pole carving was unacceptable — slate carvings earned money for the Haida and the big poles did not. The multi-talented Haida artist had no choice. Conservative, balky, independent in spirit, he still wanted to depict his treasured crests and stories. If he could not do so in wood, he would do so in slate.

The very first poles, believed to date from approximately 1855 to 1870, look much like cedar house posts and quite likely some of them are models of frontal poles or interior house posts that "dressed" Haida houses. They are broad and thin in the arc, stubby and hollow-backed, some even retaining the "house entrance" hole in the center of the pole close to the base. The carving is shallow, as on a house post. Only a few museum collections contain examples of these early slate poles.

If these first, stubby poles were indeed "model totem poles," within a few years the carver was striking out on his own, adopting the pole as a story-telling medium for his own artistic purposes. He

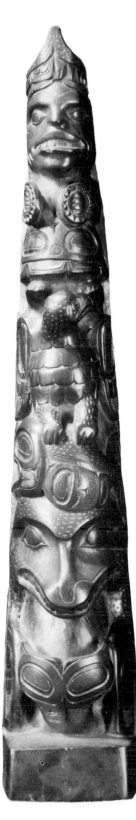

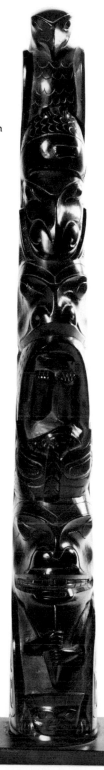

A legend pole, probably by a Tanu carver. Figures from top: eagle clasping salmon; wasco with its three whales from the sea; raven represented with human head but with wings and broken beak, possibly a depiction of raven losing his beak to the fisherman. Museum No. 1644a. Height 38 cm. Copyright, Bristol Museum and Art Gallery.

— *Bristol Museum and Art Gallery, Bristol, England*

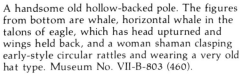

A handsome old hollow-backed pole. The figures from bottom are whale, horizontal whale in the talons of eagle, which has head upturned and wings held back, and a woman shaman clasping early-style circular rattles and wearing a very old hat type. Museum No. VII-B-803 (460).

— *National Museums of Canada, Ottawa*

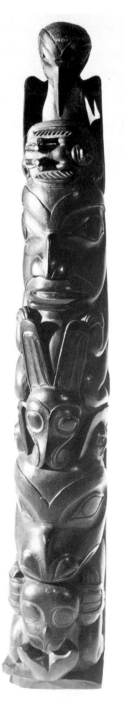

Kit Elswa's copy of a Kiusta pole, made for Swan. From top, raven with small figure on woman, butterfly, grizzly bear-killer whale with sea lion.

— *Field Museum of Natural History, Chicago*

abandoned the stump shape for a tall, slender pole. Yet even with the new shape we can find an isolated instance of a cedar pole being copied. One of the first argillite poles traceable to a specific carver was a model of a cedar pole — custom-made as a challenge.

Johnny Kit Elswa, whose name later became Elsworth, acted as guide and interpreter for James Swan of Port Townsend when the latter was collecting artifacts in the Charlottes in 1883. He drew Swan a set of designs in India ink and then demonstrated that he was equally capable of working in another medium.

Swan had been intrigued by a cedar totem pole at Kiusta which had grizzly bear with a creature in its mouth at the base, and raven at the top. "I could make out all the figures but butterfly, which I thought at first was an elephant with its trunk coiled up, but on inquiry of old Edinso (Edenshaw), the chief who was conveying me in his canoe from Masset to Skidegate, he told me it was a butterfly, and pointed out one which had just lit near by on a flower," Swan said. Edenshaw told him the legend of Raven's search for good land, and of his companion, Butterfly, hovering over Raven's head and pointing to any good land he saw with his long proboscis. "In fact," said Edenshaw, "the butterfly showed the raven round the country just as Johnny is showing you."

The idea of being compared with a butterfly so amused Kit Elswa that he made a deal. If Swan would sketch the Kiusta pole, he would carve a replica in slate when they reached Skidegate. Both men kept their bargain.[2] The Kit Elswa facsimile in slate adorned Swan's artifact-cluttered office in Port Townsend and eventually went to the Field Museum of Natural History in Chicago, where it remains today.

Swan and Kit Elswa, in Swan's office at Port Townsend, Washington Territory, April, 1886.

— *Smithsonian Institution National Anthropological Archives, Bureau of American Ethnology Collection*

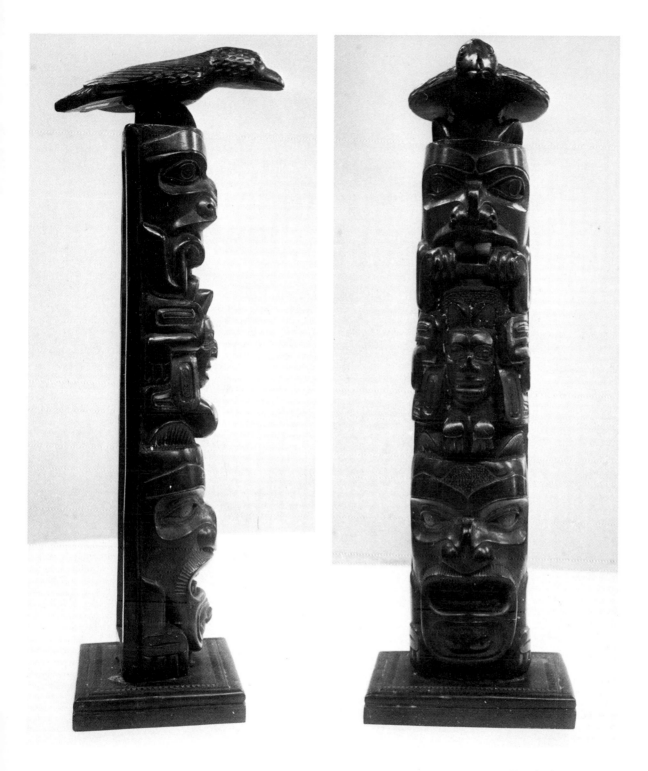

Hollow-backed pole with raven in horizontal position at top. Height 33 cm.

— *Canterbury Museum, Christchurch, New Zealand.*

However, even at this early date, the argillite pole was well on its way to becoming an independent art form thematically distinct from its cedar prototype. In the 1870s and 1880s it became taller and deeper in the arc, though it retained for some time a slightly hollowed back. Since then, it has undergone three major changes.

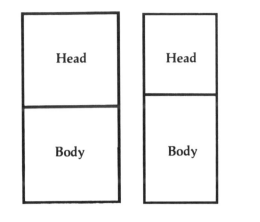

Head
Body

Pre-1900

Head
Body

1900-

The first concerns its over-all conformation. The original wide arc with its concave back was gradually abandoned in favor of a deep arc with a straight back. Second, the proportioning of the figures has altered drastically. On most of the early poles, including the "house-post" type, the crest head is approximately the same size as the body. On most poles produced in this century, the head is smaller than the body, the ratio being about forty-sixty. Third, from about 1890 to 1945, pole carvers often depicted double figures on a single pole segment — two heads one above the other or side by side — whereas after 1945 the single figure prevailed.

In the opinion of most modern carvers, the more figures an old pole contains the better. Multiplicity of figures indicates a long story, a long legend line, and not simply a sequence of crests. Poles of three and four figures are being made today to meet market demands. Three figures are considered the right number for the currently popular ten-inch (25 centimeter) pole. In the high noon of pole-making from 1880 to 1920, a great many superb multi-figured legend poles were carved.

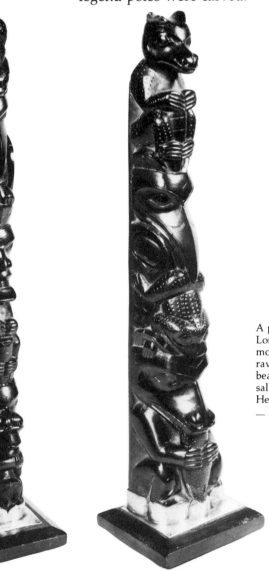

A pair of poles presented to the Marquis of Lorne and his wife Princess Louise, with silver mountings at bases. Left pole from top: frog, raven, sharkwoman, beaver; right pole: grizzly bear, raven, salmon, frog, grizzly bear with salmon. Museum Nos. A.62.62.55 A & B. (L) Height 35 cm. (R) Height 38 cm.

— *Glenbow Museum, Calgary, Alberta*

224

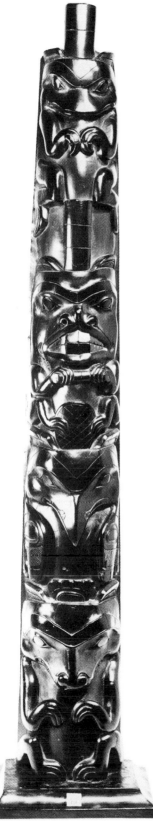

A handsome four-figure pole presented to the museum by the Countess of Kintore. Museum No. 993A. Height 74.6 cm.
— *Anthropological Museum, University of Aberdeen*

An early pole by Andrew Brown. From Top; eagle, sculpin, man, bear, frog, with human figure. Height 29 cm.
— *David Hancock collection.*

Fine 20th Century pole of two main figures with eagle on top and frog in mouth of bear. Museum No. AA29. Height 27.9 cm.
— *Centennial Museum, Vancouver*

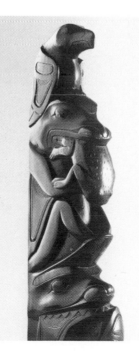

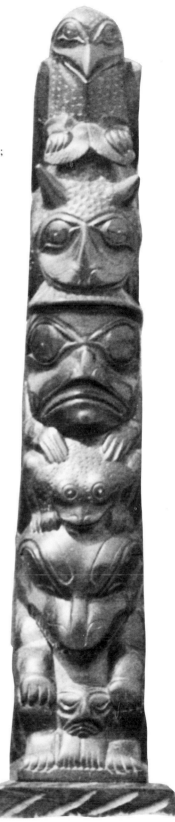

The uprooting of Haida people from their plague-stricken villages may actually have proved a stimulus to slate pole carving by arousing a spirit of competition among carvers. By 1900 scattered villagers had been gathered into Old Masset and Skidegate, either in a single move or with temporary stopovers along the route. These transplanted people, loyal to long-standing crests of their own, found themselves amid a welter of less familiar crests. The desire to assert their own crest identities would have been strong. And now, in slate, the artists among them could vaunt crests that would never again be raised in wood, at least not in the settings of their home villages. The number of outstanding carvers at Skidegate and Masset who came originally from the deserted villages is immediately obvious: Paul Jones and Thomas Moody from Tanu, Robert Miller from Gold Harbour, formerly of Tasu; Tom Price from Ninstints, John Robson from Rose Spit, George Smith from Cumshewa, Henry and Joseph Moody from Skedans, among others.

Virtually all the late nineteenth century carvers of slate poles whose names have come to us were just as capable of carving in wood as they were in argillite. Several of their names appear in data provided by James Deans to accompany a wooden model of Skidegate which was made at his direction by Skidegate carvers for the Field Columbian exposition at Chicago in 1893: John Robson, David Shakespeare, George Dickson, Moses McKay, John Cross. Two others, Philip Pearson of Ninstints and Peter Smith may also have been argillite carvers.

Certainly they knew then, as does the slate carver of today, that the pole is a decisive test of the carver's skill. Most twentieth century carvers have made poles at one time or another, so it is small wonder that so many have been produced.

This display of 19th Century argillite in an old photograph taken at Ottawa presents an opportunity to examine different styles, although no carvers' names have been recorded. The collection apparently consists mostly of poles collected by Dr. Israel Powell at Skidegate for the Geological Survey of Canada and received by its museum in 1879. In the original photo they were placed on three shelves against a woven wall hanging. Someone later whitened out the background. The collector, entry date and catalogue designations are given here, with numberings from left to right:

TOP ROW
1. Powell, 1879, VII-B-829
2. Powell, 1879, VII-B-832
3. Carved panel of shaman scene, possibly by William Dixon, collected by Dr. George M. Dawson, Skidegate, 1885, VII-B-753 (2889).
4. Powell, 1879, VII-B-784 (99); height 39.5 cm.
5. Powell, 1879, VII-B-773 (96); height 35.5 cm.

CENTRE ROW
1. Powell, 1879, VII-B-827
2. Pole with concave back; Powell, 1879, VII-B-782 (90); height 47 cm.
3. Powell, 1879, VII-B-834.
4. Powell, 1879, VII-B-783 (84); height 46.8 cm.
5. Powell, 1879, VII-B-830.
6. Pole attributed by Henry Young to John Robson (Barbeau). Powell, 1879, VII-B-835 (94); height 41.1 cm.
7. James Richardson, 1884, VII-B-752 (1392); height 39.8 cm.
8. Unknown.

BOTTOM ROW
1. Back of this pole is only slightly hollowed. Powell, 1879, VII-B-786 (95); height 40 cm.

2. A fine pole with hollow back. Dawson, 1885, VII-B-750 (2390); height 54.6 cm.
3. Another fine old pole, with chief's head at top pegged on. Powell, 1879, VII-B-781 (85); height 53.3 cm.
4. Major figures from top are chief, shark-woman, bear. Back slightly hollowed. Powell, 1879, VII-B-828 (89); height 56.5 cm.
5. Major figures from top are eagle (head of ivory lost) pegged onto pole; raven?, beaver with skil and whalebone teeth, grizzly bear. Powell, 1879, VII-B-789 (92); height 57.8 cm.
6. By same carver who made the previous pole. This eagle kept its head. Powell, 1879, VII-B-787 (93); height 56 cm.
7. Powell, 1879, VII-B-831.
8. Oval base is ornamented with circles and cross-hatching. (Note variously-shaped bases throughout). Powell, 1879, VII-B-785 (100); height 49.6 cm.
9. James Richardson, 1884, VII-B-833 (1383); height 48 cm.

— *National Museums of Canada, Ottawa*

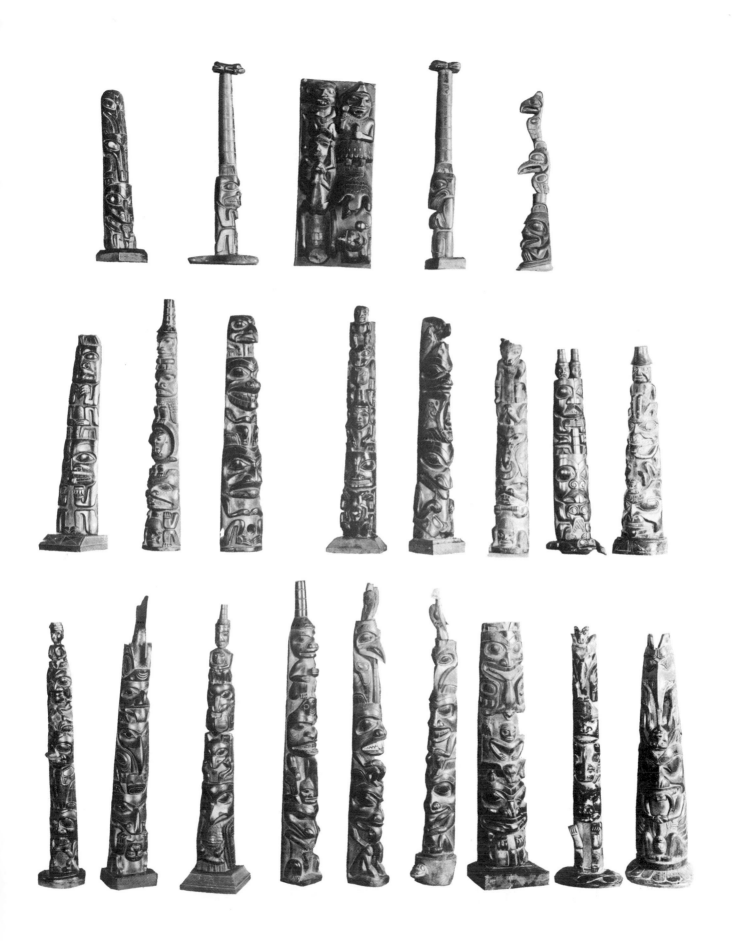

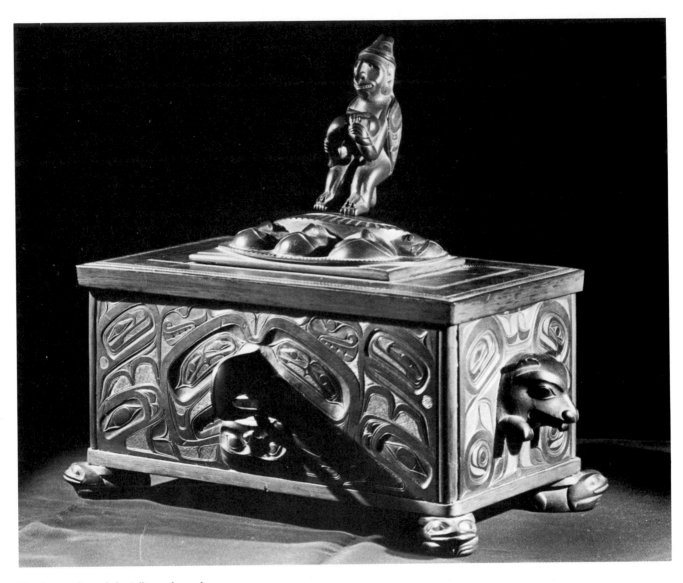

Hawk crest face of the Jelliman box, also
showing one of the end bears and front of
surmounting figure. Museum No. 10622. Length
36 cm., maximum height 34 cm.

— *Alex Barta*

Beaver crest face of the Jelliman box, also
showing surmounting figure, bear heads at ends,
and frogs for feet. Museum No. 10622.

— *Ethnology Division, British Columbia Provincial
Museum*

Highly decorated large rectangular boxes made of wood were once the furniture of Haida houses and were used principally for storage. Members of a household also owned many small decorated wood boxes in which they kept their most valuable belongings. The shaman, as we have seen, had personal boxes containing his secret articles. In Haida legends are frequent references to boxes containing food and other belongings. Thus about 1880, when the argillite carver began creating boxes in slate in response to the demands of white customers, he was perpetuating a precious part of his collective past.

The argillite box ranges from ten to seventy centimeters on its longest side. Early examples tend to be big, modern ones small. But the classical box is almost as scarce as the recorder — Canadian museums own one or two each at the most. The largest number are found in the United States in museums supplied by emissaries during the 1880s. The United States National Museum of Natural History (Smithsonian Institution) owns five boxes collected by James Swan, and the American Museum of Natural History in New York City has approximately the same number.

Large or small, the slate box is a showpiece of carving virtuosity. Here the artist is working within the same dimensions as the housefront decorator or the screen painter, and must demonstrate the same skill at organizing his designs within a square or rectangle. The long sides were usually the centers of interest. The lids were platforms for spectacular displays, giving rise to high-relief carving or upright figures attached by separate mountings. Having five surfaces for ornamentation, the box takes more time to carve than most other types of argillite carving. For this reason, as well as the care required in shipping, the largest of them were probably custom-made.

A few exceptional boxes, past and present, are examined in detail:

The first, in the British Columbia Provincial Museum, is attributed to Charles Edenshaw, and has been called both the Jelliman Box and the Origin of Mankind. It is just over thirty-six centimeters long, twenty-one centimeters wide, and sixteen-and-a-half centimeters high to the top of the lid itself or thirty-four centimeters to the top of the surmounting figure. It belonged to Jessie Jelliman, first wife of the late Charles Jelliman of Vancouver. She and her sister, who married Premier John Hart, were daughters of Donald Mackay, a Hudson's Bay Company employee whose wife was a North Coast native. In 1930, Jessie Jelliman sold this box and other argillite carvings to William Newcombe, then assistant in botany at the Provincial Museum. In 1961 it was bought by the Provincial Museum from the Newcombe estate.

On one side of the Jelliman Box is a hawk crest, with double eyes within the main eye formlines. The projecting beak curves inward to the hawk mouth, which is linked with the mouth of an inverted human face. On the opposite side is beaver, also in relief. On each end, glued in place, is bear, again in high relief. The surrounding designs on all four sides reveal this box as the work of Edenshaw, most notably in the double-eye designs and double engraving. At each corner of the base, squat frogs give a satisfying pedestal finish.

28.
Boxes

For high drama the carver placed an evocative group figure in the center of the lid. Here is depicted one legend of the origin of Haida people, through Raven from a clam or cockle. Five faces of newly-born Haida gaze up from the shell opening, while the sixth, eyes shut, is held by Raven, a detachable figure mounted on a horn spike. This is supernatural Raven. Although his head and body are of human form, the feather cloak of transition is on his back and bird feet appear over the human feet.

The closed eyes of the young Haida clasped by Raven are a bit of a puzzle. Alan Hoover, the museum's assistant curator of ethnology, suggests that they may represent death, and the idea that, in creating life, Raven is also the bringer of death. But since Raven is coaxing the people out of the shell, the closed eyes may also presage their awakening. Whatever the carver intended, this box is one of the great works of argillite, imaginatively conceived and superbly executed.

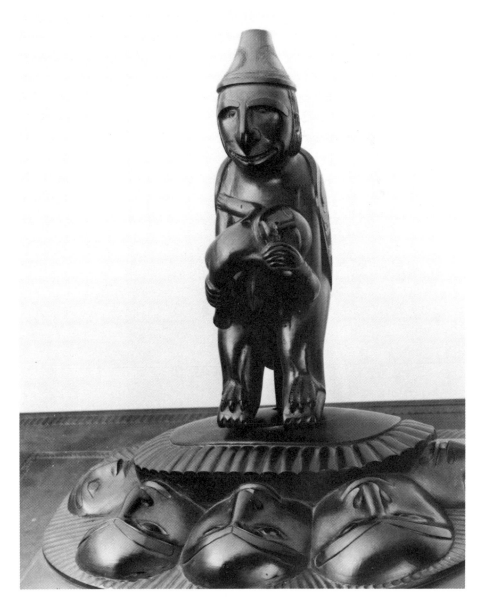

Detail of lid of Jelliman box, highlighting human forms emerging from clamshell.
— *Ethnology Division, British Columbia Provincial Museum*

A second celebrated box dates back to a once-memorable event in British Columbia history — the first visit of British royalty in the person of Princess Louise (1848-1939), fourth daughter and sixth child of Queen Victoria. In 1882 the princess accompanied her husband, the Marquis of Lorne, then Governor-General of Canada, on an official visit to Victoria, the city named in honor of her mother. The first transcontinental railway across Canada was still under construction so "Louise and Lorne," as the welcoming banners hailed them, traveled by train across the United States to the west coast, then north from San Francisco by steamer to Victoria. A few days later in New Westminster, thousands of loyal British Columbians, including 3,000 Indians, many of whom had traveled hundreds of miles, greeted the Queen's daughter. One of their chiefs presented her with silver bracelets and baskets.

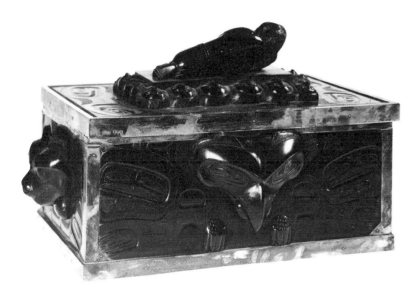

The box presented to Princess Louise. Museum No. Λ.62.62.55c. Length 36 cm., width 22 cm., height 17 cm.

— *Glenbow Museum, Calgary, Alberta*

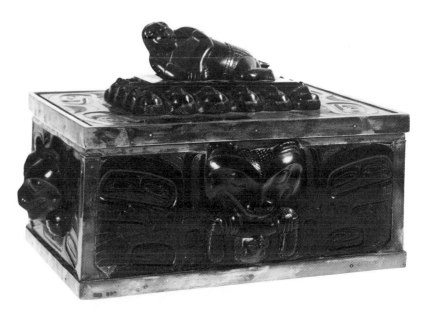

On this occasion or sometime later, Dr. Israel Powell, the first Indian commissioner for British Columbia, presented her with the argillite box.[1] It broke while being shipped to the vice-regal residence in Ottawa, and after that its various whereabouts become hazy. We can establish that it was restored in London in 1891-92 with sterling silver bindings befitting its artistry and ownership. Sometime later an argillite collector, C.P. Smith of Victoria, bought it in London from a Powell granddaughter. Smith sold it to the Glenbow Foundation in Calgary, Alberta in 1962, eighty years after the royal event that occasioned its presentation.

Although this box has been attributed to Edenshaw, recent research by Carol Sheehan, assistant curator of ethnology, Glenbow Museum, suggests it is instead the work of John Robson. In high relief on the lid reclines the figure of a high-ranking Haida woman. She rests on a rectangular base surrounded on three sides by little human heads — the recurring theme of the birth of Haida people, perhaps an allusion to Foam Woman of the Ravens. On the front side is the head of grizzly bear holding the woman berry-picker under him, his paws grasping her wrists. At the back is a high-relief head of Raven with the sun (or moon) in his beak. Each end has a grizzly bear head, also in high relief. The ornamentation includes cross-hatching in eye and wing designs, dashings to show the fur on the bears, and fine strokes to show the hair on the human heads. It is a large box: length sixty centimeters, width twenty-one centimeters, and height with lid just over twenty-four centimeters.

Powell purchased another argillite box at the same time and paid his Masset source $400 for the pair. The latter box or "casket," as its documenter anthropologist Charles Hill-Tout described it, is peculiar in that it is mounted on four argillite wheels with bone axles. "Surely atrocious," commented argillite connoisseur Harry Beas-

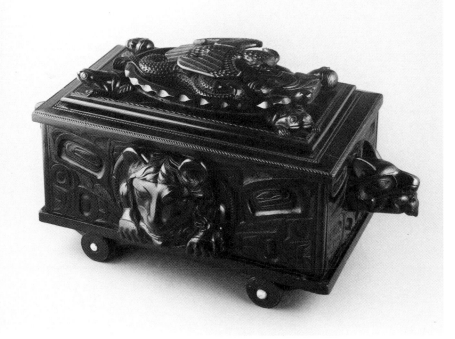

The Mrs. Israel Powell box, also known as the Spencer box. Museum No. 61ab. Length 50.8 cm., maximum height 27.9 cm.
— *Centennial Museum, Vancouver*

ley, director of the Cranmore Ethnographical Museum in Chiselhurst, Kent, in a 1936 letter to William Newcombe after seeing an illustration of this box.[2]

The quirky wheels notwithstanding, it is an outrageously impressive creation carved with unusual figures such as a bird-serpent creature on the lid and a lion head on the main face. The carriage effect of the wheels together with the lion emblem suggest that the box was made as an alternative choice for presentation to Princess Louise. In this case, Powell must have rejected the box as outré, since he gave it to his wife. Later it passed into the hands of Mrs. Jonathan Rogers of Vancouver and is now the property of the Centennial Museum in Vancouver.

Besides these three elaborately-carved boxes, there are equally beautiful boxes that are simply engraved on their five surfaces. Over the years, the average size of boxes has tended to diminish until today some of them resemble jewel cases. One finely-tapered contemporary specimen by Ed Russ (dimensions 11½ x 5 centimeters at the base, 10 x 3.7 centimeters at the top, total height 16 centimeters) is similar in shape to the Haida bent-cedar boxes which were once used for storing possessions during canoe journeys. Upright bear mother holds twin cubs on the lid, bear is on the front face, with abalone shell inlaid in ears and eyes, and on the reverse side is hawk, also inlaid with abalone shell. Four bear cubs form the base feet. Heavy roping outlines the strong, deep carving.

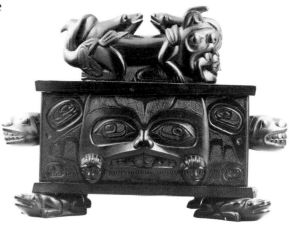

This is a copy by an unknown 20th Century carver of a box that was once in the Cunningham collection and which was attributed to Charles Edenshaw. On top, wasco bringing in whales; on this side, beaver with human faces in paws; opposite side has a full-faced eagle. Museum No. 13528. Length 18.3 cm., maximum height 15.9 cm.
— *Ethnology Division, British Columbia Provincial Museum*

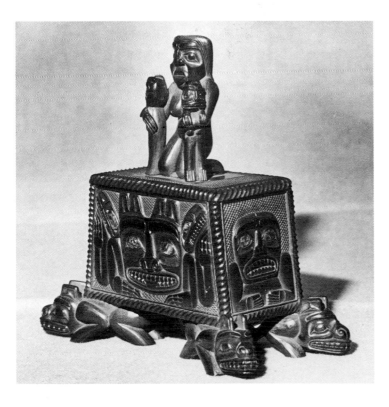

Bear mother box by Ed Russ, carved in 1978.
— *Alex Barta. Courtesy Bill McCallum*

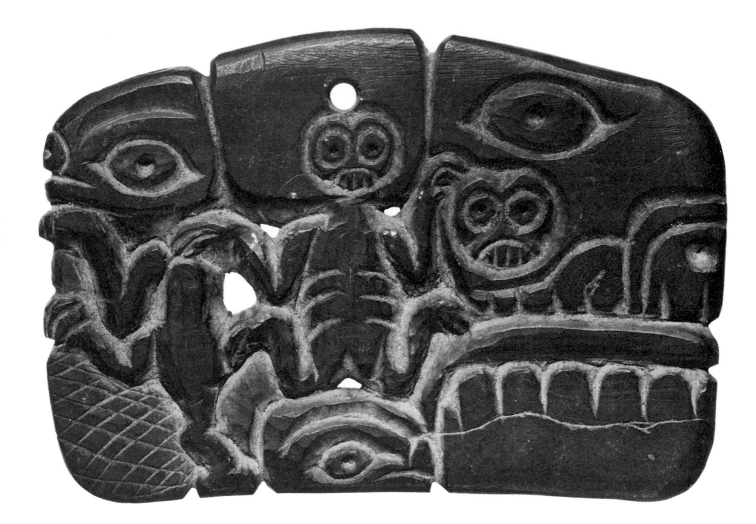

Amulet collected by Beraz, with beaver in profile
at left and five-finned whale at right. The
engraved faces are reminiscent of coastal
petroglyphs. Museum No. 91.147. Length 10
cm., height 6.5 cm.

— *Staatliches Museum für Völkerkunde, Munich*

Through the long history of argillite, carvers have created many articles of personal adornment. Probably the oldest are the amulet and the labret. Very few examples have survived from the mid-nineteenth century, which is assumed to be their latest period of manufacture. The labret, a lower-lip ornament, died out entirely, but the ancient amulet has a modern counterpart in form, if not in meaning — the medallion.

The amulets of any culture excite the imagination. Who wore them? What exactly was the belief attached to them? What was their value to the wearer? Amulets invite us to examine a very intimate aspect of the soul of human nature.

Haida amulets were personal charms or talismans. As well, they may have signified membership in a certain society, and have had ritual significance.

Both the Tlingit and Haida made amulets — of stone, ivory, bone, shell, and wood. Most of them were drilled with a small hole for cord thonging. Although they have rather late accession dates, a few argillite amulets existing in museums may be of considerable antiquity. They are engraved with the same round-eyed, round-faced outlines that stare from prehistoric petroglyphs and other mysterious carvings in stone found in widely-separated regions of British Columbia.

Labrets, the lower-lip ornaments of status worn by the Haida, Tlingit and Tsimshian women that so shocked the white merchant navigators, were made of stone and wood, sometimes inlaid with abalone shell. These lip plugs are extremely rare in argillite. One was found on the surface of a 2,000-year-old archaeological site on the east coast of the Charlottes.[1] The Centennial Museum in Vancouver has another, reputedly found at Cumshewa Inlet.

With the transformation in Haida thinking and fashions brought about by their association with whites, the labret and the amulet dropped out of the argillite repertory. Neither had relevance in this new white man's world. The amulet ceased to have meaning, and Haida women, however high-born, were dissuaded from wearing the labret. The lip pieces were still being worn in 1853 when *Virago's* sailors visited the Charlottes, but in the following twenty-five years the custom died out. "Till quite lately the females among the Haidas all wore labrets," George Dawson reported after his 1878 exploration of the islands.[2]

The amulet's pendant form, dormant for a century or more, has been revived by the argillite carver. In the last twenty-five years it has re-emerged as the medallion, usually drilled with a small hole for stringing on a gold or silver chain. The first argillite medallions were solid circular discs about 3.5 centimeters in diameter, engraved with a single crest such as killer whale. Lately they have evolved into triangular and irregular shapes, some with open-work and some with inlays.

Economics gave rise to the medallion just as economics probably influenced the start of pole-making in slate. The carver recognized a market demand for a low-priced item. At the same time, medallion-making was an excellent means of using his scraps of raw argillite. In the 1950s, a well-carved medallion sold for up to $10. Today the price runs as high as $200. Still, pendants remain one of the least

29.
Et cetera ...

Pendant-type amulet depicting three bears. Although it was obtained by the museum only in 1914, it has the look of an early work. Museum No. IV A 8803. Length 5 cm., depth 5 cm.
— *Museum für Völkerkunde, Berlin*

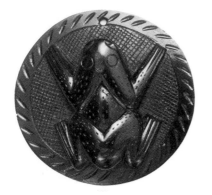

Frog and killer whale medallions by Pat McGuire.
— *Philip F. Graham*

Candlestick, good understanding of the elements within the carved figure, smooth cuts throughout. Museum No. 8454. Height 15 cm.
— *Ethnology Division, British Columbia Provincial Museum*

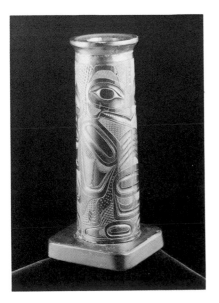

expensive creations of the slate carver. For the well-being of argillite carving, it is important that there should be attractive items available at modest prices. This most native of native British Columbia crafts has always offered something for small pocketbooks, and one hopes it always will. A finely-carved medallion is a true gem. Any collector who wishes to assemble a wall or cabinet display of medallions representative of contemporary carvers can still do so at a reasonable cost.

Other slate "jewelry" from the past is almost non-existent, primarily because of the likelihood of chipping and breakage during wear. The occasional finger ring, solid bracelet or brooch shows up in museum collections. The modern carver, however, has more than made up for the neglect of jewelry by his predecessors. As well as medallions, he has crafted a wide variety of earrings, brooch-and-earring sets, clasp pendants and tie pins. He has produced link bracelets with metal backing for support. In fact, he has created jewelry of every possible kind.

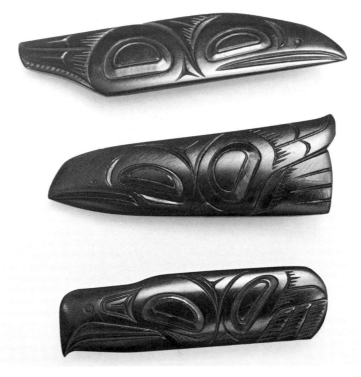

Brooches by Pat McGuire. Approximately 5.7 cm. — *Philip F. Graham*

A few household items such as cups and cutlery were made in the last century, then wisely given up. The National Museum of Man at Ottawa has a set of cups (more correctly mugs with handles), etched with the tobacco leaf design. Cribbage boards and chess sets have also been carved. Candlesticks, inkstands, penholders, bookends and ashtrays decorated in Haida motif have been produced by a few carvers, mostly in the first thirty years of this century. While they can be quite attractive, these knick-knacks hold little appeal for the modern carver. Among the "household" productions can be found a few extraordinary carvings which must

have called for tremendous effort on the carver's part. One is in the Alaska State Museum at Juneau — an exotic mantel clock set in an elaborate argillite case of admirable craftsmanship.

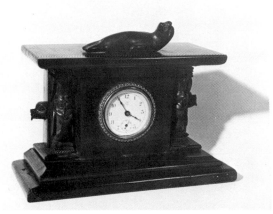

Argillite clock case, commercial face and works, on a rectangular stepped base. At one time it had a carving of a bear killing a sea lion on top. Museum No. II-B-1024. Height 13 cm., width at top 18.7 cm.
— *The Alaska State Museum. Mark Daugherty Photo*

Pendants modelled by Lisa Banfield.
— *Alex Barta*

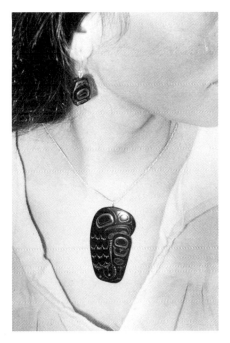

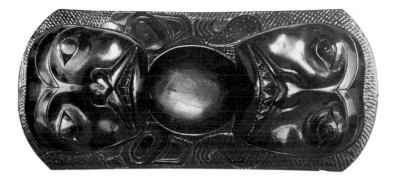

Small grease dish by Jim Mackay. Length 17 cm., width 7.6 cm. Drew collection.
— *Philip F. Graham*

237

This small, flat container is an example of Christian symbols applied to argillite. On one side an angel appears; on the other the devil. In depicting the devil, the carver reverted to his own symbolism and gave him the beak of raven stealing the moon. Still, he conveys a sense of malevolence in the devil's face. Museum No. 6370. Height 11 cm.

— *Ethnology Division, British Columbia Provincial Museum*

In the entire range of objects fashioned out of argillite, one thing is conspicuous by its absence — church plate. The cross, the chalice, and the baptismal font seem not to have been made in slate. At a time when Christian fervor was stronger than it is today, carvers must have been asked to make such objects. But if they did, we do not see them in present-day museum collections. Once in a while, though, on a panel or a bowl, one sees the representation of an angel. The wings are quite unangelic; they look more like an eagle's wings, suggesting that the artist was uncomfortable with Christian symbolism.

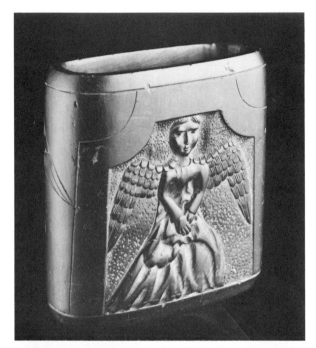

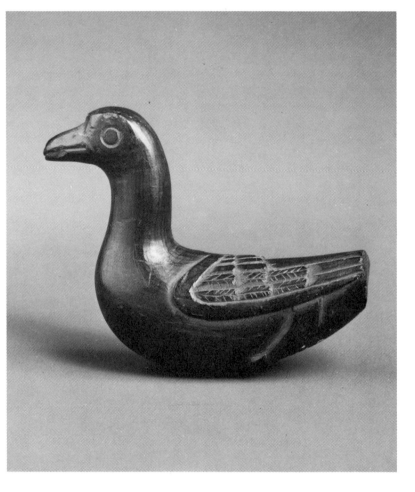

Essential simplicity in argillite: bird resembling a seagull, at one time in the Oldman collection. Museum No. IV A 8792.

— *Museum für Völkerkunde, Berlin*

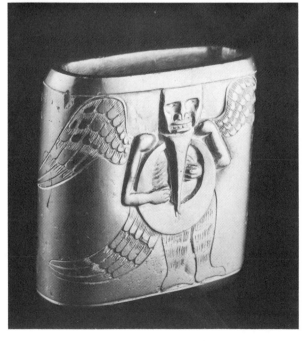

This brings us back to a point we made earlier: that the argillite carver, left to his own devices, essentially does what he wants to do. Commissions were all very well for quick money, but the real artist was intent primarily on satisfying himself, on honoring his art and his heritage.

He was able to do this and do it gloriously, even with a limited range of object forms. The prime limitations were imposed by temperament and technology, by the relative inaccessibility of the deposit compared with sources of wood, and by the nature of the material itself, particularly its breakability. Thus there was no practical domestic use for argillite in the Haida house. But for the artist who delighted in this unique material, there was ample opportunity within the range of object forms he developed, to tell the valued legends and stories of his people. One by one, year upon year, the carvers built up a pictorial record of Haida deeds and history. Through subtle variations in their treatment of each form, they bequeathed to the world an array of creative riches unequalled in scope and volume by any other native art form of the Northwest Coast.

Part 6
The
Personal
Statement

In his designs, the Haida artist is a devout conformist. His design elements — ovoids, U-shapes, split crescents — have changed little over the years and the figures he makes, whether raven or wasco or killer whale, are distinctly Haida, different from Tlingit figures (less "busily" elaborated, the Haida say) and more abstract than those of the Tsimshian. Yet each Haida artist has his own stylistic mannerisms which distinguish his work from another's and these can amount to "unsigned" signatures.

Amid the array of argillite carvings by unknown artists of the nineteenth century, certain stylistic features are revealed on a panel pipe in one museum which also appear on a panel pipe in another museum on another continent. The similarities are so striking they lead one to believe that the two pipes were carved by the same artist. Likewise, several standing-figure "thin-men" in their long frock coats appear to be the work of one particular artist. On several nineteenth century dishes, the designs and details are so consistent as to raise the possibility of their having been created by the same hand.

To whom can they be attributed? In most instances, unfortunately, their carvers remain faceless, and will probably never be known to us. It would be gratifying to think that Waekus was the creator of the two carvings exhibited in London in 1862, but that would be pure speculation. And were most of the recorders from the hand of George Gunya? Some of them look remarkably alike, but again we cannot be sure. The white people who first acquired these works did not bother to record the carver's name, and the carver himself apparently had no desire for personal acclaim. He was simply doing what was important to him, expressing himself and the values of his society. At the same time, though, if he was an experienced, decisive carver, he probably exhibited his own style, his own imprint of originality and made it a personal declaration.

Marius Barbeau was the first person to consider seriously the question of individual style in argillite carving. Although he arrived too late to save from anonymity the great majority of nineteenth century carvers, let alone identify them stylistically, he did compile biographies of a number of craftsmen from the 1880-1950 period and suggest the manner in which some of them carved. The dominant carvers of the first half of that period were Charles Edenshaw and Tom Price. In their work and in that of others, Barbeau recognized individuality in their choice of themes and carving styles. What Barbeau looked for is what one still looks for in trying to attribute a name to unsigned pieces:

1. The general conformation of the object in each category — a preferred shape. Some dish masters, for example, have tended to make ovals (Pat McGuire), blunt oblongs (Ed Russ) or tapered ovals (Tom Price). Certain pole makers structured their poles differently from others. These structuring distinctions probably date to the panel pipe era.
2. The conformation of the figures, whether one, two, or three dimensional. This means the actual contouring of raven, eagle, bear, killer whale, or whatever; the set of the head, the arch of the neck or back. Taken one step further, conformation also includes the positioning and outlining of every component —

30.
Anonymous masters

wings or arms, feet or tails, feathers, claws or fingers — the way they are either "tucked in" for integration or allowed limited freedom.

3. How the spaces are filled; the ratio of background to decoration.
4. The finishing; the detailing of design elements, and, finally, the polish.

If every experienced carver were completely consistent in all the work he did, one could adopt these guidelines with assurance. But unfortunately one cannot. A carver may originate a piece and have someone else finish it, in which case it takes on a style characteristic of the second craftsman. He may have worked in great haste, or have had an "off" day or an "off" week when he was not in peak form, so that the finished product will not be representative of his best performance. A carver might also conceivably change his style at some stage in his life, influenced by a fellow artist perhaps, although this does not seem to have happened to any great extent. John Cross, for instance, was at one time a carving companion of Tom Price, yet a typical John Cross pole is structured quite differently from a Price pole.

What may serve as a guide to the style of one established carver — conformation of figures, say — may not apply in the case of another. Nor does each necessarily exhibit the same distinctive mannerisms throughout his career. But in one respect, both the anonymous early masters and their successors like Edenshaw and McGuire were on common ground. Everything had to be just right *for them*. This is the great challenge of the identification quest: learning what was "just right" for a particular carver.

Accurate, or what one believes to be accurate, identification of a carver's work can be enormously satisfying. It is like meeting a long-lost friend from childhood, someone you have thought of from time to time, who suddenly appears in the flesh years later. A smile, a gesture, reach across the years, and then, in a flash, you remember a name. "I know you. Aren't you ------?"

With contemporary argillite, one has the answer immediately available in case of doubt and has only to look for the signature etched into the base. With older, unsigned pieces, identification becomes much more difficult. Indeed, only in Edenshaw's generation does it become meaningful to talk in terms of individual artists, each with his own identifiable style. And as with Edenshaw, there must be a substantial body of work to examine, enough that one can attempt to determine the characteristics of the mature artist. Barbeau was a pole specialist and studied pole carvings in both wood and argillite. As the most common work in the argillite repertory of the period he studied, the pole remains the best form for a test run on those old masters known to us.

We have selected ten carvers to illustrate hallmarks of individuality in carving style — three from Old Masset and seven from Skidegate. Three of them, John Cross, Charles Gladstone and Lewis Collinson, signed their later pieces, but the styles of most of the ten are distinctive enough to make signatures unnecessary. Some allowed themselves greater interpretive freedom than others, while keeping to the established argillite tradition. The seven from Skidegate conformed to the Skidegate habit of elongating ovoid outlines. The three from Masset made shorter, rounder ovoids.

We shall begin with the Masset carvers. The one whose work is easiest to identify was Isaac Chapman, of whom very little is known. A cripple who died before the age of thirty, Chapman is said to have come from Bella Bella of parents captured by the Haida and later freed. Barbeau gives an approximate date of 1908 for his death,[1] but a search in the Division of Vital Statistics at Victoria turned up no record of anyone by the name of Isaac Chapman or any of the other names he went by.[2] Yet he was apparently well-known to Charles Edenshaw, and was perhaps taught by him, though their styles are completely different.

The crests on Chapman poles are deeply undercut and therefore stand out from the body of the pole. To compensate for their outward thrust, he gave his figures flowing lines. The Chapman style is best seen if one views his poles from the side. Running the length of the shaft is a narrow, often unadorned strip from which the figures "take off." In their openness, Chapman's poles bear a certain resemblance to pipe carvings. It is almost as though a late trade pipe had been placed upright. The finishing is extremely smooth and uncluttered. Chapman had trading connections with the Cunninghams of Port Essington, and the Cunningham collection reputedly contained a large number of his poles.[3]

This pole is believed to be the work of Isaac Chapman. It dates to the end of the last century.
— *Alex Barta. Courtesy Mildred Erb*

31.
Indelible signatures

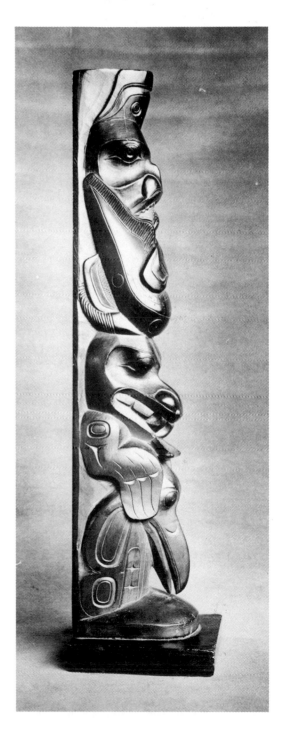

The second of the Masset stylists we have included is John Marks, who was an Eagle clansman, like Chapman. Marks sublimely disregarded convention in argillite. His poles have an extraordinary lack of symmetry, which is not to say that they are unbalanced, but rather that the figures are not compact and integrated to create the harmony that most other carvers sought. This may have been intentional, because Marks's poles have a strength — almost a virility. Marks not only carved in a peculiar style but also ventured into unusual figures, such as recumbent, mermaid-like creatures.

Andrew Brown at his work table.
— *British Columbia Government*

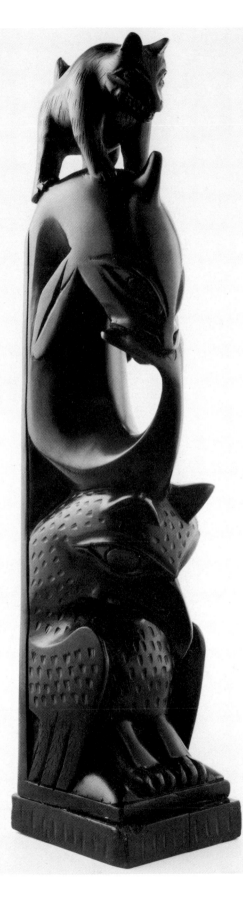

An example of John Marks's unconventional style.
— *Centennial Museum, Vancouver. Henry Tabbers Photo*

Our third Masset stylist is Andrew Brown — called Captain Brown to acknowledge his boat-building and shipping days. He was an incredibly prolific carver of poles, and a Brown pole is like no other. The faces are angular and often rough-hewn and at the top he usually placed a jut-headed eagle. The sharp outlines of his figures contrast with the fluidity of, say, a Chapman pole. His best work, and it was excellent, was done in his early years. In old age he was hampered by blindness.

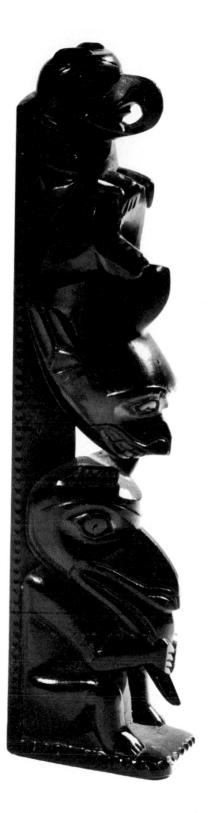

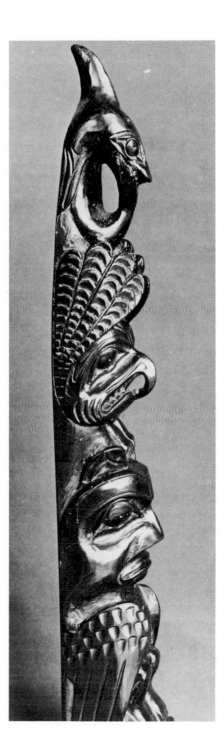

This Andrew Brown pole has killer whale instead of his familiar eagle at the top. The faces are sharply angled; surfaces lack smoothness.
— *Alex Burta. Courtesy Mr. and Mrs. M. C. Nesbitt*

A pole in the style of Isaac Chapman. The figures from top: thunderbird, whale, raven with whale in mouth.
— *British Museum*

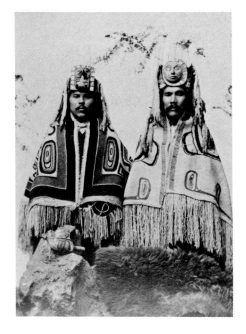

Tom Price (left) and John Robson, photographed in their ceremonial dress in Victoria, 1895-1900.
— *Ethnology Division, British Columbia Provincial Museum*

Brown was an Eagle of the Gitins division from Yan, which accounted for his partiality in using the eagle crest. He moved from one occupation to another — at various times he was a fisherman, a builder of schooners, power schooners and other power vessels, a shipper of lumber from Alaska to Masset, a housebuilder, and even a grocer. Throughout the North Coast he was known as a storyteller and humorist. He and his wife, Susan, had a great many children, and one of them, Eliza Abrahams, became an outstanding hat weaver and basketmaker.

Eliza Abrahams's son, Eli, remembers seeing his grandfather carving from daylight to dusk, day after day. "He would take boxloads of argillite — $1,500 worth at $1 an inch — to Vancouver or Rupert, at a single time." That would have been before the Second World War, because in 1947 Brown's fifteen-inch (approximately thirty-eight centimeters) poles were selling at $30 each, according to records kept by Rev. George Raley.[4] Today Eli Abrahams, who makes model houses of cedar, is what one imagines his grandfather to have been — outgoing, ready to share a joke, and willing to sit down at any time and tell a story.

From the Masset stylists, we turn now to Skidegate. If one had to choose the top-ranking Skidegate argillite carver of the past, from the few known, he would be Tom Price. Like Edenshaw, he was a master of design. Equally important, he had a great many stories to support the designs in his carvings and paintings.

In his Skidegate years, Price carved many superlative plates and platters, poles and boxes. High-relief figures, pinned and glued, adorn some of his finest dishes, and on them he frequently used the five-finned whale, a Ninstints crest. He took particular care in making his flat pieces superlative in their spatial ratios and the same design features illustrated on his dishes appear also on his poles — beautiful curving lines and "lots of roundness," as Ron Hamilton observes. You see this in the curves of his mouths, in the grandly curled nostrils, and in the eyes. Now and then he signed his pieces "Tom."

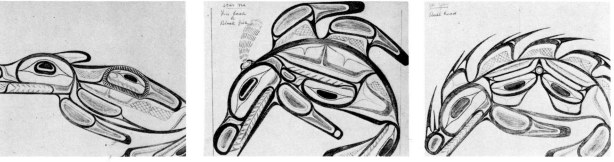

Pencil drawings by Tom Price; sea otter (Museum No. 10166i), blackfish (Museum No. 10166b), and bullhead (Museum No. 10166c).
— *Ethnology Division, British Columbia Provincial Museum*

Price came from Ninstints on Anthony Island near the south-western tip of the Charlottes. Ninstints people were fierce fighters, recognized for their individuality, and definitely not to be trifled with. He most likely moved to Skidegate as a young man in the 1880s, when Ninstints was abandoned. He would also have traveled the east coast of Moresby Island and Skidegate Inlet a good deal, because when C.F. Newcombe paid one of his many visits to the Charlottes, Price related every Haida place name on the route he knew so well by canoe.[5]

A superb pair of matching poles attributed to Tom Price by Ron Hamilton. The figures from top: killer whale, wasco, raven holding salmon, bear mother with twin cubs, and frog. Museum Nos. 4785 (top) and 4786; collector E. G. Maynard. Height for each 40 cm., width and thickness 7.5 cm.

— *Ethnology Division, British Columbia Provincial Museum*

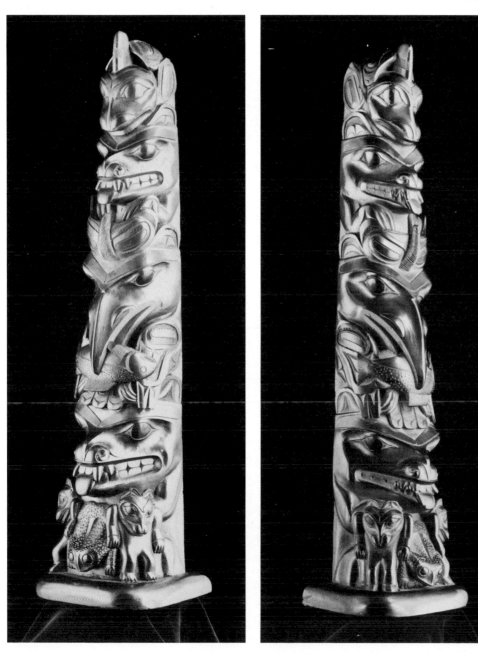

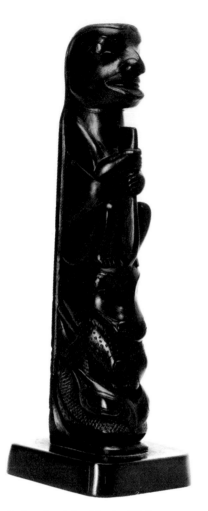

A signed pole by Charles Gladstone.
— *Philip F. Graham. Courtesy Lila Young*

Charles Gladstone.
— *National Museums of Canada, Ottawa*

John Cross, who was about the same age as Price, is best known for his poles. His figures are tightly stacked, almost compressed, yet are not in the least distorted. His frogs are stubby, and very often he depicted salmon in the mouth of bear. Perhaps the formation of a Cross pole is its most distinctive characteristic. When viewed from above, it is seen as a deep, straight-sided, oblong arc. This pole shape, combined with closely knit figures, makes Cross's poles unmistakeably his and his alone. He was carving poles in the 1880s and by the early years of this century ranked high among the leading artists at Skidegate. He was a relative of William Dixon, a little-known but able craftsman whose standards he may well have emulated. Cross was fortunate to have lived and carved as long as he did. He was the sole survivor of the foundering of a lumber-laden schooner in which Robert Cunningham's son, John, drowned.[6]

Paul Jones (c. 1847-1927) was another notable Skidegate stylist. He and his brother, Moses Jones, also an argillite carver, were of a Tanu Eagle family of Tanu Island on the east coast of Moresby Island. Tanu was still a flourishing village when George Dawson visited it in 1878. Its population was larger than Skedans and had sixteen houses ringing the shoreline and thirty finely carved cedar poles.[7]

Jones's style is best seen in his poles. The crests have a slight uptilt, the human and animal cheeks are sunken, and the mouths wide and often downturned — not at all like the curling mouths Price carved. According to C.F. Newcombe, his house crests were bear, owl, hat, eagle, whale and beaver.[8]

George Smith (1886?-1936), the fourth member of this group of contemporaries, was closely related to one of the earliest named carvers, John Smith.[9] George Smith's work has been compared with that of John Cross, but there are definite differences. Smith's crests are deeper vertically, lacking the Cross compression, and partly as a result of this, his poles appear more open than Cross poles. As Barbeau noted, the shoulders and legs have a more pronounced forward reach.[10] On the whole, Smith's poles can be taken as the most representative and typical of Haida argillite pole carving — standard in conformation and in the positioning of the figures. Smith came to live in Skidegate by a roundabout route, via Hippa Island, Chaatl and Cumshewa. He was held in high esteem by his fellow carvers at Skidegate and for good reason: he knew all the criteria for splendor in argillite.

Charles Gladstone (1878-1954), while not a prolific carver, was nonetheless among the most proficient of his generation. The dogfish was his major crest and he often depicted both it and dogfish woman. His bears had especially long muzzles.[11] Gladstone was an important link in an artistic chain. He was related to Charles Edenshaw and a grandfather of Bill Reid.

"Charlie Gladstone was doing a lot of silverwork when I was in Skidegate," the United Church minister Lloyd Hooper recalls of the last two years of Gladstone's life. "He *used* silence, and I could be quite comfortable in it if I just sat still. I might ask something about the past, and after quite a long time his eyes got a faraway look and all I'd have to do was sit still and listen."[12]

Gladstone was also a brother of the argillite carver Lewis Collinson, and how they came to have different surnames was typical of the absurd registration errors made in their childhood in the 1880s. Gladstone remembered hearing how a directive had come from the federal government decreeing that his people were to be given white names. Whoever recorded the brothers' names could not have been listening. "I told them he (Lewis Collinson) was my brother, but they gave him a different name," Gladstone told Hooper.[13]

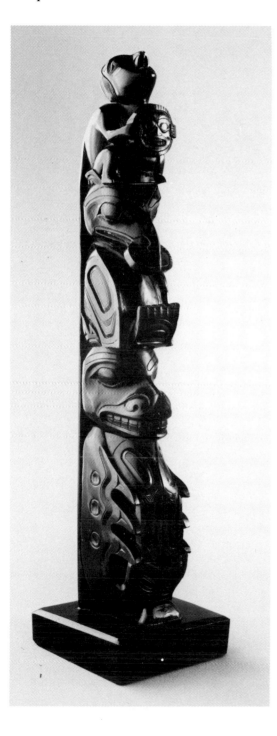

A pole by George Smith, from the Lipsett collection. Museum No. AA2301.

— *Centennial Museum, Vancouver.*

The tightly-stacked figures identify this as a John Cross pole. Actually, it is signed "John Cross Skidegate Mission" and was formerly in the Jolliffe collection. Height 17 cm.

— *Philip F. Graham*

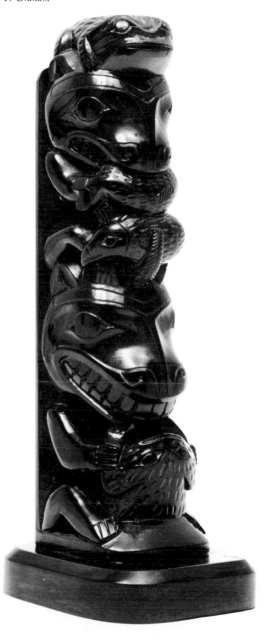

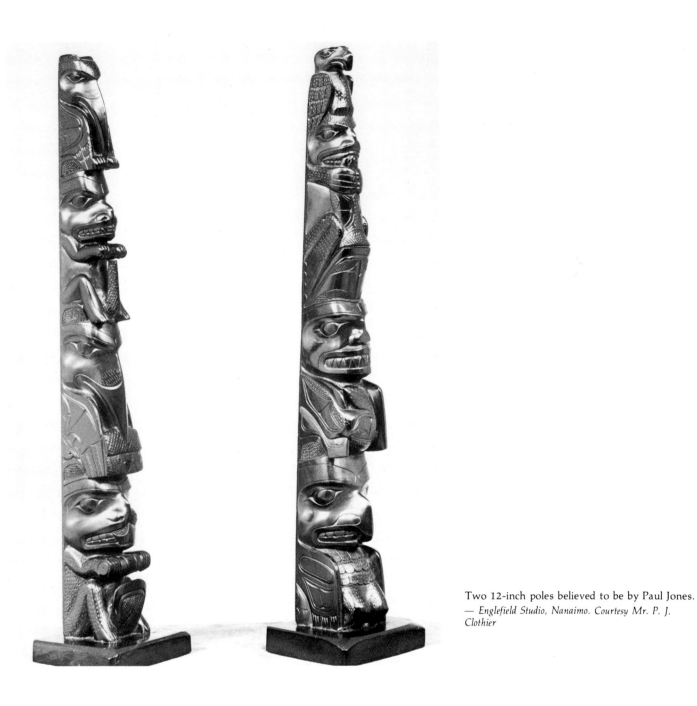

Two 12-inch poles believed to be by Paul Jones.
— *Englefield Studio, Nanaimo. Courtesy Mr. P. J. Clothier*

Lewis Collinson (1881-1970) produced a great many poles and is said to have carved shaman figures in his early days.

His style in poles was decisive. The figures are deeply carved, evenly sized, and usually begin close to the back of the pole. His ravens are long-beaked. Many of his poles were signed but, oddly enough despite those signatures, both his first and last names have often been misspelled even by well-informed writers on argillite. To add to the confusion, he also went by the name of Tom Collinson. He carved until the final year of his life.

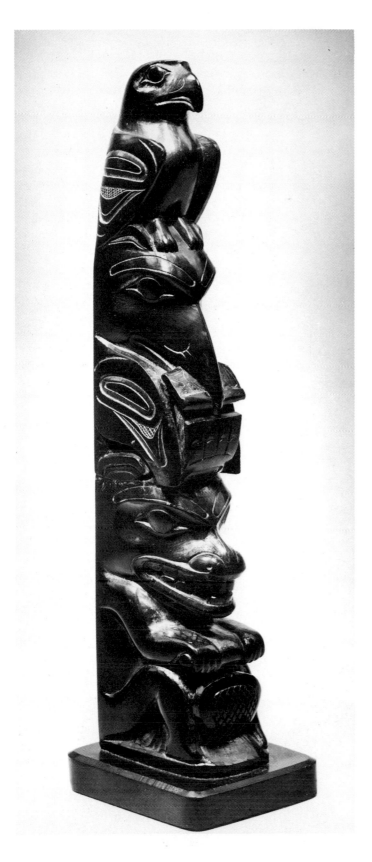

An example of the early work of Lewis Collinson. Purchased 1969, Horsley & Annie Townsend bequest.

— *Montreal Museum of Fine Arts.*

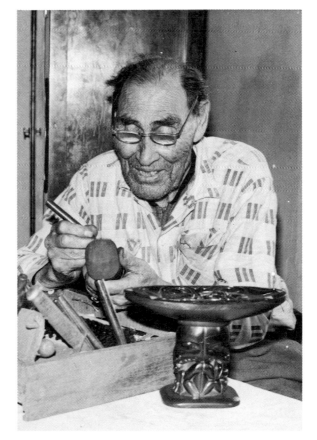

Lewis Collinson, in 1963.

— *Leslie Drew*

The last of the Skidegate masters we shall deal with here — actually, he died before Collinson — is Arthur Moody (1885-1967), a man steeped in the argillite tradition. His father or stepfather, Thomas Moody, followed by Arthur himself, and his son, Rufus, have probably contributed a greater volume of argillite than any three generations in a single family. Certain common stylistic tendencies run through the work of all three: short-beaked ravens, sharp cutoffs between figures, and with Arthur and Rufus, proclivity for creating giant-sized poles. Thomas, born in Tanu, owned the wolf crest of a Raven clan. The beavers on his poles often have long, thin incisors. Arthur is said to have learned carving from Robert Miller, who came from Tasu originally, and, like Miller, he worked quickly.[14] Arthur Moody once carved a forty-eight-inch (140 centimeter) argillite pole, and from the proceeds built himself a house at Skidegate.[15] That four-foot pole was not exceeded until after his death, when his son Rufus carved poles five and six feet tall.

Arthur Moody.
— *Leslie Drew*

In these poles, which are probably by Thomas Moody, the same execution can be seen in nose bridges and the bases, and the eagles at the top of each could be twins. Secondary aspects such as cross-hatching lack precision, but the over-all style is consistent and distinctive.

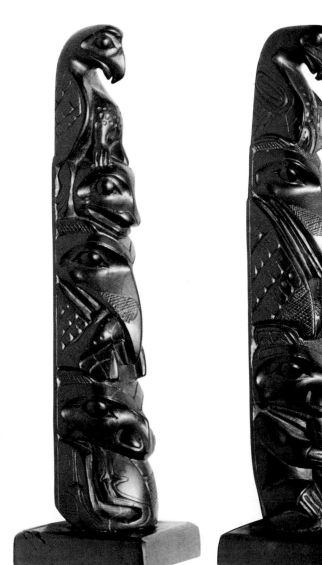

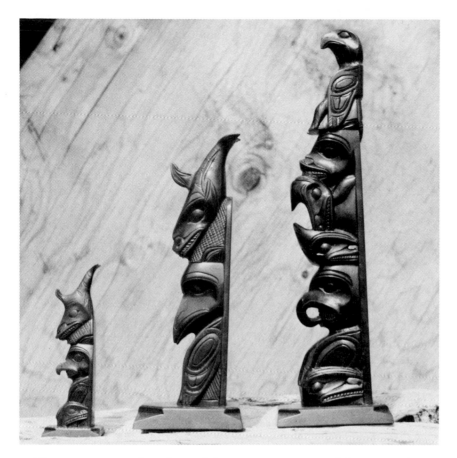

Poles by Rufus Moody
— *Government of British Columbia*

These ten are only a few of the master carvers of the past whose work is now preserved in museums and private collections. We have introduced them expressly to show how each had developed his own distinguishing style, his indelible signature. In the case of the Moodys, family tradition also effected a continuity and, in general, style was handed down from generation to generation. Thus, despite the impact of historical events on individual carvers and their work, there remains always an inherent loyalty to what is Haida — to what is theirs by birth. The result is an art that, for all its adaptability, is no less pristine than any other created before the white man set a foot on Haida ground.

Rufus Moody.
— *Government of British Columbia.*

Part 7
The
Appreciative
Eye

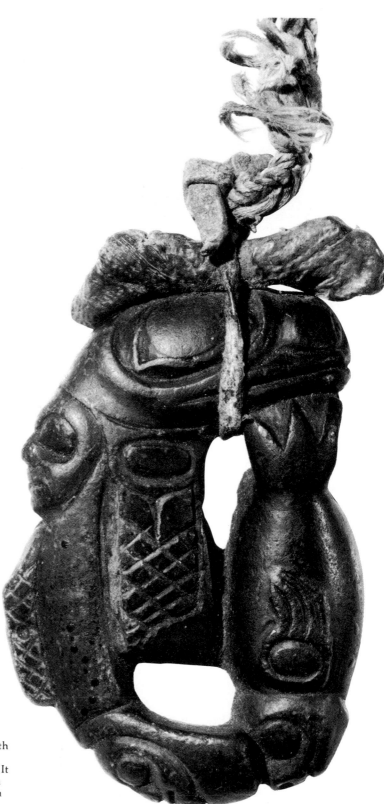

Simple yet powerful carving — an amulet with
thonging still attached. Head of whale at top,
complete seal at right, and two human faces. It
was collected by Dr. Hans Beraz who lived in
California and died in the Hawaiian Islands in
1872. Museum No. 91.141. Length 7.5 cm.
— *Staatliches Museum für Völkerkunde, Munich*

32.
The collector

Art knows no international boundaries — a fact worth remembering when we complain about how much priceless native art has gone to other countries. In the early 1800s it had nowhere to go but out. The coast had barely been discovered and the rest of what was later to become British Columbia might as well have been the dark side of the moon. Another point: art tends to gravitate toward monied fingers. The magnetism of money has always exerted an outward pull.

First, though, art must be recognized as such. Early argillite was not. It was just another of those peculiar objects that a fur trader or seaman could obtain in barter with the Pacific Northwest Coast natives. Alien? Definitely. Artistic? Hardly. Valuable? Never. Only a few men whose pathfinding careers were drawing to a close seem to have considered argillite worth preserving.

One was the Finn, Arvid Adolf Etholén. Another was Colin Robertson, the stormy petrel of the North West Company who helped negotiate its merger with the Hudson's Bay Company. Both men were conscious of their place in history, both realized they would never return to the Northwest and both took home enough argillite to qualify as collectors. All that most merchant-navigators and Hudson's Bay men did was disperse argillite. But that too could be important, as we shall see.

Apart from the individual, the only potential transporter and accumulator of Northwest Coast art was the official, government-sponsored expedition. And in this capacity only American latecomers were successful. The scientifically-equipped, globe-circling French ship *Solide*, although it stopped at the Charlottes in 1792, explored only a small corner of the islands. The Russians came next — to the waters of Russian America, now Alaska. The first Russian world voyage of Captains Krusenstern and Lisiansky, sailing in the *Nadezhda* (Hope) and the *Neva*, from 1803 to 1805, packed off the earliest and most authentic collection of Tlingit art, now in Leningrad.[1] It contained a few Haida artifacts, but apparently no argillite. The Napoleonic Wars ruled out further "official" expeditions by European powers.

Years elapsed, and then came the United States Exploring Expedition led by the impetuous Charles Wilkes of the United States navy. During his career, Wilkes was twice court-martialed (during the American Civil War he stopped the British mail ship *Trent* and, contrary to all regulations, forcibly removed two Confederate commissioners, provoking the Trent Affair which nearly involved the Union in a war with England), but nevertheless he rose to commodore. In 1841, when he brought his world-girdling expedition into the southerly waters of the Northwest, he was plain Lieutenant Wilkes. His men did procure artifacts, including slate carvings, from trading posts in the then British-controlled territory of what is now Washington State, but only in the course of more important work — military reconnaissance.[2] Wilkes would probably have continued northward had not one of his ships been wrecked on the infamous bar off the mouth of the Columbia River. This was the last of the early foreign, government-sponsored, organized expeditions that might have penetrated Haida-Tlingit territory. After that, collecting was again left to the individual.

Meanwhile, something was happening to those bartered objects that had "spread sail" around the world via the merchant adventurers. One by one, they began to reach art-conscious European capitals. Three slate carvings passed into the hands of the second Duke of Leuchtenberg (1817-1852) of the Bavarian royal family, who had the grand names of Maximilian Eugène Joseph Napoléon. He acquired the carvings honestly. He was a grandson of Napoleon Bonaparte's wife, the Empress Josephine, by her first marriage. His father, Eugène Beauharnais, first Duke of Leuchtenberg and son-in-law of the first King of Bavaria, Maximilian I (Joseph), had ably served his stepfather Napoleon as a soldier and administrator, and had been suitably rewarded. The first duke was a collector of art treasures and so, it seems, was his son who, in 1835, succeeded to the title. His three pieces of argillite could have been acquired through his marriage. His wife was a daughter of Emperor Nicholas I of Russia.

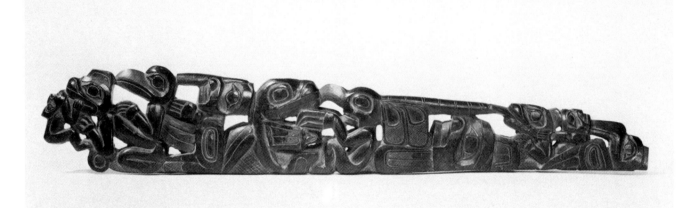

An excellent early panel pipe of Haida motif of 10 figures, some of them in transformation such as dragonfly or butterfly at center, and interesting for its legend figures that disappeared from later carvings. This was part of the Leuchtenberg collection. Museum No. 801. Length 43 cm.
— *Staatliches Museum für Völkerkunde, Munich*

All three carvings are believed to date from the early nineteenth century. One is a ten-figure panel pipe comparable in craftsmanship with the best anywhere. The second is a talisman-like seated figure, the third a simply-carved bowl.

Another panel-type piece was bought by the Bavarian royal family in 1841. This was obtained by Lamare Picquot, a French naturalist and traveler who confined his journeyings to India and East Africa, but who also bought artifacts from elsewhere, mostly from French skippers. Picquot would have been a typical collector of his period — European, educated, inquisitive. Like John Scouler and Arvid Adolf Etholén, he was alert to artistic skills in people of cultures vastly different from his own. Through the initiative of these men, collections were started, if haphazardly, before the second half of the nineteenth century.

By now, obviously, there was no need for a collector to actually visit the Charlottes. Men like Finland's Etholén, the American artist George Catlin, and Scots like Colin Robertson and later James Hector, who was surgeon and geologist on the Palliser expedition, easily obtained slate carvings at trading posts distant from the

Haida homeland. Their appreciative eye valued them either for sentimental reasons or out of a vague awareness of artistic merit.

At some time after 1850 there appears a singularly offbeat collector — one who never went near the Charlottes yet who wanted every argillite pipe he could lay his hands on — an Englishman named William Bragge. His first claim to distinction, if not eccentricity, must be that he is remembered for having been born "at 25 minutes past two in the morning" on May 31, 1823, in Birmingham.[3] After that precise start in life, he grew up to be a civil engineer. Actually, Bragge was one of those wide-awake, inquiring men of action who was superbly capable of applying his talents in diverse fields. He carried out gas lighting of the city of Rio de Janeiro. He surveyed the first railroad built in Brazil. He introduced a sewage disposal system to Rio. For his services to Brazil, Pedro II decorated him with the Order of the Rose. Back in his own country, he became a director of John Brown and Co., Sheffield, president of the Sheffield Art School, and in 1870 he filled the high office of master cutler of Sheffield. So he was not only enterprising but well-to-do. And this leads into his interest in argillite. Bragge was that now-extinct character known as an antiquarian. He bought rare illuminated manuscripts, and at one time built up a priceless Cervantes collection which was later destroyed by fire. However, his great pride was a collection of pipes and smoking apparatus from around the world.

Panel pipe of Haida and European-American motifs, from the William Bragge collection. Raiment of white man looks priestly. Pipe stem is at right end and bowl in bear's head. Museum No. D.e. 24. Length 37 cm., height 11 cm.
— *British Museum*

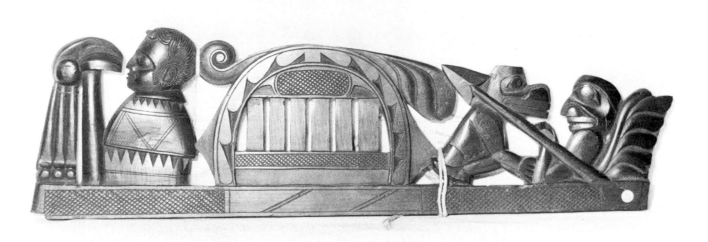

The accumulated result of his twenty years of collecting pipes and smoking paraphernalia went on public show in Birmingham in 1870. There were early English pipes dating to 1600, including "rare varieties which have names and dates and marks, small in bowl, as tobacco was rare and dear, and increasing in size to a comely 'gauntlet' pipe, as the divine weed became more commonly known," extremely rare early Dutch pipes, pipe-cases elaborately carved and inlaid; snuff mills, tobacco-stoppers, tinder boxes, porcelain pipes of Sevres, pottery pipes, beaded tobacco pouches of

James G. Swan (1818-1900), photo taken just before his 1883 trip to Queen Charlotte Islands.
— *Provincial Archives, Victoria, B.C.*

The epic bear mother figure, bought by James Swan in 1883 for $4. It is less than 15 cm. long. The museum's catalog states: "Carved by Skaowskeay, an Indian carver at Skidegate, B.C." Swan himself wrote: "It was not finished when I got it but just roughed out, and my Indian assistant Johnny Kit Elswa finished it on the voyage (from Skidegate to Victoria.)"
— *National Museum of Natural History, Smithsonian Institution*

the American Indian, leather pouches from Northern Europe, damascened Italian pipes, German pipes of agate, small metal-bowl pipes from China, Swedish pipes of iron, pipes of Venetian glass, French pipes of terra-cotta and clay, Roman pipes. A reviewer of the exhibition wrote: "Whenever a traveler returns, like Catlin, or Petherick, or Burton, or Speke, or Grant, he is cross-examined at once on pipes, and all he can or will spare are secured, to be added to the vast collection of more than six thousand pipes — representing every age and every people in the world."[4] Bragge was a busy man.

As he grew older, his pipe collection occupied more and more of his time. He was a fellow of the Society of Antiquaries, and in its hallowed halls he lectured on pipes and smoking. He also wrote on the subject. In his *Bibliotheca Nicotiana*, printed privately in 1880 four years before his death, he listed nineteen pipes "in black clay-stone, or slate . . . elaborately carved with the most singular and grotesque devices; human and animal forms being grouped and involved in extraordinary modes" and "entirely free from the influence of European civilization." These, of course, were Haida argillite pipes. Bragge would have used the word "grotesque" in its heraldic meaning, the one relevant to him as an Englishman. He was obviously delighted to have them, and the person who supplied him may well have been Catlin. At least thirteen of those pipes are now in the British Museum, the largest single assemblage by one person that exists in a public institution.

Bragge had the sort of spontaneous, unscientific, pack-rat curiosity that characterizes many of the early collectors. Their interest lay in the objects they collected — something solid and intriguing which they could grasp in their hands — and not especially in their meaning nor in the culture that had produced them.

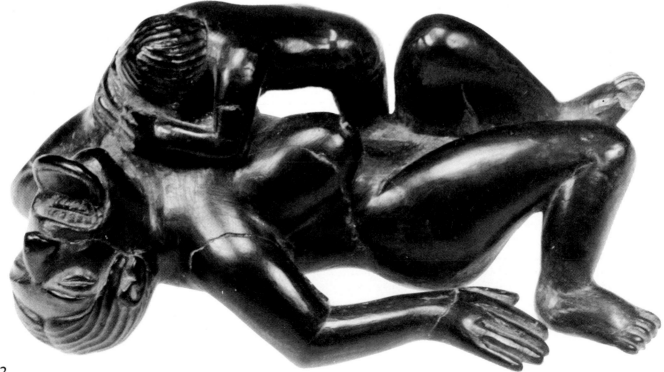

Now, as whites moved into Washington Territory and British Columbia, as trading posts grew into little towns and new towns were born, a new resident collector emerged, an enthusiastic amateur who was genuinely interested in the native cultures surrounding him. James Swan, the slight, grey-bearded "frontier scientist" of Port Townsend, Washington, was one such notable hunter-collector of relics. Another was James Deans, who had come to Victoria in 1853 as a Hudson's Bay farm recruit. Both were ardent amateur ethnologists. Because they were located more or less in the Northwest field, they were ideal contacts for outsiders wanting information and/or ethnographica. Indeed, they were forerunners of a troop of scientific investigators who beat a path to the Haida doorstep. The procession of scientists has been endless. So many have come and gone that the Haida can be excused for thinking they have been studied to death, and that science did what the smallpox epidemic did not do.

Before the rush began, two men — both Canadian government officials — realized that argillite should be preserved for Canada. One was Dr. Israel Wood Powell (1836-1915), the first Indian commissioner for British Columbia. Canadian-born, trained at McGill University, a man with impeccable connections, Powell was appointed commissioner in 1872, and soon became an honorary lieutenant-colonel in the Dominion militia in order to be eligible to wear the scarlet tunic and gold braid considered necessary to impress the costume-loving natives on his official visits to their villages.[5] Powell, however, was more than just a Mr. Dressup and an instrument for carrying out government policy. After touring the coastal villages the next year, 1873, aboard the gunboat *Boxer*, he strongly recommended that a collection of Haida art be made to form the nucleus of a provincial ethnological collection.[6] The recommendation fell flat in the financially-strapped new province of British Columbia, but Powell persevered privately and collected argillite for the Geological Survey of Canada, whose artifacts later went into the National Museum. Powell also collected at one time for the American Museum of Natural History and had misgivings about sending ethnological specimens out of Canada.

The other great early collector for Canada was the distinguished George Dawson, geologist with the Geological Survey. He so thoroughly surveyed the Charlottes in four months in 1878 that his report remains to this day the standard reference work both on the islands' physiography and on Haida life. How Dawson, the little hunchback who could out-hike men twice his strength and who was plagued with headaches on his trip, accomplished as much as he did will always be a source of amazement.

When American museums went on a collecting rampage in the 1880s and 1890s, scientists and relic hunters (sometimes one and the same person) came thick and fast. At times they almost fell over each other in the scramble. The great ethnographer Franz Boas was at Namu in 1897 when he learned, much to his annoyance, that George Dorsey was one jump ahead of him on a collecting tour for the Field Museum in Chicago. "Well, little Dorsey won't have achieved much with the help of that old ass, Deans," he wrote petulantly. What really upset him was that he had been assured in

James Deans (1827-1905).
— *Provincial Archives, Victoria, B.C.*

Dr. Israel Wood Powell (1836-1915), photo taken about 1874.
— *Provincial Archives, Victoria, B.C.*

Dr. George Mercer Dawson (1849-1901), photo taken about 1885.
— *Provincial Archives, Victoria, B.C.*

Chicago that Dorsey would not be on the Northwest Coast at the same time.[7]

The great collecting spree came at a critical time insofar as the native people were concerned. By government edict and missionary preachment, they were being forced to give up their ancient ceremonials. This meant that ceremonial objects could now be bought . . . or confiscated. Villages were being abandoned in the consolidation of survivors from the smallpox epidemic. Consequently, their great cedar totem poles could be purchased. All it required was money — and this the rising foreign museums had.

One man in particular, shrewd and knowledgeable, exploited the market to the hilt. George Thornton Emmons, a United States navy lieutenant whose father had been a member of the Wilkes expedition, established himself as the leading collector of Alaskan native art, and ranged widely through central and northern British Columbia. Emmons, Dorsey and others bought native art for themselves, for American museums, and for well-to-do private collectors in the industrialized eastern United States.

Europe entered the field quite early, in 1881, in the person of a tall Norwegian named Adrian Jacobsen. An expert seaman, widely traveled and dauntless, he had been trained at Berlin in what to look for, then sent out as an expedition, sponsored principally by the Berlin Ethnological Museum (Royal Museum für Völkerkunde) to gather material from the entire Northwest Coast. He journeyed north from Victoria aboard the old coastal steamer *Grappler*, in the company of Robert Cunningham, former missionary and trader at Port Essington. He stopped off at Cunningham's home, met his native wife, and bought a few argillite poles before proceeding to the Charlottes. At Kitkatla, Jacobsen learned that Israel Powell had been there already, collecting for the Canadian and American governments, and paying high prices — something Jacobsen himself was shortly to encounter.

At Skidegate he found that the Haida were offering their possessions at "exorbitant" prices that only a selective antiques buyer could afford. Skidegate was by now a port of call for steamers bringing tourists eager to buy on the spot or by mail. Outsiders, especially Americans, were spoiling the market, Jacobsen decided. At the same time, he was pragmatic — and prophetic. The scientific collector had to reconcile himself to the situation, he wrote, "realizing that in the future prices will probably be higher." He expressed admiration for Haida art, citing their carved wooden dishes, spoons of mountain goat horn, and carved "stone pillars" — a reference to slate poles.

Jacobsen's mode of operation was to set up in a chief's house a sort of swap shop, where he exchanged European goods for native art. "The trading went well, even though I had to pay high prices," he wrote. At Masset, where the Hudson's Bay trader helped him with his purchases, "even though many earlier visitors, especially the officers of a British warship that called there every summer, had bought almost everything, we went from house to house and found a few items."[8]

Jacobsen's Northwest Coast expedition, which carried on into Tlingit country, netted him 7,000 objects of various kinds, including

argillite. The Berlin museum had first choice, and the balance went to dealers and other museums in Europe. His younger brother, Fillip, eventually settled in British Columbia, first on the west coast of Vancouver Island and later at Bella Coola, and was himself a collector.

Before leaving Jacobsen, let us consider for a moment those prices that startled him so much. He did not say exactly what they were, but for slate carvings we know he would have paid about $5 each. Francis Poole, visiting the Charlottes in 1862, paid $5 for a "flute" which he described as having ends inlaid with lead and two of the keys represented by frogs in sitting postures. "A more admirable sample of native workmanship I never saw," wrote Poole, obviously pleased with his purchase.[9] James Swan, buying for the Smithsonian in 1883, paid $4 for the epic bear-mother figure.

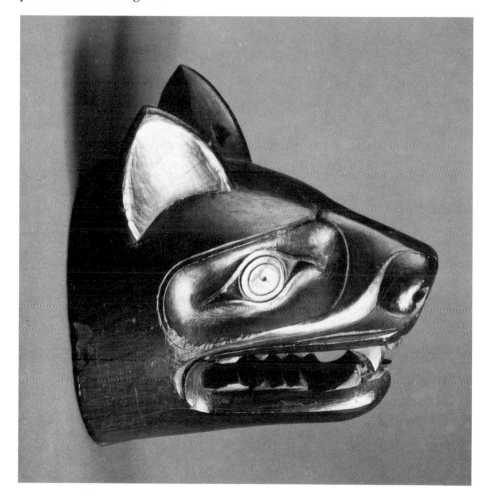

Such prices sound dirt cheap in the inflationary 1980s until we delve into what a dollar purchased in the 1880s. At Victoria, hotels charged $1 a day for board and lodging, $6 by the week. Clothing stores were selling Crimean overshirts at $1.50 and $1.75; best-quality French dress shirts were $1.80. On the North Coast, where shipping charges have always been added often irrationally, the cost of goods and services ran higher still. At Masset in 1886 flour was $3 a sack, sugar $1 for six pounds.[10] The carver knew his values.

Wolf's head, a slate box end, collected by Captain Adrian Jacobsen. Unfortunately it is now listed among the museum's kriegsverluste — Second World War losses. Museum No. IV A 776. Length 8 cm., depth 6.7 cm.
— *Museum für Völkerkunde, Berlin*

He knew how much he had to pay for groceries for the family or calico for a new dress for his wife, and he priced his work accordingly.

Adrian Jacobsen's expedition was a one-shot deal. Others came repeatedly, taking away more and more of a cultural heritage in objects no longer being produced. In time, one man had the Charlottes in his pocket. He was Charles Frederick Newcombe of Victoria. Living relatively close to the Charlottes, he could journey there more often than most American collectors and by one estimate, he made more than twenty visits between 1895 and the year he died, 1924. Newcombe had a faithful companion and packer in his son, William. Both were instrumental in the wholesale removal of native art. Charles F. supplied Emmons, Dorsey and almost any museum wanting skulls, skeletons, stone relics, halibut hooks, cedar poles, boxes, baskets, horn spoons, headdresses, every article available. Interestingly enough, the term that Newcombe — and Dawson — used for native relics was loosely written as *ikta, icta,* or *ichta,* meaning in the Chinook jargon "belongings," according to Newcombe's translation. In his dealings, Newcombe's operative phrase was: "You scratch my back and I'll scratch yours." Overriding this was a self-conscious desire to serve science. Newcombe had been trained in Aberdeen, Scotland as a medical doctor, with emphasis on alienism — the study of mental disorders. He was also a skilled botanist. As soon as he settled in British Columbia, he applied his university training to the infant science of ethnology, as a personal endeavor. His research was as wide-ranging as it was dedicated. No one in the province was more consulted on British Columbia native artifacts — though he was almost blind to their artistic merits — than Charles F. Newcombe. After him, his son William, shy, reclusive, extremely kind, became the leading authority. William had the appreciative eye that his father lacked. As a resident collecting team in the first years of this century, they were unequalled. The argillite collection of the British Columbia Provincial Museum contains many pieces obtained by the Newcombes.

During the museum-collector heyday, rivalry at times reached fever pitch. Each competitor watched the other's forays into the field like a hungry hawk. In 1897, an incident took place which so aroused J.C. Keen, Anglican clergyman at Masset, that he fired off a letter to the *Colonist* newspaper at Victoria exposing "wholesale robbery" of graves in the neighborhood of Virago Sound and North Island.

> The Indians told me that every grave had been rifled, and the boxes which contained the bodies left strewn about. In one case some hair, recognized as having belonged to an Indian doctor, and a box which had contained a body, were found floating in the sea. Now this outrage was perpetrated during last July or August, and the date coincides so nearly with the time when a party of Americans visited that region gathering materials to augment the exhibit of the Hydah Indians in the Field Chicago Museum in Chicago, that suspicion naturally rests on them, and I would ask Mr. Deans, who accompanied that party, to say whether or not he can throw any light on the

Dr. Charles Frederick Newcombe (1851-1924).
— *Provincial Archives, Victoria, B.C.*

William Arnold Newcombe (1884-1960).
— *Provincial Archives, Victoria, B.C.*

subject. That he himself had any actual share in the outrage no one who knows him will for a moment suspect; but most of your readers would, I think, feel grateful to him if he could aid in bringing to light the names of men who, however laudable their object, could so mercilessly ride roughshod over the susceptibilities of the Indians.[11]

The grave-robbing incident had a sequel. A few weeks later who should tramp over the same ground, tipped to the existence of the cave site, but Newcombe. When he questioned Dorsey about it later, Dorsey replied from Chicago: ". . . yes, I plead guilty but I had no earthly idea that you would visit the cave for skeletons." He thought Newcombe would have had better pickings on the west coast.[12]

By 1908, with James Deans dead, Newcombe was firmly in command of the Charlottes' supply. Emmons wrote him that year:

I should think the best field to collect today would be the west coast of Vancouver Island. I have never been there but have always wanted to go. There is little in Alaska and everything is expensive. I drained the Nass River last year or rather got all that Willie (Newcombe's son) left and the prices were enormous. I visited every village and got every piece I saw. There is nothing among the Tsimshians, and you have cleaned out the Haidas . . .[13]

Charles F. Newcombe supplied the Chicago Field Museum, and William, the Museum of the American Indian in New York whose wealthy benefactor, George Gustav Heye, was constantly asking him to be on the lookout for what he mockingly called "antikies." The Museum of the American Indian Heye Foundation rewarded Willie Newcombe in 1934 with life membership in the institute.

Amid the grave-robbing and the ceaseless game of one-upmanship played by the collectors, one voice was raised in nationalistic warning. The great Dawson, who had collected only for Canada and who remembered the Charlottes before the sordid

scramble began, regretted what was happening. "It is surely time that something should be done by way of legislation to preserve the antiquities of B.C.," he wrote in 1897 to C.F. Newcombe.[14]

Unfortunately, the "draining" has gone on unremittingly. One reason has been that governments devoted to free enterprise cannot bring themselves to control wheeler dealers. Another has been lack of funds.

British Columbia was clearly outbought on its own ground. The Provincial Museum was in its infancy, chronically under-financed as it was to be for years, until governments began promoting the tourist industry, and so felt obliged to amass what was left of the province's cultural legacies and to display them glamorously. The museum also suffered periodically from lack of direction by men trained in ethnography. Botanists or zoologists gave their own bias to the fabric of collection-building. The National Museum at Ottawa, which grew out of the Geological Survey of Canada, also was unable to compete with the American buyers. As long as Dawson was associated with the Geological Survey, it acquired Northwest Coast art. After his death, interest waned.

There are two, and often more, sides to every story and it would be wrong to infer that museum agents like Emmons and the Newcombes were bent solely on personal gain. Far from it. They sincerely believed they were doing mankind a service by bringing to light objects from the past and seeing to it that they were preserved for future generations. Well-endowed American and European museums, institutions that would go on to the end of time, were the logical repositories. C.F. Newcombe, when acting on behalf of museums, avoided piecemeal collecting. He tried to provide them with comprehensive collections, as complete as possible in the implements and other "industries" of the Haida. This was his rounded, scientific approach.

Moreover, native owners often were more than willing to part with their heirlooms. Many were forced to sell through economic hardship, especially in years leading up to the First World War when British Columbia was in one of its many slumps. Newcombe was paying anywhere from $60 to $80 for a cedar memorial pole in 1911, when the going rate for a common laborer among the Haida was $2.50 a day.[15] Only a person of stout principle (or a fool, some would say) could refuse such an offer. Refuse some of them did, however. (Philip Drucker to Willie Newcombe in 1937: "I saw one really old carved Haida bracelet (silver) at Skidegate — did my damnedest to buy it, but the owner wouldn't sell at any price.")[16] One wonders how long the owner held out. Museums have long memories; their filing systems at least survive economic slumps. If an object — or a whole private collection — cannot be bought now, the opportunity will come later when the owner reaches old age or dies. Should the museum memory bank fail, there are always agents to remind it. Museums always bargain from a position of strength, a fact that the little person, flattered to sell, does not always realize.

Where did argillite fit into this sorrowful picture of the great "draining" of Northwest Coast art from native villages? It did not really. The art went on leading its charmed life. Many fine early

works were swept away, but the living art was there to replace them. The great losses were in objects no longer being made — masks, staffs, rattles, headdresses, capes — all integral to ceremonials that had now vanished. The nineteenth century attitude of many eastern American museums was that an ethnographic collection should reflect a pristine culture. Argillite carving, mistakenly believed to be derived under white influence — and a trade item, to boot — did not rate. It had no class. This attitude spilled over into Canadian institutional thinking. C.F. Newcombe for instance, was not much taken with argillite. He would buy it for a museum requesting it; otherwise, he would just as soon leave it for the "amateurs."

By 1900 there was no shortage of resident "amateurs." Mission stations had opened along the British Columbia coast and to the north, the Klondike gold rush which started in 1897 had given rise to new white communities. Whites were also moving into the Charlottes. Once missionaries decided that slate carving should be encouraged, they became collectors. Rev. William Edwin Collison, a son of William Henry Collison, the first resident missionary to the Charlottes, accumulated argillite. Charles Harrison, a successor to W.H. Collison at the Masset mission, owned slate "crests." So too did Methodist ministers like Thomas Crosby and George Raley. Government functionaries and merchants whose day-to-day activities brought them in close contact with the native people collected argillite. George Cunningham, a son of Robert Cunningham, merchant and hotelkeeper of Port Essington on the south bank of the Skeena River, pioneered "resident" collecting. Many of his pieces would have been obtained in trade for goods. In fact, storekeepers and hotel proprietors have often become leading collectors and dealers on the North Coast, accepting carvings in payment of debts or in exchange for groceries and liquor.

Gradually the size of a collection began to be important, and this brings us to Thomas Deasy, the man who once stated, as we have already seen, that those early panel pipes were held by shamans while dancing. From boyhood, Deasy had learned to roll with the punches. The son of a Royal Engineer, he had come to British Columbia from England as an infant in 1859, had grown up in New Westminster, then moved to Victoria. In childhood he learned Chinook, the *lingua franca* of trade, from natives who sold fish and potatoes in both those rough-and-ready towns. At thirteen he left school to fend for himself, as a newspaper printer and a fireman. In Victoria's horse-drawn fire brigade, he rose from lantern boy to chief. For a time he also worked for Indian Affairs in southwestern British Columbia, under superintendent Powell.

Essentially Deasy was a civil servant, and as such in those days, it helped to have good political connections. In 1910, when an opening came at the Masset Indian agency which covered all the Charlottes, Deasy, who had latterly been fire chief at Nelson in southeastern British Columbia, pulled a few strings and was appointed agent at a salary of $1,200 a year — a good salary for that period.

Deasy settled down to learning his job, getting to know the Haida, and making reports. He started to acquire argillite almost immediately and by 1913 he had a "museum" in his office said to

Thomas Deasy (1857-1936).
— *Provincial Archives, Victoria, B.C.*

house "the largest assortment of black slate work in the world" — fifty pieces — which visitors delighted in inspecting.[17] A few years later his collection had grown to well over one hundred and he publicized the collection whenever he could.

Even before Deasy's arrival on the North Coast, an event had taken place which influenced the flow of carving. The founding of Prince Rupert in 1906 provided both a new outlet for carvings and a new pick-up point for collectors. Edward Lipsett was a Vancouver ship's chandler who opened a branch business in Prince Rupert. His wife, Mary, often accompanied him on his trips to the North Coast city. She was, in the words of her grandson Michael Ryan, an incurable collector of native art, Oriental art, perfume bottles, sea shells.

In native art, her primary interests were baskets and argillite. "Every time I see a good slate Haida carving, I want it . . ." she wrote to her good friend William Newcombe in 1934. That same year the wealthy American George Gustav Heye called, looked over the collection, and said she had a museum. "He said the slate collection was the best he ever saw and what was unusual for an amateur collection there was no junk." Mary Lipsett's problem now was where to house it all, and she devoted her energies to solving that problem. In August, 1941, her ambition was realized with the opening of the Edward and Mary Lipsett Indian Museum at Hastings Park in Vancouver. She was elated. "I tell Mr. Lipsett this Museum will save him the expense of erecting a monument to me when I pass on," she said.[18]

The city of Vancouver and the Hastings Park Association, of which Lipsett was a director, had shared equally in the cost of the building ($6,000). Lipsett and a director friend, Eddie Knowlton, raised the association's share by rounding up life members at $100 a head. Corporate friends of the Lipsetts donated show cases. Mary Lipsett herself personally arranged nearly all twenty-five cases with her 1,000-piece collection including 500 baskets, "the best and largest collection of Indian baskets in the world."[19] The entire collection was valued at $30,000. "Am I the proudest woman in British Columbia or in fact Canada?" she wrote shortly after the museum opening.

Unfortunately Mary Lipsett's triumph turned to despair for her family. Through custodial neglect the building was allowed to go to ruin, and the basket collection suffered serious damage. The argillite portion, though, survived, and today approximately sixty of the carvings she collected are in the Centennial Museum in Vancouver.

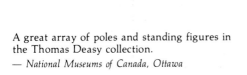

Mary Lipsett examines a basket in her collection.
— *Centennial Museum, Vancouver*

A great array of poles and standing figures in the Thomas Deasy collection.
— *National Museums of Canada, Ottawa*

Mary Lipsett's collection may well have been the largest — in Canada. But the clandestine realm of art collecting is full of surprises. It is like an old Haida gambling game: none of the other players knows who holds the sticks.

While Mary Lipsett was building her collection, a contemporary of hers living on the opposite side of the continent was quietly buying argillite by the caseload. His name was Leigh Morgan Pearsall, and his financial resources were formidable. Born in New Jersey, he moved into the financial circles of New York as a boy and soon learned the secrets of making money. In 1902 when he was 28, a friend showed him a display of arrowheads, and he decided to start gathering them himself. That same year he became a member of the New York Cotton Exchange, and there made the fortune that enabled him not only to assuage his "arrowhead fever" but also to indulge extravagantly in collecting all kinds of North American Indian art.

Whenever he could spare time off from the office, he was out mound-digging or scouring river banks for artifacts. He traveled all around the United States mainland and ventured into Canada and Alaska. If he could not find what he wanted himself, he bought from agents and dealers. By 1950 he had amassed half a million objects of North American native art big and small in his three-storey mansion in Westfield, New Jersey. "I have spent half a century and possibly $200,000 in making the collection," he told a newspaper reporter in 1953 in Melrose, Florida, where he spent his winters and where he maintained another huge house. His argillite, his great pride and only one facet of the the massive collection, numbered 545 pieces and was said to be worth a total of $500,000.

In the same interview, he told the reporter that he had taken a trip to Alaska in his younger days. En route south, the steamer had docked at a small town, which he did not identify. Pearsall and his wife walked into a store which was stocked with native art, and learned from the shopkeeper that her husband had collected some of the items as a former Indian trader. "They're in his old room back there, which hasn't been opened since he died thirty years ago," she said, pointing. Pearsall said he offered her $10 just to open the door. She opened it and inside he discovered an argillite collection. He promptly bought the lot for $5,000. "That's the way it is in collecting," he said. "We just stumble into some of the finest objects, more or less by accident."[1]

It made good newspaper reading for the folks in Florida, but the truth of the matter was that once having stumbled onto argillite, the unabashedly acquisitive Pearsall set about assembling more pieces in a brisk, methodical, business-like manner. He desperately wanted his private museum to include representative specimens of quality work in each genre. Argillite, or jadeite as it was called in collector circles at that time, struck him as unique and therefore especially desirable. From a museum acquaintance he obtained the name of a man in the Charlottes who might be a potential supplier. That man was none other than Thomas Deasy, the Indian agent at Masset, whom we have already met as the acquisitor of what was perhaps the largest collection of argillite in British Columbia up to that time.

33.
"Blessed be little . . ."

Col. Leigh Morgan Pearsall, in photo taken about 1930 for use as a board member of the New York Cotton Exchange.

In 1922, when Pearsall's letter of inquiry arrived on his desk, Deasy was thinking of retirement. He was 65 and planning to move back to Victoria to buy a house where he and his wife would live out their last years. The prospect of selling wooden totem poles, argillite, and anything else to a rich American excited him immensely. He had already sold a 160-piece collection of argillite of his own to a Vancouver lumberman, Frank Buckley. By 1922 he had accumulated another lot consisting of 100 slate poles. This he was quite prepared to sell to Pearsall — at the right price.

At the time, Pearsall had eighty-five to ninety poles purchased from Andrew Aaronson's widow in her Victoria curio shop, "the remainder of her deceased husband's collection made fifty or more years ago," he informed Deasy by letter. He had also previously bought "very nearly all the Hudson Bay Fur Company had in their Seattle store, so you can see I have been on the job trying to preserve for many years to come the workmanship of the people you and I are so much interested in." In 1923 Pearsall offered $1,000 for Deasy's latest collection, then the next year raised the offer to $2 an inch. Deasy could no longer resist. He parted with 105 poles ranging in height from six to twelve inches, a total of 900 inches, for $2,000.

Pearsall was pleased with the shipment. He wanted more and Deasy, by now living in Victoria on a federal government pension of $1,106 a year, hastened to satisfy his customer's insatiable appetite for argillite. He wrote to his old Haida friend Alfred Adams, a storekeeper at Old Masset, asking him to round up whatever he could from carvers in Skidegate and Masset. And he began negotiating to buy back the collection he had sold to Buckley a few years earlier.

Although they had corresponded a great deal, courteously and amicably (Pearsall was more than fair and square in paying up), the two men had never met. Pearsall had been trying to find time to travel west to hunt "bird" arrowheads on the Columbia River, in which event he intended to take a boat from Seattle to Victoria to meet Deasy and hear him tell of his experiences among the Haida. He would like nothing better, he told Deasy, than to meet him "on the sunny side of a barn somewhere" and listen for as long as he would talk. On second thoughts, he suggested they could sit down on the porch of the Empress Hotel, "for there we should not get too far from a good dinner." But in that summer of 1924 Pearsall was in the midst of tremendous stock markets on Wall Street, and business came before pleasure.

Pearsall was always disarmingly frank about his proclivity for making money. His late father's motto had been "Blessed be little with contentment." But said Pearsall, while his father had criticized him for "chasing the almighty dollar . . . somehow I like business and would be very fearful of what I should find to do if I quit." That was an odd statement from someone who had already found plenty to do delving into Indian mounds and combing riverbanks for arrowheads.

Deasy, meanwhile, was scurrying about buying up more argillite. Early in 1925 he was able to ship Pearsall seventy poles and three dishes at $2 an inch for a total of $1,400. Of the 700 inches,

about 500 inches in poles and the three dishes had been hustled up by Adams who charged Deasy less than $400. The day that Adams put them aboard a steamer leaving for Victoria, he wrote Deasy: "You will be pleased to get Tom Price's poles and also John Cross's and George Smith's . . . their work cost me 77 cents an inch and you must sell them separately apart from others." Almost apologetically, Adams said he had found the three carvers high in their prices, but their work was good, after all. Adams also had John Marks carving for him. These were the only carvers' names mentioned — the great Edenshaw was dead by this time. Interestingly, dishes were considered the most valuable pieces.

With this shipment to Pearsall, as with the others, Deasy guaranteed in writing that the goods were of Haida manufacture, bought directly from the Haida. Japanese imitations were in circulation, and Pearsall, increasingly knowledgeable, was wary of them. He was also apprehensive about the source of some American Indian art he was buying.

> I have in a number of instances wondered whether some of the Indian relics I was securing down in this part of the country were not being smuggled out of small museums by substituting inferior pieces . . . I am fearful that this is being done inasmuch as small city museums are managed by people receiving political appointment with frequent changes, thus leading to graft temptation.

However with Deasy as his supplier, Pearsall knew he was safe in argillite. Here was a man who had lived fourteen years among the Haida — longer than any other white man since the missionaries and the government took charge of them, so Deasy claimed — and one who knew, or claimed to know, quality workmanship. Deasy's paternal interest in the welfare of the Haida extended all the way from their health (he and his wife helped during the 1918 influenza epidemic, according to a testimonial presented by the Masset Haida when they left) to the preservation of the argillite art. He once counselled Adams: "Endeavor to make the carvers take an interest in the work, and to make it clean and get them to put as many neat figures as possible, on each totem pole. Not too many large 'bears.' " And this: "In my opinion, totem poles, from six to eight inches, well carved and polished, sell best." In this instance, the middle-man was plainly directing the course of argillite carving.

After clearing the latest shipment through the customs at Newark, unpacking the pieces and finding only one breakage which could easily be mended, then stashing them in his vault, Pearsall was ecstatic. "Now that we draw to the close of our first wild orgy of jadeite business I want to express my deep appreciation of your utmost courtesy and fair dealing," he wrote Deasy. An expert in New York who was fairly familiar with his collection had said he would be foolish to sell it for less than $75,000 and that it would be cheap for any city starting a museum at $100,000. Pearsall was not selling. In fact, he still wanted more slate poles at $2 an inch, provided they were "very old ones as well as dishes and things of that sort."

Ever enterprising, Deasy then managed a coup. After much dickering, he succeeded in buying back the 120-piece Buckley col-

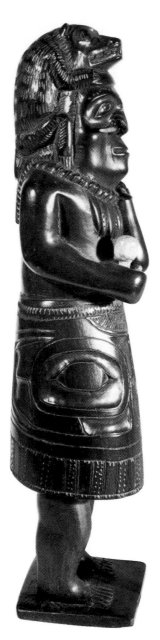

lection for $2,000 — almost double the sum Buckley had paid him ten years earlier. Adding more than sixty pieces he had scouted up in recent months, he turned the lot over to Pearsall for $3,400. He could now give assurance that Pearsall had "the best and largest collection in the world." Pearsall fully agreed. He had found that the Smithsonian Institution had comparatively few pieces, and that "the great American Museum of Natural History in New York has less than one hundred."

In his sales pitch Deasy had mentioned that the George Cunningham collection of sixty slate poles, then on loan to the Provincial Museum in Victoria, had a price tag of $5,000. If it was worth that, the Deasy-Buckley collection was worth $20,000, he suggested to Pearsall. He also promised to charge only $2 an inch for the pieces other than poles, disregarding the fact that they customarily fetched a higher price. Deasy would temptingly offer Pearsall a piece at far below market value. In this instance for example, he charged only $60 for a thirty-inch-long dish that had cost him $100.

PLEASE SHIP COLLECTION JAD(E)ITE AND OTHER ARTICLES MENTIONED ON APPROVAL HEARTILY CONGRATULATE YOU Pearsall wired Deasy on June 17, 1925.

At about the same time he wrote to say that "when it comes to smelling out the jad(e)ite work here and there about the northwest you have them all beat by a mile." A month later the collection arrived in Westfield and Pearsall accepted unhesitatingly.

Shaman wearing bear headdress, in the Pearsall collection. Museum No. P-752
Height 31 cm.
— *Florida State Museum*

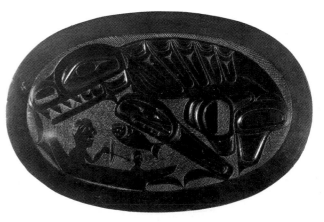

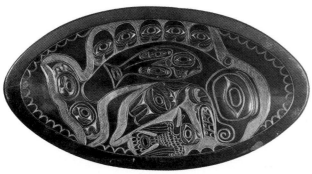

Platters from the Pearsall collection.
Museum Nos., from top: P-1195, P-1197.
— *Florida State Museum*

In this bonanza consignment, almost entirely of argillite, was one box containing 100 poles ranging from seven to thirteen inches in height for a total of 944 inches, valued at $1,880. More than half were eight to ten-inch poles. A second box contained thirty-seven pieces including thirteen dishes, the biggest twenty-four inches long; four pipes, six twelve-inch shaman figures, three other figurines, and a twenty-inch "flute" — in total about 420 inches. A third box contained two slate inkstands, one showing the Crab of Naden Harbour (illustration and legend page 208); a sea dog carving, two carved pen holders, a decorated inkstand and pen holder with covers carved, and a large dish. Pearsall did not quite know what to make of the "flute" — what we now call a recorder — which had been broken and repaired with bone before Deasy acquired it. "It is a most original piece, but more of a curiosity than anything else," Pearsall remarked. This, of course, was before the publication of Marius Barbeau's research and his dating of the rare recorders as mid-nineteenth century works.

Pearsall now considered his argillite trove to be rounded off and turned his attention to New Jersey relics. Five years later Deasy and Pearsall were still corresponding with each other, but Pearsall was no longer buying native art. The Depression was on, and he had hundreds of thousands of dollars worth of unmarketable real estate on his hands. He then owned 571 argillite carvings, by far the largest collection in the world. "I have never sold any of my Indian things and hope some day they get into some of the bigger museums where they will be kept forever intact," he declared in 1932.[2]

Pearsall died at Melrose in 1964, the day after his ninetieth birthday. His entire collection had been sold the year before to the University of Florida for $150,000, contributed by an anonymous donor. It was valued at $700,000.[3] How much the argillite portion accounted for was not stated. The range of the major clusters reflected Pearsall's shifting tastes — arrowheads (which had inspired him to collect in the first place), adzes, wooden totem poles up to thirty feet tall, hundreds of clay pots, basketry, ornamented blankets from tribes all the way from Alaska to the American mid-West, peace pipes from the plains Indians. Some of his best buys were made through people like George Thornton Emmons, who lived fairly close to him in New Jersey. According to one story, he kept his dealings so secret that not until years later did eastern American museum officials learn that he was the man who had outbid them for certain choice items.

Regardless of how much money he or she had, a person today would be unable to match Pearsall's collecting success in argillite. The classic specimens of nineteenth century and early twentieth century argillite that were within his reach have since passed into museums. With them has passed the kind of romantic, free-wheeling, big-time approach to collecting so colorfully exemplified by Pearsall in his dealings with Deasy.

The laws of economics have come into play. Scarcity has pushed up prices at an astounding rate. In North America, where the demand has been greatest, the rise in prices has been the steepest. *Examples*: In the mid-1960s a bear-mother group figurine which

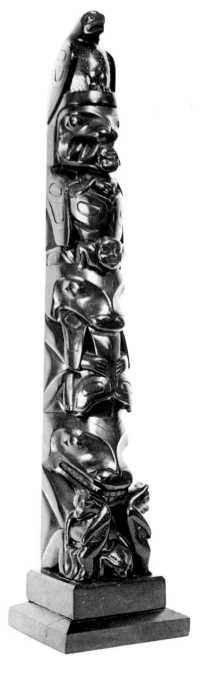

appeared to be of the Edenshaw era was peddled on the main street of Prince Rupert for less than $500. It is a handsome carving, apparently from a Haida home. In 1977 it reappeared in a Vancouver museum gift shop, was attributed to Edenshaw and bore a price tag of $40,000. A twenty-five inch pole by Jim Mackay, which the Museum of Northern British Columbia at Prince Rupert bought for $1,000 from Golden Jolliffe of Queen Charlotte City in 1965, would be worth perhaps $15,000 today on the Canadian or American west coast market.

In London, the center of gravity in the orbiting sphere of antiques, prices have been much more stable. Ten-inch shaman figurines from the past were selling at a leading auction house there in the autumn of 1976 for approximately $2,000 each. As much depends, therefore, on where one buys as on what one buys.

But while the average collector has been largely priced out of the market for classic carvings of the past, he has abundant opportunities in the present-day. The enduring art has seen to that. Private collectors today concentrate on buying works by modern carvers and, curiously enough, they have the field to themselves since museums are snail-slow in recognizing what is new and potentially valuable. Some private collectors try to build representative collections with, say, as many poles as possible, by different carvers. Some concentrate on the works of one particular carver whose talent takes their fancy. Some concentrate on one form of carving for a comparative display.

Whatever their focus, they still find ample scope for their endeavors. The fun of the "hobby" has in no way diminished since the day of the second Duke of Leuchtenberg, the spiritual patron of all the generations of argillite collectors who have followed him.

The Jim Mackay pole bought for the Prince Rupert museum may have been a reproduction of a story pole in cedar, with the eagle crest of the owner on top, followed by three stories: (1) Chief of killer whales who holds someone upside down in his mouth, making fun of this person; frog, messenger to the gods; (2) Crouching person on head of bear, who is eating killer whale; (3) Bear mother holding twin cubs.

34.
Buying today

What sort of person is this character called a collector? A strange creature who may know a great deal — or nothing — about what he collects. Atavistically, he picks up bright objects, takes them home, admires now and then, and perhaps turns them over for something else. His enthusiasm can actually become so intense that he neglects both family and friends.

Collecting has even been called a disease. The premier collector of Northwest Coast native art, George Thornton Emmons, recognized the symptoms and tried to trace their cause. "The spirit of collecting is born in us, and we are not free agents," he wrote in 1903. "My days of general collecting are over," he went on to declare, then on second thought added that whenever he was in Indian country, it would be impossible for him to resist "picking up things."[1] Emmons was then 51. He was still collecting years later.

Fortunately, not every collector has the fervor Emmons had, or there would be precious little left for the rest of us. The collector species luckily is diverse. Some members have well-lined pockets, like Pearsall; some go around almost thread-bare. Some are discriminating, highly selective; others can be all too easily pleased. At one end of the spectrum is the collector content with a single object, who nostalgically values the circumstances by which he acquired his solitary treasure. At the other end is the cold speculator, who might as well be dealing in wheat futures.

Whether a perfectly normal human trait or a pathological affliction, collecting has been a life support for argillite art. Without the collector, carving could have died at any one of several stages in its evolution. In times of economic prosperity, the collector has been especially active, ready to alight, snatch up the black beauties, and encourage the carver to create still more.

So avidly have collectors pursued argillite over the last 100 years that very few "antique" pieces can be obtained anywhere today. Most nineteenth century works are securely locked in museums and foundations. Museums swap occasionally, but only among themselves. This is not to say that finds cannot still be made in second-hand stores, where James Hooper reputedly searched so successfully. No one should dismiss the junk store as a potential source, or the church bazaar. But the chances are nonetheless slim. Virtually the only regular sources for the increasingly limited number of early pieces that go on the open market each year are the dealers, who purchase from private collectors, and the auction houses. When buying from either, the collector must be prepared to pay handsomely, since he will be competing against museums, well-endowed foundations, and private collectors richer than himself, all intent on filling gaps in their collections. As recently as four years ago, a panel pipe of undoubted merit could be bought at auction in London for less than $1,000. Buying pressure has since pushed prices higher, but in comparison with dealer prices in western North America in 1976, those London auction prices were very low. Ideally, the collector should be able to examine the carving before buying, even from a highly-reputable auction firm, because catalog descriptions do not always indicate the extent to which a piece may have been damaged. Not that some buyers care particularly, if they know they can have it repaired properly. They

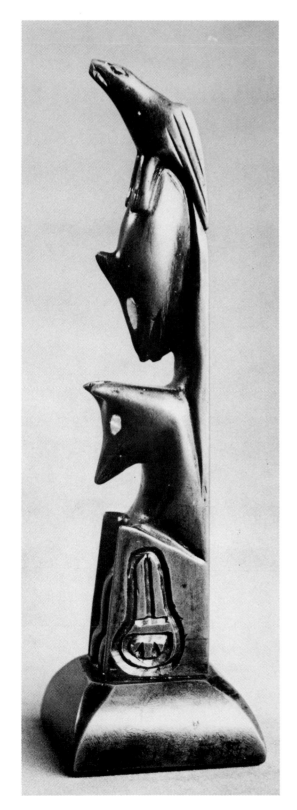

Cast-iron imitation of an argillite pole.
— *Alex Barta*

take their chances and bid by mail.

No certification authorities exist for argillite as they do, say, for classical postage stamps, to guarantee a sale item as genuine and thus protect the buyer. However, authenticity is seldom called into question, owing to argillite's specific nature and singular place of origin. The possibility of forgery always exists, but the Haida themselves keep such a close watch on the market that any forger would soon be blackballed.

From time to time, argillite imitations as distinct from forgeries, have strayed onto the market, reportedly from Japan, although not only the Japanese produce imitations. The only one we know of is cast in iron and its appearance, weight and "feel" demonstrate at once that it is not real argillite. It is a disconcerting thought, but someone somewhere in the world is probably busy collecting argillite imitations. If so, he has his work cut out. Fakes are extremely hard to find, at least on the North American west coast where they would logically have been planted.

Another substance which can sometimes be mistaken for argillite is soapstone which has been blackened. These carvings can be discerned by their heavier weight and by the fact that the blackening will rub off, unlike that of argillite attained entirely through hand-rubbing.

Molded imitations of argillite carvings made from plastic or pulverized stone, line the walls of many souvenir stores. The buyers are usually tourists who have never heard of argillite and who must wonder why these items, usually poles, should be black and not some other color. What most betrays the molded piece is a seam left from the casting.

In very recent years, museum gift shops have offered for sale molded reproductions of classical works in argillite, with price tags as high as $200. Some carvers have no objection to these copies, as long as they are plainly advertised as such. Others consider them detrimental to the legitimate argillite business.

What should the buyer of contemporary argillite look for? Largely it is a matter of personal taste, and of familiarizing oneself with the work of established carvers while keeping one's eyes and ears open for new carvers with potential. It calls for comparative study, an understanding of what constitutes quality carving, and constant searching. Generally speaking, the closer one lives to the Pacific Northwest, the better the chance of obtaining one's preferences, whether in a certain type of carving or the work of certain carvers. Since 1945 for example, Hilda Kendall has built a collection representative of as many different carvers as possible. Living at Skidegate Landing, close to the village of Skidegate, she has been in an ideal position to do so.

British Columbians less strategically located frequently call at stores to see what is on sale and to ask the names of carvers whose work particularly appeals to them. Some buy at these stores. Others buy direct from the carver, either commissioning a particular piece or requesting whatever happens to be on hand. In the case of a custom-made article, a carver will take a few weeks, maybe months, to complete it, depending on how much else he has to do. But if he promises to make a piece, he will. And he will see that it reaches its

destination in perfect condition. Most carvers are as close as a telephone call to the Charlottes, Prince Rupert, Vancouver or Victoria. But because most of them do not advertise, their names must be obtained through "leads" from other sources.

Learning about argillite, like learning about any other art, takes exhaustive study. This means reading, starting with Marius Barbeau's publications which are issued by the National Museum of Canada (see bibliography). It also means looking at argillite long and critically. It means handling it, getting to know the feel of it. It means trying to understand and appreciate the distinctive heritage that every carver expresses in his designs.

The inquiring mind will find itself led into many green fields apart from the unique one of argillite, and then unexpectedly, back to it again. The reward one gains will be in direct ratio to the study devoted to the subject.

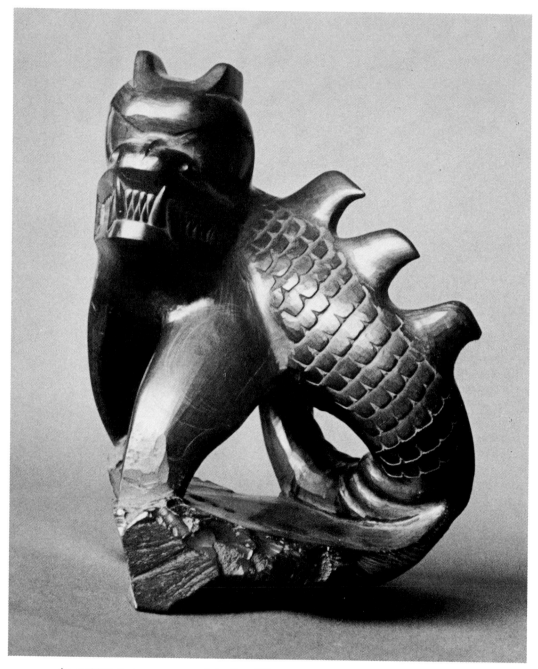

An exciting contemporary work by Ron Wilson, this needs a revolving platform for prime viewing. Asked what he was calling it, Wilson replied "Does it need a name?" then suggested sea monster.

- Ron Wilson

As we have already indicated, the conditions under which the argillite carver functions have never been better than they are today. He has gradually assumed control of the market. By extending the scope of his sales he has all but eliminated price-fixing by dealers. And by sheer quality of workmanship, combined with a shift away from the pole, he is forcing an end to pricing by the inch.

Meanwhile, the popular appeal of argillite has grown enormously. Those who were attracted by it in the past — the fur trader, the artist, the missionary, the government-appointed Indian agent — have been replaced by a wider, more diversified audience. At long last, museums are beginning to hold exhibitions of argillite alone, in its own right, rather than mixed in with other Northwest Coast native arts. The exhibitions are assembled from their own holdings which as we have seen, consist largely of argillite from the past. What they should also be showing are the best contemporary works, for many of these are just as beautiful in their own way, as the classics. Educationally, an exhibition of argillite from its beginning to the present day would be of the greatest value, since it would demonstrate how two very different cultures came together and interacted — and not at the expense of the distinctive Haida identity.

The current trend in carving tends toward the free-form single figure of Haida legend. In one sense, this is a simple realization of the amount of information that has been lost. Young carvers of today admire an Edenshaw pole or a Tom Price platter because of its abundant design, its symbolic richness; they realize that the old-time carver knew more of the Haida heritage than they do. Yet, out of their limited knowledge, they "give," proportionately, perhaps even more than the early carver gave in his creation. They also know that by talking to their elders, by researching Haida history, by examining the wooden carvings which molder in the deserted villages, they can, even as the twenty-first century approaches, regain some of that lost awareness.

In asking what motivates argillite carvers today, we find the same two reasons that gave rise to the profusion of fine carving in the 1880s — a desire both to keep traditions alive and to earn money. To our question of why they took up argillite carving, several present-day carvers replied as follows:

Robert George Collison: "to earn money"; his son, Steve: "got interested watching my father"; Denny Dixon: "for enjoyment and a living"; Tom Hans: "for money"; Lavina Lightbown: "to carry on the tradition of our forefathers"; George Yeltatzie: "to understand my culture in further depth." But all will agree that, as they delve deeper, their craftsmanship deepens in quality.

Technically, the finest modern works are masterpieces of composition, sculpting and finishing. Individual stylists can be identified by one or more of those elements. Henry White often introduces forceful figures from legend whose faces have harsh, haunting expressions. Ed Russ emphasizes the three-dimensional; his poles are carved all the way around. Even in his dishes and medallions he strives for a three-dimensional effect. He often applies a rough-texture finish instead of a high gloss. Ron Wilson is probably the greatest innovator of the present generation. In freeing figures

Ed Russ holds one of his plates.
— *Alex Barta*

from conventional placing, he has shown how great beauty can be achieved in free form and three-dimensional carving. He is more a sculptor than a carver. Pat Dixon, now in middle age the oldest of the "young" generation, is like the George Smith of a previous generation, the model carver whose work is the standard against which the work of others can be measured. A master of the rules of design, he is especially skilled in transferring designs onto planes and creating illusions in depth. Greg Lightbown, whose interlacing figures are strokes of genius, perhaps knows better than any carver how to use space. In an almost indefinable way, the spatial sensibilities of all the expert carvers of today reflect their presence in the space age. Theirs is a cosmic view, yet one that is peculiarly Haida.

The contemporary state of the art is more than merely a tribute to the skill of our present-day carvers. It is also a testament to the remarkable ability of argillite art to survive and even to flourish, given half a chance. Above all, as the continuous expression of a people, it demonstrates the essential strength and impregnability of the Haida culture. All those who have seen what the argillite artist is achieving today can only rejoice. They may even come to the very conclusion that we ourselves have: the best of argillite is yet to come.

Sea wolf, by Ed Russ.
— *Alex Barta*

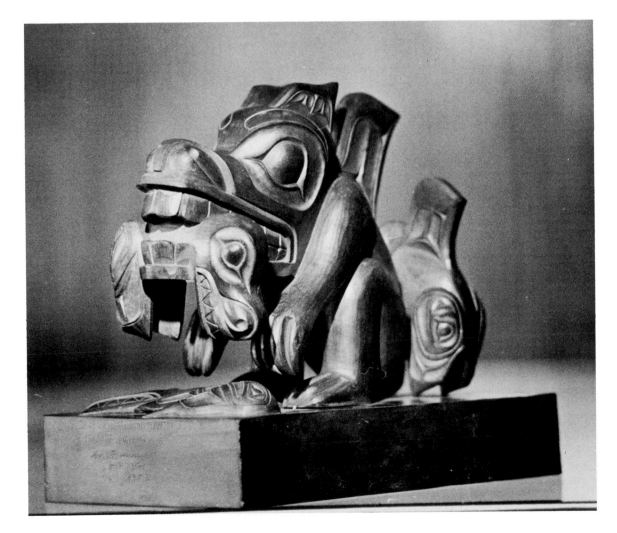

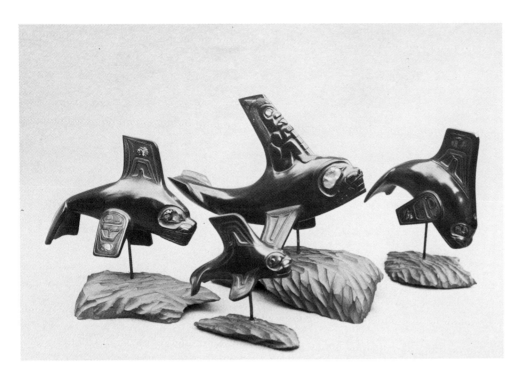

Pod of lively killer whales by Henry White tells part of a familiar, multi-versioned legend. The human figure carved into the dorsal fin of the largest whale, which is 28 cm. long, represents Guhnarh, whose wife was captured and taken away. During his efforts to locate and free his wife, he was helped by the Killer Whale People and was transported on the back of their leader. Lightbown collection.

John Yeltatzie's representation of Susaan, a famous Haida strongman, seizing a sea lion and tearing it in half. Height 15.5 cm. including the base. Lightbown collection.

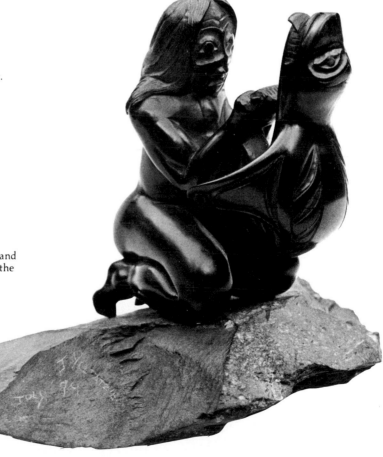

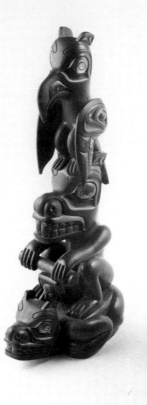

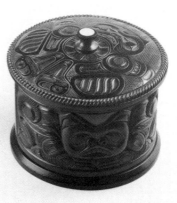

Figure by Ed Russ (23 cm. × 7.5 cm.) and circular box by Henry White (11 cm. × 9 cm.)
— *Centennial Museum Gift Shop, Vancouver. Henry Tabbers Photo*

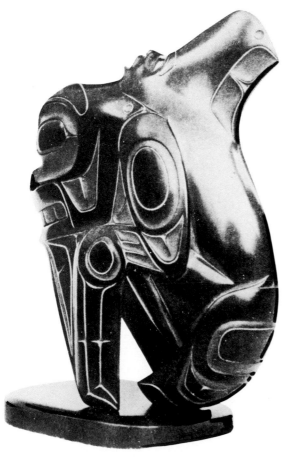

Expertly-carved free form by Ron Russ.

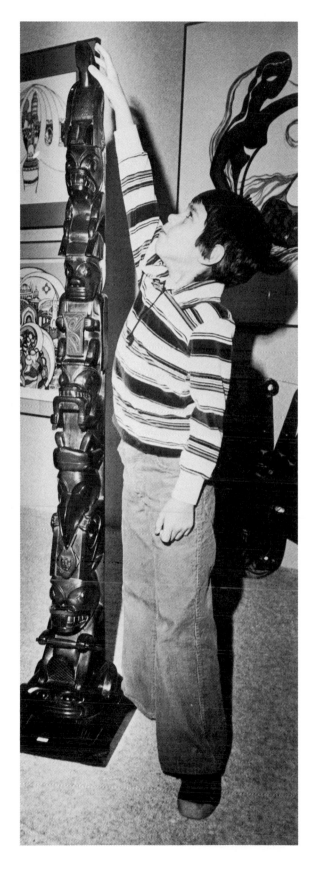

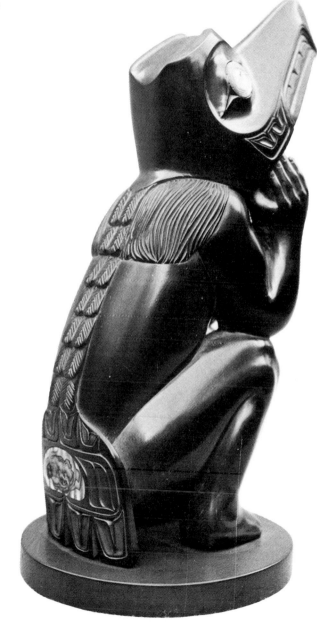

Young Nick Wilson can barely reach to top of this 160-centimeter-high pole by Alfred Collinson.
— *Alex Barta*

Haida in the dress of a Raven dancer, by Henry White. Height 24 cm. Lightbown collection.

Appendices Chronology

1700? Haida breakaways from northern Queen Charlotte Islands form new settlements on Prince of Wales archipelago and become known as Kaigani Haida.

1774 Juan Perez in *Santiago* calls at Charlottes and trades briefly with Haida.

1778 Landfall at Nootka Sound by James Cook — first whites to set foot on what would become British Columbia.

1784 Gregory Shelikhov founds first permanent Russian settlement in North America, at Kodiak.

1786 La Pérouse discovers Dixon Entrance and is first to suggest that Charlottes are separated from mainland.

1787 George Dixon of England trades with Haida at North Island for sea otter furs, establishes insular nature of Charlottes, names them and Dixon Entrance.

1788 Two more British traders, Charles Duncan and William Douglas, sail through Hecate Strait.

1789 Spaniards establish base at Nootka. Ceded to Britain under Nootka Convention of 1790.

 John Kendrick, commander of first fur-trading expedition from Boston to Northwest Coast, claps two Haida chiefs in irons as hostages for furs, starting long and bitter animosity toward "Boston men."

1791 Etienne Marchand, French scientific expedition leader, enters Cloak Bay in *Solide,* makes observations, prepares first chart of harbors.

 Koyah, town chief of Ninstints, tries to avenge Kendrick insult and loses — forty to sixty Haida slaughtered.

1792-93 George Vancouver correctly charts outlines of Charlottes for Britain.

1793 Alexander Mackenzie reaches coast overland from Canada, greeted by Bella Coola natives.

1794 Chief Cumshewa, aided by Koyah, captures American schooner and kills all but one of crew.

1799 Granting of charter to Russian American Company.

1801 Maritime fur trade reaches its peak, 23 vessels working Northwest Coast.

1804 Aleksandr Baranov lays foundation of Sitka.

1805 Lewis and Clark expedition reaches mouth of Columbia River.

1810 John Jacob Astor founds Pacific Fur Company which establishes its Astoria base at mouth of Columbia.

1819 Fur trader Roderick McKenzie becomes first known collector of argillite by acquiring a panel pipe.

1820 Merger of Hudson's Bay Company and North West Company, leading to dominance of Hudson's Bay Company in Northwest Coast trade.

1824 Fort Vancouver established on Columbia River.

1825 *William and Ann,* first Hudson's Bay Company ship to compete against Boston ships on Northwest Coast, visits Charlottes with John Scouler aboard as surgeon-naturalist.

1829 A missionary calls at Charlottes — Jonathan Green of Oregon Crusade.

1830 Sea otter near extinction.

1831 Hudson's Bay Company establishes Fort Simpson at mouth of Nass River.

1830 First, very small collections of argillite being acquired by men associated with fur trade.

1836 First paddlewheel steamer on Northwest Coast, the Hudson's Bay Company's *Beaver,* goes into service.

1839 Russia leases Alaska Panhandle to Hudson's Bay Company and turns over its Stikine River fort.

1843 James Douglas of Hudson's Bay Company chooses site for Fort Victoria.

1849 Founding of Hudson's Bay Company post at Fort Rupert on northern Vancouver Island.

1851 Hudson's Bay Company ship *Una* finds small quantity of gold on Charlottes.

 American vessel *Georgianna* with prospectors aboard wrecked in Skidegate Inlet.

1852 Hundreds of American gold-seekers reported heading for Charlottes. Governor Douglas fears colonization and annexation of Charlottes by U.S. Britain establishes sovereignty

over Charlottes, appoints Douglas lieutenant-governor.

American vessel *Susan Sturgis* seized by Haida near Masset, her occupants captured and ransomed.

1853	Royal Navy establishes presence, H.M.S. *Virago* surveys Queen Charlotte waters.
1857	Anglican lay missionary, William Duncan, comes to west coast.
1858	Fraser River gold rush brings thousands of immigrants to Victoria. Northern natives, including Haida, begin mass summer excursions to Victoria.
1860	H.M.S. *Alert* visits Charlottes on law-and-order mission.
1862	Smallpox epidemic devastates Haida villages.
	Argillite goes on public exhibition in London.
	William Duncan builds his "New Jerusalem" at Metlakatla.
	Stikine mining activity stimulates argillite sales.
1866	Crown colonies of British Columbia and Vancouver Island, including Charlottes, are united.
1867	The Alaska Purchase. Steamer traffic begins between San Francisco, Victoria and Sitka.
1869	Hudson's Bay Company trading post established at Masset.
	First transcontinental railway completed in United States.
1870	Start of consolidation of Haida villages.
	Carving of miniature poles in argillite increases substantially.
1871	British Columbia becomes part of Dominion of Canada.
1872	Dr. Israel Powell named Indian Commissioner for British Columbia, only province to have such a commissioner.
1876	William Henry Collison arrives at Masset to set up first Christian mission in Charlottes — for Anglicans.
	Indian Act marks decline of traditional native forms of government.
1878	First scientific survey of Charlottes by George Dawson. He writes first detailed account of Haida life, takes first known photographs of Haida villages.
1880s	Increased activity among argillite carvers.
1883	Two amateur investigators of Haida arts, James Deans and James Swan, visit Charlottes separately.
	Northwest Coast Indian agency established at Metlakatla.
	Lay teacher for Methodists arrives at Skidegate.
1896	Start of Klondike gold rush.
1906	Founding of Prince Rupert.
1910	Separate Indian agency for Charlottes established at Masset, with Thomas Deasy as agent.
1920	Death of Charles Edenshaw.
1922	Leigh Pearsall begins argillite dealings with Thomas Deasy.
1927	Death of Tom Price.
1929	Start of Great Depression, which curtails markets for argillite.
1939	First major exhibition of Northwest Coast native art, at Seattle.
	Marius Barbeau makes first visit to Charlottes, to study Haida carvings.
1941	Slatechuck deposit reserved for Haida use exclusively.
1947	Barbeau's second visit to Charlottes for closer study of argillite carving.
1953	Publication of Barbeau's, *Haida Myths Illustrated in Argillite Carvings.*
1957	Publication of Barbeau's, *Haida Carvers in Argillite.*
1958	Pat McGuire concentrates on argillite carving.
1960s	Classes for young carvers conducted by Rufus Moody at Skidegate and Claude Davidson at Masset.
1969	Carole Natalie Kaufmann thesis: "Changes in Haida Indian Argillite Carvings, 1820-1910."
1970	Death of Pat McGuire.
1970s	Strong revival in argillite carving.
1974	Opening of Queen Charlotte Islands Museum at Skidegate.
1977	Robin Kathleen Wright thesis: "Haida Argillite Pipes."

Argillite Carvers Past and Present

The following list has been compiled from various Haida and white sources, and should not be regarded as definitive. Many nineteenth century carvers are unknown, and information concerning several twentieth century carvers is fragmentary or almost non-existent. Dates for most of the carvers of the past were obtained from the Division of Vital Statistics, Victoria. An "S" or "M" after a name indicates the home village — Skidegate or Old Masset. An asterisk indicates a full-time carver as of 1979.

Archie Abrahams. (1954-) M.

Victor Adams. (1924-) M. Best known for his work in gold and silver.

Richard Adkins. (1955-) M. Studied under Richard Yeltatzie.

Eli Bell. (1919-) M. Carved mostly in his younger years.

William Bellis. (1963-) S. Raven.

Andrew Brown. (1879-1962) M. His Haida name, Owt'iwans, meant Big Eagle, and was inherited from a grandfather of Hippa Island. Brown himself came from Yan. Carved a great many poles in a long career and often signed them.

John Brown. Slate carvings by him were displayed at the Prince Rupert Exhibition in 1924. He may have been the John Brown who was a son of Andrew and Susan Brown, born 1908.

Edmund Calder. (c.1900-1978) S. A carver for most of his adult life; made many poles.

Isaac Chapman. (c.1880-c.1908) M. An exceptionally talented argillite carver. Carved mostly poles and was also a canoe painter. A cripple from birth, he began carving early in his brief life.

Frank Charles. (1875-1940s) M. Lived mostly at Cape Mudge and Campbell River.

***Alfred Collinson.** (1951-) S. Eagle, Haida name Skildugl, grandson of Lewis Collinson and Arthur Moody; started carving in 1960-61 "for fun" and has made pendants, free-forms, boxes, poles. Signs Alfie Collinson.

Brad Collinson. (1959-) S.

Floyd Collinson. (1953-) S.

***Herman Collinson.** (1934-) S. A pole-maker. Signs Herman Collinson.

Lewis Collinson. (1881-1970) S. Eagle, Chief Skidegate. Also went by the name of Tom Collinson. A prolific carver in slate (poles, figurines), wood and silver.

Steve Collinson. (1952-) S.

Ernie Collison. M. Carves off-season when not commercial fishing.

Robert George Collison. (1897-1970) M. Raven, carver of poles starting in 1950s. Signed R.G. Collison.

Ron Collison. M. Also a woodcarver.

***Steve Collison.** (1940-) M. Eagle, son of Robert George Collison. Began carving in 1956 (poles), currently does sculptures. Signs S.R. Collison, Haida.

Gordon Cross. (1911-) S. Born at Claxton cannery, Skeena River, son of John Cross. Began carving in 1940 "with a jackknife" and has made poles, bookends, dishes. Sometimes signs his pieces, G. Cross.

John Cross. (1867-1939) S. Haida name Neeslant. An Eagle (wasco) chief at Skidegate, born at Chaatl, and closely related to William Dixon. The carvers Pat and Denny Dixon and Nelson Cross are grandsons. Noted for his poles in slate and wood. Also an expert tattooist and jewelrymaker.

Nelson Cross. (1951-) S. Silversmith and argillite carver. Began by carving medallions as a child.

***Claude Davidson.** (1924-) M. Raven, grandson of Charles Edenshaw and son of Robert Davidson, Sr.

***Reg Davidson.** (1954-) M. Son of Claude Davidson. Carving since 1970.

Robert Davidson. (1885-1969) M. Eagle, a hereditary chief of Yan, also known as Robert Gunya, canoe-builder. Married Florence Davidson, daughter of Charles Edenshaw. Florence Davidson is a well-known hat weaver and button blanket maker.

***Robert Davidson.** (1946-) M. Eagle, son of Claude Davidson; began carving at about age twelve; apprenticed with Bill Reid and studied for one year Vancouver School of Art. Silver and gold jewelry, argillite, wood carving, silk screen prints.

Agnes Davis. (1933-) M. Taught by her brother, Claude Davidson.

Fred Davis. M. A highly-promising young carver.

Freda Diesing. M. Wood carving (masks), argillite, prints.

Denny Dixon. (1940-) S. Carving since 1969, pendants, poles, plates.

George Dixon. A nineteenth century carver, named for the fur-trading sea captain.

***Pat Dixon.** (1938-) S. Brother of Denny Dixon and, like him, often carves raven and eagle. Carving since 1961. Dishes, pipes, poles.

William Dixon. Haida name, Ayaii, lived until approximately 1900, and was the father of George Smith. An outstanding carver of dishes and shaman figurines.

Charles Edenshaw. (1850?-1920) Eagle chief of Masset. Top-ranking artist in several mediums, and the best-known argillite carver.

Donald Leroy Edgars. (1955-) M.

Joe Edgars. M.

Charles Gladstone. (1878-1954) S. Close relative of Charles Edenshaw, and grandfather of Bill Reid. A major carver in wood, argillite and silver. Signed some of his later works.

Clayton Gladstone. S.

Bill Gladstone. S. Son of Charles Gladstone.

Joe Gray. A nineteenth century carver of Skidegate.

George Gunya. A nineteenth century maker of slate "flutes" and reputed one-time owner of the Slatechuck deposit.

Henry Hans. (1940-1967) S. A son of Isaac Hans.

Isaac Hans. (Died 1961) S. A Raven, the last person born at Skedans — his family left three days after he was born. Married a daughter of Henry Young.

Joseph Hans. (1923-1947) S. Eagle, son of Isaac Hans.

***Thomas Hans.** (1925-) S. Eagle, Haida name Iyea. A carver since 1937, of poles and occasional dishes. Signs Tom Hans Iyea.

Jim Hart. M.

Sharon Hitchcock. (1951-) M. An outstanding artist in various mediums.

***Melvin Hutchingson.** (1953-) S. Also called Ding Hutchingson. Haida name Gingida. A grandson of Jimmy Jones. Makes boxes, free-forms, pipes.

Moses Ingram. (1906-) M.

Clarence Jones. (1928-) S.

Earl Jones. M.

James Jones. (1874-1959) S. Haida name Feath-now.

Mollie Jones. S. A carver of ashtrays.

Moses Jones. (?-1926) S. From a Tanu family. A noted wood carver.

Paul Jones. (c.1847-1929) S. Brother of Moses Jones. An outstanding carver, especially of poles. Father of Albert Jones, co-discoverer of the Tasu iron mine.

Roy Jones. (1924-) S.

Walter Kingego. A nineteenth-twentieth century carver of a Rose Spit family. Made figurines, including chief and shaman figures.

Johnny Kit Elswa. A highly-skilled nineteenth century argillite and wood carver.

Bill Lightbown Jr. (1956-) M. Son of Lavina Lightbown.

Greg Lightbown. (1953-) M. Son of Lavina Lightbown. Exceptionally fine carver.

Lavina Lightbown. (1921-) M. Haida name, T'how-hegelths. Raven, a granddaughter of Charles Edenshaw. Carver of plates and sculptures.

Jim Mackay. (c.1890-c.1945) S. A carver of poles, bowls, dishes, candleholders, ashtrays.

Gerry Marks. (1949-) M. Grandson of John Marks; a silversmith and argillite carver. In 1971 he trained with Freda Diesing at Prince Rupert.

John Marks. (1876-1952) M. An unconventional stylist in argillite, and a jewelrymaker.

James McGuire. (1954-) S. Brother of Pat McGuire.

Pat McGuire. (1943-1970) S. A first-rate carver and silversmith. Also produced watercolors and ink drawings. A descendant of Charles Gladstone.

Moses McKay. S. A nineteenth century carver.

Robert Miller. (1860-1930) S. Thunderbird clansman, born at Tasu (Vital Statistics); worked quickly, carved only in slate, and produced many fine poles.

Sandy Miller. (1952-) S. Lives in Prince Rupert.

Clarence Mills. S.

Gary Minaker.

Arthur Moody. (1885-1967) S. A chief of the Tanu wolf clan, and a son or stepson of Thomas Moody. Arthur learned carving from Robert Miller, and made many poles. Also an accomplished band player.

Garner Moody. (1958-) S. Grandson of Arthur Moody.

Henry Moody. (1872-1945) He and his wife drowned near Lawn Hill. His roots were in Skedans and he owned crests of mountain goat, grizzly bear and wasco. Son of Job Moody.

Job Moody. S. An active carver in 1907, according to C.F. Newcombe.

***Rufus Moody.** (1923-) S. Prolific argillite carver and instructor. Has produced the tallest argillite poles. Holder of Canada Medal.

Thomas Moody. (c.1877-1947) Born at Tanu, a fine carver of his generation.

Frank Paul. Early twentieth century silver and argillite carver.

Marjorie Pearson. (1928-) S.

Tim Pearson. (1887-1961) S. Carved most of his life, especially when he retired from fishing in 1950.

Wayne Peterson. M. Lives in Prince Rupert.

Francis Pollard. (1953-) S.

Glen Pollard. (1957-) S.

Jack Pollard. (1907-) S. Eagle (beaver), born Claxton cannery, Skeena River. Carved from 1968-1974.

Mildred Pollard. (1915-) S. Wife of Jack Pollard, and a granddaughter of Amos Russ. Began carving at age 24 and stopped a few years ago when her Has made small poles and medallions.

Wally Pollard. (1938-) S.

Tom Price. (1860-1927) S. According to C.F. Newcombe, he was Chief Taan of Ninstints, and among his crests was the five-finned blackfish, a Ninstints crest. A master carver of plates and platters, poles and boxes.

Norman Pryce. (1926-) S. Raven, born at Hippa Island, son of Jimmy Jones. Learned argillite carving from Charles Gladstone at age 11 during his last year of school. A pole carver primarily and uses beaver, bear, raven, eagle. Signs N. Pryce.

***Randy Pryce.** (1952-) S. Son of Norman Pryce, cousin of Alfred Collinson. Has carved pendants, pipes, free-forms.

Sam Qaoste. (Died 1892) Also made canoes, masks, big wooden poles.

Bill Reid. (1920-) S. Internationally-known master craftsman, especially in jewelry, but also in argillite. Has lived in Vancouver most of his career. Design expert.

Robert Ridley. (c.1855-1934) M. A chief of Yan, uncle of Andrew Brown. Carved in wood and argillite.

John Robson. (c.1830-1900) He belonged to the grizzly bear clan of the Ravens of Rose Spit. An expert designer, and noted carver of dishes, figurines, boxes and poles, whose work is only now starting to be identified. Robson interpreted for C.F. Newcombe.

Andrew Rosang. (1947-) S.

***Ed Russ.** (1953-) M. Eagle, Haida name Gitajung. Carving since 1972. At first poles and pendants, later plates, boxes, pipes, sculptures. Signs Ed Russ, Haida (and date).

Faye Russ. (1953-) S. Wife of Ed Russ, a student of Rufus Moody. In turn, taught argillite carving to Ed Russ.

Gary Russ. (1943-) S.

Ronald R. Russ. (1953-) M. Raven, carving since 1972, pendants, sculptures, poles. Signs R. Russ.

David Shakespeare. A nineteenth century carver in wood and argillite.

Ed Simeon. (1942-) M.

George Smith. (1866?-1936) S. Belonged to the thunderbirds, and was from Cumshewa, of a family of Hippa Island and Chaatl. Highly-esteemed for his plates,

bowls and a great many poles. Possibly carved trade pipes.

John Smith. Father of George Smith. Worked in period 1860-1870.

Daniel Stanley. (1880-1911) A competent, occasional carver of argillite, not of poles.

Bill Stevens. (1927-) S.

Johnny Stevens. S.

Raymond Stevens. (1952-) S. Eagle, born in Prince Rupert.

Wilfred Stevens. (1941-) S. Raven. Nephew of Gordon Cross and Raymond Cross. Carving since 1959, learned from Pat Dixon; a pole maker. Signs W. Stevens.

Hector Thompson. M.

Waekus. Known to have carved argillite in Victoria about 1860.

Amos Watson. (c.1887-c.1947) His family was from Cape Ball, and he lived at Kitkatla. Carved in wood and argillite. Is said to have carved pipes and shaman figurines.

Louis Weden. (1947-) M.

Richard Weden. (1963-) M.

Brian White. (1937-) M.

Chris White. (1962-) M.

Douglas White. (Died 1977) M.

Gary White. M.

Henry White. (1945-) M. Son of Lavina Lightbown.

Morris White. (1931-) M.

Paul White. M.

Terry Williams. (1953-) S. Raven, a pupil of Rufus Moody. Began by making pendants, earrings, ashtrays. Later made boxes and plates.

***Douglas Wilson.** (1943-) S. Eagle, Haida name Nung-keith-ga, grandson of Solomon Wilson. Began carving seriously in 1970.

Ronald Wilson. (1945-) S. Eagle, uses Haida name Gitsgah as his signature. Carving since 1962. Learned from Tim Pearson and Arts of the Raven exhibition held in Vancouver in 1967.

***Wayne Wilson.** (1949-) S. Eagle, Haida name Skaagwi. Has carved medallions, poles, dishes. Signs Wayne Wilson.

Joshua Work. (c.1865-c.1935) Haida name Yaehlnao. Born and trained at Skidegate, lived at Port Simpson. An outstanding carver of beaver bowls, also a canoe-maker.

Clive Wyatt. M. Lives in Vancouver, and worked with Pat Dixon for a time.

Alex Yeltatzie. (c.1870-c.1945) M. A Stastas Eagle, kinsman of Charles Edenshaw. His main crest was the beaver.

George Yeltatzie. (1950-) M.

Harold Yeltatzie. (1953-) M.

John Yeltatzie. (1952-) M.

Richard Yeltatzie. (1956-1974) M. Killed in 1974, at age 19, in a plane crash near Prince Rupert.

Don Yeomans. M. A nephew of Freda Diesing.

Matthew Yeomans. (c.1870-c.1945) M. Highly-regarded carver of wood and argillite.

Daniel Young. S.

George Young. (c.1850-1924) S. A carver of dishes.

Henry Young. (1872-c.1950) S. A Rose Spit Raven who carved slate poles (signed some of his works), and made pencil drawings of Haida designs.

James Young. (1923-) S.

James Young, Jr. (1943-) S.

Lonnie Young. (1945-) S.

Argillite in Museums

In 1977-78 we conducted a survey of argillite in museums around the world. More than anything else, it showed its wide distribution as well as the potential for research.

We were unable to ascertain what argillite is owned by museums in Spain. We were also unsuccessful in obtaining information from the Soviet Union. The Hermitage Museum, Leningrad, informed us that it has no argillite; the Department of American Ethnography, Institute of Ethnography, Leningrad, replied only that its museum has no argillite earlier than 1840. As for the People's Republic of China, Hsia Nai, leading archaeologist in Peking told us that as far as he knew, none exists in museums in his country.

The summaries that follow are by no means complete, but have been selected from a general-interest viewpoint:

CANADA

Canadian museums reflect the endeavor of just over one hundred years of collecting. Attitudes of some long-standing institutions have been ambivalent toward argillite, and have tended to favor the old over the new, all but ignoring twentieth century artists. Nowhere in Canada do we find a public museum devoted exclusively to gathering and displaying argillite. This may come in time - in British Columbia, one would hope.

Calgary, Alberta
Glenbow Alberta Institute has built up a collection of more than 130 pieces - a fine, balanced showing.

Kleinburg, Ontario
McMichael Canadian Collection, with more than thirty well-chosen pieces.

Montreal, Quebec
McCord Museum, about thirty carvings.

Ottawa, Ontario
The National Museum of Man has, in effect, Canada's national collection. It numbers close to 200 pieces, more than half of them obtained before 1900 by the Geological Survey of Canada with Dawson, Powell and Aaronson as the sources. Also argillite from the Lord Bossom collection.

Prince Rupert, B.C.
Museum of Northern British Columbia has about thirty pieces, primarily twentieth century.

Queen Charlotte Islands, B.C.
Queen Charlotte Islands Museum at Skidegate. A late starter — hopes enough public-spirited donors will come forward to enable it to make a showing.

Toronto, Ontario
Royal Ontario Museum, approximately forty pieces including two pipes collected by the painter Paul Kane.

Vancouver, B.C.
Centennial Museum has close to 200 pieces, a wide-ranging collection including argillite from the Lipsett collection.

Vancouver, B.C.
University of British Columbia's Museum of Anthropology is a delight to visit because all its argillite is on display (one of the rewards of a new building!). Much of this collection was purchased from the family of W.E. Collison through a fund created by British Columbia lumber magnate, H.R. MacMillan.

Victoria, B.C.
The British Columbia Provincial Museum probably has the largest collection of any Canadian institution, a substantial part of it having been acquired only recently. The collection is strong in poles and pipes. A few exceptional examples in these and other categories were bought in 1961 from the estate of William Newcombe. (Newcombe had a hard falling out with the museum. He was engaged as a botany assistant in 1928, then peremptorily dismissed four years later. He turned his back on the museum, with the result that it had to wait until his death to buy his Northwest Coast collection.)

UNITED STATES

The richest nation in the world ought to have the most argillite — and indeed it has. Many of its institutional collections were endowed by wealthy patrons of the arts who also had a good eye for choice material. New England museums have some of the

earliest argillite on record. And far away, in the forty-ninth state, Alaska, are two small but exceptionally fine collections, in Juneau and Sitka.

Highlights:

Berkeley, California
Lowie Museum of Anthropology, University of California. A small but notable collection.

Cambridge, Massachusetts
Peabody Museum of Archaeology and Ethnology, Harvard University. An important medium-sized collection including ten panel pipes, charms, and a recorder. More than half of the collection came from Frederick Hastings Rindge (1857-1905), multi-millionaire philanthropist and scion of an old New England family who spent the last years of his life in California and there bought native art. This museum has possibly the oldest argillite on record — a panel pipe collected by Scottish-born fur trader Roderick McKenzie (1761?-1844) prior to 1819 and purchased by the American Antiquarian Society from McKenzie, of Terrebonne, Lower Canada. McKenzie was a cousin of Alexander Mackenzie who made the first overland journey across North American (north of Mexico) to the vicinity of present-day Bella Coola. Roderick built Fort Chipewyan on Lake Athabasca, and was in charge of the post during his cousin's epic journeys to the Arctic and Pacific Oceans. He retired from active participation in the fur trade in 1801, bought the seigniory of Terrebonne in 1804, and lived there until his death.

Denver, Colorado
Denver Art Museum. A small collection that includes fine pieces.

Gainesville, Florida
Florida State Museum, University of Florida has the Pearsall collection — more than 450 pieces — nearly 400 poles, twenty-five dishes, many of them superb; and a remarkable number of shaman figurines; pipes, and miscellaneous items.

Juneau, Alaska
Alaska State Museum, about twenty-five pieces, many of exceptional quality, including two panel pipes of recent acquisition.

New York City
American Museum of Natural History has a major collection — close to ninety pieces including thirteen bowls and sixteen pipes. An important segment of its nineteenth century argillite is from the Bishop collection and was formed by Israel Powell.

New York City
Museum of the American Indian, Heye Foundation — more than sixty pieces widely representative in object types, including two pipes figured by Catlin, a flute collected by Lady Franklin in 1861, and several works collected by George Thorton Emmons.

Salem, Massachusetts
Peabody Museum's approximately twenty-five piece collection includes five pre-1832 pipes, one of them, a panel pipe, collected by John Hammond before 1821.

Seattle, Washington
Thomas Burke Memorial Washington State Museum has about thirty pieces, from the Ann and Sidney Gerber collection.

Stanford, California
Stanford University Museum of Art. The twenty-five piece collection of various types, was given by Jane L. Stanford, wife of Leland Stanford, the university's founder.

Washington, D.C.
United States National Museum — Smithsonian Institution — has a substantial collection including pipes and dishes from the Wilkes expedition, 1841, with worthy additions forty years later from James Swan.

BRITISH ISLES

Britain built an empire through global exploration on a scale unprecedented in history. Geography enabled the fruits to return to one tight little island. England and Scotland have some fine early collections. Except for the British Museum collection, most of them are small.

ENGLAND

Brighton
Royal Pavilion, Art Gallery and Museums had among its pieces a pole carved by John Cross and presented to Sir Percy Vincent, Lord Mayor of London, in 1936.

Cambridge

Cambridge University Museum of Archaeology and Anthropology has more than fifteen pieces. Earliest dating, 1846.

Ipswich

Argillite in the Ipswich Museum includes a massive bowl, and a pole bequeathed by Nina Layard, a relative of Sir Austen Layard, excavator of Ninevah.

Liverpool

Merseyside County Museums with an excellent collection of more than twenty pieces, reflects that port city's role in shipping in the last century.

London

The British Museum has a grand array of nineteenth century argillite, more than eighty pieces, exceptionally strong in panel pipes and other pipes of which at least thirteen were collected by William Bragge. Also included is argillite from the collection of the Seattle-born anthropologist, Bruce Inverarity, bought in 1976. The British Museum's entire Northwest Coast collection has its genesis in Captain James Cook's landfall at Nootka Sound in 1778 on his third and final world voyage, but argillite was not among the items picked up then. Earliest entry date for the British Museum's argillite is 1837.

London

The Horniman Museum has two recorders.

Oxford

Pitt Rivers Museum, a few choice pieces.

SCOTLAND

Aberdeen

The Anthropological Museum at University of Aberdeen has a small but significant collection including pipes presented by Captain William Mitchell, who served the Hudson's Bay Company on the Northwest Coast in the mid-1800s.

Edinburgh

Royal Scottish Museum, with a creditable holding. Nearly half its collection, including five pipes and two whistles, was given in in 1861 by James Hector, surgeon and geologist on the Palliser expedition. Hector discovered the Kicking Horse Pass in the Canadian Rockies and mapped the North Saskatchewan River. He later founded the New Zealand Institute. Became Sir James Hector.

Perth

Perth Museum and Art Gallery has probably the oldest museum aggregation in the British Isles — five pipes given by Colin Robertson in 1833, plus other pieces.

EUROPE

Despite bombings and looting during the Second World War, several museums in East and West Germany still have argillite from pre-war days. Nevertheless, much of the Northwest Coast art that Adrian Jacobsen conscientiously gathered, packed and shipped to Germany has gone forever — apparently inadequately protected at the time. The Museum für Völkerkunde in Leipzig, for example, lost much of its once-splendid American collections in a single air raid on December 4, 1943. "A single piece of Haida carving has been preserved, although slightly damaged. It is a black slate pipe . . ." a museum official reported woefully in 1977.

Elsewhere in Europe, small but historically important collections exist.

FRANCE

Paris

Musée de l'Homme has twelve pieces, including the panel pipe that John Scouler collected in 1825.

FINLAND

Helsinki

National Museum of Finland has ten pieces, mostly panel pipes pre-1860 including those collected by Arvid Adolf Etholén.

DENMARK

Copenhagen

National Museum of Denmark, with very fine nineteenth century items.

GERMANY

Berlin

Museum für Völkerkunde, more than thirty pieces, fourteen of which were collected by Adrian Jacobsen and accessioned in 1882; also choice items acquired by the collector-dealer William Oldman.

Hannover

The Niedersächsisches Landesmuseum's very small argillite collection is significant for its documentation. It was obtained during the 1861 visit to Victoria of Israel Joseph Benjamin.

SWEDEN

Stockholm

Etnografiska Museet's more than twenty pieces (poles and figurines) were donated in 1904 by Professor Gustav Retzius (1842-1919), one of the founders of the Swedish Society for Geography and Anthropology, established in 1877. In 1892-93 he and his wife, Anna Hierta-Retzius, who was engaged in social reforms for women, went on a field trip to the U.S. to study its universities and different Indian tribes. At the World Columbian exposition in Chicago, Retzius met the eminent anthropologist Franz Boas — and the famous amateur ethnologist and traveler Adrian Jacobsen. The latter meeting must have stood him in good stead, for later Retzius visited the Northwest Coast with Fillip Jacobsen as his escort. Many of the objects Retzius collected were assembled by Fillip and shipped to him after his return to Sweden. The argillite appears to be the work of only one or two carvers.

Notes

Chapter 1 NOTES

1. Newton H. Chittenden, *Official Report of the Exploration of the Queen Charlotte Islands for the Government of British Columbia,* Victoria, 1884, Progress Report No. 3, p. 38.

Chapter 2 NOTES

1. Kathleen E. Dalzell, *The Queen Charlotte Islands 1774-1966* (Terrace: Adam, 1968), pp. 14-15.

2. J.C. Beaglehole, *The Voyage of the Resolution and Discovery, 1776-1780,* Part Two; (Cambridge: University Press 1967), p. 1475. Published for the Hakluyt Society.

3. George Dixon, *A Voyage Round the World* (London: 1789), p. 201.

4. Dr. Robert Levine, personal communication, 1979.

5. J.H. van den Brink, *The Haida Indians* (Leiden: E.J. Brill, 1974), p. 22.

6. *The Journal of William Sturgis,* edited by S.W. Jackman; (Victoria: Sono Nis Press, 1978), p. 17.

7. Johan Adrian Jacobsen, *Alaskan Voyage 1881-1883,* translated by Erna Gunther from the German text of Adrian Woldt; (Chicago and London: University of Chicago Press, 1977), p. 19.

8. Etienne Marchand, *A Voyage Round the World,* translated from the French by C.P. Claret Fleurieu; (London: 1801), Vol. 1, p. 281.

9. Bill Holm, *Northwest Coast Indian Art, an Analysis of Form* (Seattle and London: University of Washington Press, 1965), p. 93.

10. George M. Dawson, *Report on the Queen Charlotte Islands 1878* (Montreal: Dawson Brothers 1880), p. 117.

11. Ibid., p. 119.

12. Ibid., p. 119.

13. Forrest E. LaViolette, *The Struggle for Survival, Indian Cultures and the Protestant Ethic in British Columbia* (Toronto: University of Toronto Press, 1973), pp. 38-42.

14. James Deans, *Tales from the Totems of the Hidery,* Vol. 2, (Chicago: Archives of the International Folk-lore Association; 1899), p. 11.

15. Extract from a translation by Capt. Harold Grenfell of Caamano's Journal of 1792 in Newcombe anthropology correspondence (uncataloged) (Provincial Archives of British Columbia).

16. Erna Gunther, *Indian Life on the Northwest Coast of North America As Seen by the Early Explorers and Fur Traders during the Last Decades of the Eighteenth Century,* (Chicago and London: University of Chicago Press, 1972), p. 135.

Chapter 3 NOTES

1. John Swanton, *Contributions to the Ethnology of the Haida,* Memoirs of The American Museum of Natural History, Jesup North Pacific Expedition, 1905, Vol. 5, p. 16.

2. Ibid, p. 38.

3. George M. Dawson, *Report on the Queen Charlotte Islands 1878* (Montreal: Dawson Brothers 1880), p. 122.

4. Emily Carr, *Klee Wyck,* (Oxford University Press, 1941), pp. 90-91. Used by permission ©1941 by Clarke, Irwin & Company Ltd.

5. Swanton, *Contributions to the Ethnology of the Haida,* p. 79.

6. Ibid, p. 94.

7. Philip Drucker, *Indians of the Northwest Coast,* Bureau of American Ethnology, Smithsonian Institution Anthropological Handbook No. 10, (New York: McGraw-Hill Book Co. Inc., 1955), p. 166.

Chapter 4 NOTES

1. F.V. Longstaff, "The Beginnings of the Pacific Station and Esquimalt Royal Naval Establishment," third annual report and proceedings, British Columbia Historical Association, 1925.

2. George M. Dawson Diary, August 18, 1878, Department of Rare Books and Special Collections of the McGill University Libraries.

3. A. Sutherland Brown, "Geology of the Queen Charlotte Islands," *British Columbia Department of Mines and Petroleum Resources Bulletin* No. 54, (Victoria, 1968), and interviews with the author of this bulletin.

4. *A Narrative of the Adventures and Sufferings of John R. Jewitt* (Middletown: Loomis and Richards, 1815), p. 77.

Chapter 5 NOTES

1. Newton H. Chittenden, *Official Report of the Exploration of the Queen Charlotte Islands for the Government of British Columbia,* Victoria, 1884, Progress Report No. 4, p. 55.

2. *Annual Report of the Minister of Mines, 1906,* Province of British Columbia, Victoria: King's Printer, 1907, p. 81.

3. Diary of Survey of Black Slate Deposit, Rutherford correspondence, Provincial Archives of British Columbia.

4. Dr. Arthur Irwin, Minerals Division, Indian Affairs, Ottawa, personal communication, 1977.

5. Statutes, Province of British Columbia. No. 617 Land Act.

Chapter 6 NOTES

1. Robin Kathleen Wright, "Haida Argillite Pipes," M.A. Thesis, University of Washington 1977, p. 26.

2. Newcombe correspondence, miscellaneous notes on Haida slate 6c, Provincial Archives of British Columbia. The sample was sent by a W.H. Dempster.

3. Knut Fladmark, personal communication, 1977.

4. Thomas Deasy to Leigh M. Pearsall, letter dated August 5, 1924; Deasy correspondence, Provincial Archives of British Columbia.

5. Lloyd Hooper, personal communication, 1978.

Chapter 7 NOTES

1. George T. Emmons, "Slate Mirrors of the Tsimshian," *Indian Notes and Monographs,* Museum of the American Indian, Heye Foundation, 1921, pp. 7-10.

2. Dawson diaries, August 18, 1878.

3. George Dixon, *A Voyage Round the World,* (London: 1789), p. 243.

4. Knut Fladmark, personal communication, January 19, 1977.

5. George M. Dawson, *Report on the Queen Charlotte Islands 1878,* (Montreal: Dawson Brothers 1880), p. 33B.

6. "Historical Archaeology in North America," edited by Ronald M. Getty and Knut R. Fladmark, Department of Archaeology, University of Calgary, 1973, p. 76.

7. William Newcombe, in letter to Marius Barbeau, Victoria, March 15, 1928; Canadian Centre for Folk Culture Studies, National Museum of Man, National Museums Canada, Ottawa.

8. Knut Fladmark, personal communication, 1977.

Chapter 8 NOTES

1. George M. Dawson, *Report on the Queen Charlotte Islands 1878,* (Montreal: Dawson Brothers 1880), p. 114B.

2. Nancy J. Turner and Roy L. Taylor, "A review of the Northwest Coast tobacco mystery", *Syesis,* Vol. 5 (1972), p. 250.

3. Newcombe notes, miscellaneous ethnological No. 81, Provincial Archives of British Columbia.

4. Ibid, extract from letter to Dr. Charles F. Newcombe from Rev. J.H. Keen.

5. Robin Kathleen Wright, "Haida Argillite Pipes," M.A. Thesis, University of Washington 1977, p. 35.

6. R. H. Hall, "Wondaw," *The Beaver,* July, 1924, pp. 366-367.

7. Robin Kathleen Wright, "Haida Argillite Pipes," p. 37.

8. George Catlin, *North American Indians,* (Edinburgh: John Grant, 1926), p. 263.

9. Ibid, Vol. 2, letter No. 54.

10. John C. Ewers, senior ethnologist, National Museum of Natural History, Smithsonian Institution, personal communication March 16, 1978.

11. Christian Feest, personal communication Aug. 1. 1978.

12. John Scouler, "Journal of a Voyage to North West America 1824-26," *Oregon Historical Quarterly,* March, 1905, p. 178.

13. Aurel Krause, *The Tlingit Indians,* translated by Erna Gunther,(Seattle: University of Washington Press, 1956), pp. 141-198.

14. George M. Dawson, *Report on the Queen Charlotte Islands 1878,* p. 122B.

15. Andreas Lommel, *Shamanism: The beginnings of art,* (New York-Toronto: McGraw-Hill Book Co., 1967), pp. 25-148.

16. Deasy correspondence, letter from Deasy to Judge F.W. Howay, Masset, July 26, 1921, Provincial Archives of British Columbia.

Chapter 9 NOTES

1. Wilson Duff, "Mute Relics of Haida Tribe's Ghost Villages," *Smithsonian Magazine,* September, 1976, pp. 84-87. Duff's spelling of Hoya is Koyah.

2. Dawson diaries, August 13, 1878.

3. John Scouler, "Journal of a Voyage to North West America 1824-26," *Oregon Historical Quarterly,* March, 1905, p. 192.

4. Etienne Marchand, *A Voyage Round the World 1791,* (Paris: 1801), p. 338.

5. James W. van Stone, "An Early Nineteenth Century Artist in Alaska, Louis Choris and the first Kotzebue Expedition," *Pacific Northwest Quarterly* Vol. 51, No. 4, October, 1906, p. 16.

6. George M. Dawson, *The Extinct Northern Sea-Cow and Early Russian Exploration in the North Pacific,* 1894.

7. Pirjo Varjola, Museovirasto, Helsinki, Finland, personal communication, June 14, 1977.

8. *The Journals of Captain James Cook on His Voyage of Discovery: The Voyage of the Resolution and Adventure 1772-1775,* edited by J.C. Beaglehole (Cambridge: University Press, 1961), p. 532, Published for the Hakluyt Society.

9. John Scouler, "Observations on the Indigenous Tribes of the North West Coast of America," *The Journal of the Royal Geographical Society of London,* Vol. 11, (1841), p. 218.

10. George Verne Blue, "Green's Missionary Report on Oregon, 1829," *Oregon Historical Quarterly,* Vol. XXX, No. 3, September, 1929, p. 271.

11. Jonathan S. Green, *Journal of a Tour on the North West Coast of America in the year 1829,* Reprint for New York City: Charles Fred Heartman, (1915), pp. 84-86.

Chapter 10 NOTES

1. C.F. Newcombe notebook 1902, Newcombe collection, Provincial Archives of British Columbia.

2. John Scouler, "Journal of a Voyage to North West America 1824-26," *Oregon Historical Quarterly,* March, 1905, p. 193.

3. Robert Brown, "On the Physical Geography of the Queen Charlotte Islands," Proceedings of the Royal Geographical Society, Session 1868-69, p. 388.

4. James Douglas, Record Office Transcripts, Hudson's Bay Company, Vol. 726, 1856.

5. Benjamin II on British Columbia, a section from his *Drei Jahre in Amerika* translated by Martin Wolff, issued by the Archives Committee of the Canadian Jewish Congress, Montreal, April, 1940, p. 1.

6. *Three Years in America* Vol. II by (I.J.) Benjamin translated from the German by Charles Reznikoff; The Jewish Publication Society of America, Philadelphia, 1956, pp. 145-146.

7. Robert Brown, "On the Physical Geography," etc., p. 389.

8. Sophia Cracroft, *Lady Franklin Visits the Pacific Northwest,* edited by Dorothy Blakey Smith (Victoria: Public Archives, 1974), p. 79.

9. James Cooper, harbormaster at Esquimalt, report of October 10, 1860, of cruise of H.M.S. *Alert,* Colonial correspondence File 347, Provincial Archives of British Columbia.

10. *The Daily British Colonist,* April 18, 1861.

Chapter 11 NOTES

1. George M. Dawson, *Report on the Queen Charlotte Islands* 1878, p. 105B.

2. W.H. Collison, *In the Wake of the War Canoe,* (London: 1915), p. 107.

3. W.H. Kearny, New Westminister, to Thomas Deasy, undated letter, Deasy correspondence, Provincial Archives of British Columbia.

4. W.H. Collison letter dated February, 1877 Masset; Church Missionary Society, London.

5. Ibid.

6. W.H. Collison letter dated April 4, 1878; Church Missionary Society, London.
7. Franz Boas, *Popular Science Monthly,* March, 1888.
8. J.H. van den Brink, *The Haida Indians,* (Leiden: E.J. Brill, 1974), p. 90.
9. Marius Barbeau called him Lovatt Miller but, as Richard S. Wilson points out, Robert, his correct name, was difficult for the Haida to pronounce, and Barbeau's ear apparently did not detect the mispronunciation.
10. R. Maynard diary, Trip to Alaska 1882, Provincial Archives of British Columbia.
11. James Deans's notes, Field Museum of Natural History, Chicago.

Chapter 12 NOTES

1. George M. Dawson, *Report on the Queen Charlotte Islands,* p. 160B. Exchanging of names by chiefs and ships' captains was a common gesture of goodwill during the early maritime fur trade.
2. "Worthy Haida Chief," *Victoria Daily Colonist,* June 26, 1897, p. 6.
3. Ibid.
4. Newton H. Chittenden, *Official Report on the Exploration of the Queen Charlotte Islands,* 1884, p. 72.
5. Lavina Lightbown, personal communication, 1978.
6. Ibid.
7. Ibid.
8. Ibid.
9. Ibid.

Chapter 13 NOTES

1. Alfred Adams to Thomas Deasy letter, undated except for 1934, Deasy correspondence, Provincial Archives of British Columbia.
2. M.J. Williams to W.A. Newcombe letter July 17, 1934, Newcombe correspondence (uncataloged) Provincial Archives of British Columbia.
3. Lyn Harrington, "Haida Carver in Argillite," *Canadian Geographical Journal,* July, 1951, p. 38.
4. Transactions involving Thomas Deasy, Deasy correspondence, Provincial Archives of British Columbia.
5. Thomas Deasy, letter to Indian Affairs March 2, 1918, quoted by J.H. van den Brink, *The Haida Indians* (Leiden: E.J. Brill, 1974), p. 116.
6. Lloyd Hooper, personal communication, 1978.
7. Carole Natalie Kaufmann, Robin Kathleen Wright, Wilson Duff.

Chapter 14 NOTES

1. Gordon Jolliffe, a merchant of Queen Charlotte City, was both a collector and dealer in argillite.
2. Andrew Brown (1879-1962), a Masset argillite carver.
3. By placing his figure of Steel at the bottom of the pole, the carver relegated him to a position of least importance.
4. Davidson saw an analogy in shape between a wad of telegrams and a classic square, flat depiction of a beaver house, sometimes including a fish, which appears in Haida designs, drawn from a well-known legend.

Chapter 15 NOTES

1. Reg Ashwell, "The Art of Pat McGuire," *Westworld,* September-October, 1976, p. 35.
2. Mike McGuire, personal communication, 1978.

Chapter 16 NOTES

1. George Yeltatzie, personal communication, 1978.

Chapter 17 NOTES

1. John Swanton, *Contributions to the Ethnology of the Haida,* Vol. 5, p. 79.
2. Ibid., p. 107.
3. Ibid., p. 112.
4. Ibid., p. 29.

Chapter 18 NOTES

1. Ron Hamilton, personal communication, 1978.
2. John Swanton, *Contributions to the Ethnology of the Haida,* Vol. 8, p. 27.
3. James Deans, *Tales from the Totems of the Hidery,* Vol. 2, (Chicago: 1899), Archives of the International Folk-lore Association, p. 374.
4. Ibid., p. 61.

Chapter 19 NOTES

1. George M. Dawson, *Report on the Queen Charlotte Islands* 1878, p. 107B.

Chapter 20 NOTES

1. Marius Barbeau, *Haida Myths Illustrated in Argillite Carvings,* Bulletin No. 127, Anthropological Series No. 32, National Museum of Canada, 1953, p. 376-77.
2. George Catlin, *North American Indians,* Vol. 1, (Edinburgh: John Grant, 1926), p. 263.
3. Wilson Duff, *The Indian History of British Columbia,* Vol. 1, Anthropology in British Columbia Memoir No. 5, (1964), Provincial Museum, p. 82.
4. Dr. Martin Hocking, personal communication, 1978.
5. C.F. Newcombe-George T. Emmons correspondence, Newcombe correspondence (uncataloged) PABC.
6. Robin K. Wright, "Haida Argillite Pipes," M.A. Thesis, University of Washington, 1977, p. 48.

Chapter 21 NOTES

1. Claude Lévi-Strauss, "The Art of the Northwest Coast at the American Museum of Natural History," *Gazette des Beaux-Arts 24* (1943), p. 180.

Chapter 22 NOTES

1. William Fraser Tolmie, *History of Puget Sound and Northwest Coast,* 1878, p. 14, Provincial Archives of British Columbia.
2. Derek Pethick, *S.S. Beaver: The Ship That Saved the West,* (Vancouver: 1970), Mitchell Press Ltd., pp. 24-41.
3. *The Reminiscences of Doctor John Sebastian Helmcken,* edited by Dorothy Blakey Smith, (Vancouver: University of British Columbia Press, 1975), p. 132.
4. D.W. Higgins, *The Mystic Spring,* (Toronto: 1904), William Briggs, p. 269.
5. Franz Boas, notes in *The Chilkat Blanket,* by George T. Emmons, Memoirs of the American Museum of Natural History, Vol. III 1907, p. 371.

Chapter 23 NOTES

1. Marius Barbeau, *Haida Carvers in Argillite,* Bulletin No. 139, National Museum of Canada, Queen's Printer, 1957, pp. 4-9.
2. W.C.P. Baylee, "Vancouver and Queen Charlotte's Island," *The Colonial Church Chronicle,* May, 1854, p. 414.

3. Etienne Marchand, *A Voyage Round the World,* Vol. 1, Paris: 1801, p. 298. This edition was translated from the French by the French historian Comte Charles Pierre de Fleurieu of the National Institute of Arts and Sciences, Paris, and was based on the journal of Prosper Chanal, one of the captains on the Marchand expedition. The original was printed in Paris in 1797.

Chapter 24 NOTES

1. Sotheby's Catalogue of the Cole Collection of Pacific Northwest Coast Art, p. 11.
2. G.H. Inskip, "Remarks on some Harbours of Queen Charlotte Islands, North-West Coast of America, " *The Nautical Magazine and Naval Chronicle,* December, 1855, p. 621.
3. Frederick Whymper, *Travel and Adventure in the Territory of Alaska,* (New York: 1869), Harper & Brothers, p. 105.
4. James Deans, *Tales from the Totems of the Hidery,* p. 11.
5. Dawson Diaries Queen Charlotte Islands Cruise (Aug. 23) 1878, McGill University Library, Montreal.

Chapter 25 NOTES

1. Nick Gessler and Trisha Gessler, "A comparative analysis of argillite from Kiusta," *Syesis* Vol. 9, (1976), pp. 13-18.
2. Marius Barbeau, *Haida Carvers in Argillite,* p. 10.
3. Ibid., pp. 32-55.
4. Deasy correspondence, Provincial Archives of British Columbia.
5. Dawson Diaries Queen Charlotte Islands Cruise 1878, McGill University Library, Montreal.

Chapter 26 NOTES

1. Marius Barbeau, *Haida Carvers in Argillite,* pp. 29-32.

Chapter 27 NOTES

1. Erna Gunther, *Art in the Life of the Northwest Coast Indians,* (Seattle: 1966), Superior Publishing Co., p. 168.
2. James Swan, "The Carvings and Heraldic Paintings of the Haida Indians," *West Shore,* August, 1884, p. 254.

Chapter 28 NOTES

1. Charles Hill-Tout, "A Unique Native Carving," *Museum and Art Notes;* Art, Historical and Scientific Association of Vancouver, June, 1932, p. 4.
2. Harry Beasley to William Newcombe September 5, 1936, Newcombe correspondence (uncataloged) Provincial Archives of British Columbia.

Chapter 29 NOTES

1. Knut Fladmark, personal communication, 1977.
2. George Dawson, *Report on the Queen Charlotte Islands,* p. 108B.

Chapter 31 NOTES

1. Marius Barbeau, *Haida Carvers in Argillite,* p. 179.
2. Richard S. Wilson of Skidegate has heard from oldtimers that Chapman died of the effects of exposure after a boat he occupied overturned near North Island. If this was so, it could account for the absence of a death record.
3. Marius Barbeau, *Haida Carvers in Argillite,* p. 184.

4. George Raley papers, Provincial Archives of British Columbia.
5. C.F. Newcombe miscellaneous ethnographical notes, Newcombe collection, Provincial Archives of British Columbia.
6. John Cross file, undated Vancouver newspaper clipping, Provincial Archives of British Columbia.
7. George M. Dawson, *Report on the Queen Charlotte Islands 1878*, p. 169B.
8. C.F. Newcombe notebook 1903, Newcombe collection, Provincial Archives of British Columbia.
9. Erna Gunther, *Art in the Life of the Northwest Coast Indians*, (Seattle: 1966), Superior Publishing Co., p. 174.
10. Marius Barbeau, *Haida Carvers in Argillite*, p. 97.
11. Ibid., p. 130.
12. Lloyd Hooper, personal communication, 1978.
13. Ibid.
14. Marius Barbeau, *Haida Carvers in Argillite*, p. 108.
15. Arthur Moody, personal communication, 1961.

Chapter 32 NOTES

1. Erna Siebert and Werner Forman, *North American Indian Art*, (London: Paul Hamlyn Ltd., 1967), p. 9.
2. G.P.V. Akrigg and Helen B. Akrigg, *British Columbia Chronicle 1778-1846* (Vancouver: Discovery Press, 1975), p. 331.
3. Rev. F.M. Best, Saffron Walden, Essex, family genealogist, personal communication, 1978.
4. *Birmingham Daily Post* December 16, 1870.
5. Powell biographical files, Provincial Archives of British Columbia.
6. Ibid.
7. *Ethnography of Franz Boas: Letters and Diaries of Franz Boas Written on the Northwest Coast from 1886 to 1931*. Rohner, Ronald P., ed. (Chicago: University of Chicago Press, 1969) Family letters (1897), p. 221.
8. Johan Adrian Jacobsen, *Alaskan Voyage 1881-1883*, from the German text of Adrian Woldt, translated by Erna Gunther, (Chicago: The University of Chicago Press, 1977), pp. 7-24.
9. Francis Poole, *Queen Charlotte Islands*, (London: 1872), p. 256.
10. Charles Harrison letter dated May 26, 1886; data courtesy J.H. van den Brink.
11. *Colonist*, October 31, 1897, p. 8.
12. Dorsey, Field Chicago Museum, to C.F. Newcombe, letter dated October 26, 1897; Newcombe correspondence, Provincial Archives of British Columbia.
13. Emmons to C.F. Newcombe, letter dated March 7, 1908, Newcombe correspondence,Provincial Archives of British Columbia.
14. Dawson to C.F. Newcombe, letter dated November 9, 1897, Newcombe correspondence,Provincial Archives of British Columbia.
15. References Newcombe correspondence, Provincial Archives of British Columbia.
16. Drucker to W.A. Newcombe, letter dated April 8, 1937, Newcombe correspondence,Provincial Archives of British Columbia.
17. *Vancouver Sun*, April 26, 1913, p. 9.
18. Mary Lipsett to W.A. Newcombe, letter dated September 26, 1941, Newcombe correspondence,Provincial Archives of British Columbia.
19. Ibid.

1. *Florida Times-Union,* Jacksonville, Fla., April 14, 1953, p. 20.
2. Deasy correspondence, Provincial Archives of British Columbia, the source of most of the information and quotations cited in this chapter.
3. *Florida Times-Union,* April 11, 1964, p. 28.

1. Emmons to C.F. Newcombe, letter dated February 22, 1903; Newcombe correspondence, Provincial Archives of British Columbia.

Selected Bibliography

AKRIGG, G.P.V. and Helen B.:
 British Columbia Chronicle 1778-1846. Vancouver: Discovery Press, 1975.

APPLETON, Frank M.:
 "The Life and Art of Charlie Edenshaw," *Canadian Geographical Journal,* July, 1970.

ASHWELL, Reg.:
 "The Art of Pat McGuire," *Westworld,* September-October, 1976.

BARBEAU, C. Marius:
 Totem Poles (Two Vols.) National Museum of Canada Bulletin 119, 1950.
 Haida Myths: Illustrated in Argillite Carvings. National Museum of Canada Bulletin 127, 1953. *Haida Carvers in Argillite.* National Museum of Canada Bulletin 139, 1957.
 Medicine-Men on the North Pacific Coast. National Museum of Canada Bulletin 152, 1958.

BARBEAU, Marius, and WILSON, Clifford:
 "Tobacco for the Fur Trade," *The Beaver* (March), 1944.

BAYLEE, W.C.P.:
 "Vancouver and Queen Charlotte's Island," *The Colonial Church Chronicle,* May, 1854.

BEAGLEHOLE, J.C.:
 The Voyage of the Resolution and Discovery 1776-1780, Two Vols., Cambridge: University Press 1967. Published for the Hakluyt Society.

BENJAMIN, I.J.:
 Three Years in America, Vol. II, translated from the German by Charles Reznikoff, The Jewish Publication Society of America, Philadephia, 1956.

BOAS, Franz:
 The Ethnography of Franz Boas, Letters and Diaries Written on the Northwest Coast from 1886-1931 compiled and edited by Ronald P. Rohner. Chicago: University of Chicago Press, 1969.

BROWN, Robert:
 On the Physical Geography of the Queen Charlotte Islands, Proceedings of the Royal Geographical Society session 1868-1869.

CARR, Emily:
 Klee Wyck. Toronto: Oxford University Press, 1941.

CATLIN, George:
 North American Indians, Being Letters and notes on their manners, customs, and conditions, written during eight years' travel amongst the wildest tribes of North America, 1832-1839. John Grant: Edinburgh, 1926.

CHEVIGNY, Hector:
 Russian America. New York: Viking Press, 1965.

CHITTENDEN, Newton H.:
 Official Report of the Exploration of the Queen Charlotte Islands for the Government of British Columbia, Victoria, 1884.

COLLISON, W.H.:
 In the Wake of the War Canoe. London, 1915.

 Letters to the Committee of the Church Missionary Society, London, England, 1873-1880.

CRACROFT, Sophia:
Lady Franklin Visits the Pacific Northwest, edited by Dorothy Blakey Smith. Victoria: Provincial Archives, 1974.

DALZELL, Kathleen E.:
The Queen Charlotte Islands 1774-1966. Terrace, B.C.: C.M. Adam 1968.

DAWSON, George:
"Report on the Queen Charlotte Islands 1878," Geological Survey of Canada, Montreal, 1880.
Dawson Diaries, McGill University Library.
The Extinct Northern Sea-Cow and Early Russian Exploration in the North Pacific. Lecture to the Royal Geographical Society, 1894.

DEANS, James:
Tales from the Totems of the Hidery, Vol. 2. Archives of the International Folk-lore Association, Chicago, 1899.
Notes on Haida Model Houses. Field Museum of Natural History, Chicago.

DEASY, Thomas:
Correspondence 1919-1935, PABC.

DIXON, George:
A Voyage Round the World, London, 1789.

DOCKSTADER, Frederick J.:
Indian Art in America. Greenwich, Conn.: New York Graphic Society, 1962.

DOUGLAS, James:
Record Office Transcripts, Hudson's Bay Company, PABC.

DRUCKER, Philip:
Indians of the Northwest Coast. Bureau of American Ethnology, Smithsonian Institution Anthropological Handbook No. 10, New York: McGraw-Hill, 1955.

DUFF, Wilson:
The Indian History of British Columbia. Vol. 1, Anthropology in British Columbia, memoir No. 5, 1964.
Arts of the Raven. Masterworks by the Northwest Coast Indians. Catalog text, Vancouver Art Gallery, 1967.
"Contributions of Marius Barbeau to West Coast Ethnology," excerpt from *Anthropologica,* 1964.
"Mute Relics of Haida Tribe's Ghost Villages," *Smithsonian Magazine,* September, 1976.

ELISCU, Frank:
Slate of Soft Stone Sculpture. Philadelphia: Chilton Book Co., 1972.

ELLS, R.W.:
"Report on Graham Island," Geological Survey of Canada, 1906.

EMMONS, George Thorton:
Slate Mirrors of the Tsimshian. Indian Notes and Monographs Series, Museum of the American Indian, Heye Foundation, 1921.
Collections, PABC.

FLADMARK, Knut R.:
The Richardson Ranch Site: A 19th Century Haida House, Historical Archaeology in Northwestern North America, edited by Ronald M. Getty and Knut R. Fladmark, Department of Archaeology, University of Calgary, 1973.

GESSLER, Nick and Trisha:
"A Comparative Analysis of Argillite from Kiusta," *Syesis,* Vol. 9, 1976.

GLATTHAAR, Trisha Corliss:
"Tom Price (c.1860-1927): The Art and Style of a Haida Artist." M.A. Thesis, University of British Columbia, Vancouver, 1970.

GREEN, Jonathan S.:
Journal of a Tour on the North West Coast of America in the year 1829, reprinted for New York: Charles Fred Heartman, 1915.

GUNTHER, Erna:
Art in the Life of the Northwest Coast Indian. Seattle: Superior Publishing Co., 1966.
Indian Life on the Northwest Coast of North America. Chicago: University of Chicago Press, 1972.

HARNER, Michael J. and ELASSER, Albert B.:
Art of the Northwest Coast. Catalog for an exhibition at the Robert H. Lowie Museum of

Anthropology at University of California at Berkeley, 1965.

HARRINGTON, Lyn:
"Haida Carver in Argillite," *Canadian Geographical Journal,* July, 1952.

HILL-TOUT, Charles:
"A Unique Native Carving," *Museum and Art Notes,* Art, Historical and Scientific
Association, Vancouver, June, 1932.

HOLM, Bill:
Northwest Coast Indian Art: An Analysis of Form. Seattle: University of Washington Press,
1965.

INVERARITY, Robert Bruce:
Art of the Northwest Coast Indian. Berkeley and Los Angeles: University of California Press,
1950.

JACOBSEN, Adrian:
Alaskan Voyage 1881-1883, translated by Erna Gunther from the German text by Adrian
Woldt. Chicago: University of Chicago Press, 1977.

JACOBSEN, Fillip:
Reminiscences, PABC.

JEWITT, John:
A Narrative of the Adventures and Suffering of John R. Jewitt. Middletown, Conn: Loomis and
Richards, 1815.

KANE, Paul:
Paul Kane's Frontier, edited by J.R. Harper. Toronto: University of Toronto Press, 1971.

KAUFMANN, Carole Natalie:
"Changes in Haida Indian Argillite Carvings 1820-1910." Ph.D. Thesis, University of
California, Los Angeles, 1969.
Functional Aspects of Haida Argillite Carvings, in Ethnic and Tourist Arts from the Fourth World,
edited by Nelson H.H. Graburn. Berkeley, Los Angeles, London: University of
California Press, 1977.

KRAUSE, Aurel:
The Tlingit Indians, translated by Erna Gunther. Seattle: University of Washington Press,
1956.

LAVIOLETTE, Forrest E.:
The Struggle for Survival: Indian Cultures and the Protestant Ethic in British Columbia. Toronto:
University of Toronto Press, 1973.

LOMMEL, Andreas:
Shamanism: The Beginnings of Art. New York and Toronto: McGraw-Hill Book Co., 1967.

LONGSTAFF, F.V.:
The Beginnings of the Pacific Station and Esquimalt Royal Naval Establishment. Third annual report
and proceedings, B.C. Historical Association, 1925.

McCRACKEN, Harold:
George Catlin and the Old Frontier. New York: Dial Press, 1959.

MACNAIR, Peter:
"Inheritance and Innovation: Northwest Coast Artists Today," *artscanada,* December
1973 - January 1974.

MARCHAND, Etienne:
A Voyage Round the World. Paris, 1797; London 1801.

MAYNARD, R.
Diary, PABC.

MEEK, Jack:
Primitive Musical Instruments of the North West Coast, PABC.

MINISTER OF MINES:
Annual report, Province of British Columbia, 1907.

MILLER, Polly and Leon Gordon:
Lost Heritage of Alaska. Cleveland: The World Publishing Co., 1967.

MORRIS, Desmond:
Manwatching, a Field Guide to Human Behavior. Harry N. Abrams, Inc., New York,
1977.

MORRIS, Percy A.:
A Field Guide to Shells of the Pacific Coast and Hawaii. Boston: Houghton Mifflin, 1966.

NEWCOMBE, Charles Frederick:
Correspondence, collections, notebooks, PABC.

NEWCOMBE, William:
Correspondence, PABC.

NIBLACK, Albert P.:
The Coast Indians of Southern Alaska and Northern British Columbia, Report 1888, United States National Museum, 1890.

PETHICK, Derek:
S.S. Beaver, The Ship That Saved the West. Mitchell Press Ltd., Vancouver, 1970.

POOLE, Francis:
Queen Charlotte Islands, a Narrative of Discovery and Adventure in the North Pacific. London, 1872.

PROVINCIAL ARCHIVES OF BRITISH COLUMBIA:
Colonial Office correspondence.

RUTHERFORD, J.A.:
Correspondence, PABC.

SCOULER, John:
"Journal of a Voyage to North West America 1824-26," *Oregon Historical Quarterly,* March, 1905.

SIEBERT, Erna and FORMAN, Werner:
North American Indian Art. London: Paul Hamlyn Ltd., 1967.

STURGIS, William:
The Journal of William Sturgis, edited by S.W. Jackman, Victoria: Sono Nis Press 1978.

SUTHERLAND BROWN, A.:
"Geology of the Queen Charlotte Islands," British Columbia Department of Mines and Petroleum Resources Bulletin No. 54, 1968.

SWAN, James:
"The Carvings and Heraldic Paintings of the Haida Indians," *West Shore,* August, 1884.

SWANTON, John R.:
Contributions to the Ethnology of the Haida, Memoirs, American Museum of Natural History, Jesup North Pacific Expedition, vol. 5, 1905; vol. 8, 1909; vol. 10, 1910.
Haida Texts and Myths, Bureau of American Ethnology, Washington, D.C. Bulletin 29, 1905.
Haida Songs (with Franz Boas), Publications of the American Ethnological Society vol. 3, 1912.
The Indian Tribes of North America. Smithsonian Institution Bureau of American Ethnology, Bulletin 145, 1952.

TOLMIE, William Fraser:
History of Puget Sound and Northwest Coast. Victoria: 1878. PABC.

TURNER, N. and TAYLOR, R.L.:
"A Review of the Northwest Coast Tobacco Mystery," *Syesis,* Vol. 5, 1972.

VAN DEN BRINK, J.H.:
The Haida Indians - Cultural Change Mainly between 1876-1970. Leiden: E.J. Brill, 1974.

VAN STONE, James W.:
"An Early Nineteenth-Century Artist in Alaska, Louis Choris and the first Kotzebue Expedition." *Pacific Northwest Quarterly,* October, 1960.

WHYMPER, Frederick:
Travel and Adventure in the Territory of Alaska, formerly Russian America - now ceded to the United States - and in various other parts of the North Pacific. New York: Harper & Bros., 1869.

WRIGHT, Robin Kathleen:
"Haida Argillite Pipes." M.A. Thesis, University of Washington, Seattle, 1977.
"Haida Argillite Ship Pipes," *American Indian Art magazine,* Winter (1979), pp. 40-47.

Index